The Sense of Semblance

The Sense of Semblance

PHILOSOPHICAL ANALYSES
OF HOLOCAUST ART

Henry W. Pickford

FORDHAM UNIVERSITY PRESS *New York* 2013

THIS BOOK IS MADE POSSIBLE BY A COLLABORATIVE GRANT
FROM THE ANDREW W. MELLON FOUNDATION.

Library of Congress Cataloging-in-Publication Data

Pickford, Henry W.
 The sense of semblance : philosophical analyses of
Holocaust art / Henry W. Pickford.
 pages cm
 Summary: "Drawing on work in contemporary
analytic philosophy and Adorno's normative
aesthetic theory, this book aims to show how selected
Holocaust artworks in a variety of media (lyric poetry
by Paul Celan, Holocaust memorials, quotational
texts by Heimrad Bäcker, Claude Lanzmann's film
Shoah and Art Spiegelman's graphic novel Maus)
fulfill both aesthetic and historical requirements of
the genre" — Provided by publisher.
 Includes bibliographical references and index.
 ISBN 978-0-8232-4540-6 (hardback)
 1. Holocaust, Jewish (1939–1945), and the arts.
I. Title.
NX180.H59.P53 2013
700'.458405318—dc23
 2012027761

Printed in the United States of America

15 14 13 5 4 3 2 1

First edition

for my mother and in memory of my father

CONTENTS

ACKNOWLEDGMENTS

A critical writer, so it seems to me, would also do best to orient his method in accordance with this little adage [*Primus sapientiae gradus est, falsa intelligere; secundus, vera cognoscere*]. First let him find someone to argue with; he will thereby gradually find his way into the subject matter, and the rest will follow of its own accord.

—G. E. LESSING[1]

This book began while I was living and studying in Berlin, where to my astonishment a political and cultural clamor arose in response to the design and unveiling of the memorial in the Neue Wache as the "Central Commemorative Site of the Federal Republic of Germany." I wrote a journalistic essay on the controversy that grew into an article and eventually Chapter 2 of the present study. I am grateful to my advisors, Karsten Harries, Winfried Menninghaus, and most especially, William Mills Todd, for their valuable advice and friendship over the years. During this time I benefited greatly from conversations with Geoffrey Hartman, Otto Pöggeler, Michael Theunissen, Albrecht Wellmer, and especially Christoph Menke. Wellmer's "Mittwochskolloquium" at the Institut für Hermeneutik was an ideal forum for debate, dialogue, and intellectual camaraderie during my time in Berlin. This book is also informed by the egalitarian and ecumenical, but no less rigorous spirit of intellectual inquiry I encountered while subsequently studying philosophy at the University of Pittsburgh, a spirit that has sustained me throughout this project. For their tuition, generosity, and support, I thank Bob Brandom, Steve Engstrom, Anil Gupta, John McDowell, and Kieran Setiya. Several colleagues and friends, including Lorna Finlayson, Gordon Finlayson, Benjamin Hale, and Chad Kautzer, read parts of the manuscript and offered invaluable suggestions. R. Clifton Spargo and Michael G. Levine revealed themselves as external readers of the manuscript for Fordham University Press; their copious, meticulous, and astute criticisms and recommendations improved the final version in countless ways.

This book was completed during a challenging year, when I realized my great fortune to have such sage and steadfast friends, in particular, Cordula Bandt, Ken Gemes, Barry Scherr, Tim Sergay, Pam Shime, Rochelle Tobias, William Todd, Eric Walczak, Christine Young, and Kuang-Yu Young. At CU Boulder I want to thank the Philosophy Department for welcoming an interloper so warmly; I have benefited greatly from discussions, suggestions, and encouragement from David Boonin, Mitzi Lee, Graham Oddie, and most especially, Bob Hanna. Likewise, Scot Douglass, Zilla Goodman, Elissa Guralnick, Saskia Hintz, Jim Massengale, and Tracey Sands have all provided wise counsel and good cheer when most needed. I am also especially grateful to my department's program assistants, Karen Hawley and Janis Kaufman, whose conscientious and convivial support makes my work much, much easier. My thanks to Tim Riggs and Eric Walczak, who provided essential assistance with the visuals, and to Steve Bailey, wise in all things technical. My profound gratitude goes to Bruce Benson, president of the University of Colorado, Kathleen Bollard of Faculty Affairs, and especially John Frazee of Faculty Relations: without their judicious support, this book would not have been completed. Finally, I want to express my deepest appreciation to Helen Tartar, Tom Lay, and the entire staff at Fordham University Press, for support extending far beyond the typical purview of an academic press.

My thanks to the Fulbright Commission and the Deutscher Akademischer Austauschdienst for financial support during my sojourn in Berlin, the Deutsches Literturarchiv in Marbach, and Eric Celan, for permission to examine unpublished writings of Paul Celan, Barbara Schäche of the Landesarchiv Berlin for last minute help with photographs, and the University of Colorado, Boulder, for a Kayden grant that helped underwrite the costs of image reproductions and permissions.

Early versions of parts of Chapter 1 appeared in *Zeitschrift für Ästhetik und Allgemeine Kunstwissenschaft* 47.2 (2002) and *Essays in the Art and Theory of Translation*, edited by L. A. Grenoble and J. M. Kopper (Lewiston, NY: Edwin Mellen Press, 1997). An early version of Chapter 2 appeared in *Modernism/Modernity* 12.1 (2005). An early version of Chapter 3 appeared in *Modern Austrian Literature* 41.4 (2008). I thank the publishers for permission to reprint this material in revised form.

Introduction

The Judgment of Holocaust Art

Each artwork is a system of irreconcilability [*ein System von Unverein-barkeit*]. . . . By their spiritual mediation [the elements] enter into a contradictory relation with each other that appears in them at the same time that they strive to solve it. The elements are not arranged in juxtaposition but rather grind away at each other or draw each other in; the one seeks or repulses the other. This alone constitutes the nexus of the most demanding works.

—THEODOR W. ADORNO[1]

I. APPLIED NORMATIVE PHILOSOPHICAL AESTHETICS

Political controversies surrounding Holocaust memorials and museums, and critical debates regarding Holocaust testimonies, films, and literature, rely on an often unarticulated assumption: the possibility of successful and unsuccessful Holocaust artworks. If that is the case, what are the normative criteria of judgment for Holocaust artworks? How does a successful Holocaust artwork *work*; that is, how does it function, and where does a failed artwork go wrong? Are there specific requirements, or problems, inherent in any artwork, regardless of aesthetic medium, that purports to be about the Holocaust? This book aims to provide a philosophical-aesthetic framework for laying bare such requirements and appreciating the ensuing problems of Holocaust artworks, and for then considering various exemplary attempts to meet those requirements and solve those problems. Because the philosophical reflections that appear here are anchored firmly in the specific problems raised by Holocaust artworks—indeed, by individual artworks—in the chapters that follow, the relevant term would be *applied* philosophical aesthetics. And since the problems possess a normative aspect, for at issue is what a Holocaust artwork *should* be like if it is to succeed, this is a *normative* rather than exclusively descriptive inquiry.

In this respect the present study can be viewed as making explicit the implicit general normative requirements that perhaps motivated earlier critics in their evaluations of specific Holocaust literary texts. In his path-breaking 1975 book, Lawrence L. Langer, for instance, claimed that "there are two forces at work in . . . the literature of atrocity: historical fact and imaginative truth. . . . History provides the details—then abruptly stops. Literature seeks ways of exploring the implications and making them imaginatively available."[2] Langer thereby identifies the two potentially countervailing requirements in Holocaust art: that the work be historically accurate or authentic, and that it nonetheless be art. He sketched a psychological model of how these requirements might be met by the work and perceived by the reader:

> The significance of the literature of atrocity is its ability to evoke the atmosphere of monstrous fantasy that strikes any student of the Holocaust, and simultaneously to suggest the exact details of the experience in a way that forces the reader to fuse and reassess the importance of both. The result is exempted from the claims of literal truth but creates an imaginative reality possessing an autonomous dignity and form that paradoxically immerses us in perceptions about the literal truth which the mind ordinarily ignores or would like to avoid.[3]

Likewise other critics at that time sought evaluative criteria for their practical criticism of the emerging genre of "Holocaust literature" and saw the central tension inhabiting such artworks to be between historical fact and artistic imagination. Thus Alvin Rosenfeld and Sidra Ezrahi both aligned specific works along a spectrum from pre-dominantly documentary genres of diary and memoir, through "documentary literature" to myth as "the most radical absorption of the historical events into the imagination."[4] These critics' invocation of the artist's imagination, however, entails at least three dubious consequences. First, it shifts the focus of investigation from the artwork itself to the psychology of its production, which is less apposite in cases of nonliterary Holocaust artworks such as memorials and films. Second, if the imagination is more than merely a placeholder for the aesthetic features of an artwork, then the critic owes us at least a sketch of a theory of the imagination and its role in aesthetic production--no easy task.[5] Third, these critics' emphasis on aesthetic production obscures equally significant questions of aesthetic reception, since the success of a specific Holocaust artwork might well rely, at

least in part, on its cognitive or affective uptake by its audience. For these reasons, rather than speaking of the "imaginative transformation of history," the present study draws on philosophical aesthetics in order to specify as precisely as possible how a Holocaust artwork negotiates the demands of historical fact and aesthetic expression.

2. FIRST PRINCIPLES

By "Holocaust artwork" I mean the class of any artwork that is about the Holocaust, that is, the intentionality or content of which includes reference, direct or indirect, to the Nazi project of humiliation, deprivation, degradation, and extermination against the Jews and other marked groups.[6] Such a broadly stipulated definition allows me to consider artworks of quite different media: the lyric poetry of Paul Celan, public memorials in Berlin, concrete-quotational texts by Heimrad Bäcker, the film *Shoah,* and the graphic novel *Maus.* By extension, whatever general conclusions I draw about these specific works should *mutatis mutandis* hold for other artworks that fall within the extension of this class.

Working from such a definition also seems to track accurately the historical genesis of "Holocaust Studies" in Europe and the United States, where the subject matter is primary, and the disciplinary context secondary; thus the Shoah has been studied across disciplinary lines such as history, literary studies, art and architecture, film studies, and psychoanalysis. The enormity of the event, in epistemological, moral, and political terms, overshadows otherwise seemingly steadfast disciplinary boundaries.

The second reason to define Holocaust artwork as I have is that it arguably tracks specific desiderata that must be fulfilled by any member of its class. That is, I wish to claim that any Holocaust artwork, unlike artworks unrelated to the Holocaust or nonaesthetic works related to the Holocaust, must fulfill at least two requirements in order to be successful. First, it must maintain a *historical relation,* in that it must in some way refer to, invoke, bear an intentional relation to the Holocaust. Second, it must maintain an *aesthetic relation,* in that it must in some way evince aesthetic properties of some sort, properties that induce an aesthetic experience of the work by the subject.[7] One might wish to argue that there is a third desideratum, that a Holocaust artwork must maintain a *moral-political relation,* in that it must condemn the Holocaust or publicly mourn or honor its victims,

but I shall not assume so. One might object, for instance, that such a relation in fact short-circuits experience of the artwork by replacing such experience by, or subsuming it under, a proffered lesson or morale.[8] Therefore I think it sufficient if a Holocaust artwork display a tone and decorum proper to its subject matter, and such matters fall within the artwork's aesthetic relation.

If we understand the genre of Holocaust artwork in this way, then we obtain the contours of a certain problem: How can an artwork maintain both relations? If it loses the aesthetic relation, it becomes a historical document or artifact or "merely informative," or—perhaps the antithesis of bearing any aesthetic relation—pure chronicle. If it loses the historical relation, it becomes aesthetically autonomous or self-referential or "merely formal," or—the antithesis of bearing any historical relation—myth. A successful Holocaust artwork thus must maintain these two relations, must be *aesthetic-historical*. Furthermore, the two relations themselves appear to be related: they seem to be contraries and at least in some respects inversely related. By this I mean that the two relations can helpfully be viewed as two contrary *tendencies*: the more the artwork tends toward the historical, the more attenuated its aesthetic properties become, and the more it tends toward aesthetic autonomy, the more attenuated its historical reference becomes. This suggests that we think of the two relations as dialectically related: in one aspect being mutually independent (their respective tendencies), in another aspect being reciprocally dependent or co-constitutive (the tendencies' inverse relationship to each other). If we understand the dual desiderata of Holocaust artworks in this dialectical manner, then Adorno's reworking of philosophical aesthetics might provide us with a helpful general orientation within the tradition.[9]

3. THE DIALECTIC OF AESTHETIC SEMBLANCE

Adorno's *Aesthetic Theory* is the most sustained dialectical treatment of two traditions in the philosophy of art: aesthetic heteronomy, represented by Hegel, and aesthetic autonomy, represented by Kant.[10] While Adorno works within the Hegelian framework, he continually mobilizes Kantian insights concerning the aporetic nature of aesthetic experience in order to subvert the Hegelian theory of art as a potentially harmonious reconciliation of sensuous intuition and conceptual content.

Adorno clearly follows Hegel in seeing art as having a special rela-
tionship to *truth* and *history* (as opposed to a priori conditions of cog-
nition, for instance, as with Kant). Like Hegel's, Adorno's is a norma-
tive theory of art: only "genuine" or "authentic" artworks maintain
such a nonaesthetic truth-relation. For Hegel, beauty is "the sensuous
appearing [*scheinen*] of the Idea,"[11] that is, the complete harmony or
reconciliation of conceptual content expressed and sensuous mate-
rial *qua* medium of expression (in the Idealist vocabulary, reconcili-
ation of essence and appearance, universal and particular, spirit and
intuition, form and content, and so on). While arguably there are his-
torical instances of art that approach the harmonious reconciliation
between conceptual content and sensuous material (for Hegel, clas-
sical Greek sculpture and architecture), there is an implicit tension
between these two poles because the means—sensuous material—art
must employ in order to remain art defeats its goal of expressing an
ideal—nonsensuous—content.[12] That tension inheres in the very con-
cept deployed by Hegel to characterize art: as the *appearance* of a uni-
fied meaning, art is mere *semblance* or even *illusion*: the harmonious
depiction of an ideal exists merely in, and in virtue of, the medium
of aesthetic presentation, not in actuality. This is art's doubled char-
acter as "*Schein*"—a term translated as "appearance" as well as
"semblance" or "illusion." Because art's medium of expression is
not wholly ideal or conceptual, in that the medium relies on sensu-
ous experience, Hegel argues that art was necessarily superseded by
the conceptual discourse of philosophy, whose discursive language is
equal to the task of expressing complex cognitive content.[13]

Adorno rejects the Hegelian norm of the harmonious reconcilia-
tion of this doubledness, for such harmony is "affirmative" and hence
uncritical in a society drastically in need of critique.[14] For Adorno, the
aesthetic affirmation belies the conditions of want and suffering inher-
ent in the modern late capitalist world and serves to maintain those
conditions.[15] More important for the argument of this book, how-
ever, such affirmation overlooks the constitutive "tension" between
the poles of cognitive content and sensible material:[16]

> According to their internal constitution, artworks are to dissolve
> everything that is heterogeneous to their form even though they are
> form only in relation to what they would like to make vanish. They
> impede what seeks to appear [*erscheinen*] in them according to their
> own a priori. They must conceal it, a concealment that their idea
> of truth opposes until they reject harmony. Without the memento

of contradiction and nonidentity, harmony would be aesthetically
irrelevant.[17]

That is, heteronomous elements and relations should dissolve into the
autonomous form of the artwork, but aesthetic autonomous form is
defined in contrast to, and hence dependence on, precisely such heter-
onomous relations.[18] Thus "dissonance is the truth about harmony"
and "the rebellion against semblance, art's dissatisfaction with itself,
has been an intermittent element [*Moment*] of its claim to truth from
time immemorial."[19] If objectivation is the development into an inde-
pendent, self-identical object, then "artworks themselves destroy
the claim to objectivation that they raise."[20] Hence, "today the only
works that really count are those which are no longer works at all."[21]

The constitutive conflict within art means that genuine art for
Adorno has a double task. On the one hand it must remain autono-
mous, a "*Fürsichsein*":[22] it should not be economically appropriated
as another fungible commodity or politically appropriated as a dis-
cursive "message." In the first case it simply repeats or imitates reign-
ing social conditions; in the second it simply becomes direct state-
ment.[23] In both cases art renounces its *specificum* as art, its "character
of semblance" (*Scheincharakter*): its capacity as artistically worked
sensuous materiality to elicit an aesthetic experience, which Adorno
understands as the *appearing* (*Erscheinen*) of *apparent* meaning or
sense (*Sinn*) beyond the sensuous elements themselves.[24] By contrast,
as art it must resist its own tendency toward unified aesthetic har-
mony; that is, it must also dialectically break or negate its *specificum*
as art—its *Scheincharakter*—and become a nonaesthetic "*Fürand-
eressein*."[25] The impossible task of genuine artworks, according to
Adorno, is to at once dynamically incorporate the tendency toward
aesthetic autonomy and the tendency toward aesthetic heteronomy,
whereby the experience of the artwork is precisely the perceived dyna-
mism of those countervailing tendencies.

This doubled requirement—that an artwork both adhere to its
autonomous logic as art and that it negate that logic—is expounded
by Adorno as the "antinomy" and the "dialectic of aesthetic sem-
blance [*Schein*]"[26] in *Aesthetic Theory*, though it dates back to the last
chapter of his earlier book on Kierkegaard.[27] For Adorno, *Schein* is
the historically changing but always potentially diremptive "aesthetic
a priori." Indeed the concept of *Schein* within the philosophical tradi-
tion is equally divided, between meaning "deception, illusion," on the
one hand, and "revelation, visibility," on the other.[28] On my reading,

Schein becomes the point of nonsubsumptive, negative-dialectical mediation between aesthetic autonomy and heteronomy, or in the case of Holocaust artworks, the aesthetic and the historical tendencies, respectively. As Albrecht Wellmer glosses: "The modern work of art must, in a single pass, both produce and negate aesthetic meaning; it must articulate meaning as the negation of meaning, balancing, so to speak, on the razor's edge between affirmative semblance and an anti-art that is bereft of semblance."[29] The successful or "authentic" artwork must *both* maintain *and* disintegrate aesthetic semblance in a negative-dialectical relationship in which aesthetic and historical elements, processes, properties constitute the artwork without achieving a harmonious, dialectically synthesized unity. We can term these dual desiderata the *normatively minimalist framework* for Holocaust artworks: "In artworks, the criterion of success is twofold: whether they succeed in integrating thematic strata and details into their immanent law of form and in this integration at the same time maintain what resists it and the fissures that occur in the process of integration."[30] In another passage Adorno restates the dialectic of aesthetic semblance as follows: "Art is true insofar as what speaks out of it—indeed, it itself—is conflicting and irreconciled, but this truth only becomes art's own when it synthesizes the dirempted and thus makes it determinate in its irreconcilability. Its paradoxical task is to attest to the irreconciled while at the same time tending toward reconciliation; this is only possible because of its non-discursive language."[31] Thus, according to Adorno, it is precisely thanks to the double-character of artworks, their nondiscursive (that is, nonconceptual) language, that they have the capacity to stage the conflict of countervailing tendencies (autonomous vs. heteronomous, sensuous vs. cognitive, aesthetic vs. historical).[32] Moreover, the artwork as it were contains the conflict through the *determinateness*, the specificity, of the conflicting elements and relations. Hence each individual artwork will require precise interpretation, a careful tracing of the irreconcilable conflicts that paradoxically constitute it.

Adorno identifies a number of hermeneutical consequences that arise from this double-character of art, which he also calls art's "riddle character" (*Rätselcharakter*).[33] Classical hermeneutics moves from the artwork or text to its meaning, but precisely that movement is suspended by aesthetic experience understood as the irreconcilable conflict between the elements of the artwork and its pretension to coherent sense. The artwork appears to make sense, elicits interpretation,

while refusing its remainderless translation into fully discursive cogni-
tive content. The antinomial character of aesthetic semblance entails
that "authentic"—that is, normatively successful—art traces out the
conflict within itself between aesthetic autonomy and heteronomy,
the site of which is *Schein* itself. Thus Adorno writes, "The task of
aesthetics is not to comprehend artworks as hermeneutical objects; in
the contemporary situation, it is their incomprehensibility that needs
to be comprehended."[34]

Perhaps not surprisingly, Adorno identifies a double-nature of the
corresponding experience of authentic artworks. The first element
is an internal processual experience, by which one engages with the
work as though reenacting or performing it, thus encountering the
conflicts that constitute it. Adorno's favored simile is the performance
of a musical score:

> Adequate performance requires the formulation of the work as a
> problem, the recognition of the irreconcilable demands, arising from
> the relation of the content [*Gehalt*] of the work to its appearance
> [*Erscheinung*], that confront the performer. . . . Since the work is
> antinomic, a fully adequate performance is actually not possible, for
> every performance necessarily represses a contrary element. The high-
> est criterion of performance is if, without repression, it makes itself
> the arena of those conflicts that have been emphatic.[35]

The second element is external, discursive, philosophical reflec-
tion that should, however, accompany rather than succeed the first
moment: "The demand of artworks that they be understood, that
their content be grasped, is bound to their specific experience; but
it can only be fulfilled by way of the theory that reflects this experi-
ence"; thus, "aesthetic experience is not genuine experience unless it
becomes philosophy."[36] The aesthetic experience of successful Holo-
caust artworks in turn requires concomitant philosophical under-
standing, the elaboration of which is the goal of this study.

4. POSTMODERNISM AND THE CONTRIBUTION
OF PHILOSOPHY

The antinomial conflict advocated here between aesthetic autonomy
and heteronomy, the reciprocal interruption between the contrary
aesthetic and historical tendencies, may suggest dichotomies drawn in
debates surrounding "postmodernism," which have informed recent
studies of Holocaust historiography and art.[37] At its most general

level, these debates have posited a stable, unified, totalizable meaning on the one hand, and an unstable, dispersed or nontotalizable meaning on the other. In the introduction to his edited volume on Holocaust historiography, *Probing the Limits of Representation*, Saul Friedlander succinctly sets the terms of the debate on postmodernism with respect to Holocaust historiography and art:

> Postmodern thought's rejection of the possibility of identifying some stable reality or truth beyond the constant polysemy and self-referentiality of linguistic constructs challenges the need to establish the realities and the truths of the Holocaust; conversely, the very openness of postmodernism to what cannot yet be formulated in decisive statements, but merely sensed, directly relates to whoever considers that even the most precise historical renditions of the Shoah contain an opaqueness at the core which confronts traditional historical narrative.[38]

In Friedlander and in a wide range of historical and critical scholarship, we find a general contrast drawn between, on the one hand, a stable meaning, referent, or representation and, on the other, an unstable or dispersed or self-reflexive meaning, or nonrepresentational performativity. This contrast in turn could be conceived in terms of the respective tendencies I outlined above: the tendency for an artwork to reduce to its factual historical, referential relation (one species of aesthetic heteronomy), on the one hand, and the tendency for it to reduce to its aesthetic properties or effects (various species of aesthetic autonomy), on the other. In these debates surrounding postmodernism and the Holocaust, it is then possible to discern oscillating positions advocating one tendency or the other.

Thus in a series of writings Berel Lang argues on moral grounds for an ideal of "nonrepresentational representation" of the Holocaust, that is, that conventions of imaginative literature should be "denied, subordinated to the constraints of history" because they entail "the possibility of Holocaust *mis*representation."[39] Consequently, he argues for the preeminence of the genres of chronicle and diary because they vouchsafe the greatest historical authenticity.[40] However, by eschewing all aesthetic properties in his ideal of Holocaust representation, Lang effectively collapses artworks into historiography, because aesthetic properties threaten to falsify, fictionalize, or otherwise aestheticize historical authenticity. Lang's dismissal of the aesthetic rests on the unproven assumption that no artwork can fulfill the desideratum of historical veracity, let alone contribute to historical understanding

in virtue of its aesthetic structure and attributes. The following chapters thus, inter alia, offer counterexamples to that assumption.

Conversely, Brett Ashley Kaplan seeks to resurrect the concept of beauty and advocate its role in successful Holocaust representations. Whereas Lang deplores art's capacity to obscure historical facts, Kaplan champions it, for she "use[s] beauty to designate texts that offer ambiguous, diverse, complicated, open-ended reflections on the Holocaust." However, such a cognitive construal of the concept of beauty would require something like Kant's aesthetic theory to connect beauty to aesthetic pleasure. Even more problematic, she justifies the use of aesthetic pleasure in Holocaust representations solely as a means to prolong the recipient's attention to the representation: "Many readers and viewers of Holocaust literature, art, and memorials confess that where the historical documentary might not affect them deeply, the aesthetic power of art encourages them to remember the Holocaust rather than shunt it aside. I therefore argue that . . . beautiful representations can enhance Holocaust remembrance." Although the antithesis of Lang's dismissal of the aesthetic, Kaplan's view shares with it a failure to consider the potential dialectical relationship between the aesthetic and the historical in Holocaust artworks, this time in favor of an overt *instrumentalization* of aesthetic pleasure "as a means of catalyzing Holocaust memory," ultimately another variant of Lang's subordination of art to the constraints of history.[41]

By contrast, the requirements of historical veracity and authenticity can be subordinated or instrumentalized to serve arguably aesthetic ends. James E. Young and Saul Friedlander have characterized such tendencies as exhibiting a "redemptory" will to somehow recuperate historical loss and suffering through aesthetic means.[42] Manifestations of this tendency might include the sentimentalism and formal harmony of films like Spielberg's *Schindler's List* and Benigni's *Life is Beautiful*, or the mythic fantasy of a film like Tarantino's *Inglourious Basterds*.[43] An intriguing variant of this problematic is the scandal and ensuing debate surrounding Benjamin Wilkomirski's *Fragments*, purportedly the memoir of a survivor who spent his childhood in the camps that has been unmasked and decried as the fabrication of a Swiss-born clarinet maker named Bruno Doesseker. Some thinkers and critics, including Berel Lang and Michael Bernard-Donals, have defended the book *despite* its historical inauthenticity because its aesthetic or rhetorical effect upon the reader raises awareness of

the Holocaust or transmits a "traumatic effect" and thus "may well function as a vehicle for [traumatic] witnessing even though it does not qualify as testimony," where "witnessing" here means recognizing the epistemological and narratological disruption wrought by undergoing a traumatic experience:[44]

> But as accounts of horrible events that are inaccessible to the memories of the tellers, such testimonies by those who survived and by those who merely claim to have done so or who have merely read survivors' accounts function similarly and have similar effects: they indicate an event as it occurs before anyone's ability to speak of it, not so much in their accordance with the facts of history (facts that are accessible only through narrative) but in the way they disrupt the narrative of history and force the reader, or the interviewer, to see something horrible, perhaps a trace of the traumatic event.[45]

By such reasoning any work that achieves a traumatic effect, regardless of its relation to historical facts, would in principle merit consideration as Holocaust literature: a work of fiction, so the argument would go, while not testimony of the Holocaust, in virtue of its similarity of function could induce its readers to recognize the conditions of any witnessing of trauma.[46] But this argument trades on an equivocation of the meaning and significance of witnessing, from the first-personal experience of terrible events (the historical precondition and historical relation of Holocaust testimony) to, ultimately, the reader's registering of a text's functional effect. The causal history that produced the text is elided in favor of the causal production by the text of a specific kind of affective response.[47] Avishai Margalit's clear-eyed verdict on the *Fragments* scandal is apposite here: "Under a charitable account, Wilkomirski underwent a spiritual act of identification, but he did not experience a personal encounter that is a necessary condition for being a witness, let alone a moral witness," where to be regarded as a moral witness one "should witness—indeed, they should experience—suffering inflicted by an unmitigated evil regime."[48] By denying or diminishing the requirement of historical authenticity in favor of a work's functional effect, either in terms of general heightened awareness of the Holocaust for Lang, or specific awareness of trauma for Bernard-Donals, each of these arguments subordinates the historical relation to aesthetic structure and effect, broadly conceived.

It is a premise of this study that these arguments should be rejected along with *any* form of instrumentalist subordination of *either*

tendency, for such subordination shifts the criterion of adequacy, ulti-
mately even to a nonhistorical, nonaesthetic sphere: profit or popular-
ity (in the case of an artwork's commodification), political, social, or
moral ideals (in the case of an artwork's "message"). Adorno's stric-
tures against *both* the instrumentalization of art *and* the illusion of
art's self-sufficiency should guide us here:

> But the function of art in the totally functional world is its func-
> tionlessness; it is pure superstition to believe that art could inter-
> vene directly or lead to an intervention. The instrumentalization of
> art sabotages its opposition to instrumentalization; only where art
> respects its own immanence does it convict practical reason of its
> lack of reason. Art opposes the hopelessly antiquated principle of *l'art
> pour l'art* not by ceding to external purposes but by renouncing the
> illusion of a pure realm of beauty that quickly reveals itself as kitsch.
> By determinate negation artworks absorb the *membra disjecta* of the
> empirical world and through their transformation organize them into
> a reality that is a counterreality, a monstrosity.[49]

Therefore, following Adorno, we can claim that the subordination
or instrumentalization of either the historical or aesthetic tendency
denies the specific negative-dialectical relationship between the ten-
dencies that characterizes successful Holocaust artworks.

Other critics conceive the "postmodern dichotomy," outlined by
Friedlander above, specifically in terms of an artwork's producing or
failing to produce meaning via mimetic representation. Here the con-
trast is between historical reference and knowledge conceived as real-
ist representation and recognition, on the one hand, and aesthetic or
literary experience conceived as noncognitive, antirealist, self-reflex-
ive, or performative, on the other. Thus James E. Young advocates
"postmodern memory work" and "counter-monuments" that sub-
vert realist representation in favor self-referential, open-ended pro-
cessual meaning production.[50] Robert Eaglestone finds that the defin-
ing characteristic of Holocaust testimony as a genre is its thwarting
"the pleasures of [the reader's] identification" and "easy consump-
tion," through textual devices he explicitly associates with postmod-
ern literature: "Postmodern novels, too, mix genres, try to defy iden-
tification, lack closure, foreground their own textuality."[51] Likewise
the incorporation of "trauma theory" into historiography and criti-
cism can be understood in terms of the general dichotomy, for on this
theory witnessing a traumatic event entails the constitutive inability
to comprehend or represent it: for instance, Shoshana Felman, Dori

Laub, and Cathy Caruth understand their project as "the first stage of a theory of a yet uncharted, nonrepresentational but performative, relationship between art and culture, on the one hand, and the conscious and unconscious witnessing of historical events, on the other."[52] Subsequently, some critics have elevated trauma theory into a general framework for interpreting Holocaust memoirs and artworks. Michael Rothberg's theory of "traumatic realism" describes forms of art that incorporate indices of absence: "Instead of indicating an object or phenomenon that caused it, and in that sense making the referent present, the traumatic index points to a necessary absence . . . [it] does not embody the real but evokes it as felt lack, as the startling impact of that which cannot be known immediately." Such works therefore "recognize the nonsymbolizable remainder of the real," through incorporating indirect evocations of the victims, often by incorporating metonymic tropes of the possessions that survived them.[53] Alternatively, work by Michael Bernard-Donals and Richard Glejzer problematically links traumatic witnessing to experiencing the Kantian sublime and "the divine," apparently because each experience exceeds complete cognitive understanding while causing a specific affective response.[54] Ernst van Alphen interprets Holocaust literature exclusively in terms of an artwork's performative "reenacting" of trauma: "When I call something a Holocaust effect, I mean to say that we are not confronted with a representation of the Holocaust, but that we, as viewers or readers, experience directly a certain aspect of the Holocaust or of Nazism, of that which led to the Holocaust."[55] Hence in these theories of the Holocaust as traumatic event, the historical relation is that which resists representation and disrupts understanding, while producing a distinctive noncognitive affect that defines in part the meaning of the artwork.[56] Although the "postmodern dichotomy" is admittedly sketched in extremely broad strokes here, it suggests a hypostatization of positions that, according to Adorno's dialectic of aesthetic semblance, in a successful artwork should rather be viewed as dynamically co-constitutive and reciprocally countervailing tendencies.

While these recent debates have shifted focus from the artist's imaginative transformation of history to issues of meaning and representation, *both* the various contrast-pairs often deployed in the "postmodern dichotomy" (for example, representational vs. performative, closed vs. open, totalizable vs. untotalizable, referential vs. self-referential), *and* the language of Adorno's philosophical aesthetics may well benefit

from incorporating more technical concepts and methods of analysis from philosophy after "the linguistic turn."[57] When Adorno speaks of the constitutive "tension" between the poles of an artwork as, for example, "the a priori fissure [Riß] between the mediate and immediate,"[58] or "the reciprocal relation of the universal and the particular,"[59] he relies on the vocabulary of German Idealism while driving its fundamental conceptual oppositions to the very extremes of their semantic potentials in order to invoke, by determinate negation, that which they cannot signify. Likewise when Adorno speaks of the "play of forces,"[60] or artworks' being "force fields of their antagonisms,"[61] or the "riddle-character" and "puzzle-image" of an artwork, he deploys illuminating and suggestive metaphors that nonetheless may be more precisely explicated with the conceptual resources of contemporary philosophy. Therefore, I claim, *both* the language of the "postmodern dichotomy" *and* Adorno's philosophical aesthetics will benefit from being supplemented by the work of recent Anglophone philosophy, which offers the precise analytic means required to elucidate the determinate inflection of the dialectic of aesthetic semblance in an individual artwork. Thus the primary claim of this book is that theoretical resources from contemporary philosophy can provide lucid and illuminating explications of how specific Holocaust artworks succeed in fulfilling their dual desiderata, by "making them *determinate* in their irreconcilability," to recall Adorno's prescription cited earlier. But the justification for this claim must reside in the persuasiveness of the following chapters, in which figures, concepts, and arguments from the European and Anglophone philosophical traditions are deployed and evaluated according to the criterion of enhancing our understanding of the problems entailed by Holocaust artworks. As Adorno wrote in the draft introduction to his *Aesthetic Theory*: "That today a general methodology cannot, as is customary, preface the effort of reconceiving aesthetics, is itself of a part with methodology."[62] The case studies presented in the following chapters do not illustrate a narrow thesis in the conventional sense. Rather in the broad range of the various media of artworks considered, these readings seek to exemplify not only the disparate means by which Holocaust artworks fulfill the dual desiderata of the normatively minimalist framework, but in turn to exemplify the manifold philosophical discourses required to explicate precisely those disparate means.

Lastly, while cultural and literary critics over the last fifty years have familiarized themselves with phenomenological and postphenomenological philosophy on the Continent, I would suggest that a

more ecumenical consideration of recent Anglophone philosophy can also serve to elucidate the complexities of artworks. In short, over and beyond this book's intent to elucidate specific ways in which individual Holocaust artworks negotiate the dual desiderata incumbent upon them, it should also be read as advocating the precise insight which lines of thought and inquiry from so-called analytic philosophy can provide to those critics who are prepared to study them.

5. PLAN OF THE BOOK

In Chapter 1 I trace lines of affiliation and influence between Osip Mandelshtam's theory of dialogic poetry and Paul Celan's conception of poetry as a *Daseinsentwurf*, a projection of human being through time. Then, through a critical juxtaposition of Jacques Derrida's and Hans-Georg Gadamer's theories of linguistic meaning and understanding, I demonstrate how the causal theory of names as developed by Saul Kripke and modified by Gareth Evans can best elucidate how specific historical references within Celan's poems operate within and against the poem's tendency toward aesthetic autonomy.

In Chapter 2 I contrast two public memorials of the Holocaust in Berlin today, using Walter Benjamin's theory of dialectical images to explode the mythic unity presented by the first memorial and to illuminate the second memorial's successful aesthetic presentation of historical texts, in this case the Nuremberg racial laws. Benjamin's notion of "non-sensuous similarities," the cognitive basis for the perception of dialectical images, can be understood as a form of tacit knowledge, by means of which, I argue, the second memorial might effectively elicit genuine historical consciousness of the Shoah and its institutional afterlife.

In Chapter 3 I turn to works by the Austrian concrete poet Heimrad Bäcker composed entirely of quotations of historical texts surrounding the Holocaust and its aftermath. Here the well-developed literature on quotation in contemporary Anglophone philosophy of language can help us understand precisely the aesthetic properties and perhaps the phenomenological effects attending the determinate form of quotation used by Bäcker, along with the danger of reactualization to which such aesthetic-quotational texts are perpetually vulnerable.

In Chapter 4 I compare Claude Lanzman's film *Shoah* and Art Spiegelman's graphic novel *Maus* in terms of a revised Sartrean theory

of the imagination. The incorporation of testimony in each artwork, I argue, becomes the locus of a dialectic of semblance that turns on the role of the imagination. By recourse to a Wittgensteinian notion of expressive knowledge and a specific epistemological theory of testimony, I reveal a related asymmetry in each work between the visual and verbal sources of knowledge, and I argue that precisely the asymmetries *between* these sources constitute for each work its specific aesthetic presentation of a historical knowledge that foregoes direct presentation.

Thus on the basis of Adorno's normatively minimalist framework, each chapter offers a sustained, determinate analysis of individual artworks as specific inflections of the "dialectic of semblance" manifest in the dual desiderata borne by Holocaust artworks, explicated as precisely as possible with the discursive means afforded us by contemporary philosophy.

Mandelshtam's Meridian

On Paul Celan's Aesthetic-Historical Materialism

Ultimately philosophical research must decide to ask what kind of being in general language has. Is it an innerworldly pragmatic tool, or does language have the mode of being of Dasein, or neither of the two? What sort of being is that of language, that it can be 'dead'?

—MARTIN HEIDEGGER[1]

Every sign *by itself* seems dead. *What* gives it life?—In use it is *alive*. Is life breathed into it there?—Or is the *use* its life?

—LUDWIG WITTGENSTEIn[2]

Important artworks reveal ever new layers, age, grow cold, die.

—THEODOR W. ADORNO[3]

The poetry of Paul Celan has played a salient role in the ongoing debate surrounding linguistic meaning and interpretation, even when the stakes of that debate extend beyond the experience or interpretation of artworks altogether. Thus both Jacques Derrida and Hans-Georg Gadamer have written book-length commentaries on selected poems of Celan, and although at odds in their fundamental philosophical commitments, both thinkers find support for and instantiation of their respective views on meaning and understanding in general in their readings of Celan's poetry in particular.

While the debate of "deconstruction vs. hermeneutics" has received much attention in literary theory and philosophy,[4] far less attention has been paid to the exact nature of aesthetic experience in its relationship to nonaesthetic discourses that these philosophical positions presuppose. We can fruitfully situate this question within Adorno's dialectic of aesthetic semblance, understood as the tension and movement between the poles of aesthetic autonomy on the one hand and heteronomy with the nonaesthetic on the other that characterizes

genuine artworks for Adorno. In the specific context of Holocaust art, that dialectic might be best described as moving between the poles of *monument* (constructing a "fitting" aesthetic artifact while adhering to aesthetic considerations such as coherence, genre, sense, even harmony and beauty) and *document* (foregoing such aesthetic considerations altogether in favor of factual documentation: names, dates, places, events). In the first extreme (aesthetic autonomy) aesthetic semblance in the sense of "illusion" or "myth" can usurp any reference to nonaesthetic reality, tantamount to dismissing any relevance of historical chronicle to the tasks of representation or commemoration; in the second extreme (referential autonomy) aesthetic semblance is abandoned altogether in favor of factual reconstruction, tantamount to dismissing any relevance of aesthetic construction to the tasks of representation or commemoration. The normative minimalist framework advocated in this study claims that a successful Holocaust artwork will maintain the tension between both poles of the dialectic of aesthetic semblance within aesthetic experience.

Two apparently opposed conceptualizations of aesthetic experience—Idealist and deconstructive aesthetic theories—surprisingly converge in maintaining aesthetic semblance. Traditional Idealist aesthetics holds that the successful artwork is to take up reality's contingencies and contradictions and harmoniously reconcile them in aesthetic semblance, conventionally centered on the trope of the symbol. It is then merely one step to see the aesthetic reconciliation as a proleptic promise of the utopian possibility of actually reconciling society's and nature's antagonisms in what Schiller called the "aesthetic state."[5] Conversely, deconstructive readings of literature by Paul de Man and Jacques Derrida draw on the untotalizability and undecidability of reference in aesthetic semblance to reveal the irreconcilable differences and deferrals of language and linguistic understanding in general. In the first case, art's *specificum* is its sublation of difference; in the second case, art's *specificum* is its revelation of semiotic *différance*. In both cases art's specificity renders it autonomous vis-à-vis everyday, nonaesthetic experience, and in *that* sense aesthetic semblance remains intact. It is from this sense of aesthetic semblance that Celan will take a significant step back, and toward, as I shall show, a unique form of *aesthetic-historical* materialism, which in turn fulfills the dual desiderata of the minimalist framework for Holocaust art.

Celan's retreat from aesthetic semblance, I shall argue, lies in his lyrical dialogism, in which nonaesthetic reference operates *within* and

against aesthetic semblance. Historical and philosophical interests alternate in my exploration of Celan's lyrical dialogism, the origins of which likely lie in concepts developed by Mikhail Bakhtin in his study of novelistic prose, while de Man's critique of Bakhtin's concept of dialogicity from the standpoint of aesthetic semblance initially defines the guiding problems of reference and linguistic understanding which underlie Celan's ambitions (§1). Celan found a specifically lyrical form of dialogism and address in the essays of his poetic alter ego Osip Mandelstam (§§2–3), concepts that Celan developed in his two most important poetological essays (§§5–6). Against Derrida's quasi-transcendental construal of linguistic understanding, I draw on work by Wittgenstein and Gareth Evans in arguing for an intersubjective conception of meaning reference having both naturalistic and normative dimensions (§4), and I claim that this theory best elucidates the kind of aesthetic-historical materialism at work in Celan's poetry (§7), which Gadamer's implicit Idealism can only dismiss as "occasional" and inessential (§8). I conclude by offering close readings of two Celan poems according to this theory, in which nonaesthetic reference and linguistic understanding operate both *within* and *against* aesthetic semblance in order to enact the natural history or "mortality" of the proper-name references (§9).

1. BAKHTIN AND THE LITERARY DEVICE OF DIALOGUE

In "Discourse and the Novel," Bakhtin offers an essential criterion for distinguishing the novel from lyric poetry as, one could say, Weberian ideal-types. In terms of speech genres, "the poet is a poet insofar as he accepts the idea of a unitary and singular language and a unitary monologically sealed-off utterance. These ideas are immanent in the poetic genres with which he works."[6] The novel, by contrast, is characterized by "heteroglossia" and "the double-voiced word" such that any monological speech, any singular speaking voice, is relativized and introduced into a dialogue, which, by virtue of its "dialogicity," cannot be subsumed under a final utterance. The "double-voiced word" is Bakhtin's term for describing the characteristic discourse of the novel that assumes two speakers involved in an unfinalizable dialogue. By contrast he claims that the poetic trope "cannot presuppose any fundamental relationship to another's word, to another's voice. The polysemy of the poetic symbol presupposes the unity of a voice with which it is identical, and it presupposes that such a voice

is completely alone with its own discourse."[7] In their lucid summary of Bakhtin's position, Gary Saul Morson and Caryl Emerson identify the distinctive characteristic of poetic trope—as opposed to nonfinalizable dialogicity—as its referential-representational relationship to an object: "Whether that interrelationship [of meanings in a poetic trope] is understood logically, ontologically, emotively, evaluatively, or in any other way, one is still speaking of the relation of words to their objects. One can discuss its complexity through the theoretical discourse of 'signified' and 'signifier.'"[8]

However, in his critical review de Man argues that "dialogicity" itself becomes a trope for Bakhtin. After establishing that Bakhtin's understanding of trope as "an intentional structure directed toward an object" is epistemological, that is, concerned with the referential link between a trope and its meaning or referent,[9] de Man counters that "the opposition between trope as object-directed and dialogism as social-oriented discourse sets up a binary opposition between object and society that is itself tropological in the worst possible sense, namely as reification."[10] If I understand de Man correctly, he is observing that Bakhtin equivocates between two meanings of "dialogism." In the first case, "dialogism" would designate sociality in the sense of what Bakhtin calls "exotopy," which, if it is not "object-directed" (that is, involving a relationship of reference or representation), does not provide the means for distinguishing anything (and therefore falls into what de Man calls "the categories of precritical phenomenalism"). In the second case "dialogism" would indicate individual voices to the extent that they can be individuated within novelistic discourse, yet in this case those voices would be tropes, object-oriented intentional structures for which Bakhtin provides a rich descriptive poetics. And in this case the problem of aesthetic semblance—the possible suspension of a referential relationship to the nonaesthetic—returns: "It is possible to think of dialogism as a still formal method by which to conquer or to sublate formalism itself. Dialogism is here still a descriptive and metalinguistic term that says something about language rather than about the world."[11]

Although Mathew Roberts, whom Morson and Emerson cite affirmatively, maintains that "the 'confrontation' of these two theorists cannot occur around a problematic or conceptual opposition immanent to either" because of their "fundamentally different attitudes of the dialogic and hermeneutic epistemologies,"[12] perhaps the confrontation can be reformulated as follows. Bakhtin seems to elide the

epistemological intricacies of aesthetic semblance by trying to incorporate citation, sidelong-glances, the double-voiced word as *events* of social reality. De Man claims that *within* the literary text these devices are just that—literary devices that may *represent* a many-voiced sociality but which, as representation (mimesis), do not circumvent aesthetic semblance; therefore the analysis of such devices is not unlike "the analysis of dialogue in novels, not unlike American formalism."[13] For de Man, Bakhtin's attempt to bridge the relationship between fiction and reality turns dialogue itself into a trope (and indeed, Bakhtin often speaks of the image [образ] of a language or speech genre), a poetic device or intentional structure directed toward an object, although here the object is polyphonic, nontotalizable, and so on. Nonetheless, the mimetic impulse of representation remains, and therefore so too the epistemological uncertainty of aesthetic semblance, that is, uncertainty about the nature of its reference.

On the one hand, against Bakhtin I want to claim that there is a type of poetry that nonetheless escapes his characterization of the lyric as monological, timeless, and finalized. Moreover, I will argue that this form of "dialogicity" or nonfinalizability actually fulfills the role Bakhtin assigns to prose without succumbing to de Man's critique, since these dimensions of phenomenal actuality and address are nonrepresentational precisely as Bakhtin's dialogics of the novel, as exemplified in Dostoevsky, are not. Thus, on the other hand, I will argue against de Man and claim that this lyrical "dialogism" does break with the epistemological problem of aesthetic semblance and therefore also produces a historical, albeit nonrepresentational, relationship within such poetry. The lyrical "dialogism" I have in mind was discussed by Osip Mandelshtam, perhaps in direct response to Bakhtin, and developed and exemplified in a radical fashion by Celan.

2. DIALOGUE AND ADDRESS IN MANDELSHTAM

Mandelshtam's *Conversation About Dante* (*Разговор о Данте*) was almost certainly engaged in a side-long polemical glance at Bakhtin worthy of the master.[14] Bakhtin's *Problems of Dostoevsky's Poetics* had been published in 1929 and had likely been a topic of conversation between Mandelshtam and Andrei Bely in 1933, when Mandelshtam was working on his text during the spring and summer in Koktebel (Crimea).[15] Passages such as the following leave little doubt as to at least one of the Bakhtinian "superaddressees" of the text

(indeed, with whom is the poet *conversing*?): "The scandal in literature is a concept going much further back than Dostoevsky, however, in the thirteenth century and in Dante's writings it was much more powerful. Dante collides with Farinata [canto x of *Inferno*] in this undesirable and dangerous encounter just as Dostoevsky's rogues run into tormentors in the most inopportune places."[16] Bakhtin had written at length about the role of scandal in Dostoevsky's novels, but Mandelshtam's next allusion is even more direct: "It is absolutely false to perceive Dante's poem as some extended single-line narrative or even as having but a single voice,"[17] he writes, before introducing an extended poetological simile drawing on Bach's choral fugues. Indeed, in the very first page of the essay Mandelshtam seems to be arguing against Bakhtin's representational notion of poetic tropes and his privileging of prose narrative, for the poet claims that "poetry establishes itself with astonishing independence in a new extraspatial field of action, not so much narrating as acting out in nature by means of its arsenal of devices, commonly known as tropes"; and lest the reader assume that tropes are to be interpreted in terms of their intentional objects—the move de Man makes—the poet praises his Italian precursor as "a strategist of transmutation and hybridization."[18]

While Mandelshtam's theory of tropological semantics is both rich and unfortunately far from clear, here I want only to emphasize his account of the mutability across time of a trope's comprehension— as an event of recontextualization—rather than its representational signification. Alluding to Potebnja's notion of the inner image of a word and Bergson's notion of *durée réelle*, Mandelshtam avers that "any given word is a bundle, and meaning sticks out of it in various directions,"[19] and he defines a "peculiarity of poetic material" as its "convertibility" (обращаемость) or "transmutability" (обратимость), which seems to constitute a potential for semantic change (in another passage he speaks of associations) far richer than the actually historically delimited range of meaning: "Only in accord with convention is the development of an image called its development."[20] Once Mandelshtam has grounded the fundamental transmutability of poetic meaning as a potential inhering in the poetic material, he can, concluding his conversation, emphasize the *performativity* and *directionality* of its actualization over its representational function:

> Poetic material does not have a voice. It does not paint with bright colors, nor does it explain itself in words. It is devoid of form just as it is devoid of content for the simple reason that it exists only in

performance. The finished poem is no more than a calligraphic prod-
uct, the inevitable result of the impulse to perform. If a pen is dipped
into an inkwell, then the resultant thing is no more than a set of let-
ters fully commensurate with the inkwell. . . . In other words, syntax
confuses us. All nominative cases must be replaced by the case indi-
cating direction, by the dative. This is the law of transmutable and
convertible poetic material existing only in the impulse to perform.[21]

With this theory of the performativity (that is, emphasis on the pro-
cessual, potentially infinite interpretability, or recontextualization of
the poem)[22] and directionality of the poetic material in artistic pro-
duction, Mandelshtam can thus claim, implicitly against Bakhtin,
that, "contrary to our accepted way of thinking, poetic discourse is
infinitely more raw, infinitely more unfinished than so-called 'conver-
sational' speech."[23]

However, the performative "directionality" in the production of
poetry—the understanding of nouns as being "in the dative case"—
also entails a category that is equally important for the reception of
poetry, namely its *addressivity*, which Mandelshtam had theorized in
an earlier essay and to which the *Conversation About Dante* alludes
in title and argument: "О собеседнике," slightly mistranslated as "On
the Addressee" rather than the more literal "On the Interlocutor."[24]
In a central image of shipwreck and perdition, which recurs in Celan,
Mandelshtam introduces his notion of poetic friendship and addressee:

> Every man has his friends. Why shouldn't the poet turn to his friends,
> to those who are naturally close to him? At a critical moment, a
> seafarer tosses a sealed bottle into the ocean waves, containing his
> name and a message detailing his fate. Wandering along the dunes
> many years later, I happen upon it in the sand. I read the message,
> note the date, the last will and testament of the one who perished.
> I had the right [я имел право] to do so. I have not opened someone
> else's mail. The message in the bottle was addressed to the one who
> finds it. I found it. That means, I am its secret addressee [я и есть
> таинственный адресат].[25]

Mandelshtam's essay sketches out further characteristics of the
"secret" or "providential" addressee and interlocutor through a vari-
ety of polemical oppositions. The characteristics I wish to emphasize
revolve around an implicit model of *political-ethical* understanding
that has escaped the notice even of those critics who have noted the
"message in a bottle" motif.[26] Mandelshtam charges the Symbolists
with being exclusively interested in acoustics and therefore of having
"ignored the juridical, as it were mutual relationship [юридическое,

так сказать, взаимоотношение] which attends the act of speaking (for example: I am speaking: this means people are listening to me and listening to me for a reason, not out of politeness, but because they are obliged [обязаны] to hear me out)."[27] This distinction in poetological accent *between* poetic schools is then expanded into a normative genre-specific principle that distinguishes prose *from* poetry: "The prose writer always addresses himself to a concrete listener, to the dynamic representative of his age. Even when making prophecies, he bears his future contemporary in mind. . . . The poet is bound only to his providential addressee. He is not compelled to tower over his age, to appear superior to his society."[28] With this move Mandelshtam can set his notion of poetic interlocutor off against both conventional civic poetry (with which it might at first be confused) and modernist, hermetic poetry (for which the poet Balmont stands), because for Mandelshtam (1) the interlocutor is not a concrete audience but rather a "more or less distant, unknown addressee";[29] and (2) there is not the asymmetry between a poetic persona who condescends, either from a position of superior knowledge or supercilious self-involvement, to the listener. So Mandelshtam can categorically conclude "without dialogue [диалог] lyric poetry cannot exist."[30] Two caveats are in order, as well. First, the interlocutor is *more* than merely the virtual, "implied reader" that is reconstructed from the formal properties of the literary text, since the unknown addressee is as it were a "promissory" interlocutor who is then "redeemed" by the historical reader and her encounter with the poem.[31] Second, the interlocutor is *more* than merely the deictic referent of a poetic text, since for Mandelshtam there is an obligation incumbent upon the addressee, a "mutual relationship" between poem and reader; whereas reference belongs to the dimensions of epistemology and ontology, obligation belongs to the dimension of politics and ethics: that of friendship. The message in the bottle, as "last will and testament," is addressed to the poet's "friends, to those who are naturally close to him."

There is some indication that Mandelshtam is drawing on Idealist vocabulary in his notion of the poetic encounter when, for instance, he condemns Balmont's "blatant individualism" in distinctly Fichtean terms: "On the scales of Balmont's poetry, the pan containing the 'I' dips decisively and unjustly below the 'Not-I.' . . . Balmont's individualism emerges at the expense of someone else's 'I.'"[32] Moreover, Mandelshtam expresses the poetic encounter itself in language reminiscent of the early Idealist model of "mutual recognition" (*gegenseitige*

Anerkennung), of one's attaining self-consciousness only through the encounter with an other:[33]

> Without dialogue, lyric poetry cannot exist. Yet there is only one thing that pushes us into the interlocutor's embrace: the desire to be astonished at our own words, to be captivated by their novelty and unexpectedness. The logic is merciless. If I know the person with whom I am speaking, I know in advance how he will react to my words, to whatever I say, and consequently, I will not succeed in being astonished in his astonishment, in rejoicing in his joy, in loving in his love. The distance of separation erases the features of the loved one. Only from a distance do I feel the desire to tell him something important, something I could not utter directly seeing his face before me as a known quantity. Allow me to formulate this observation more succinctly: our sense of community is inversely proportional to our real knowledge of the addressee and directly proportional to our felt need to interest him in ourselves.[34]

According to Mandelshtam's existentialist version of this model, the lyric poet's vocation is grounded in the "felt need" to attain a "sense of community" through the anticipated encounter with an unknown and distant interlocutor, whose very distance and unfamiliarity increases the desire "to tell him something important." Such an encounter is defined by its unique particularity, actuality, and unpredictability, and the "air of verse" is this "element of surprise": "Only reality can call into life a different reality" (только реальность может вызвать к жизни другую реальность);[35] therefore the lines of Sologub, whom Mandelshtam extols against Balmont's self-indulgent individualism, "continue to live long after they were written, as events, not merely as tokens of past lived experience" (как события, а не только как знаки переживания).[36] Finally, this mutual recognition for Mandelshtam as well as for Fichte grounds self-legitimacy, for the "right" (право) the finder has to read the message in the bottle is mirrored in the "sense of rightness" (правота) of the poet, which is the very definition of poetry for Mandelshtam: "After all, isn't poetry the consciousness of being right? [ведь поэзия есть сознание своей провоты]. . . . When we converse with someone, we search his face for sanctions, for a confirmation of our sense of rightness [правота]. Even more so the poet";[37] whereas the asymmetry of Balmont's poetic habitus is "unjust," François Villon does not "tower above his age" or "appear superior to his society." Thus the two characteristics that Mandelshtam singles out in Sologub and finds absent in Balmont, "love and admiration for the interlocutor and the poet's consciousness of being right" (любовь

и уважение к собеседнику и сознание своей поэтической правоты)[38]
reflect, constitute, and legitimate each other in the encounter of poetic
reading and transmission:[39] "Poetry as a whole is always directed
toward a more or less distant, unknown addressee, in whose exis-
tence the poet does not doubt, not doubting in himself."[40] In turn, the
confidence in the future existence of his addressee assures the poet of
his own existence.

Certainly here lies a historical and philological question of influ-
ence, since it appears that key elements of Bakhtin's theory, such as
the nonfinalizability, dialogicity, eventhood, and ethical aspects of
the "act of speaking" are clearly intimated in Mandelshtam's essay
of 1913, prior to Bakhtin's earliest published work (1919) and even
prior to his seminal but at the time unpublished "Toward a Philoso-
phy of the Act" (1919–20). Historical research would need to consider
Bakhtin's lectures and reading groups and, to the extent possible, the
dissemination of his and Mandelshtam's ideas informally throughout
the Petersburg intelligentsia of the time; these questions lie beyond
the goals of the present study and will not be pursued here. Rather,
another direction of transmission will be charted: for the fragmen-
tary, even germinal, nonmimetic attributes of poetry—directionality,
actuality, temporality, addressivity to friends—that Mandelshtam so
exuberantly proclaimed did indeed reach a providential addressee,
who became a devoted interlocutor.

3. CELAN'S DIALOGUE WITH MANDELSHTAM

The intensity with which Paul Celan considered himself to be one if not
the "secret interlocutor" of Mandelshtam is adumbrated by personal
recollections, unpublished materials, and provisionally, by the presence
of Mandelshtam's thought in Celan's own poetological statements,
translations, and poetry.[41] During the years 1958–61 Celan devoted
himself to translating poetry from the Russian, including Blok, Esenin,
Khlebnikov, and others, but Mandelshtam entered his poetic process
as no other Russian poet did. Initial studies emphasized Celan's bor-
rowing of certain motifs from Mandelshtam (stone, black earth, geo-
logical strata, and so on),[42] while other scholars have explored how
Celan's "imitations" of Mandelshtam's poems subtly weave his own
poetic principles with those of his elective Russian precursor.[43] Ber-
nard Böschenstein, who knew the poet well, has revealed that Celan
"believed himself to be one with Mandelshtam for important stretches

of his life," to the point of the poet calling himself "Pawel Lwowitsch Tselan. Russkij poët, in partibus nemetskich infidelium."[44] Indeed, from the vantage point of trauma theory,[45] one could speculate that Celan's sense of "survivor's guilt," that he did not perish with his parents in the Ukranian concentration camp "Cariera de Piatra" (literally, "quarry") on the river Bug,[46] in part motivated the identification with a Jewish poet whose first book of verse is entitled *Kamen'* (stone) and who did perish in a camp. Both Celan and Mandelshtam identified their poetic vocation with the influence of their mothers, and both poets were the same age when they lost their mothers, and Celan translated Mandelshtam's elegy to his mother.[47] In his introduction to his Mandelshtam translations Celan refers to a contemporary report from the *Times Literary Supplement* conjecturing that Mandelshtam returned from Siberian exile only to perish at the hands of the German occupation forces in a transit camp.[48] In the biographical notice he wrote for the publication in 1960 of his Mandelshtam translations in Enzensberger's *Museum der modernen Poesie* he specifies, "Some sources give 1937 as the year of his death, according to others he died in Vladivostok in 1938; it is more likely that he lived until 1943 and was murdered in a Stalinist concentration camp [*Konzentrationslager*] or as *The Times Literary Supplement* surmises, by Himmler's executioners under the German occupation";[49] the nexus of Stalinist and Nazi concentration camps is given a temporal coincidence, as Celan's parents were also murdered in the winter of 1942–43. There thus emerges a chiasmus between Celan, a Jewish poet whose "mother tongue" quite literally was German,[50] and who did not perish with his parents in a Ukranian camp, and Mandelshtam, a Russian-speaking Jewish poet who did perish in a German camp.[51] Among Celan's posthumous papers is found the following text:

BRUDER OSSIP 21.6.61

Es spielt der Schmerz mit Worten:
er spielt sich Namen zu
er sucht die Niemandsorte,
und da, da wartest du.

Du bist der Russenjude,
der Judenrusse, und

(BROTHER OSIP 21.6.61

Pain plays with words:
it plays out names to itself

it seeks the no-man's-places,
and there, there you wait.

You are the Russian-Jew,
the Jew-Russian, and . . .)[52]

In the final lines, the semantic chiasmus—syntactic parallelism but
an inversion of sense—brings together in passing the national, eth-
nic, cultural coordinates of Mandelshtam's identity ("Du bist . . . ")
and arguably of Celan's identity as well, since his homeland Czer-
nowitz fell within Soviet dominion after the war, at the time this note
was written.[53] This meeting in passing of the chiasmus is an encoun-
ter (*Begegnung*), a term that plays a decisive role in the "Meridian"
speech, as we shall see. It is not an ultimate identity or a sublation of
contradictions, but rather a positing of names that results in an ellipti-
cal traversal of those coordinates, which also indicates their possibil-
ity for exchange and inversion in time: a meridian.

(. . .)
Die Silbermünze auf deiner Zunge schmilzt,
sie schmeckt nach Morgen, nach Immer, ein Weg
nach Rußland steigt dir ins Herz,
die karelische Birke
hat
gewartet,
der Name Ossip kommt auf dich zu, du erzählst ihm,
was er schon weiß, er nimmt es, er nimmt es dir ab, mit Hän-
 den,
du löst ihm den Arm von der Schulter, den rechten, den linken,
du heftest die deinen an ihre Stelle, mit Händen, mit Fingern,
 mit Linien,

—was abriß, wächst wieder zusammen –
da hast du sie, da nimm sie dir, da hast du alle beide,
den Namen, den Namen, die Hand, die Hand,
da nimm sie dir zum Unterpfand,
er nimmt auch das, und du hast
wieder, was dein ist, was sein war,
(. . .)[54]

(The silver coin on your tongue melts,
it tastes like morning, like always, a way
towards Russia climbs into your heart,
the Karelian birch tree
has
waited,
the name Osip heads for you, you recount to him,

what he already knows, he takes it, he takes it from you, with
 hands
you loosed the arm from his shoulder, the right one, the left
 one,
you fasten yours in their places, with hands, with fingers, with
 lines,

—what had broken off grows together again –
there you have them, take them, there you have both,
the name, the name, the hand, the hand,
there take them as a pledge,
he too takes what you have
again, what is yours, what was his,
[. . .])

In the letter of August 30, 1961, Celan wrote that he had found some-
thing "meridian-like" ("*Meridianhaftes*") in the fact that Mandelsh-
tam, like Celan himself, had become embroiled in a scandal of alleged
plagiarism with undertones of anti-Semitism, a similar meeting-in-
passing across time and space.[55]

"Meridian," the *circulus meridianus*, the noon-day imaginary
line of longitude that links and divides the places on the earth where
simultaneously the sun stands at its zenith, is Celan's term of art for
the imaginary lines of communication of which Mandelshtam speaks
in "On the Interlocutor" and Celan in his main poetological text,
"Der Meridian," the speech he gave in Darmstadt on October 22,
1960, upon receiving the Büchner Prize. In a letter to the philosopher
Otto Pöggeler (November 1, 1960), Celan wrote, "It was a dark sum-
mer—you know already. And the Büchner prize was, to the very end,
an ordeal, that is, it was also a challenge and an affliction. Really.
Now it's over, I even, indeed at the very last moment, got a (kind of)
speech onto paper; a few phrases from the Mandelshtam-broadcast—
I thought of you—had to be included, as islands to other islands."[56]

What are these islands? They are passages, *topoi*, from Celan's
radio broadcast for two speakers—a dialogue—entitled "The Poetry
[*Dichtung*] of Osip Mandelshtam," that was broadcast by Nordde-
utscher Rundfunk on March 19, 1960; these passages recur in Celan's
poetological writings, all of which were composed during the time he
was translating Mandelshtam intensively. The passages, some slightly
reworked, others verbatim, are not placed in quotation marks, nor
does Mandelshtam's name or poetry appear anywhere in these poeto-
logical texts. Yet there is, perhaps, an oblique acknowledgment, an

address of sorts. On the final page of the "Meridian" Celan writes of quotation marks, using the two expressions for them—"goose-feet" and "hare's ears"—he had found in Jean Paul's writings: "And yet: is there not precisely in [Büchner's play] 'Leonce und Lena' these quotation marks that are invisibly smiled [*unsichtbar zugelächel-ten*] toward the words, that perhaps do not want to be understood as goose-feet [*Gänsefüßchen*], more as hare's ears [*Hasenöhrchen*], that is, as something that not completely without fear [*furchtlos*] is listening beyond itself and the words?"[57]At the outset of the radio broadcast, after relating Mandelshtam's habit of laughing at inappropriate moments, to which we shall return, Celan recounts a further biographical trait:

1st Speaker: . . . Mandelshtam is overly sensitive, impulsive, unpredictable. Moreover he has an almost indescribable timidity [*Furchtsamkeit*]: for instance if a path leads past a police station, he darts sideways, suddenly changes direction.

2nd Speaker: And this "Hare's foot" [*Hasenfuß*, colloquial for "coward"] among all the important Russian lyric poets whom life leads out beyond the first post-Revolutionary decade—Nikolaj Gumiljov is shot in 1921 as a counterrevolutionary; Velimir Khlebnikov, the great Utopianist of language, dies of starvation in 1922—this so timid Osip Mandelshtam will be the only unruly and uncompromising one, "the only one who—as a younger literary historian (Vladimir Markov) attests—"never went to Canossa."[58]

Is Celan, who translated Khlebnikov and whose morphological transformations of various languages recall this "Utopianist of language"—and U-topia is another name for the meridian, Celan says—is he, perhaps, addressing, or listening to, Mandelshtam the "*Hasenfuß*" in the smiling metathesis of "*Gänsefüßchen*" and "*Hasenöhrchen*"?[59]

We are at a nexus, between, from one direction, historical, singular *specifica* pertinent to a text's *genesis*, and from another direction what could be called the aesthetic *validity* of the text, its readability, as such. Peter Szondi, in his reading of Celan's late poem "DU LIEGST," showed *both* how the poet enciphered his personal experiences during a visit to Berlin in the poem while removing the explicit title, date, and place (December 23-24, Berlin; the original title "Eden" refers to a hotel by that name in Berlin) *and* how the poem's own literary structure and allusions nonetheless create meaning, how the poem remains *open* to readers ignorant of the enciphered autobiographical allusions, toward a future other who did not accompany

the poet as Szondi did during those days.[60] This double temporal rela-
tion between the poem's "whence" and its "whither" is developed by
Celan in his "Meridian" speech and, further, implicitly demonstrates
the inadequacy of de Man's model of aesthetic semblance as tropolog-
ical illusion. Since that model rests on philosophical presuppositions
of deconstruction more clearly elaborated by Derrida and exempli-
fied in his reading of Celan, I shall offer a brief critique of that read-
ing in the context of alternate theories of reference and then return to
Celan's poetics.

4. MEANING AND REFERENCE: DERRIDA, WITTGENSTEIN, AND EVANS

In *Schibboleth: pour Paul Celan*, Jacques Derrida interprets the date
and the shibboleth as quasi-transcendental infrastructures that have
the same differential structure as do signs in general.[61] In order to be
comprehensible, a sign must be differential vis-à-vis other signs in a
semiotic system yet also be iterable (able to recur in a potentially illim-
itable number of contexts). Both of these axes of difference-in-identity
(synchronic vis-à-vis other signs, diachronic vis-à-vis future contexts
of utterance) militate against the possibility of assigning to or recov-
ering from a sign an originary intentional meaning. Since recovering
such an intention from a text is the task of traditional hermeneutics,
and since the full intentional presence of meaning is the metaphysical
presupposition underwriting hermeneutics, deconstruction casts into
question both the metaphysical concept of sense and the hermeneuti-
cal theory of its recovery.[62]

Reading Celan, Derrida locates these subversive structures in the
date and the shibboleth, both of which he says function "like a proper
name,"[63] the conventional designation for singular terms in linguistic
philosophy. For Derrida, the date is a necessary condition for the pos-
sibility of specifying singular experience while also, through its iter-
ability, necessarily effacing the singularity of that experience:

> It is necessary that the unrepeatable be repeated in it, effacing in itself
> the irreducible singularity which it denotes. It is necessary that in a
> certain manner it divide itself in repeating, and in the same stroke
> encipher or encrypt itself. Like *physis*, a date loves to encrypt itself. It
> must efface itself in order to become readable, to render itself unread-
> able in its very readability. For if it does not annul in itself the unique
> marking which connects it to an event without witness, without other
> witness, it remains intact but absolutely indecipherable. It is no longer

even what it has to be, what it will have had to be, its essence and its
destination, it no longer keeps its promise, that of a date.[64]

That is, if a date signified only a unique, singular experience, it would
lack those differential relationships that are a priori necessary for that
experience to be recognizable *as* an experience; yet, precisely those
differential relationships, because they are theoretically illimitable,
necessarily include the possibility of iteration, displacement, hence
the annulment of the unique experience. Therefore the ontology of
the date, like that of the sign, is not that of full presence to conscious-
ness: "A date is not something which is there, since it withdraws in
order to appear."[65]
Likewise the shibboleth, a word whose pronunciation functions to
distinguish between two groups of people and whose semantic sig-
nification ("ear of corn") is incidental, since it is through its phone-
mic difference that it makes all the difference for those who can or
cannot pronounce it, illustrates the transcendental condition for the
possibility of meaning, "différance" (a written shibboleth of sorts):
"Shibboleth marks the multiplicity within language, insignificant dif-
ference as the condition of meaning."[66] Thus both date and shibbo-
leth as constituents of Celan's poems are nonhermetic and nonher-
meneutic: "A nonhermetic secret, [the poem] remains, and the date
with it, heterogeneous to all interpretive totalization, eradicating the
hermeneutic principle. There is no one meaning, for the moment that
there is date and shibboleth, no longer a sole originary meaning";[67]
"The shibboleth, here again, does not resist translation by reason of
some inaccessibility of its meaning to transference, by reason of some
semantic secret, but by virtue of that in it which forms the cut of a
nonsignifying difference in the body of the written or oral mark, writ-
ten in speech as a mark within a mark, an incision marking the very
mark itself."[68]
The force of Derrida's arguments derives from, and ultimately
remains indebted to, their critique of a metaphysical notion of mean-
ing as full presence to consciousness as paradigmatically presented by
Husserl in his *Logische Untersuchungen*.[69] For Derrida, these quasi-
transcendental structures are the necessary condition for the possibil-
ity and impossible totalizability of temporality, signification, indeed
intentional experience as such:

> What one calls poetry or literature, or art itself (let us not distin-
> guish them for the moment), in other words a certain experience of

language, of the mark, of the trait *as such*, is nothing perhaps but an intense familiarity with the ineluctable originarity of the specter . . .

. . . No, the circumcision of the word [the unconcealing of meaning as iterable event] is not dated in history. In this sense, it has no age, but calls forth the date. It opens the word to the other, and the door, it opens history and the poem and philosophy and hermeneutics and religion.[70]

To the extent that Derrida's argumentation remains a critique of the claim to a totalized knowledge present to consciousness, it remains itself transcendental and within the tradition of metaphysics. At one place in his text on Celan he does, in the form of theoretical statements, consider the move from the transcendental, metaphysical, and descriptive to the empirical, practical, and normative conditions of sense:

Shibboleth marks the multiplicity within language, insignificant difference as the condition of meaning. But by the same token, the insignificance of language, of the properly linguistic body: it can only take on meaning in relation to a *place*. By place, I mean just as much the relation to a border, country, house, or threshold, as any site, any *situation* in general from within which, practically, pragmatically, alliances are formed, contracts, codes, and conventions established which give meaning to the insignificant, institute passwords, bend language to what exceeds it, make of it a moment of gesture and of step/interdiction [*pas*], secondarize or "reject" it in order to find it again.[71]

Derrida's indebtedness to metaphysics leads him to see the transcendental (im)possibility of fully conscious intentionality of meaning or reference of a proper name (dates, shibboleths, and so on) as "the ineluctable loss of the origin,"[72] and to describe in a deconstructed vocabulary of metaphysics the doubled references (historical and literary) Szondi acknowledged in the poem "DU LIEGST":

. . . concerning the circumstances in which the poem was written, or better, concerning those which it names, codes, disguises, or dates in its own body, concerning the secrets of which it partakes, witnessing is *at once* indispensable, *essential* to the reading of the poem, to the partaking which it becomes in its turn, and finally *supplementary, nonessential*, merely the guarantee of an excess of intelligibility which the poem can forgo. *At once* essential and inessential. This *at once* derives, this is my hypothesis, from the structure of the date.[73]

This description, the hypostatization of "at once" and the metaphysical opposition essential/inessential, and so on, work *only* at the

transcendental level of the (im)possibility of recovering a purportedly unitary, originary meaning and temporality of the text. They indicate that Derrida remains within the ambit of the metaphysical tradition he seeks to deconstruct.[74]

Meaning as full intention, self-presence to consciousness, Husserl's position, and meaning as infinitely deferred, fissured, and nontotalizable to consciousness, Derrida's position, can be considered as the two horns of a dilemma that emerges from the picture of meaning as a matter for monological consciousness and theoretical knowledge as opposed to intersubjective name-using practices and practical abilities. Thus for the Husserlian position it becomes unclear how we could ever understand someone else's meaning, or, which amounts to the same thing, be wrong about what we mean, because the normative aspect of meaning, the particular use of an expression being right or wrong, falls out of the picture. Likewise Derrida's position, that the possibility of our not knowing the full meaning of an expression or its context of occurrence is a necessary aspect of the structure of the sign, entails that here too meaning is deferred, so that we can never wholly justify the intended meanings of the expressions we use. Both positions rest on the assumption that meaning is *always* a matter of interpretation: that understanding the meaning of an expression means following a rule, and that *that* means interpreting each of its applications, whereby the justification for each application is either self-evident (Husserl) or necessarily underdetermined (Derrida).[75] Both positions address the gap that obtains between learning an expression as a rule and the use (in uttering and understanding it) that one makes of it in the future: Husserl overlooks the gap; Derrida hypostatizes it. Both allow no room for Wittgenstein's *first insight*, that meaning is "grounded" in nothing deeper than intersubjective normative practices. By contrast, for Husserl I cannot be wrong in my use/understanding of an expression since it is self-evident to me; for Derrida I cannot be right in my use/understanding because it is never exhaustively self-evident to me. In Husserl's position the regress of interpretation is abruptly halted at monological self-evidence, in Derrida the regress of interpretation is infinitely removed from monological self-evidence.

Wittgenstein's *second insight* that I shall put to work holds that there is a way of following a rule that is *not* an interpretation: "'Obeying a rule' is a practice. And to *think* one is obeying a rule is not to obey a rule,"[76] where I take "thinking" here to mean precisely interpreting, offering a justification via interpretation. Wittgenstein's

point, as elucidated by John McDowell, is that there are situations where the step of interpretation does not occur, for instance in following a sign-post: "When I follow a sign-post, the connection between it and my action is not mediated by an interpretation of sign-posts that I acquired when I was trained in their use. I simply act as I have been trained to." Since "the training in question is initiation into a custom," Wittgenstein "is led to say such things as 'I obey the rule *blindly*.'"[77] This is Wittgenstein's famous "bedrock" where "I have exhausted the justifications" and "my spade is turned,"[78] because "following a rule is FUNDAMENTAL [*am GRUNDE*] to our language game."[79] Yet while justification comes to an end, normativity does not: "To use a word without a justification does not mean to use it without a right [*zu Unrecht*, hence also 'wrongfully']."[80]

Wittgenstein's notions of a language game embedded in a custom or a practice avoids both horns of the dilemma entailed by assimilating understanding to interpretation, the assumption made by both Husserl and Derrida.[81] But a condition for the possibility of meaning *is* normativity—that a speaker can be wrong in his use or understanding of an expression, that reference can fail, be empty, or name a different object from the speaker's intended referent. Wittgenstein's two insights, the normative, intersubjective notion of rule-following together with the rejection of the view that all understanding is necessarily interpretation, successfully evade the dilemma.[82] Some language games, like "pointing something out and naming it," "describing," "giving an order," or "expressing pain" are constitutive of their practice. Asked for a justification of their operation, one can only give a *natural history* of their contingent development, for there is no deeper-lying interpretation that *could* be an ultimate, metaphysical justification. Such pragmatic "rule-following" is not metaphysically present to consciousness (in phenomenological parlance, "thematized") in the way Derrida's target must claim, for there is always the possibility that future new applications of the rule will encounter an underdetermined context, take a different path, be decided by fiat, and so on.[83] This is not an irrefutable fissuring of metaphysical presence, since no such claim for presence (knowing a rule as knowing all its possible applications) is made; it is rather a description of the natural history of a rule and its applications, the life of that rule, the insight that a proper name is tantamount to a culture's form of life: as Gareth Evans says, "names have lives."[84] These practices are eminently empirical, contingent, but *also* normative. McDowell puts

it thus: "When I understand another person, I know the rules he is going by. My right to claim to understand him is precarious, in that nothing but a tissue of contingencies stands in the way of my losing it. But to envisage its loss is not necessarily to envisage its turning out that I never had the right at all."[85] Another way of putting this is that because meaning goes all the way down in a given linguistic community's institutions, customs, and practices, because in the final analysis, after all interpretations and justifications there is nothing more to be said, rather only to be shown ("This is what we do"), it is the shared command of a language that makes meaning possible without that knowledge needing ultimately to be arrived at by interpretation, and hence also it is the shared membership in a linguistic community, the continued existence of which is itself a historical contingency, which "grounds" meaning practices that are, despite such historical contingency, normative. To ask for more justification than this is precisely to raise the metaphysical claims that give rise to the dilemma whose horns have fixed Husserl and Derrida.

Once we have shifted from a transcendental to a contingent, normative conception of meaning, we can consider a naturalistic account of proper-name reference that likewise evades the metaphysical dilemma outlined above. Gareth Evans develops and qualifies an insight formulated by Saul Kripke against the so-called descriptive theory of names. That theory holds that a proper name's meaning or reference is determined by the associated bodies of information (typically expressed in definite descriptions) possessed by the users of the name; some sort of interpretation is then necessary to determine which descriptions are in play in any given use of the name.[86] Kripke's idea is that that body of information, the denotation of a name, is determined not by some notion of fit between available descriptions and any given speaker and context of utterance, but by *causal* origin: the denotation is individuated by source, and a series of reference-preserving links tying any given use of that name back to its origin.[87] However, while Kripke holds that the causal relation is between an object's being initially "baptized" with a name and the speaker's contemporary use of the name, for Evans it obtains between that object's "states and doings" (that is, information that continues to be ascribed to it and which circulates in the linguistic community: its ongoing importance within the living context of the community) and the speaker's body of information about the object. In this way Evans can offer the following definition:

'NN' is a name of x if there is a community C

1. in which it is common knowledge that members of C have in their repertoire the procedure of using 'NN' to refer to x (with the intention of referring to x)

2. the success in reference in any particular case being intended to rely on common knowledge between speaker and hearer that 'NN' has been used to refer to x by members of C and not upon common knowledge of the satisfaction of x by some predicate embedded in 'NN.'[88]

This ties together several of the points raised against the metaphysical dilemma above: a speaker learns the practice of using name 'NN' to refer to x by being trained in its use, that is, causally. It is not the case that the name 'NN' somehow metaphysically "contains" or "indicates" all the predicates (descriptions) that are ascribed to x and that one then undertakes to understand the fit between those descriptions and the speaker's intention in using the name on a given occasion—the model upon which Derrida's critique exacts such damage. When a speaker is asked why she uses 'NN' to refer to x, the correct answer is not "because 'NN' 'has' descriptions d1, d2, . . . dn and I meant some subset of them," but rather "because we here in C have used 'NN' just to point out x." The "life" of 'NN' as a proper name for x is thus one with the continued practice of calling x 'NN,' and that practice can change.

Evans considers such a change in the life of a proper name and introduces a further refinement in his ideas. In considering what he calls "proper-name-using-practices" he draws the distinction between "producers" and "consumers" in the given community. Producers are acquainted with x and have dealings with x, as well as knowing that x is called 'NN.' It is the actual pattern of interactions with x that ties the name to the object (or person) x: when a producer uses the name 'NN' the intended meaning is the object x with which he is practically engaged; hence there is no interpretive detour through possible descriptions of x. Consumers are *not* acquainted with x and are introduced into the practice with explanations like "NN is the di" where di is some description, or by hearing sentences in which the name 'NN' is used. When a consumer uses the name 'NN' the referent is determined by determining which name-using practice (there may be several competing ones) he is participating in: the intended meaning is the referent of the name as used in that practice. Consumers are not able to introduce new information into the practice because they are not directly

acquainted with the object, and so they must rely on the information-altering transactions of the producers. One may thus say that an ordinary proper name is used subject to a convention, but that only the producers can be said to know of the convention *not* hermeneutically (by, say, interpreting descriptive information), but causally, by using it to individuate an object with which they interact practically.

For Evans, an ordinary proper-name-using practice can be thought of as having a "natural life-cycle": "It is easy enough to understand what is meant by saying that a name-using practice survives over time; the practice survives through the introduction of new members by those who are already members."[89] One of the virtues of Evans's account is the ease with which it can explain change or loss of reference. Consider the name 'NN' used by both producers and consumers to refer to the object (or person) x. At some later time x and/or the producers practically (causally) familiar with x have disappeared, and a growing number of the linguistic community's members now mistakenly call object (person) y 'NN'; however, as a growing number of members practically interact with y as 'NN' (and hence produce descriptions of 'NN' as y for consumers), reference failure occurs naturalistically: "At this point, I think we can say that the name 'NN', as used in this practice, no longer has a referent. One could no longer point to y and say 'This is not NN.' . . . [T]here may remain, embodied in the practice, a good deal of information derived from x, and these are traces of the practice, in the past, of using the name to refer to x. So long as any serious quantity of these traces remains, the practice can still reasonably be said to embody a confusion."[90] That is, because reference is determined not by theoretical knowledge whose totality is (un)available to consciousness but by intersubjective normative use, reference failure is not a *metaphysical* sundering of referential purity but a contingent, *historical* rupture in the name-using-practice of a linguistic community. Finally, if eventually all information derived from x were to be lost, then the name 'NN' would finally be regarded as a name for y: "From the point of view of the users of the name, it is as though the previous practice—the one concerning x—had never existed. If someone attempts at this point to say, of y, 'This is not NN,' there is nothing in the practice itself to which he can appeal. All he can do is tell a story about how y got his name."[91] The *exchange* of referent—y for x—of NN marks the natural life-cycle of NN within its constituent linguistic communities, and one can rescue the name's original reference only by recounting its genealogy.

Evans's naturalistic picture shows how reference is grounded in a communal practice that can explain the change of reference which Derrida grounds in the internal (metaphysical) structure of the sign. Returning to "DU LIEGST" and Szondi's article, we can offer an explanation without recourse to the essential/inessential supplementarity of which Derrida speaks. The references in the poem to Celan's and Szondi's experiences on that December day are proper names operative within the linguistic community of two people: Celan and Szondi, both inhabiting the role of producers, since they are each practically (causally) acquainted with the referents. Celan's later effacing the title, date, and location of the poem worked to imperil the availability of these name-using practices for consumers, subsequent readers of the poem, and moreover imperil the "life of the names" to such an extent that Szondi felt obliged to *testify* to those name-using practices, to rescue them by telling the story of how those names got their references. As *witness* to the initial name-giving, Szondi has acquaintance with the references as a producer, in this case uniquely so (besides Celan).[92] Once Celan occludes those name-using-practices, renders their contingency even more precarious than it nonetheless is, only Szondi can tell their story. If names have lives, as Evans suggests, then the survival of these names (these name-using practices in this linguistic community) rests on Szondi's testimony, necessarily and uniquely. Might one say that Szondi felt *obliged* (Mandelshtam's word to designate the relationship between poem and addressee) to bear witness, to narrate the historical passing of this specific name-using practice, this community? In what does the obligation lie? Just as many other, painstaking readings of Celan's poems have rescued, to the extent possible, such micrological name-using-practices, might one say that Celan's poetics induces a certain historical experience, of the radical *mortality* of names? "No one / bears witness for the / witness" (*Niemand / zeugt für den / Zeugen*),[93] where as well as "to testify, bear witness," "*zeugen*" means "to procreate."[94]

This is not merely a case of ambiguity or polysemy, since those concepts presuppose fixed meanings somehow "present" in the poem and whose correct candidate the exegete is to interpret hermeneutically: Szondi did not "interpret" the references to that Berlin day, he recognized them, because he was directly acquainted with their referents, for instance that "Eden" is the name of a Berlin hotel. Concepts such as ambiguity and polsemy underwrite the very notion of art and aesthetic semblance that Celan works against, as we shall see

when we turn to his "Meridian" speech. Nor is it apparent how an exegete could discriminate between the so-called inessential, autobiographical information and the "essential," universal, aesthetic, and so on, information as "the" meaning of the poem, since precisely the distinction between essential and inessential, particular and universal presupposes the metaphysics of aesthetic semblance again. Rather this is a compositional technique of Celan by which a contingent, evanescent (what Celan calls the "already-no-more" in the "Meridian") historical name-using practice inhabits the language of the poem, language that in turn is *also* aesthetically constructed and available to an aesthetic reading, just as Szondi notes that the poem "DU LIEGST" through its lexical density (biblical allusions, and so on) and construction (rhythm, parallelisms) is still (what Celan calls the "ever-yet" in the "Meridian") "readable" as a poem; the proper names of a poet from a historically "mortal" community inhabit the aesthetic semblance of the poem, such that the poet is "given with" the poem.

5. CELAN'S POETOLOGY: THE BREMEN SPEECH

In his "Bremen Speech" (January 26, 1958), Celan writes:

> For the poem is not timeless. Certainly, it raises a claim of infinity, it tries to reach through time—through time, not beyond time.
>
> Since it is a manifestation of language and hence according to its essence dialogical, the poem can be a message in a bottle, sent in the—certainly not always very hopeful—belief that someplace and sometime it could be washed up on shore, on heartland perhaps. Poems are also in this sense underway: they are heading towards something.
>
> Towards what? Towards something open, something that can be occupied [*besetzt*], towards a thou [*Du*] which can be addressed, towards a reality that can be addressed [*ansprechbare Wirklichkeit*].[95]

The intersubjective and normative nature of meaning, the condition of its possibility being a name-using-practice within a linguistic community, is brought into stark relief when that community, that shared web of meanings, *cannot* be presupposed. This is the point of departure for Celan, for his poems: hence the mutual dependence between gaining a reality and addressing a Thou. Whereas for Mandelshtam the poet is sure of the existence of his addressee because he is sure of himself and his sense of being right, for Celan the poem can at most raise a claim, attempt to find a reality that can be addressed: it

is the addressee to whom Celan is beholden, through whom he can "project reality" and "gain direction."[96] Mandelshtam's figure of the poem's providential addressee as a "friend" is here both intensified and rendered more indefinite—a Thou. The intimacy of this relationship is perhaps signaled by the evocation of Freud's concept of cathexis (*Besetzung*), the libidinal investment of an object by the psyche;[97] however, Martin Buber's existential phenomenology of dialogue surely also inhabits Celan's thoughts here.[98]

That the poem is "underway," that "it tries to reach through time" rather than being timeless marks Celan's departure from the poetics of aesthetic autonomy, either its Idealist model of the artwork as the harmonious symbolic reconciliation of all antagonisms or its semiotic inversion in Derrida and de Man, where the artwork is the site of endless allegorical difference and deferral.[99] That is, the pretense of aesthetic semblance to autonomy, the ontological distinction between an artwork and everyday objects, and hence also from noninterpretive, nonhermeneutic name-using practices, makes art the privileged site for Derrida's critique of linguistic understanding (as art was the privileged site for the Romantics' reconciliation of idea and reality), what Habermas calls Derrida's "aestheticization of language."[100] But to the extent that Celan's poetics works *within* and *against* art as aesthetic semblance to save and thematize contingent, historical name-using practices, his poetics in turn is the privileged site for correcting Derrida's reading, for showing not only that intersubjectivity is "co-originary" (*gleichursprünglich*) with the structure of the sign as enabling conditions of meaning and reference, but also its vulnerability.

In his description of Mandelshtam's first collection of poems, *Kamen'*, Celan explicitly denies that the poems have anything to do with a Symbolist poetics of "word music," "tone colors," or "mood poetry," nor are they a "'second' reality" that would symbolically rise over "the real"; rather "their images resist the concept of metaphor and emblem; they have a phenomenal character."[101] Not unlike Bakhtin, Celan sets off the phenomenal character against an understanding of poetry as linguistic trope. And in an earlier short text (1958) Celan had stressed the performative, annunciative "project" of poetic language:

> [The language of German lyric poetry] does not transfigure, does not 'poeticize', it names and posits, it attempts to measure out the domain of what is given and what is possible. To be sure language itself, language as such is never at work here, but always under the speaking I's particular angle of incidence of his existence, for whom contour and

orientation are at issue. Reality does not exist, reality must be sought and gained.[102]

Poetry for Celan, as in the great odes of Mandelshtam, does not mimetically reproduce an anterior reality, nor is it a wholly autonomous exercise in beauty, affect, or self-reference. Rather poetic language is the medium within which the poet attempts to "be true" and to "attain reality." Amid all the losses, Celan says, language alone remained "what was attainable, near and unlost"; "In this language I tried, in those years and in the years afterwards, to write poems: in order to speak, in order to orient myself, in order to reconnoiter where I found myself, where things were taking me, in order to project [*entwerfen*] reality. It was . . . event, movement, being underway, it was the attempt to gain direction."[103]

The poet is, then, the one who "goes with his *Dasein* to language, reality-wounded and reality-seeking,"[104] *through* time. At the end of the Mandelshtam radio broadcast, as its own paragraph, stands the equally apodictic and gnomic definition: "Poems are projections of a human being: the poet lives after and according to them" (*Gedichte sind Daseinsentwürfe: der Dichter lebt ihnen nach*);[105] it is echoed in the "Meridian" speech: "Poems . . . are paths, upon which language becomes voiced, they are encounters, paths of one voice to a perceiving Thou, creaturely paths, *Daseinsentwürfe* perhaps, a sending oneself out ahead to oneself, in search of oneself . . . a kind of returning home [*Heimkehr*]."[106] Celan has transformed a largely *receptionsaesthetic* concept in Mandelshtam—the providential addressee of a poem—into an *existential* definition of a poem's mode of being: as *Daseinsentwürfe*, poems share the temporal structure of human being (*Dasein*). Martin Heidegger, who also inhabits this speech in more ways than can be discussed here,[107] conceives the temporal structure of each individual as follows:

> Es entwirft das Sein des Daseins auf sein Worumwillen ebenso ursprünglich wie auf die Bedeutsamkeit als die Weltlichkeit seiner jeweiligen Welt. Der Entwurfcharakter des Verstehens konstituiert das In-der-Welt-sein hinsichtlich der Erschlossenheit seines Da als Da eines Seinkönnens. Der Entwurf ist die existenziale Seinsverfassung des Spielraums des faktischen Seinkönnens. . . . Das Verstehen ist, als Entwerfen, die Seinsart des Daseins, in der es seine Möglichkeiten als Möglichkeiten *ist*.[108]

> ([Understanding] projects the being of *Dasein* [the mode of being specific to human existence] upon its for-the-sake-of-which just as

originarily as it does upon the worldliness of its respective world. The projective character of understanding constitutes the being-in-the-world in regards to the disclosure of its here/now as the here/now of its ability to be. The project is the existential way of being of the scope of its actual ability to be. . . . Understanding is, as projection, the way of being of *Dasein*, in which it *is* its possibilities as possibilities.)

The poem exists in the same mode as human being (*Dasein*); the poem projects through time a linguistically articulated reality, its language as its ownmost possibility. Each poem is therefore a projection, a possible way of continuing to be, beholden to the addressee who would actualize that reality by recognizing its language, entering into a linguistic community of sorts. As projections into the future of "ownmost" possibilities, poem and person are "ecstatic," complex forms of actualization in time (*Zeitigung*), as Heidegger says.[109] Mandelshtam's language, says Celan in the broadcast, is "language actualized in time" (*gezeitigte Sprache*; original underlining).[110]

6. CELAN'S POETOLOGY: THE "MERIDIAN" SPEECH

Celan provided his most elaborate poetological meditation in "The Meridian," his acceptance speech at receiving the prestigious Büchner Prize in literature on October 22, 1960. In the speech, which incorporates intricate allusions to Georg Büchner's works and letters as well as unacknowledged borrowings from his earlier radio broadcast on Mandelshtam, Celan considers how poetry (*Dichtung*) takes place within and eventually against art (*Kunst*), by momentarily interrupting art's tendency toward aesthetic autonomy and myth. Indeed, his diverse critical reflections on art amount to an attack on aesthetic semblance *qua* tendency toward aesthetic autonomy:

1. Mimesis tends to fix its living subjects in a Medusa-like gaze, when Celan quotes Büchner's *Lenz*: "Sometimes one would like to be a Medusa's head, in order to be able to transform a group into stone and then call to people."[111]

2. Art is artifice and artificial, when Celan, invoking Büchner's comedy of automata and puppets on strings, *Leonce und Lena*, quotes the character Valerio with his "rasping, clattering voice": "Nothing but art and mechanism, nothing but paper covering and clock springs!"[112]

3. Art tends toward generic conventionalism (its "gift of ubiquity") and theatricality, when Celan refers to the condemned in Büchner's play *Dantons Tod*, preparing their speeches, all of which the townspeople "had seen before").[113]

4. What art as myth, a "marionette-like, iambic-fivefooted and . . . childless thing,"[114] lacks is natural history, individuation, mortality, the mode of human being. As Celan repeatedly says in the speech, "art comes again" (*Die Kunst kommt wieder*), an eternal recurrence of the same.[115]

At the outset of the speech, poetry "comes between" (*kommt dazwischen*), interrupts art that, without this interruption, could endlessly sustain conversation-cum-entertainment (*Unterhaltung*, not *Begegnung*, "encounter," or *Gespräch*, "conversation"). Celan uses similar language to explain the effect of Mandelshtam's first book of poems upon the Russian literary milieu: "These poems estrange [*befremden*]," and he cites Zinaida Gippius's remark that "something had gotten in there" (*Etwas war da hineingeraten*): an interruption. In the broadcast, Mandelshtam, he as a person, an I, is also said to have something estranging (*Befremdendes*), a little uneasy, uneven (*Ungereimtes*): "Suddenly one hears him laugh out—in situations where one would expect a completely different reaction; he laughs much too often and much too loudly."[116] At the conclusion of the broadcast, an interruption is again described, referring to Mandelshtam's poem "1 January 1924": "Thus it comes to a break out of contingency: by laughing. By that familiar 'nonsensical' laughter of the poet—by the absurd."[117] Art's interruption occurs through a *temporalizing* of the intersubjective basis of meaning and a process of referential *exchanges* that operate as the poem is received as it were "posthumously" by subsequent linguistic communities.

Celan develops this notion of poetry's interruption of art though an allusive reading of some of the characters in Büchner's *Dantons Tod*. The minor character Lucile, "blind to art" (*kunstblinde*), interrupts the prescribed plot of public execution, of those who will recite their "artful" words like market hawkers and will deliver speeches celebrating their "going together into death," of wanting to die "twice," and Camille's theatrical, alienated death (for only two scenes later, says Celan, can we sense that it was indeed his death). She interrupts this hackneyed, repetitive artifice with her exclamation "Long live the king!" which Celan calls a "counter-word . . . a word that no longer

stoops before the 'loafers and parade nags of history.'" The allusion is to a letter by Büchner to his wife, part of which reads:

> I studied the history of the Revolution. I felt as though annihilated under the ghastly fatalism of history. In human nature I find a terrible equality, and in human relations an inevitable violent force [*Gewalt*], bestowed on all and none. The individual [is] only foam on the wave, greatness a mere accident, the rule of genius a puppet play, a laughable struggle against an iron law, to recognize it the highest thing possible, to control it impossible. I wouldn't dream of stooping before the parade nags and loafers of history. I've accustomed my eye to blood.[118]

Lucile's counterword Celan calls "a step,"[119] and "an act of freedom," precisely against the understanding of history as inevitable fate, homogeneous continuum: precisely the temporal equivalent to aesthetic semblance as myth. To turn against this mythic time in the name of the singular individual and thereby in the name of the absurdity of the human, is a revolution of sorts: Celan is reported to have "characterized the originary moment of the poetic [*das Dichterische*] as an awkward revolt against historical time."[120] Lucile's word is thus not a wish for monarchical restoration, but homage to "the majesty of the absurd that testifies [*zeugen*] to the presence of the human [*die Gegenwart des Menschlichen*]." Lucile is, like Mandelshtam, "someone who has perceived language and shape [*Gestalt*] and also . . . breath, that is, direction and fate," for whom "language has something person-like and perceivable," singular directionality.[121]

Poetry travels back along the path of art (Celan's verb for this reversal, this way back, is consistently "*zurücklegen*," with perhaps a faint echo of "*zurechtlegen*," "to carefully lay out, set ready," but also, "to bring into order"), to reveal its implicit singular *Daseinsentwurf*, the natural history of the poem. This is shown by Celan in Büchner's alienated figure of Lenz (from Büchner's eponymously titled short prose text), who, Celan says, takes a step further back from art than Lucile, a step Celan takes by moving backward from the figure of Lenz to the "direction of this *Dasein* by searching for the historical Lenz," for "poetry attempts to see the shape [*Gestalt*] in its direction, poetry rushes ahead";[122] the poet follows the poem's *Daseinsentwurf*. Thus Celan places the individual's directionality in italics [here rendered in bold]: "*wohin er lebt, wie er hinlebt. . . . So hatte **er** hingelebt*." Whereas "art creates I-distance" and makes one "self-forgotten" (*selbstvergessen*), poetry projects the figure and direction of

a singular person. The direction is one's own mortality, Heidegger's "being-toward-death," as Celan recounts Lenz's life by *naming* (there is no main verb in Celan's passage here) the "true" Lenz by his association with a *date*: the "person" Lenz—he "as an I" instead of one occupied with questions of art—who "on the 20th of January went through the mountains" (*den 20. Jänner durchs Gebirg ging*). "*Jänner*"—the Swabian, for Celan Hölderlinian,[123] form of "*Januar*"—in Celan's poetics is the *name* of one's *dated* mortality: Lenz's "20th of January" and Celan's 20th of January, the date in 1942 of the Wannsee conference, which determined his direction, his fate, and that of his family, his compatriots, his country. "*Jännernacht*" is how Celan translates Mandelshtam's "Советская ночь" (Soviet night),[124] and one of his posthumous poems begins:

EINGEJÄNNERT
in der bedornten
Balme. (Betrink dich
und nenn sie
Paris.)[125]

(In-januaried
in the bethorned
cavern. [Become drunk
and call it
Paris.])

Lenz's wish to walk on his head ("*auf dem Kopf gehen*," an inversion of the idiomatic "*den Kopf obenhalten*," meaning to keep one's wits) Celan reminds us, inverts, reveals the heavens beneath him as an abyss:[126] Celan tentatively asks whether here "we find the place where the person can release himself as an—estranged—I?" Lenz's wish to walk on his head is a step further than Lucile's "Long live the king!" because the former is a "terrible muteness" (*furchtbares Verstummen*), but both are instances of interruption, acts of absurd freedom and awkward revolt against mythic art and mythic history, what Celan calls a "turn of breath" (*Atemwende*): "Who knows, perhaps poetry retraces the path—also the path of art—for the sake of such a turn of breath?"[127]

The path that poetry retraces passes between two uncanninesses, two kinds of foreignness (or "exiles": "*Fremden*"), two kinds of self-forgetting: on the one hand, Lenz's muteness, the loss of language altogether, and on the other, the dangers of art: Medusa and automata. Between these two forms of foreignness, Celan asks whether

perhaps "for this unique short moment" it might be "possible for an I, *here* and *in such a manner* [**hier** und **solcherart**; italicized, punctualized in the original], to be set free, though estranged, and with this I something other [*ein Anderes*] might also be set free?" It is important to note that there is not the slightest indication that a restoration takes place that would negate time or its effects. On two occasions Celan says that the "I" that is released is "estranged, made strange" (*befremdet*). And yet this is the place from which the poem is "itself" (*es selbst*), attains the same individuation, breath, fate, direction, *mortality*, as Lenz and Lucile, because a *Daseinsentwurf.* "Perhaps each poem," he says, has "its own '20. Jänner' inscribed within it" and perhaps such poems "attempt to remain mindful of such dates."[128]

This punctual, singular passage of a poem as *Daseinsentwurf* is marked by two temporalities: the *first* temporality is the poem's "attention" and "concentration" upon its dates. "But don't we all write ourselves from such dates? And which dates do we consign [or: write] ourselves to?" (*Aber schreiben wir uns nicht alle von solchen Daten her? Und welchen Daten schreiben wir uns zu?*) A parabasis of sorts, and the first time Celan has spoken of "us" in his address there and then in Germany, has linked his 20th of January to theirs, perhaps the closest Celan comes in the address to concretely evoking the date of another conference of sorts where he and they were "written apart" (*auseindergeschrieben*), as he writes in the poem "Engführung."[129]

The *second* temporality is that of the poem's encounter with every new reader: "But the poem speaks!" Although mindful of its dates, although attaining its estranged singularity through that mindfulness, the poem also speaks, now, always and again, in the present tense, to its addressee. And yet, even in its speaking, says Celan, it speaks "*on the behalf of an other*" (**in eines Anderen Sache**, in italics) even on the behalf of a "*completely Other*" (**ganz Anderes**);[130] but also, in its legal connotations, "in the cause, the concern of an other" as in suing for someone else's justice. This momentary suspension between poem and its other Celan calls a pause for breath (*Atempause*):[131] though threatened with the accelerating "swiftness" (in the Bremen address he speaks of the "loss of history," "*Geschichtslosigkeit*"),[132] the poem lingers (*verweilen*, echoing Faust's "Linger yet! you are so beautiful!" [*Verweile doch! du bist so schön!*]),[133] poised and attentive (*verhoffen*), and "proceeds toward that 'other' which it thinks to be attainable, able to be set free, vacant perhaps, and thereby turned toward

or addressed to [*zugewandt*] it, the poem—let's say: like Lucile."[134]
This other, which the poem makes for is at once also turned toward
the poem, addressing it, just as Lucile, turned from the eternal same
of political theater and turned toward the dead king, will speak in
his cause. This encounter between the speaking poem and its other
is described by Celan in explicitly *temporal* terms: "The poem stands
its ground on the edge of itself; in order to exist, it calls and regains
itself uninterruptedly out of its already-no-more [*Schon-nicht-mehr*]
into its ever-yet [*Immer-noch*],"[135] from the dates of which it is mind-
ful into the still possible address to another to whom it is addressed.

"This ever-yet can surely only be a speaking [*Sprechen*]. Thus not
language per se [*Sprache schlechthin*] and presumably also not a 'cor-
responding' that first comes from the word [*nicht erst vom Wort
her "Entsprechung"*]. . . . But rather actualized language." Celan's
polemic is here directed against a transcendental reading that would
locate the condition of possibility for poetry and language use *solely*
in an ontological 'correspondence' to language without considering
the intersubjective dimension of "actualized language."[136] Specifically
the dismissive allusion is to Heidegger's pronouncements in a lecture
entitled "Die Sprache" on the essence or presencing (*Wesen*) of lan-
guage as the enabling, world-disclosing "word" to which humans
"co-respond" ("*ent-sprechen*") by entering into the ontological space
of significance, of things that can be named and spoken about:

> The way according to which the mortals, summoned from the dif-
> ference [*Unter-Schied*] into this, for their part speak [*sprechen*] is:
> corresponding [*das Entsprechen*]. . . . The mortals speak, in so far as
> they hear. They attend to the commanding [or naming: *den heißen-
> den Ruf*] call of the stillness of the dif-ference, even when they do
> not know it. Hearing perceives the command of the difference, which
> brings it into the sounding word. The hearing-perceiving speaking
> is co-responding [*Ent-sprechen*]. . . . Language speaks. Its speaking
> commands the dif-ference to come, dispossesses the world and things
> into the simplicity of their innerness. Language speaks. Man speaks,
> to the extent that he corresponds to language.[137]

In 1960 Buber gave a lecture entitled "The Word that Is Spoken"
(Das Wort, das gesprochen wird), which criticized "existential mono-
logism" and polemicized against the later Heidegger's philosophy
of language (including "Die Sprache," given by Heidegger the year
before in the same lecture series) for its exclusion of intersubjective
linguistic understanding:

We do not find determinative the human being confronted with things, which he would need to answer to in order to bring them to their full thingliness. No matter how fundamental this act may be, we find determinative to be human beings with each other, who undertake to come to an understanding [*verständigen*] about situations. Not things, but situations are primary; and if Stefan George's saying, may there be no thing where the word is lacking [from George's poem "Das Wort"], precisely is apposite for things, it is inapplicable to situations with which human beings are familiar before they come to know things.[138]

"Actualized language" in turn is Buber's terminology for the eventhood of language in a dialogical encounter between an I and Thou, an encounter conditioned by the mutual concern, attention (*Zuwendung*), and we recall the structural role of "*zuwenden*" in the "Meridian" speech.[139]

How are we to understand the poem's being mindful of its dates and its "actualized language"? We are at the first island from Celan's unpublished Mandelshtam radio broadcast, which provides additional context:

The poem is the poem of one who knows that he speaks under the angle of incidence of his existence, that the language of his poem is neither 'correspondence' nor language in itself, but rather <u>actualized</u> language [<u>*aktualisierte*</u> *Sprache*], voiced and voiceless at once, set free under the sign of an indeed radical individuation, but at the same time an individuation that remains mindful of the limits set it by language, the possibilities accorded it by language.[140]

The passage recurs verbatim in the "Meridian," except for the substitution of "creatureliness" for "existence" (the poem is creaturely, terrestrial, as Büchner is a "poet of the creature," Celan says). The radio broadcast elaborates more fully than the "Meridian" speech:

The place of the poem is a human place, "a place in the universe," certainly, but here, here below, in time. The poem remains, with all of its horizons, a sublunary, a terrestrial, a creaturely phenomenon. It is the language of a singular person become figure [*Gestalt gewordene Sprache eines Einzelnen*], it has concrete objectivity, objective continuity, presence. It stands into time. [*es hat Gegenständlichkeit, Gegenständigkeit, Gegenwärtigkeit, Präsenz. Es steht in die Zeit hinein.*][141]

And this too is echoed in the "Meridian." Finally, an unpublished preliminary note by Celan on Mandelshtam also speaks to this passage:

And thus one will also understand that M.'s poems are not "hermetic," as is repeatedly said of them, but rather open, opened wide to the eye that attempts to comprehend them in their entire temporal depth [*Zeittiefe*].

Conclusion: place of man—a place in the universe.[142]

"Obscure" and "hermetic" were characterizations of his own poetry against which Celan struggled throughout his life.[143] The citation "a place in the universe" comes from the following poem from Mandelshtam's first collection:

Пусть имена цветущих городов
Ласкают слух значительностью бренной.
Не город Рим живет среди веков,
А место человека во вселенной.

Им овладеть пытаются цари,
Священники оправдывают войны,
И без него презрения достойны,
Как жалкий сор, дома и алтари.[144]

(Let the names of flourishing cities
Caress the ear with passing significance.
Not the city of Rome lives amongst the ages,
But the place of man is in the universe.

Czars try to possess him,
Priests justify wars,
And without him homes and altars,
Like pitiful rubbish, are worthy of contempt.)

This poem itself speaks of two temporalities (that of the transitory importance accorded cities despite their claim to mythic eternity versus the place of man within the universe, within time) and two notions of human existence (the impersonal theater of power and conquest versus the homes and altars that derive their importance from being personally, intimately inhabited). From the viewpoint of the singular individual, the continuum of history and the possessions of power are worthy of contempt without human presence; this too Celan saw as an "awkward revolt against historical time," in the radio broadcast claiming "for [Mandelshtam] the Revolution is . . . the onset of the Other, the revolt of those below, the uprising of the creature."[145] "Actualized language" thus might be considered the linguistic act of utterance within a concrete speech-situation, the second temporality outlined above. But Celan is also suggesting that the "temporal

depths" of a poem includes past concrete speech situations whose comprehension is *not* assured.

Corresponding to the two temporalities of the poem are two *encounters* by which, like the temporalities, an inversion, an exchange, occurs as the poem moves through time. The poem is "lonely and underway." But "he who writes it, remains given with it [*ihm mitgegeben*]. But does not the poem stand precisely for that reason, thus already here, in the encounter—*in the secret of the encounter?*"[146] This is the *first* encounter, the poem's *first* "turn of breath": the poet attends, accompanies the poem, and in this sense there is *already* an encounter, between the poem and the poet. The encounter is "secret" for precisely the reasons Szondi illustrates in his essay on the poem "DU LIEGST": because the poet's names and dates are meaningful, referential only within the contingent community to which he belongs; his "twitches" and "intimations" inhabit the poem as that community's natural history; as that community is mortal *so too is the poem mortal.* This is what the poem *may* give, what *may* be set free from the fatalism, contingency, and twin uncanninesses of art and silence. This possibility, the modality of the "may," is the poem's "pause for breath."

But there is a *second* encounter, a second "turn of breath": the poem needs an other, an interlocutor (*Gegenüber*), "it consigns [or speaks, *sich zuspricht*] itself to it." "For the poem that proceeds toward the other, every thing, every person is a figure [*Gestalt*] of this other." The poem, not the reader, tries to devote attention to everything it encounters, for all the shapes, contours, color, structure, and so forth, and the "twitches" and "intimations" of that creatureliness that the aesthetic semblance of art immobilizes and eternalizes. The poem becomes "conversation—often it is a desperate conversation" (*Gespräch—oft ist es verzweifeltes Gespräch*).

Celan elaborates upon this idea in the second island from the Mandelshtam radio broadcast:

> These poems are the poems of someone perceiving and attentive, towards what appears, querying and addressing what appears [that is, phenomena]; they are a <u>conversation</u> [*Gespräch*]. In the space of this conversation that which is addressed constitutes itself, comes to presence, gathers about the I who addresses and names it. But in this presence that which is addressed and that which, as it were, has become a <u>Thou</u> [*Du*] through the act of naming brings with it its otherness and foreignness. Even in the here and now of the poem, even

in this immediacy and nearness it allows its distance also to speak, it preserves what is most its own: its time.[147]

My translation cannot capture the movement in Celan's prose by which the neutral and neuter *"das Angesprochene"* (that which is addressed) becomes the intimate, familiar form of address, "Thou" (*Du*) thus enacting in prose the very process he ascribes to poetry.[148] It is no longer clear that this encounter is limited to the relationship in aesthetic production between the poet's singular autobiographical experience and its transcription in the poem. Rather Celan is here describing an action that occurs within the poem itself. That action is defined by both nearness and proximity, key terms that are thematically and structurally operative in the essay as a whole. The vantage point in fact has been inverted, exchanged, in the figure of chiasmus. Closeness and immediacy now are associated with the poem itself, the ever-renewed actuality of its language in each new encounter with a reader. However, the foreignness or exile, the distance is now associated with the autobiographical-historical aspects of the poem, its dates, "its time." That is, the historical, singular trajectory (angle of inclination, names and dates) of the poet has undergone a kind of transmutation (Mandelshtam's word) or exchange: the 'I' set free is "estranged" (*befremdet*), as Celan insists, through its second encounter—the reading of the poem by someone who is merely a consumer or who perhaps does not belong to the name-using community from which the poet (and poet's presence in the poem) derives. The model of reading at work here is *not* the construal of understanding as the translation of a nonlinguistic meaning from one language to another (exactly the presupposition that both motivates classical hermeneutics and its deconstructive critique), and we recall that the translator Celan responded to a survey about literary bilingualism by denying its possibility, claiming, "Poetry is the fateful one-timeness [*das schicksalshaft Einmalige*] of language."[149] Rather it is translation understood as transmutation or transformation, a chain of transmission by which the references of names can be lost, names acquire new references, and so on: exactly the type of natural history of names discussed in terms of Evans's causal theory of names above. This is the "darkness" of which Celan says, "This is, I believe, if not the congenital, then surely the darkness from a—perhaps self-projected—distance or foreignness that is assigned to poetry for the sake of an encounter."[150] Celan elsewhere says this "'gray' language" "is more sober, more factual, it distrusts the 'beautiful,' it tries to be true."[151] This *congenital*

darkness, *with* which the poem is *born*, as it were, and self-projected (*selbstentworfene*), is the opacity of the individual poet's names and dates by which he (and his linguistic, historical community) is "given with" the poem. "Poems are also gifts—gifts to the attentive. Gifts that convey fate," wrote Celan in a letter to Hans Bender.[152]

In the Mandelstam radio essay Celan likewise describes a nexus of times and exchange in a passage he also incorporates into the "Meridian" speech:

> It is this tension between the times, one's own and the foreign one, that lends the Mandelshtamian poem that painful-speechless vibrato by which we recognize the poem. (This vibrato is everywhere: in the intervals between the words and the strophes, in the "haloes" ["*Höfe*"] in which the rhymes and assonances stand, in the punctuation. All this has <u>semantic relevance</u>.) The things approach each other, but even in this togetherness there speaks too the question of their whence [*Woher*] and whither [*Wohin*]—a question "remaining open," "coming to no end," pointing into what is open and can be occupied [*das Offene und Besetzbare*], into what is empty and free.[153]

In the radio broadcast Celan specifies that "this question" is realized not only in the thematics of Mandelshtam's poems, but that it also "takes form in the language: the word—the name!—shows a tendency to the substantive, the adjective vanishes, the 'infinitive,' the nominal forms of the verb predominate: the poem remains open to time [*zeitoffen*], time can join in [*hinzutreten*], time participates [*partizipiert*]."[154] "*Zeittiefe*" and "*zeitoffen*": mindful of their dates and moving forward in time through new encounters with new readers, establishing a chain of transmission, estranging (*befremdend*) and contingent, with every actualization of the poem's language. At the very conclusion of the broadcast the speaker recalls Mandelshtam's preference for the Latin gerundive, adding, "The gerundive—that is the future passive participle."[155] Not only does the frequent transformation of finite verbs into substantivized forms common in Celan's translations of other poets here find one motivation.[156] It suggests that this praxis of translation is no less important to Celan's own poems, that they be considered *translations of themselves*, through time and via successive readers, as "gifts conveying a fate," as "*Daseinsentwürfe*" that actualize certain (always other) possibilities of the poem's language in each new reading, because the form of the poem's language is constitutively open to the future. A late lyric speaks of this with astonishing, terrible simplicity:

DU LIEGST HINAUS
über dich,

über dich hinaus
liegt dein Schicksal,

weißäugig, einem Gesang
entronnen, tritt etwas zu ihm,
das hilft
beim Zungenentwurzeln,
auch mittags, draußen.[157]

(YOU LIE BEYOND
over yourself,

over yourself beyond
lies your fate,

white-eyed, from a song
escaped, something joins it,
which helps
with the uprooting of tongues,
also at midday, outside.)

This is, I suggest, nothing less than the natural history of a poem, its preservation-through-transformation of its own time, the time of its proper names, a precarious preservation more transposition than translation ("*übersetzen*," to ferry across, "literally" a "*metaphorein*") of pain into language:

Die in der senk-
rechten, schmalen
Tagschlucht nach oben
stakende Fähre:

sie setzt Wundgelesenes über.[158]

(In the verti-
cal, narrow
day-gorge, upwards
poling the ferry:

it takes
wound-read across.)

The actualization of the poem's language is not a hermeneutical sublation, the presence of a unified meaning; rather, the phenomena bring the question of their whence and whither: their own form and direction, both the historical past they encipher and the futural possibility of their newly accrued meanings and references, their being

"read" in new contexts. If "names have lives," as Evans said, then a poem's life is the dates and names it remains mindful of as it moves through time, addresses to the other who would recognize those dates and names: this is the poem's breath, fate, direction. As Mandelshtam said elsewhere in the *Journey to Armenia*: "At the very deepest levels of language there were no concepts, just directions, fears and longings, needs and apprehensions."[159]

A poem's continual possibility of new actualizations is perhaps exemplified by the sole instance of his poetry that Celan cites in the "Meridian" speech, a strophe from the opening poem "Voices" ("Stimmen") of the volume *Sprachgitter*:[160]

> Stimmen vom Nesselweg her:
> *Komm auf den Händen zu uns.*
> Wer mit der Lampe allein ist,
> hat nur die Hand, draus zu lesen.
>
> (Voices from the path of nettles:
> *Come to us on your hands.*
> Whoever is alone with the lamp,
> has only his hand to read from.)

The strophe is composed entirely of tenseless constructions: a noun phrase in the first line, an imperative in the second, and a gnomic apothegm in the third and fourth. Whereas in *Sprachgitter* only the initial word, "*Stimmen*" is in italics, here only the second line, the address, is italicized, and we have mentioned, without systematically exploring, Celan's use of italicization in the "Meridian" speech to indicate individuation and temporal directionality (for example, speaking of Lenz, "*Er, er selbst . . . So hatte er hingelebt*," and so forth [here in bold]). The poem is by its construction *zeitoffen* (indeed, as far from hermetic as one can imagine), it takes on meaning as it moves temporally through encounters, so that the second line, in the new context of the speech, becomes an *utterance* commanding or requesting Celan to come on his hands, that he walk on his head, as Lenz did on the 20th of Jänner, and we note Celan saying he wrote the poem "from my 20th Jänner," and his apprehensions about traveling to Germany, about abiding, unacknowledged fascism and resurgent neofascism in Germany.[161] Whereas the imagery of the second strophe in "Voices" takes up and develops a scene along a river, the context that *may* emerge here is *perhaps* more "desperate," as Celan says the poem's conversation often is.[162] For Job (in Luther's translation of 1545), in answering the accusations of his visitors, offers a parable of

his reversed fortune, his affliction, likening himself to an unsteady lamp, "He that is ready to slip with his feet is as a lamp despised in the thought of him that is at ease ["*Stoltzen*," "the proud," in Luther's translation]" (*Job* 12: 5), and lamenting his having become a pariah, such that now those "Who cut up mallows ["*Nesseln*," "nettles," in Luther's translation] by the bushes and juniper roots for their meat" (*Job* 30: 4) call to him:

> Among the bushes they brayed [*rieffen*, "called" in Luther's translation]; under the nettles [*Nisteln*] they were gathered together.
> They were children of fools, yea, children of base men: they were viler than the earth.
> And now I am their song, yea, I am their byword. (Job 30: 7–9)

Perhaps this is also given with the poem. In the essay "Fate and Character," two concepts that also operate in the "Meridian," Walter Benjamin claimed that although the two concepts are causally independent, they do coincide: "It is no accident that both orders [of fate and character] are connected with interpretive practices and that in chiromancy character and fate coincide authentically."[163] The lines of one's palm may also be a meridian. The poem speaks now, after the consideration of Lenz's wish to walk on his head, after his and Celan's 20th Jänner, differently, because a meridian has connected the two, Lenz and Celan: "I find that which connects and leads like the poem to an encounter."[164] Perhaps Celan, in coming to Germany, in giving this address, is living after and according to that strophe's *Daseinsentwurf*, heeding those collected among the bushes and nettles, becoming their byword.

7. CELAN'S NATURAL HISTORY OF NAMES

How might this "life of a poem," this transmission process, be understood by Celan? Speculations might begin with Mandelshtam's program of "Hellenism":

> Hellenism is the conscious surrounding of man with domestic utensils instead of impersonal objects; the transformation of impersonal objects into domestic utensils, and the humanizing and warming of the surrounding world with the most delicate teleological warmth. Hellenism is any kind of stove near which a man sits, treasuring its heat as something akin to his own internal body heat. And finally, Hellenism is the Egyptian funerary ship in which the dead are carried, into which everything required for the continuation of man's earthly wanderings is put, down to perfume phials, mirrors, and

combs. Hellenism is a system, in the Bergsonian sense of the term, which man unfolds around himself, like a fan of phenomena freed of their temporal dependence, phenomena subjected through the human "I" to an inner connection.[165]

The final words above may be considered a preliminary formulation of the meridian as the trope of Celan's poetics, his ever-renewed attempt in each poem (and translation) to free the phenomena of their temporal dependence—what he calls "contingency"—and through the "secret encounter" of the poem to poetically create an inner connection. In his drafts for the radio broadcast on Mandelshtam Celan often noted the term "temporal halo" (*Zeithof*) and in the broadcast speaks of the "halos" in a poem as having semantic relevance (cited above). "*Zeithof*" has thematic importance in several poems, and in Celan's posthumous verse collection *Zeitgehöft*.[166]

Husserl introduces the term "*Zeithof*" in his lectures on inner time consciousness (1928). There, repeatedly using the image of a comet's tail, he explains that in the course of perception each percept, as it sinks into the past, acquires a certain indexicality, a temporal halo composed of a memory of what had just preceded it and an expectation of what will succeed it. In this way the continuity of lived perception is constituted: "Thus everything is *at once* present with perception and primary memory, and yet it is not itself perception and primary memory."[167] The successive intentional linkage between memory (retention) and expectation (protention) preserves the temporal ordering of experience in consciousness. A perceived object, he later says, possesses a "halo of intentions" (*Hof der Intentionen*): nontemporal (spatial) indices that lend it location in perceived space, and a "temporal index" (*Zeitstelle*) and "temporal adumbrations" (*Zeitabschattungen*) that likewise secure temporal identity (for example, duration and succession) to the perceived object in consciousness.[168] "Every perception has its retentional and protentional halo," and in memory, as opposed to "mere imagination," "this entire intentional complex," "this doubled halo" has "the character of actuality."[169] Hans-Michael Speier has surmised that "the concept 'temporal halo' in Celan appears to be applied to poetology, as instructions for the reading of a poem. The disparate parts, as temporal halos that form continuities, are to be linked up into *one* perception."[170] I would qualify this account based on what has been discussed above: as Celan says, "the things approach each other, but even in this togetherness there speaks too the question of their whence and whither":[171]

the perception of the continuity then may occur *alongside* the ever-open reading of the poem, just as poetry (*Dichtung*) travels along the same path of art (*Kunst*): or like a message in a bottle, or an Egyptian funereal ship "into which everything required for the continuation of man's earthly wanderings is put." Returning to Szondi's article on "DU LIEGST," we can say that the references he located to the afternoon he and Celan spent together in Berlin are loosely connected via such temporal halos, such that they function, *besides* their other semantic possibilities, as a codified perceptual memory *for Celan and Szondi alone.* They thus preserve the continuity of a certain historical community, as it were, by preserving the indices of their experience.

As history recedes some of these temporal halos will lose their *addressees*, those capable of recognizing and actualizing them into a perception. Perhaps Celan's concepts of *Meridian* and *Niemand* should be understood in this context. *Niemandsorte*, as in the note on "Brother Ossip," are those places, names, dates—proper names—that have disappeared in exactly the manner Evans outlined above: they have lost their references through the contingency of their natural history and that of the linguistic community in which they are used, in which they *can* refer. *Niemandsorte* are also the locations marked on the "children's map" at the end of the "Meridian" speech, indicating Seßwegen (in former Livland, where Reinhold Lenz was born), Czortków (in former Galicia, where Büchner's first literary editor, Karl Emil Franzos, was born; Celan calls him a *compatriot* he has found "here," in the "Meridian" speech, in its natural history), Czernowitz (in former Bukowina, former Großdeutschland, former Romania, former Советский союз—and where Celan was born). In a different context, Alisdair MacIntyre has presented some of the political consequences of the apparently recondite question of how proper-name reference functions, for example, the Irish name "Doire Colmcille" and its later, English name, "Londonderry":

> But, it may be asked, are these not simply two names for one and the same place? The answer is first that no proper name of a place or person names any place or person *as such*; it names *in the first instance* only *for* those who are members of some particular linguistic and cultural community by identifying places and persons in terms of the scheme of identification shared by, and perhaps partially constitutive of, that community. The relation of a proper name to its bearer cannot be elucidated without reference to such identifying functions. And second that 'Doire Colmcille' names—embodies a communal intention of naming—a place with a continuous identity

ever since it became in fact St. Columba's oak grove in 546 and that 'Londonderry' names a settlement made only in the seventeenth century and is a name whose use presupposes the legitimacy of that settlement and of the use of the English language to name it. Notice that the name 'Doire Colmcille' is as a name *untranslatable*; you can translate the Gaelic expression 'Doire Colmcille' by the English expression 'St. Columba's oak grove'; *but that cannot be the translation of a place name, for it is not itself the name of any place.*[172]

The "natural history" of proper names can also testify to their unnatural—that is, political—fates: names can disappear or be "disappeared." Celan writes, "None of these places can be found, they don't exist, but I know where, at least now, they would have to exist [*wo es sie, zumal jetzt, geben müßte*]."[173] A meridian links such lost *Niemandsorte* and *Niemandszeiten* of forgotten history in the modality of an unreal, *counterfactual* subjunctive, rescues them and brings them into a new encounter, *possibly* creates a new perception of their memory in a new now-time: *Jetztsein* says Husserl of perception, *Jetztzeit* says Benjamin of the historical materialist's recognition of the past. Celan's poems are addressed, dispatched toward, need their addressee, for the sake of that encounter. *Niemand* is the only addressee perhaps who could regain all the continuities of the *Zeithöfe*: as Celan writes in the "Conversation in the Mountains," another text he tells his audience in the "Meridian" that he wrote from his "20th Jänner," "To whom, cousin, should he talk? He doesn't talk, he speaks, and whoever speaks, cousin, talks to no none who speaks, because no one hears him, no one and No one … " (*Zu wem, Geschwisterkind, soll er reden? Er redet nicht, er spricht, und wer spricht, Geschwisterkind, der redet zu niemand, der spricht, weil niemand ihn hört, niemand und Niemand …*);[174] "*Niemand zeugt für den Zeugen*" (No one bears witness for the witness), here understood as a positive statement, the providential addressee who would redeem the lost history, also a form of revolt.[175]

O einer, o keiner, o niemand, o du;
Wohin gings, da's nirgendhin ging?
O du gräbst und ich grab, und ich grab mich dir zu,
und am Finger erwacht uns der Ring.[176]

(O one, o none, o no one, o thou:
Where did the path go, when it lead nowhere?
O you dig and I dig, and I dig myself to you,
and on our finger the ring awakes.)

This invocation to no one and to you, the concluding strophe of the first poem in the collection *Niemandsrose*, that is dedicated to Mandelshtam's memory, perhaps alludes to Mandelshtam's two great Pindaric odes "The Horseshoe-Finder" and "Slate-Pencil Ode." In the first ode the horseshoe and even the poet's words are dug up from the earth, as time leaves its teeth marks on a coin later unearthed; in the opening lines of the second ode a "powerful joint" is posited between star and star, "the stony path for an old song, / the language of flint and air, / flint and water / horseshoe and finger-ring . . . " The concluding lines of the ode, and Celan's translation of them:

И я теперь учу дневник
Царапин грифельного лета,
Кремня и воздуха язык
С прослойкой тьмы, с прослойкой света,
И я хочу вложить персты
В кремнистый путь из старой песни,
Как в язву, заключая в стык
Кремень с водой, с подковой перстень.[177]

(Das Tagebuch studiere ich
des Sommers mit den Griffelzeichen,
studier, wie Luft, wie Kiesel spricht,
die Lichtspur drin, die Dunkelheiten.
Könnt ich die Finger in den Kies
des Lieds von einst tun, wie in eine Wunde,
so daß ich Wasser dort und Stein zusammenschließ,
den Huf- zum Fingerring dort unten . . .)[178]

Celan has made certain displacements: "ulcer" to "wound"; the noun "language" to the verb in the present tense "speaks"; "stratum of darkness, stratum of light" to the more asymmetrical, precarious "the trace of light within, the darknesses," but most drastic is perhaps the change in modality from Mandelshtam's present tense "I want to put my fingers on the stony path of the old song" to Celan's unreal conditional/optative "If I could put my fingers in the gravel of the song from the past, as in a wound . . . " This is the modality of *Niemand*, perhaps also of Celan's identification with Mandelshtam; perhaps this is the ring that awakes on the finger at the opening of *Niemandsrose*.

In one sense, then, Celan's poems are addressed to himself and those of his historical community, for the poems are his attempt to "win reality," "to gain direction" through the construction of *Zeithöfe* of private and public history, necessary for the intersubjective (normative)

grounding of meaning; in another sense, they are addressed to *Niemand*, the addressee that would recognize all the temporal adumbrations, would be mindful of all the poem's dates. In Israel Celan is reported to have said, "All my letters were true; only the addressees were false."[179]

Names have lives; name-using practices have natural histories; poems are *Daseinsentwürfe* after which (or whom, even) the poet lives, with which he is given. If the poetry alongside the art, the message in a bottle, finds no "heartland" (*Herzland*),[180] then it remains addressed to *Niemand*. We speak of live metaphors and dead metaphors; we should start thinking of poems this way. Celan ends his short introduction to his collection of translations from Mandelshtam: "The selection presented to the German-language reader with this book should first and foremost be given the chance that remains the primary one among many for all poetry: the chance to merely exist."[181]

8. MEANING AND REFERENCE: GADAMER

Celan's poetics of temporal and referential exchange operates both within and against aesthetic semblance not only in its deconstructive version of aesthetic autonomy; the poem's natural history also uncovers the Idealist moment in hermeneutical theory. In *Truth and Method* Hans-Georg Gadamer presents the idea that textual understanding, like understanding in general (*Verständigung*), results from a "fusion of horizons" (*Horizontverschmelzung*), the horizon of the text or interlocutor with the horizon of the interpreter:

> Understanding a tradition . . . undoubtedly requires a historical horizon. But it cannot be an issue of one acquiring this horizon by placing oneself within a historical situation. Rather, one must always already have a horizon in order to be able to place oneself within a situation. . . . This placing of oneself is not the empathy of one individual for another, nor is it the subjection of another person to our own criteria, but **it always means the attainment of a higher universality [*Allgemeinheit*] that overcomes, not only one's own particularity [*Partikularität*], but also that of the other.** The concept of 'horizon' suggests itself here because it expresses the superior farsightedness that the person who is seeking to understand must have. . . . There is no more an horizon of the present in itself [*für sich*] than there are historical horizons. *Understanding, rather, is always the process of fusing horizons that are imagined to exist in themselves.*[182]

Habermas has criticized the theory for its implicit conservatism, since
for Gadamer the horizon of the tradition, in which both text and
interpreter stand, operates as a corrective, through prejudgments
(*Vorurteile*) inherent in it, limiting the scope and range of acceptable
readings and hence ideology critique from the perspective of the con-
temporary reader and his interests: "Gadamer's prejudice in favor of
the legitimacy of prejudices (or prejudgments) validated by tradition is
in conflict with the power of reflection, which proves itself in its abil-
ity to reject the claim of traditions."[183] However, Celan's thoughts on
Mandelshtam represent another critique from quite another direction,
implying that Gadamer is *not* conservative *enough*. If, for Habermas,
Gadamer does injustice *to the present* by granting too much author-
ity to the past in every new encounter with a text from the tradi-
tion, then, for Celan, Gadamer does injustice *to the past* by fold-
ing its ownmost particular time into an overarching, homogeneous
horizon of "the" tradition. This can be seen in Gadamer's dismis-
sive understanding of "the occasional": "The real meaning of a text,
as it addresses [*anspricht*] the interpreter, is precisely not dependent
on the occasionality [*das Okkasionelle*], which the author and his
original audience represents. At least, it [the sense] is not exhausted
by it. For it is always also co-determined by the historical situation
of the interpreter and thus also by the whole of objective course of
history."[184] In the epilogue to his collected interpretations of Celan's
poetry Gadamer maintains his position to the point of eschewing
the need to consider autobiographical or Jewish allusions, misunder-
standing Celan's own claim that his poems are "open" to mean that
they contain nothing occasional or private:

> Basically, I agree with the poet that everything is found in the text,
> and that all biographical-occasional moments belong to the private
> sphere. . . . Understanding a poem correctly requires one in all cases
> to completely forget private and occasional information. It just isn't
> there in the text. All that matters is understanding what the text itself
> says, irrespective of any guidance which might be provided by outside
> information.[185]

Whereas Gadamer discounts the importance of the occasional for
hermeneutical understanding because he is intent on maintaining the
authority of a unitary tradition ("the objective course of history" is
not a child's map) and thereby tacitly maintains an Idealist version
of aesthetic autonomy, for Celan it is precisely the occasional that
must survive both despite art's tendency to myth and in virtue of art's

constitutive possibility of recontextualization. As he wrote in the preliminary notes on Mandelstam, "Only when it allows the evanescence [*Vergänglichkeit*] of things and of itself to speak too does the poem have a chance of enduring."[186]

Here Celan perhaps has noticed something "meridian-like" between Mandelshtam and Walter Benjamin, whose fifth thesis on the philosophy of history opens: "The true image of the past flits by. The past can be seized only as an image that flashes up at the moment of its recognizability. . . . For it is an irretrievable image of the past which threatens to disappear in any present that does not recognize itself as intended in that image."[187] Does this describe Celan's procedure of removing the external dates, place names, titles from his poems, as he did with "DU LIEGST"? Is Celan not only preserving personal, forgotten, children's history but also thematizing—holding while gesturing toward its passing—the precariousness of its passing? For Benjamin, "Historicism offers the 'eternal' image of the past, the historical materialist furnishes an experience with the past which is unique [*einzig*] . . . to blast open the continuum of history,"[188] and "To articulate the past historically does not mean recognizing it 'the way it really was.' It means appropriating a memory as it flashes up in a moment of danger. For the historical materialist it is a matter of holding fast to an image of the past as it suddenly appears to the historical subject in a moment of danger. The danger threatens both the continued existence of the tradition and its recipients."[189]

NACHMITTAG MIT ZIRKUS UND ZITADELLE

In Brest, vor den Flammenringen,
im Zelt, wo der Tiger sprang,
da hört ich dich, Endlichkeit, singen,
da sah ich dich, Mandelstamm.

Der Himmel hing über der Reede,
die Möwe hing über dem Kran.
Das Endliche sang, das Stete, –
du, Kanonenboot, heißt "Baobab".

Ich grüßte die Trikolore
mit einem russischen Wort –
Verloren war Unverloren,
das Herz ein befestigter Ort.[190]

(AFTERNOON WITH CIRCUS AND CITADELLE

In Brest, before rings of fire,

in the tent, where the tiger lept,
there I heard you, finitude, singing,
there I saw you, Mandelshtam.

The skies hung over the roadstead,
the sea-gull hung over the crane.
The finite sang, the constant, –
you, gunboat, are called "baobab."

I greeted the tricolor
with a Russian word –
What was lost was unlost,
the heart a fortified place.)

The very title evokes the meridian through a literal reading of "*Nach-mittag*" (= "*nach Mittag*," "after or toward the midday"), an ety-mological reading of "*Zirkus*" (from the Latin *circus* "circular line, circle, ring") and an associational reading of "*Zitadelle*" ("*Zitat*," "citation"). The motifs of the tiger's leap, the circus's arena, the sky, and the revolution as the return of what was lost actualize—in all its particularity, however—Benjamin's concept of history: "History is the subject of a construction whose site is not homogeneous, empty time, but time filled full by now-time [*Jetztzeit*]. . . . Fashion senses the topical [*das Aktuelle*] in the undergrowth of what 'once was.' It is the tiger's leap into the past. But it takes place in an arena where the ruling class gives the commands. The same leap under the open skies of history is the dialectical leap Marx understood as revolution."[191] That is, fashion interprets the past for contemporary interests, but fashion's interests are those of a class society, whereas historical mate-rialism, as in Marx's *Eighteenth Brumaire*, likewise presents the past for contemporary interests, but revolutionary ones. Celan's poem is a site of construction just as Benjamin outlines it. Benjamin's tiger of history in turn evokes Mandelshtam for Celan, just as "to Robespi-erre ancient Rome was a past charged with now-time, a past which he blasted out of the continuum of history."[192] The second strophe con-tinues Benjamin's thought from the (circus) arena to the open skies, where the idea of a dialectical image (what Benjamin calls "history come to a standstill") is evoked in images of a "suspended" sky and a "suspended" gull. The "revolutionary" dialectical leap of finitude and constancy (line 7) emerges in an act of absurd naming: "you, gunboat, are called 'baobab,'" an awkward revolt, together with the chiasmus of greeting the emblem of the French Revolution with a Russian word. Brest, the French military harbor Celan was visiting,

evokes the Russian city of the same name (and perhaps the fatal Brest-Litovsk agreement of 1918, when the Soviet regime ceded its western territories to Germany and Bukowina in turn became part of Romania), but perhaps also the archaic word "*Brest*," "affliction," from the Middle High German meaning "weakness," to which the Russian greeting—здравствуйте, literally "be healthy, prosper"—would be a salving response. The citadel is thus not the physical fortifications of the harbor (an earlier draft of the poem was entitled "Afternoon with Circus and Bastion"), but the citability of the past. The individual's ability to construct *Zeithöfe* of the past, his awkward revolt against historical time is what fortifies ("*befestigen*" can also mean "moor," "tie up," as a boat) the poet's heart.

Does Celan construct his poems to conduce toward Benjamin's sense of historical experience, the experience of tradition together with the reflexive experience of its passing away, tradition (*Überlieferung*) understood as the historically contingent name-using practices of a specific historical community, and tradition understood as the transmissibility (*Überliefbarkeit*) of the poem beyond the community that is falling away, has fallen away from it? Do Celan's poems, on the edge of themselves as art, on the edge of their own survival, make phenomenal and induce the experience of their own mortality *and* transmissibility? If so, then Celan poetics might profitably be understood as a distinctly aesthetic-historical materialism.

9. AN ARCHAEOLOGY OF NAMES: "SCHIBBOLETH" AND "IN EINS"

Mortal (*zeittief*) and ever recontextualizable (*zeitoffen*), referentially foreclosed and aesthetically processual, the aesthetic-historical materialism of Celan's poetics becomes most palpable when his poems resist hermeneutical subsumption, when—as Mandelshtam wrote in his "Horeshoe-Finder"—names and addresses show time's teeth marks.

SCHIBBOLETH

Mitsamt meinen Steinen,
den großgeweinten
hinter den Gittern,

schleiften sie mich
in die Mitte des Marktes,

dorthin,
wo die Fahne sich aufrollt, der ich
keinerlei Eid schwor.

Flöte,
Doppelflöte der Nacht:
denke der dunklen
Zwillingsröte
in Wien und Madrid.

Setz deine Fahne auf Halbmast,
Erinnrung.
Auf Halbmast
für heute und immer.

Herz:
gib dich auch hier zu erkennen,
hier, in der Mitte des Marktes.
Ruf's, das Schibboleth, hinaus
in die Fremde der Heimat:
Februar. No pasaran.

Einhorn:
du weißt um die Steine,
du weißt um die Wasser,
komm,
ich führ dich hinweg
zu den Stimmen
von Estremadura.[193]

(SCHIBBOLETH

Together with my stones,
the ones weeped large
behind the lattice,

they dragged me
into the middle of the market,
there,
where the flag unfurled, to which I
swore no oath.

Flute,
double-flute of the night:
think of the dark
twin-dawns
in Vienna and Madrid.

Set your flag at half-mast,
memory.

At half-mast
for today and always.

Heart:
give yourself to be known also here,
here, in the middle of the market.
Call it, the shibboleth, out
into the exile of the homeland:
February. No pasaran.

Einhorn:
you know about the stones,
you know about the water,
come,
I'll lead you out beyond
to the voices
of Estremadura.)

A poem whose first two strophes comprise a narrative of refusal—
like Lucile's "counter-word"—a refusal to swear allegiance in the
marketplace: perhaps, at those times, in Czernowitz, to the Russians,
then to the Rumanians and Germans, then to the Russians again, as
the mapmakers produced names and more names, when a homeland
became exiled. Then a series of apostrophes, counteroaths, counteral-
legiances, counternames and counterdates, optatives and imperatives,
invocations that remain tenseless, *zeitoffen*: to the double-flute of
night, to memory, to the heart, to a unicorn. The final strophe, which
Derrida does not read: "*Einhorn*," which Celan's first English trans-
lator renders "unicorn," a general term for a fictional natural kind,
indeed perhaps the very emblem of aesthetic semblance as myth.[194]
Yet it is also—homonymically—a proper name, for whom we late-
born have only *zeittief* definite descriptions.[195] Definite description
d1: Erich Einhorn, the young friend of Celan who shared his enthu-
siasm for the Workers' Uprising in Vienna in 1934 and the Republi-
can forces' defense of Madrid in 1936, the friend who knows about
the stones and the water, the quarry and the river; "*No pasarán*," the
slogan which united the Republican forces in solidarity, a solidarity
that is preserved in the apostrophe to Einhorn, the call to him that
remains *zeitoffen*.[196]

Definite description d2: Erich Einhorn, the friend who went with
the Soviet Red Army when they abandoned Bukowina, who worked
as a translator in Moscow all those years, like Celan, in exile, trying
to balance languages, words, homelands:

mit
geatmeten Steppen-
halmen geschrieben ins Herz
der Stundenzäsur—in das Reich,
in der Reiche
weitestes, in
den Großbinnenreim
jenseits
der Stummvölker-Zone, in dich
Sprachwaage, Wortwaage, Heimat-
waage Exil.[197]

(with
breathed steppe-
stalks written into the heart
of the hours' caesura—into the empire,
into the furthest
of empires, into
the great internal rhyme
beyond
the mute peoples' zone, in you
language-scales, word-scales, homeland-
scales of exile.)

(Where "*Stummvölker*" constitutes a multilingual pun on the Russian "немец" "German," which derives from the word meaning "mute";[198] and where Celan's "*Großbinnenreim*" evokes the National Socialist political mission of "*Großbinnenraum*," the idea of a greater German empire.)

Definite description d3: Erich Einhorn, the friend living in Russia with whom Celan then corresponded, who sent Celan a new publication from Moscow, *Тарусские страницы*, an anthology of writings from the "Thaw," including poems by Tsvetaeva:[199]

Von einem Brief, von ihm.
Vom Ein-Brief, vom Ost-Brief. Vom harten,
winzigen Worthaufen, vom
unbewaffneten Auge . . . [200]

(From a letter, from him.
From the Ein-letter, from the East-letter. From the hard
tiny heap of words, from the
unarmed eye . . .)

An encounter, an attempt to gain orientation, direction, reality. An addressee who still knows the names, the dates and what they meant.

Celan returns to them, in solidarity, in the collection *Niemandsrose*
(1963), dedicated to the memory of Mandelshtam:

IN EINS

Dreizehnter Feber. Im Herzmund
erwachtes Schibboleth. Mit dir,
Peuple
de Paris. *No pasarán.*

Schäfchen zur Linken: er, Abadias,
der Greis aus Huesca, kam mit den Hunden
über das Feld, im Exil
stand weiß eine Wolke
menschlichen Adels, er sprach
uns das Wort in die Hand, das wir brauchten, es war
Hirten-Spanisch, darin,

im Eislicht des Kreuzers "Aurora":
die Bruderhand, winkend mit der
von den wortgroßen Augen
genommenen Binde—Petropolis, der
Unvergessenen Wanderstadt lag
auch dir toskanisch zu Herzen.

Friede den Hütten! [201]

(IN ONE

Thirteenth February. In the heart-mouth
an awakened shibboleth. With you,
Peuple
de Paris. *No pasarán.*

A lamb to the left, he, Abadias,
the old man from Huesca, came with his dogs
across the field, in exile
stood white a cloud
of human aristocracy, he spoke
a word into our hand, that we needed, it was
shepherd-Spanish, in there,

in the ice-light of the cruiser "Aurora":
the brother's hand, waving with the
bandage from the word-large
eyes—Petropolis, wandering
city of the unforgotten also
lay tuscany close to your heart.

Peace to the cottages!)

The failed Paris Commune of 1870 (Chamfort's slogan *"Guerre
aux châteux! Paix aux chaumières!"* that also opens Büchner's rev-
olutionary broadsheet *Hessischer Landbote*), *no pasarán*, and the
failed election of the *Frente Popular* in Spain, February 1936, the
failed Viennese Workers' general strike with street-battles in Febru-
ary (*"Feber,"* the Austrian variant of the month) 1934, the October
Revolution in 1917, that all too quickly ushered in again what it had
hoped to overturn. Moments of danger in which revolution broke
open the continuum of history, moments of human solidarity, as Han-
nah Arendt would say, and as Celan said in a letter explaining what
he believed in,[202] the revolt of the creature, as Celan said of Man-
delshtam's enthusiasm for the revolution. Yet failed moments, per-
haps, for Celan, because in each case the individual was quickly sub-
sumed into higher ideologies. Hence the shepherd Abadias, for whom
the cloud of "human aristocracy" stands as objective correlative, and
who Celan's biographer surmises was one of the Republican veter-
ans escaped to France and whom Celan may have met while studying
medicine in Tours in 1938–39.[203] Hence in a passage Derrida does not
read, Celan evokes his "brother": "Petropolis" recalls Mandelshtam's
poem "В Петрополе прозрачном мы умрем" (In diaphanous Petrop-
olis we shall die), which Celan translated,[204] a poem that leaves no
doubt about the revolution, and a "traveling city" perhaps because of
the names the "flourishing city" accrues, with "passing significance":
St. Petersburg, Petrograd, Leningrad (and now, St. Petersburg again).
Yet the poem is addressed to him who, while slowly wasting away in
a Siberian camp, would read from a tattered copy of the Tuscan poet
Petrarch. A fragment for a poem:

OSSIP MANDELSTAMM

War es Eis—was wars

Wars das Eis—was wars,
woran er noch glaubte?
Er, der Petrarca las,
laut, in Sibirien.

Einer kam heim nach Brjansk,

(OSIP MANDELSHTAM

Was it ice—what was it

Was it the ice—what was it,
that he still believed in?

He, who was reading Petrarch,
aloud, in Siberia.

One came home to Brjansk,)

In his autobiography Ilya Ehrenburg reported that in 1952 an agron-
omist from Brjansk told him that Mandelshtam had died in 1940
and how, fatally ill, the poet had sat before the camp's fire reading
Petrarch's sonnets: perhaps as an awkward revolt, a counterword
like Lucile's, against historical time.[205] Likewise the conclusion of
"HINAUSGEKRÖNT" (in *Niemandsrose*):

(...)

(und wir sangen die Warschowjanka.
Mit verschilften Lippen, Petrarca.
In Tundra-Ohren, Petrarca.)

Und es steigt eine Erde herauf, die unsre,
diese.
Und wir schicken
keinen der Unsern hinunter
zu dir,
Babel.[206]

([And we were singing the Warsawjanka.
With silt-filled lips, Petrarch.
In tundra-ears, Petrarch.]

And earth climbs upward, ours,
this [earth].
And we'll send
no more of ours down
to you,
Babel.)

The Warsawjanka was famously sung during the Polish Uprising of
1830–31 and became the foremost Russian Workers' song. Alexandr
Blok varied the words and rhythm of the song in parts 10 and 11
of his masterpiece, "The Twelve," probably the first Russian poem
Celan translated.

Within "IN EINS," as within the parentheses (German "*Klam-
mern*," with just an echo of "*Kammern*," "chambers") of "HINAUS-
GEKRÖNT" and other poems, we find two apostrophes, then: one
public, virtually universal ("*Peuple de Paris*"), the other private, par-
ticular (often Mandelshtam): the coincidence of "aeon" (*Äon*) and

"heartbeat" (*Herzschlag*). In the introduction to his Mandelshtam translations, Celan writes:

> Ist bei dem im Jahre 1891 geborenen OSSIP MANDELSTAMM das Gedicht der Ort, wo das über die Sprache Wahrnehmbare und Erreichbare um jene Mitte versammelt wird, von der her es Gestalt und Wahrheit gewinnt: um das die Stunde, die eigene und die der Welt, den Herzschlag und den Äon befragende Dasein dieses Einzelnen. Damit ist gesagt, in welchem Maße das Mandelstammsche Gedicht, das aus seinem Untergang wieder zutage tretende Gedicht eines Untergegangenen, uns Heutige angeht.[207]

> (. . . for Osip Mandelshtam, born in the year 1891, the poem is the place where by means of language that which can be perceived and attained is gathered around that center from which it gains shape and truth: around the *Dasein* of this individual, questioning the hour, one's own and that of the world, the heartbeat and the aeon. This indicates the degree to which the Mandelshtamian poem, the poem of one who has been destroyed that emerges again from out of destruction, concerns us today.)

Celan's poems thus have two axes of address, as they have two encounters (the poet with the poem, and the poem with the reader) and two temporalities (the poem is both *zeittief* and *zeitoffen*): the first addressee—real as in Einhorn, Szondi, and others, or in the limit-case the virtual *Niemand*—will know the names and references, by having survived the evanescence of the name-using practices of a linguistic community; the second addressee, who will not belong to that mortal community, but who nonetheless will encounter them during her aesthetic experience of the poem.

Celan's *historical materialism* lies in just these proper names, their referents and their perhaps irretrievable loss, as Evans describes it. But Celan attempts to save these names through recourse to *aesthetic* semblance, by inscribing them within artworks—as their *Zeittiefe*—that, as artworks, are constitutively open—*zeitoffen*—to ever-new encounters with future readers: "Art, thus also the Medusa's head, the mechanism, the automata, the uncanny strangeness [*Fremde*] which is so hard to differentiate and perhaps is only *one* after all—art lives on [*die Kunst lebt fort*]."[208] Not "*weiterleben*" but "*fortleben*": in a specific direction, *henceforward*, as it were. In this way Celan's poems—neither simply artistic monuments nor historical documents—negotiate the dialectic of aesthetic semblance: the open-ended processuality of aesthetic experience assures that those historical names and dates will be *commemorated* by those who, in their

imperfect understanding of the poem, nonetheless *attend* to them. This is neither an Idealist recuperation nor a transcendental relinquishment of the linguistic meanings that subtend a community's life, but rather a sober and sustained response to the natural history and mortality of those meanings. In the "Meridian" speech Celan cites Benjamin citing Malebranche: "Attentiveness is the *natural* prayer of the soul."[209] Adorno was perhaps thinking of Celan when in *Aesthetic Theory* he wrote, "If the question as to the future of art were not fruitless and suspiciously technocratic, it would come down to whether art can outlive semblance" and "Semblance is not the *characteristica formalis* of artworks but rather *materialis*, the trace of the damage artworks want to revoke. Only to the extent that its content is unmetaphorically true does art, the artifactual, discard the semblance produced by its artifactuality."[210]

10. CODA

As we shall see in the next chapter, physical memorials are erected by survivors, yet name and indeed often address the dead. Celan's poems, by taking Mandelshtam's motifs to their limit, perhaps should be seen as linguistic memorials, at the limit of themselves *as art*, preserving private addresses to friends encrypted within aesthetic experience. Once we see that Celan's poems travel this limit-line of the aesthetic, we can perhaps recognize related commemorative gestures that travel the limit-line from the other side, beyond the conventional boundaries of literature and the aesthetic:

> The [Russian] paper said that Lieut. Gen. Boris Gromov, the commander of Soviet forces in Afghanistan, would be the last Soviet soldier to leave the country, crossing the border at the Soviet town of Termez at 10 A.M. on Feb. 15.
>
> "He will cross without looking back," it said. "Then he will stop and make a short speech, but only to himself. It will last one minute and seven seconds. It will not be written down or listened to."
> —*The New York Times*, January 8, 1989

Conflict and Commemoration

Two Berlin Memorials

People make their own history, but they do not make it of their own accord; they do not make it under circumstances of their choosing, but under circumstances directly found, given and transmitted from the past. The tradition of all the dead generations weighs like a nightmare on the brain of the living. And just when they appear to be engaged in overturning themselves and things, in creating something entirely new, precisely in such epochs of revolutionary crisis they anxiously conjure up the spirits of the past to their service and borrow from them names, battle slogans and costumes in order to present the new scene of world history in this venerable dress and this borrowed language.

—KARL MARX[1]

For since we are just the results of earlier generations, we are also the results of their aberrations, passions and errors, even crimes; it is not possible to get entirely free of this chain. If we condemn those aberrations and consider ourselves beyond them, then that doesn't dispel the fact that we come from them. In the best case we produce a conflict between our inherited, ancestral nature and our knowledge, indeed even a battle of a new strict discipline against what has been worn and born from time immemorial.

—FRIEDRICH NIETZSCHE[2]

On the afternoon of November 14, 1993, the so-called People's Day of Mourning (*Volkstrauertag*), the Central Commemorative Site of the Federal Republic of Germany (*Zentrale Gedenkstätte der Bundesrepublik Deutschland*) was unveiled in the modest, neoclassical building originally designed by Karl Friedrich Schinkel, called the Neue Wache, or "New Watch." President Richard von Weizsäcker, Chancellor Helmut Kohl, Bundestag President Rita Süssmuth, Bundesrat Vice President Henning Voscherau, and Constitutional Court President Roman Herzog entered the building and laid five wreaths at the

base of the statue, which bears the inscription "To the Victims of War and Tyranny" (*Den Opfern von Krieg und Gewaltherrschaft*). Outside, cordoned off by steel barricades and several hundred riot police in body armor, with plastic shields and leather truncheons, facing a group of spectators and protestors half their number, a solitary soldier stepped forward from the honor guard, raised his trumpet and played an elegiac theme from Brahms under cold and drizzly skies. The entire event lasted less than ten minutes.

These largely symbolic proceedings, however, had been preceded by months of acrimonious controversy that had already led to the decision to erect a separate "Memorial for the Murdered Jews of Europe" near the Brandenburg Gate and to further discussion about a second monument to the Roma and Sinti victims of Nazism. Thus the central commemorative site was fissured and fractured before it was opened. The controversy was very different from the reception which has greeted another recent memorial in Berlin, a project located in the Bavarian Quarter (a formerly Jewish neighborhood, decimated and depopulated by a raft of National Socialist actions) and constructed according to very different principles. Those principles are suggestive for thinking about memorials to the National Socialist past in Germany and, more important, share critical affinities with Walter Benjamin's notion of "dialectical images" as the sites of historical materialism and remembrance, in which a historical object is constructed out of the juxtaposition of its past and present material forms, affective attunements, and ideological functions. Benjamin's avowed method of "Telescoping . . . the past through the present" [N 7a, 3], while exploding the politics of universal reconciliation at work in the Neue Wache by effecting a "dissolution of 'mythology' into the space of history" [N 1, 9], underlies the Bavarian Quarter memorial, in which "the materialist presentation of history leads the past to place the present in a critical question" [N 7a, 5].[3]

First, however, I situate my observations within the ongoing debates about modernity and "collective identity" in general, and German social memory in particular, and suggest a methodological shift from a psychological model of collective identity to a consideration of cultural resources and their discursive transmission (§1). In the next sections (§§2–3) I present the history of the Neue Wache and examine the confluence of military and civil discourses that constitutes its conflictual "blind spot." In a brief critical excursus (§4) I consider memorials of the Holocaust, including the recent "Memorial

to the Murdered Jews of Europe," that revolve around concepts of representational negativity, before analyzing the Bavarian Quarter memorial (§5).

I. MODERNITY AND CULTURAL MEMORY

There is no such thing as the guilt or innocence of an entire nation. Guilt, like innocence, is not collective, but personal.

—BUNDESPRESIDENT RICHARD VON WEIZSÄCKER,
May 8, 1985

Memorials in our time possess a dialectical relationship to the end of what the French historian Pierre Nora calls the tradition of memory. According to Nora, "We speak so much of memory because there is so little of it left":

> These *lieux de mémoire* are fundamentally remains, the ultimate embodiments of a memorial consciousness that has barely survived in a historical age that calls out for memory because it has abandoned it. They make their appearance by virtue of the deritualization of the world—producing, manifesting, establishing, constructing, decreeing, and maintaining by artifice and by will a society deeply absorbed in its own transformation and renewal, one that inherently values the new over the ancient, the young over the old, the future over the past.[4]

What Nora calls the "acceleration of history" and "the lack of spontaneous memory" seems to imply a nostalgia for tradition-bound substantive *Gemeinschaft*, but we can deepen his insight by placing it alongside related diagnoses of modernity: the transition from a stratified to a functional society (Luhmann), the disenchantment of traditional societies in the rise of abstract and bureaucratic rationality (Weber), the alienation of life-world and labor (Marx, Lukács), the intertwining of technical progress with failed political emancipation (Horkheimer and Adorno), the loss of traditional continuity in storytelling (Benjamin), and the general rationalization of production and irrationalization of societal relations micrologically analyzed in the phenomena of mass culture (Kracauer). In fact, the analysis of the "memorial cult" at the turn of the century by the young Alois Riegl offers a more nuanced and dialectical historical framework than Nora's, by juxtaposing the nineteenth century as the era of "historical value" with the onset of a contemporary era of

"age value": the latter reflected a superhistorical notion of objective knowledge, manifesting itself in a tireless pursuit of exacting restoration of past architecture, the former reflected the awareness of fashion, of the swift and inexorable transition from new to old, and manifested itself in an appreciation of the effects of time, the process of aging, in themselves.[5]

Preliminarily then, we can situate the question of the significance and role of monuments and memorials against the background of the loss of traditional contexts of significance that has become a commonplace characteristic of modernity in all these analyses. However, public remembrance is not only conditioned by the fact that spontaneous memory in a homogeneous communal life-world has largely vanished but, more important, by the existence of a *multiplicity* and *heterogeneity* of narratives and traditions vying for the status of public memory. Recent German history provides one unparalleled example of this phenomenon, the one I shall discuss here; multicultural American society provides another.[6]

Discussions of German postwar memory have concentrated around the notion of personal and, by analogy, collective identity. So, for instance, Eric Santner's penetrating book *Stranded Objects: Mourning, Memory and Film in Postwar Germany* undertakes to answer the question "What are the strategies and procedures by which a cultural identity may be reconstituted in post-Holocaust Germany?"[7] I will return to this question momentarily, but for now let me cast an initial skeptical glance at Santner's question by noting that it was most likely one of the questions motivating Helmut Kohl's government as well when it reincarnated the Neue Wache. Santner himself, however, takes a first step toward undermining a singular notion of cultural identity by differentiating between generations. Whereas according to Alexander and Margarete Mitscherlich, whose analyses of the postwar German "psyche" form Santner's *terminus a quo*, first-generation Germans sought to evoke notions of universal reconciliation and "drawing a line" or "mastering" their past and repressing any feelings of guilt, second-generation Germans receive their sense of the past from their parents' stories, as one survey summarizes: "Fleeing advancing armies, bombed out, homeless and unemployed, hidden from Allied police, arrested and jailed, these parents are remembered by their children as victims of the war, as victims of a lost war."[8] It should be noted that some recent, that is, post-Cold War, representations of the war in popular culture clearly reflect

this self-understanding, for instance, Helke Sander's documentary
BeFreier und Befreite, about the rape of German women by advancing
Russian soldiers, and Joseph Vilsmaier's 1993 film *Stalingrad*, which
depicts decent Wehrmacht soldiers commanded if not commandeered
by diabolical SS officers. In both cases the revisionist portrayals of
Germans as victims have proved controversial: at one point Sanders's
film suggests a tacit equality (if not equity) between German women
and Jews;[9] in Vilsmaier's film the idealized moral line drawn between
Wehrmacht and SS is belied by the Wehrmacht's documented partici-
pation in genocidal actions in the East.[10]

Although Santner acknowledges the marked differences in the atti-
tudes of first and second generations, he still formulates the gener-
ational problem as one of conflicted collective identity based on a
social-psychological model of individual identification:

> The core dilemma is that the cultural reservoir has been poisoned,
> and few totems seem to exist which would not evoke such traumatic
> ambivalence that only a global foreclosure of all symbolic legacies
> would prevent further contamination. To carry out their labors of
> self-constitution the second and third generations face the double
> bind of needing symbolic resources which, because of the unman-
> ageable degrees of ambivalence such resources arouse, makes these
> labors impossible. . . . The double bind of having to identify with
> figures of power one also at another level needs to disavow—of being
> faced with a homeopathic cure that may prove to be overly toxic—
> leads to what the Mitscherlichs, in 1967, referred to as an *"Identifi-
> kationsscheu,"* a resistance to identification with parents and elders,
> in the second generation.[11]

Yet a further attenuation of generations argues for reconsidering the
context in which and *extent to which* the social-psychological model
of mourning has purchase: the third generation is so far removed
from the events that their information is provided less by personal tes-
timonial than by today's educational institutions and entertainment
media. In being institutionalized as history, what was *psychologically
lived* or reported first-hand experience becomes *discursively and/or
symbolically constructed and transmitted* simulacra of experience,
what Santner aptly terms "the cultural reservoir."

Santner emphasizes that "postwar generations have inherited the
psychic structures that impeded mourning in the generations of their
parents and grandparents" and

> face the complex task of constituting stable self-identities by way
> of identifications with parents and grandparents who, in the worst

possible cases, may have been directly implicated in crimes of unspeakable dimensions, thereby radically impeding their totemic availability. But even where direct culpability is absent, these elders are individuals whose own self-structures are likely to have been made rigid by a persistent core of repressed melancholy as well as the intense aggressions associated with unmourned narcissistic injuries, namely, the sudden and radical disenchantment of Nazi phantasms.[12]

It is perhaps Santner's (and the Mitscherlichs') strong Freudian interpretive approach that leads him to attach such force to the "inheritance" of psychic *structures* that *originate* in the *family* ("the legacies . . . of the Nazi period are transmitted to the second and third generations at the sites of the primal scene of socialization, that is, within the context of a certain psychopathology of the postwar family"[13]), rather than considering a less determinative model of attitudes, prejudices, and actions that are made available, produced, transmitted, activated by culture. Yet precisely that assumption of determinative familial genesis of personality structure makes the popular rise of Nazism and its phantasms itself difficult to explain, unless one ascribes the behavior of its fervent supporters to the psychic structures learned in turn at their elders' knees in the Kaiserreich, and to their elders, and so on. Again, on this assumption it would seem appropriate to continue the kind of psychoanalytically inflected surveys of public opinion and family structures that Frankfurt School members conducted during the 1940s and 1950s, work that in my opinion should by all means be continued and expanded today. However, Santner's own study focuses on the transmission of images, attitudes, and behavior in the cultural milieu of film and literature, which presumably affect the individual long after her "psychic structures" have been "inherited" in her early formative years in the family. Thus Santner applies the psychoanalytic approach of individual psychology to a collective, cultural identity—a methodological move I shall consider shortly—while in fact offering perceptive analyses of what should rather be called "collective" or "social" memory, understood as the "cultural reservoir" of historical images and narratives available to individuals in a given society.

Generational differentiation is only one way in which a notion of *the* German collective identity undergoes empirical attenuation. In the wake of events which Santner's book, published in 1990, could not have addressed, the third generation finds itself in an entirely new

context of an abruptly reunified Germany that—at least officially—
is no longer characterized by ideological division. A German collec-
tive identity, even posed simply as a task, is already composed of two
traditions and two spheres of experience from two social systems, a
political conflict of collective narratives more than a psychological
working through of mourning. Finally, besides the multigenerational
and (for lack of a better term) multi-ideological attenuation of a Ger-
man collective identity, there is a multicultural dimension, in which
national, ethnic, religious, and cultural identities are *not* coextensive.
Whereas first-generation "guest workers" (a more apt term would
be "permanent immigrants") from Turkey, Greece, or Italy remain
largely unintegrated into German society, their sons and daughters,
granted only provisional German citizenship by *jus soli* as of the year
2000,[14] are wholeheartedly Berliners, native German speakers, and
so on without, however, being "German." Clearly their relation-
ship to a collective "German identity" and social memory involves
an entirely different framework, including the poetics of memorials.
In April 1996, on the initiative of the League for Human Rights and
Azize Tank, the representative for foreigners (*Ausländerbeauftragte*)
in the Charlottenburg District of Berlin, a memorial was erected in
front of the Federal Administrative Court building in Berlin to the
Turkish student Cemal Altun. Altun had fled to Berlin in 1981 and,
after being detained by the police, applied for political refugee sta-
tus: the Turkish government accused Altun of political terrorism and
demanded his extradition. On August 30, 1983, after thirteen months
in detention, Altun was brought to the court for his second hearing,
though no one could tell him how long he would still have to remain
in prison. When a guard unlocked his handcuffs, Altun leapt to his
death from an open sixth-story window. The memorial includes a text
in German and Turkish referring to the constitutional right to politi-
cal asylum [Figure 1].[15]

What I have been calling the empirical "attenuation" of a supposed
singular German collective identity, whose (re)generation Santner's
book explores, suggests rather that we speak of different *contexts*
of identity: ranging from personal (with its criteria of authenticity
and self-realization), through religious, ethnic, cultural, economic, up
to national and legal (citizenship) and moral (international human
rights, for example).[16] A given situation may address or activate any
one (or several) of these levels of identity, so that it becomes perti-
nent for that situation.[17] This suggests a "postconventional" notion

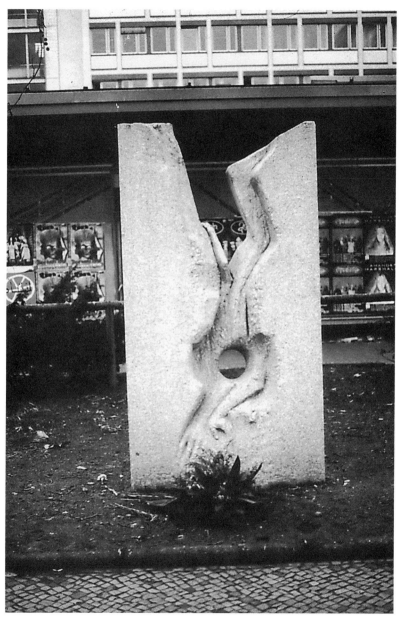

Figure 1. Memorial to Cemal Kemal Altun by Akbar Behkalam. Author's photograph.

of identity that is no longer theorized by an analogy to Freudian psychology's concept of egological identification but rather admits a variety of contexts of identity.[18] Thus the memorial to Cemal Altun may address members of the Turkish community in Berlin differently than other city residents at the level of cultural identity; at the level of legal and moral identity one would hope the address is more universal.

Besides the empirical attenuation of collective identity in the classical sense, there is also a methodological point to be raised in considering social memory. Already in the 1920s the historian Marc Bloch criticized Durkheim's pupil, Maurice Halbwachs, for his easy borrowing of terms from individual psychology and then nonchalantly prefacing them with the adjective "collective."[19] To the extent that Santner projects Freudian notions of successful mourning as a reconstruction of egological identity after loss onto the plane of collective (national or cultural; Santner speaks of them apparently interchangeably) identity, he too is vulnerable to that criticism. Bloch himself also explored social memory but stressed the process of transmission rather than group-psychological identity. Paul Connerton has drawn the lesson I shall follow here as well: "If we want to continue to speak, with Halbwachs, of collective memory, we must acknowledge that much of what is being subsumed under that term refers, quite simply, to facts of communication between individuals . . . to study the social formation of memory is to study those acts of transfer that make remembering in common possible."[20]

Thus *either* the egological analogy is maintained but a multitude of overlapping, stratified, interpenetrating multiauthored collective identities within a pluralistic framework is accepted, *or* a change in focus is necessary from "collective identity" to competing, potentially conflicting public discourses of remembrance and transmission. I would therefore like to shift the emphasis from the social-psychological notion of collective identity to that of contradictory historiographical discourses, which are discernible and available to the historian and cultural critic in a way that collective psychology is not, and which constitute the "archive" out of which social memory undergoes an ongoing process of construction and reconstruction. These discourses form orientation points for individual memory, action, and "improvised predispositions" (in Bourdieu's words) in the various contexts of identity suggested above. In this way social memory as "cultural reservoir" in fact is the counterpart to methodological individualism and not to collective identity. Furthermore, the discursive conflicts in the

construction and transmission of social memory, like the collisions of primeval continents in plate tectonics, produce surface fractures and sudden eruptions of energy at long-established fault lines, such as the impact of the last fifty years of German history upon a small building on Unter den Linden.

Genealogically, the end of World War II produced two Germanies, and each commemorated its genesis as a way to justify its claim to authenticity of tradition and political legitimation against the background ideologies of the Cold War. So the German Democratic Republic (GDR) viewed itself as the continuation of the Weimar Republic's communist left who fought fascism and portrayed the Federal Republic as the continuation of the capitalist organization of society that "necessarily" led to fascism and imperialism. The GDR's double bind was, of course, that it paraded itself as the workers' state that arose from the ruins of totalitarianism while denying its own totalitarian lineaments. The workers' uprising on June 17, 1953, represents that double bind in all its tension.

By contrast, the Federal Republic of Germany (FRG) faces a different kind of paradox. Its self-understanding holds that West Germany was liberated by the Allies from . . . itself, in Nazi guise. Or rather, the story stands on the distinction between a Nazi *tyranny* that usurped the incipient *democracy* of the Weimar Republic and drove Germany to ruin. The rupture of 1945 represents Germany being liberated from its own dictatorship: Germans were *both* agents of their regime—no matter how unwilling or unknowing—who sacrificed for their fatherland *and*, so the story goes, passive victims of that regime. This leads to a perennial problem in negotiating the closure of the Nazi regime and the origin or rebirth of (West) German democracy, since in a sense it is the same event under two different descriptions as, for instance, in the controversy about whether May 8 should be commemorated as the "day of capitulation" or the "day of liberation."[21] Furthermore, the legitimacy of the FRG was also continually contrasted with the illegitimacy of the other German state: the communist totalitarianism was equated, more or less openly, with the prior national-socialist one. This allowed a reversed projection. The FRG could exploit the rule of force as exhibited in the GDR (most graphically, the killings at the wall and the suppression of the strikes and demonstrations on June 17, 1953) to dramatize the way the Nazi regime had made resistance impossible; this secured the necessary historiographical rupture between Nazi past and democratic present.

The fact that the dissolution of the GDR is at least in large part due to the populist impulses for change in a broad spectrum of the population (as for instance in the Leipzig and Berlin demonstrations in the autumn of 1989), that is, precisely the kind of broad resistance that did *not* occur during the Nazi regime, is of course more problematical and less acknowledged. Moreover, the case of resistance the FRG chose to make paradigmatic, the failed attempt on Hitler's life by a group of Wehrmacht officers led by Claus Schenk, Graf von Stauffenberg, draws on another tradition that stands in a more complex relationship to National Socialism. For the July 20, 1944, plot was organized and led by army officers of Prussian aristocratic background intent on saving Germany from absolute defeat and occupation by the Russians (thus recapitulating the classic "Weimar choice" between Bolshevism—often personified as "Jewish"—and fascism all over again), and there is no indication that their vision included a democratic form of government. Thus the official sanctioning of their attempted coup d'état in conjunction with the official disregard, if not omission, of leftist resistance organizations before and during the war (the latter orchestrated from Moscow) indicates an unbroken line of Prussian militarist patriotism within the FRG which, though latent, is an available historical-narrative resource. So when Kohl's press spokesman was asked if the chancellor was disappointed not to have been invited to the commemorative ceremonies in Normandy marking the fiftieth anniversary of D-Day, he quipped, "Do you seriously believe the Bundeskanzler places any value in participating in a celebration of the defeat of German soldiers?"[22]

Thus, on the one hand, both East and West Germany constructed discourses of national legitimacy through denial of the prior national self-image, while on the other hand, they tried to claim the proper continuity with an even earlier tradition. The confluence of contradictory historiographies often results in symbolic conflict, and such conflict is perhaps nowhere more noticeable than in public memorials that seek to rescript these various histories into one story, one *mythos*. One such neuralgic point is the small memorial located on Unter den Linden between the Humboldt University and the German Museum of History and known as the Neue Wache. If, according to Benjamin, "the historical object, by virtue of its monadological structure, discovers within itself its own [dialectical] pre-history and post-history" [N 10, 3], then the Neue Wache is a preeminent monad, for this modest memorial more than any other state building has been

programmatically used in each of its concrete historical forms to provide the then current German state with a unifying image of national legitimation. If "to write history means giving dates their physiognomy" [N 11, 2], then the incarnations of the Neue Wache amount to a dialectical image of the failed project to symbolically found a German national-cultural identity. Each attempt, each incarnation, has failed, I claim, for two reasons: *first* because of the conflation of military memorial and civil—usually national—monument inscribed in the very building's history. Indeed this is a recurrent conflict in the hybrid genre of national monument and military memorial throughout modern German history. The *second* reason for the Neue Wache's failure is that the equally conflicted postwar genealogies of national self-legitimation likewise conflate the civil and military dimensions of their narratives: on the one hand, the GDR and reunified Germany wish to establish a complete break with the National-Socialist political past, while on the other hand, they strive to maintain the national-cultural military tradition of honoring their war dead. This double bind of trying to rewrite contradictory narratives into one story, one *mythos*, results in a symbolic conflict at whose center stands the Neue Wache.

2. THE NEUE WACHE: HISTORY

"What is holy?" asks Goethe in one of his distichs and answers: "That which brings together many souls." In this sense we can say that the holy, with the purpose of realizing and maintaining this solidarity, constituted the first instance of an independent architecture. The most familiar example of this comes down to us in the legend of the Tower of Babel.

—G. W. F. HEGEL, "Architectural Works Built to Unite Peoples"[23]

My Morellian suggestion is that a brief consideration of the history of the Neue Wache, and the constellation of forces that has shaped it and to which it in turn has given expression, more than the Reichstag or the many castles and palaces reveals the conflicts of modern Germany's "cultural resources," conflicts that from the outset condemn to failure any attempt to reconcile them within the building.

The Neue Wache is a small, unprepossessing building. Its origins stretch back to 1786, when a soldiers' watch station, called the Kanonierwache, was located on the main thoroughfare Unter den

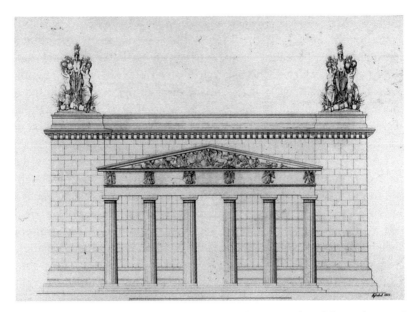

Figure 2. Schinkel's design of the Neue Wache. Reproduced from plate 4 of
Karl Friedrich Schinkel, *Collection of Architectural Designs.*

Linden across from the king's residence. It was one of thirty-four
buildings located throughout the city at gates, barracks, royal houses,
and so on. The soldiers at the Kanonierwache, later called the Königs-
wache, were responsible for security in the area surrounding the Ber-
lin city castle and the king's residence. The original wooden struc-
ture soon proved too small for them and, in the wake of Napoleon's
defeat, too modest, and so in the spring of 1816 Friedrich Wilhelm
III commissioned his chief privy architect Karl Friedrich Schinkel to
design an impressive but, because of massive debts accrued during
the Wars of Liberation, also an economical "Neue Wache." Schin-
kel's design called for a neoclassical pavilion with a duty room for
about one hundred soldiers of the Imperial Watch, Fourth Guards
regiment, and a detention cell [Figure 2]. Schinkel wrote, "The design
of this solitary and free-standing building is in a rough imitation of
a Roman *castrum*, hence the four quite solid corner towers and the
inner courtyard."

 In addition to its military use, the building also served to commem-
orate the victory over Napoleon, that is, as a national monument.

Thus the intended tympanum relief designed by Schinkel depicts a battle in which, as he wrote in his *Sammlung Architektonischer Entwürfe* (1819–40),[24] "A Victory in the center decides in favor of the heroes fighting on the right side; on the left are represented the final efforts, the exhortation to battle, flight, the plunder and pain of the family awaiting their fate; on the right one can see the overwhelming emotion and mourning for a fallen comrade."

The tympanum was finally built in 1842 by Johann Gottfried Schadow, the leading neoclassical sculptor of his day. Schadow had already designed the Quadriga—the female figure of Victory, standing in a war chariot, her brow adorned with a chaplet of oak leaves—for the Brandenburg Gate, which was unveiled in 1791 as the "gate of peace" (*Friedenstor*). Following the Wars of Liberation the Quadriga, which Napoleon had hauled off to Paris in 1806, was returned to the Brandenburg Gate, now renamed a "triumphal gate" (*Siegestor*) at the head of Unter den Linden's "Via Triumphalis," henceforth the main avenue of Prussian parades, in which the Neue Wache played an integral role. The intended sculptures of victory trophies to crest the corner towers were never built. Originally it was planned to erect statues of five generals who had helped defeat Napoleon, but because of budgetary considerations only three were realized: Blücher across the street near the Opera house, and von Bülow and Scharnhorst flanking the Neue Wache. The statues were unveiled in 1822 on the anniversary of the battle of Waterloo [Figure 3]. Likewise the chestnut tree grove adjoining the Neue Wache boasted a permanent exhibit of captured French howitzers: war trophies from the Wars of Liberation. After the castle received its own regiment of soldiers, the Neue Wache's function became purely ceremonial, and extravagant military parades passed by it to celebrate the defeats of Denmark (1864), Austria (1866), and France (1871). On August 1, 1914, the general mobilization orders were announced from its steps, as were the demobilization orders four years later.

After the abdication of the Kaiser in 1918 the building fell into disuse, serving as emergency housing for the homeless, among other functions. On August 3, 1924, on the tenth anniversary of the beginning of World War I, Reichspresident Friedrich Ebert expressed his desire for a "national monument of honor" (*Reichsehrenmal*) that would "serve to mourn the past and embody the vital energy and the will to freedom of the German people." Hindenburg wanted to erect a panoply of Prussian war heroes; however, the war veterans,

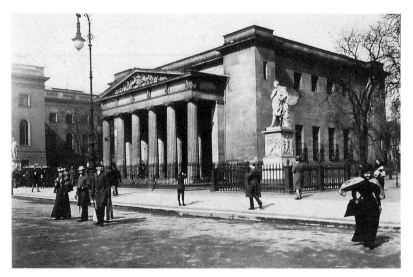

Figure 3. Neue Wache, 19th C. Landesarchiv Berlin.

many of whom were former members of various wings of the Youth
Movement, pleaded for a national memorial in a natural rather than
an urban setting. Controversy and indecision lingered on until 1929,
when Otto Braun, Minister-President of Prussia, decided to trans-
form the Neue Wache into a "Memorial Site for the Fallen of the
World War" (*Gedächtnisstätte für die Gefallenen des Weltkrieges*)
and asked for proposals for the interior. Heinrich von Tessenow's
design was accepted [Figure 4]. Light-gray limestone plates cover the
walls, and dark basalt-lava stones form a floor mosaic. In the center
a black memorial stone, marked "1914–1918" and bearing a large
silver oak-wreath, represents the "Altar of the Fatherland." Two can-
delabra flank the altar to the rear in each corner, and a large opening
four meters in circumference and encircled in bronze is cut in the ceil-
ing above the altar. In his review of the memorial for the *Frankfurter
Zeitung* Siegfried Kracauer wrote:

> Of course, one can erect emotional memorials and reinforce the inter-
> pretation ascribed to them by means of some symbol or other—but
> haven't we had enough of our Bismarck towers? It is simply the case
> that a positive statement is virtually impossible for us at this time. We
> cannot countenance it either in the literary language nor in the lan-
> guage of architecture. . . . Why? In Germany in any case, it is because
> we are much too divided on questions of the most important and vital
> kind, so that we cannot come together through some insight that

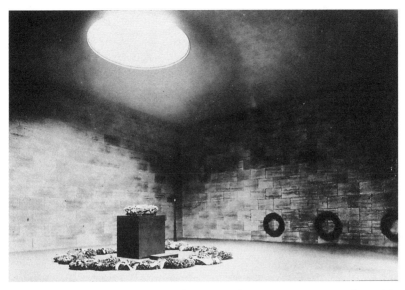

Figure 4. Neue Wache interior by Heinrich von Tessenow. Landesarchiv
Berlin/Waldemar Titzenthaler.

would unite us. Thus, with the memorial it can only be a question of
a necessarily pragmatic solution. The deliberate presentation of con-
tent is not what is needed—what do most people today know about
death?—but rather the most extreme abstinence of content. A memo-
rial site for the fallen in the World War: if we want to be honest, it
should not be much more than an empty room. And precisely this is
the propriety of Tessenow's design: that he only wants to give what
we possess . . . that is not much, indeed it is very little, but in con-
sideration of our present economic and intellectual life it is precisely
enough. Tessenow's proper modesty knew how to avoid smuggling in
metaphysical contraband and restricted itself to the dignified propor-
tions of the memorial site.[25]

Politicians did not demonstrate such self-restraint in their evalua-
tion at the opening ceremony of the redesigned Neue Wache on June
2, 1931. The German army minister (Reichswehrminister) Groener
embedded the Neue Wache squarely in the Prussian military tradi-
tion of war memorials: "We consecrate today the remodeled Neue
Wache to the fallen of the world war. Built by the warriors [Kämpfer]
of Leipzig and Belle-Alliance, for a century it was the emblem of the
Prussian army. The heroic greatness of its form is equal to the great-
ness of heroism and the greatness of the sacrifices [Opfer] that ever
new generations have made so that Germany may live."[26]

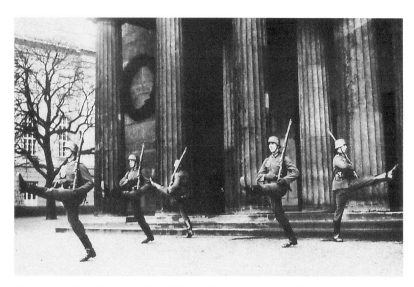

Figure 5. Neue Wache, Third Reich. Landesarchiv Berlin.

Indeed in 1934 the Neue Wache became a "memorial of honor" (*Ehrenmal*) for fallen soldiers and an inspiration for new ones. A large oaken cross was affixed to the rear wall and candles and candelabras were placed around the altar to convey a greater sense of piety. The Christian iconography of the cross echoed the characteristic adornment on World War I veterans' graves as well as the Nazi memorial to Schlageter and Hindenburg's crypt within the Tannenberg memorial. The civil police posted before the building were replaced by an honor guard of Wehrmacht soldiers of the "Guards Regiment of Berlin" [Figure 5]. The changing of the guard on Sunday, Tuesday, and Friday was a public spectacle, as was the wreath-laying ceremony by Hitler on "heroes' remembrance day" (*Heldengedenktag*), the precursor to *Volkstrauertag* [Figure 6]. During World War II fallen generals were given their final honors before the Neue Wache.

Bombs damaged the building badly toward the end of the war: the roof burnt away, two columns were shattered, the southeastern corner collapsed, the memorial stone was partially melted in the heat of the bombing, and the wreath was eventually stolen [Figure 7]. Tessenow said of the ruin, "If it were now up to me, I would not give the building any other form whatsoever. As damaged as it is now, it truly speaks history. A little cleaning up and straightening out, and let it stand as it is."[27]

Figure 6. Neue Wache interior, Heldengedenktag. Reproduced from *Die Neue Wache als Ehrenmal für die Gefallenen des Weltkrieges.*

The Neue Wache along with the other neoclassical buildings of Unter den Linden fell within the Russian sector of occupied Berlin [Figure 8]. In 1948 the local communist government considered tearing down the Neue Wache because of its militaristic history and because people continued to lay flowers and wreaths there in remembrance of their (fascist) dead, even after the building's iron doors had been chained shut. However, the Soviets interceded, reasoning that the building and its military symbolism represented Russian and German "friendship" in their having joined forces to defeat Napoleon: the military tradition was once again invoked and renewed. The Neue Wache was transformed into a museum of Soviet-German friendship, with slogans and large portraits of party members. The statues of Bülow and Scharnhorst were removed and their pedestals given Russian and German inscriptions honoring Stalin.

On February 10, 1949, the Freie Deutsche Jugend (FDJ) demanded that the Neue Wache, as a symbol of Prussian militarism, be demolished, an argument that did in fact lead to the demolition of several neoclassical buildings designed by Schinkel: the Berlin city castle in 1950, the Potsdam city castle in 1959–60, and the Potsdam Garnison Church in 1968. But the Neue Wache was saved by its central location

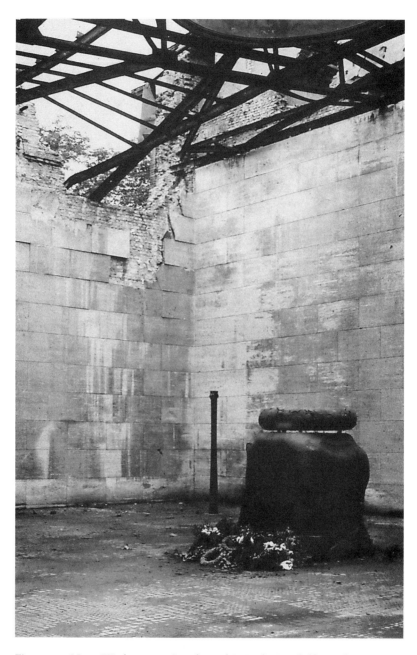

Figure 7. Neue Wache, 1945. Landesarchiv Berlin/Rudolf Steinhäuser.

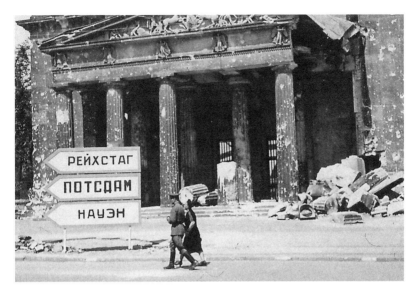

Figure 8. Neue Wache, late 1940s. Landesarchiv Berlin.

on Unter den Linden and by the resolution passed by the Fifth Party
Congress of the SED in 1950 that by 1965 the "center of the capital of
the GDR" should be completely rebuilt: the new East German state,
founded on October 7, 1949, demanded a fitting capital. In the initial
phase of East German architecture (1949–55) Lothar Bolz, the minis-
ter for construction of the GDR (Minister für Aufbau der DDR), stip-
ulated that the capital's architecture—so long as it could be integrated
into socialist inner-city planning—was to be rebuilt in the national
and regional traditions, in ideological contrast to the "Americaniza-
tion" of the Federal Republic's architecture just across no-man's land.
Returning to a national architectural tradition meant above all that
the historical center, the so-called *Forum Fridericianum* of Unter
den Linden—the Neue Wache, the Armory, the National Opera, the
Prinzessinnenpalais—was to return to Schinkel's classicism.[28]

Renovations began in 1951: indeed, the Neue Wache was among the
very first buildings to be rebuilt in the service of the new East German
nation, as though the proper relationship to the historical tradition
had to precede the building of socialist architecture such as the Minis-
try for Foreign Affairs (1963–66) or the Palace of the Republic (1973–
76). On September 21, 1956, the magistrate of East Berlin passed the
final decree to make the Neue Wache a new admonitory memorial

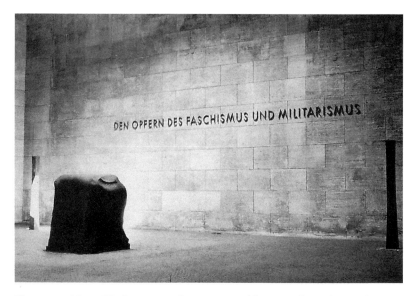

Figure 9. Neue Wache interior by Heinz Mehlan. Landesarchiv Berlin.

(*Mahnmal*) for "the victims of fascism and both world wars." The
architect Heinz Mehlan restored the interior, removed the oaken
cross, replaced the inscription of "1914–1918" with the final formu-
lation, "To the Victims of Fascism and Militarism" (*Den Opfern des
Faschismus und Militarismus*), and kept the now disfigured "Altar of
the Fatherland" [Figure 9]. The restoration was completed in 1960,
and the Neue Wache reopened with a military ceremony. On May 1,
1962—the year that mandatory military service was introduced in
the GDR—two NVA (Nationale Volksarmee, or National People's
Army) soldiers of the elite "Friedrich Engels" Guards Regiment took
up the posts that had been vacated by their National Socialist prede-
cessors. Every Wednesday at 2:30 pm the changing of the guard took
place in full military regalia; it soon became a tourist attraction com-
parable to Lenin's tomb or Buckingham Palace and was broadcast live
on the state radio [Figure 10].

 In 1966 the Neue Wache was closed for interior remodeling by
the architect Lothar Kwasnitza, because—according to the GDR
souvenir book on the Neue Wache—"it became ever more clear that
the interior design of the memorial [*Mahnmal*] did not correspond
to the understanding of socialist society."[29] The uneasy combination
of admonitory memorial and national self-image was redesigned,

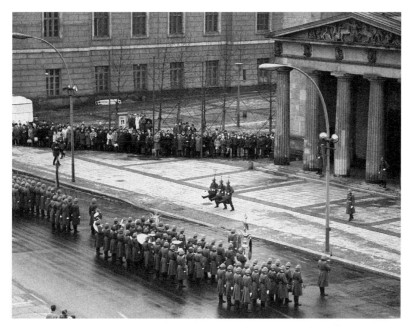

Figure 10. Neue Wache exterior, changing of the guard. Landesarchiv Berlin/Breitenborn, F Rep. 290-02-23, Nr. 80.

probably in connection with the upcoming twentieth anniversary of the GDR (October 7, 1969). The national crest of the GDR (hammer and compass) was chiseled into the rear wall, and the inscription was transferred to the side wall. Tessenow's altar was removed and replaced by a gas-fed eternal flame as was the custom in the Soviet Union. Probably in imitation of the memorial to the unknown soldier in the Kremlin wall unveiled in 1967—itself an imitation of similar national war memorials in Britain and France erected after World War I—the remains of a resistance fighter shot by the SS and the remains of a German soldier killed in Eastern Prussia were exhumed and placed under the stone floor; the unknown soldier was buried with the soil from nine battlefields, the unknown resistance fighter with the soil from nine concentration camps.[30] A glass cupola sealed the ceiling opening, and the basalt-lava floor was covered by bright, polished marble plates. The honor guard's watch station was moved to the adjoining Museum of German History (formerly the Prussian Armory), and cameras were installed to monitor the eternal flame and the interior [Figure 11]. The last changing of the guard took place

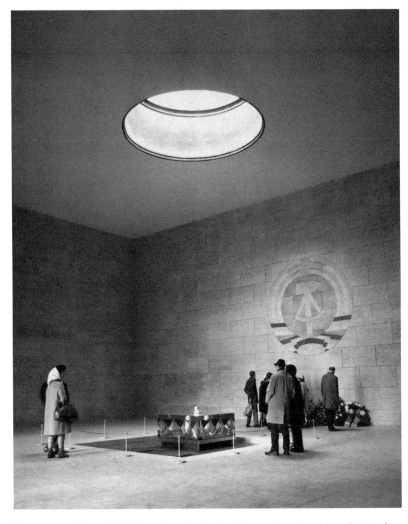

Figure 11. Neue Wache interior by Lothar Kwasnitza. Landesarchiv Berlin/ Breitenborn, F Rep. 290-02-23, Nr. 78-1.

on October 2, 1990. After reunification the GDR crest was removed from the rear wall, otherwise the interior was left intact but unused.

 In West Germany the need for a memorial to the dead was dictated first and foremost by pragmatic reasons, above all the "international protocol" of foreign dignitaries laying wreaths at each other's war memorials. The first incarnation of such a memorial was a bronze plaque with the inscription "To the Victims of Wars and Tyranny,"

erected in the court garden (*Hofgarten*) in Bonn on June 16, 1964, and dedicated by President Lübke "in memory of the victims of the people's uprising on June 17th," the first in a long line of surreptitious ideological identifications by West German politicians of East Germany and Nazi Germany performed while doing nothing more suspect than laying a wreath. Because of the campus atmosphere of the Hofgarten, which adjoins several university institute buildings, the "wreath-laying site" (*Kranzniederlegungsstelle*), as the memorial was derogatorily nicknamed (it was also more cynically called the "wreath-dumping site," *Kranzabwurfsstelle*), was moved in 1969 to the Northern Cemetery (Nordfriedhof) in Bonn where ninety-six Russian prisoners of war who had been worked to death and seventeen members of the Waffen-SS are buried.

In 1981 Bundeskanzler Schmidt proposed the establishment of a memorial for all those "who through the errors [*Irrtümer*] and the crimes of the Third Reich gave up their lives, be it in prisons and concentration camps, be it in the homeland in the bombing war or on the fronts of the Second World War." The German War Graves Commission (*Verein für deutsche Kriegsgräberfürsorge*, or VdK) responded with an aide-mémoire proposing as a "national place of honor" (*nationale Ehrenstätte*) a "national commemorative site for the war-dead of the German people" that would have as a "unifying symbol" a "proportionately oversized crown of thorns, suspended in the air or just above the ground."[31] Protests by the representatives of the Jewish community in Germany at the Christian symbolism quashed the proposal.

The embarrassment of lacking a "central wreath-laying site" was exacerbated by the public outcry when President Reagan and Chancellor Kohl fulfilled their obligations to "international protocol" at Bitburg Cemetery on the fortieth anniversary of the end of the war.[32]

On January 27, 1993, the Federal cabinet under Chancellor Kohl announced that a "central commemorative site of the Federal Republic of Germany" (*Zentrale Gedenkstätte der Bundesrepublik Deutschland*) would be erected in the Neue Wache and would be opened on November 14, "the people's day of mourning" (*Volkstrauertag*) of that year. *Volkstrauertag*, the last Sunday before the first Advent, dates back to the "remembrance day" (*Gedenktag*) introduced in 1923 to honor the dead of the First World War, itself in imitation of the French national day of mourning (November 11) introduced in 1922. The "day of remembrance" was renamed "heroes' remembrance day"

(*Heldengedenktag*) in 1934 and reintroduced and renamed *Volks-trauertag* under the Adenauer government in 1952. By way of justify-ing his decision Kohl said that the institution of a central memorial site in Berlin was a "signal that the move [of the government] to Ber-lin will not be delayed."[33] Like the East German government before it, the new reunified Federal Republic rebuilt and "rebaptized" the Neue Wache before any other official building in Berlin. Indeed, around 1993 as the Allied forces prepared their leave-taking ceremonies, the restoration of the German prewar national tradition began in earnest: for instance, the statue to Kaiser Wilhelm that had been destroyed in 1945 was rebuilt and replaced in the Deutsches Eck outside Koblenz (September 2, 1993).

In answer to protests over the lack of public and government dis-cussion surrounding Kohl's decision, a two-hour debate ensued in parliament: five experts were consulted (two pro, three contra); no alternatives were proposed. The Berliner Amt für Denkmalpflege, the city's office of memorial preservation, which had been working on the Neue Wache's interior and had recommended maintaining the 1969 design, was "considered in an advisory capacity only." In his address to the parliament during the debate Kohl informally adduced four reasons for moving forward quickly with the memorial:

1. The state required a site for wreath-laying ceremonies with foreign dignitaries.

2. Because fewer Germans could directly remember the war (as opposed to those who learn about it only through school, books, and so on), the issue had to be decided quickly. Kohl reminded the audience that, as with several persons present, the "fate of my own family"—his brother fell in the closing days of the war—was a "completely 'normal' fate of a Ger-man family."

3. Kohl's choice of a sculpture for the memorial's interior, of a mother and dead soldier-son, best represents the "tragedy of this century" because, he explained, as mothers and wid-ows "women are victims of war and violence who have been affected by the horror of this century in a particular way," and he alluded to the fate of women in Bosnia at the time. "The mourning of a mother expresses pain but also reminds us that we have to maintain the personal worth of the indi-vidual. . . . The belief in the indestructibility of the individual

is the core of all religious and philosophical traditions that underlie our Western culture. And thus we assure ourselves also of a legacy that grounds humanism [*Menschlichkeit*]."

4. Finally, there were letters of support for the project from the "League of the War-Blinded" and the VdK (War Graves Commission), which Kohl read aloud.[34]

There was nothing in Kohl's parliamentary address to indicate that he saw the Neue Wache as anything more or other than a national war memorial to Germany's dead soldiers. There was no parliamentary decision procedure, no vote, no referendum, no advisory committee formed. In the first words of an open letter to the *Frankfurter Allgemeine* newspaper, Christoph Stölzl, the director of the German Historical Museum and a Kohl appointee, justified the reason: "The federal government has decided about the design of a commemorative site of great political symbolism. The government did not take the path of public discourse (hearings, competition, jury) but decided to return to tradition. This is not as unusual as it seems to many critics. The selection of other state symbols of the Federal Republic, like flags and hymns, was also made in this way."[35] The nexus of the Neue Wache's military and national traditions was thus upheld.

So, the Neue Wache is once again redesigned: its interior is restored to the form it had in the Weimar Republic according to Tessenow's *original* plan. The glass cupola is removed, uncovering the opening in the ceiling, and the floor and wall plating now imitates Tessenow's design. A sculpture by Käthe Kollwitz of a mother embracing her dead son, which Kohl had chosen, is enlarged fivefold into slightly larger-than-life size and placed in the center of the interior [Figure 12]. The new inscription reads: "To the Victims of War and Tyranny" (*Den Opfern von Krieg und Gewaltherrschaft*) [Figure 13].

Questions were immediately raised about the sculpture's appropriateness, as Kollwitz's diary revealed its complex genesis. Entries indicate that she encouraged, against her husband's protests, their son Peter in his wish to volunteer for the army in the first ecstatic days of World War I, when members of the romantic Youth Movement were swept up in rhapsodic patriotism. Because he was underage, Peter required the permission of his father, Karl, in order to enlist, and with the support of his mother he finally received it. Kollwitz wrote, "I stand up, Peter follows me, we stand at the door and embrace and kiss and I implore Karl on Peter's behalf.—This one hour. This sacrifice

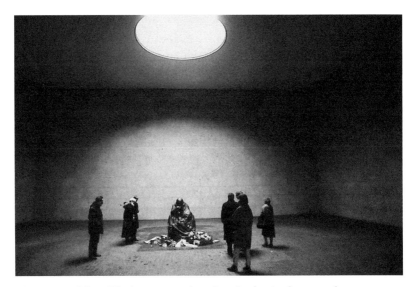

Figure 12. Neue Wache, current interior. Author's photograph.

[*Opfer*] to which he charmed [*hinriß*] me, to which we charmed Karl."[36] Within a month, in his first action, Peter lay dead on a field in Flanders. The death of her son became the overriding theme in her drawings and sculptures: she addresses her dead son in her diary, reports to him about "your memorial."[37] Yet, most striking is the fact that the image of mother and dead son—with Käthe Kollwitz and Peter as models—already recurs often in her early work, well *before* the war, before Peter's death, thus complicating a simplistic story of art being used to come to terms with a painful loss. Instead, the ideology that shaped her artistic subject matter seems continuous, indeed complicit with the ideology that "charmed" her into "charming" her husband into signing Peter's permission papers.[38] That ideology, in her art as in her life, is replete with Christian motifs of sacrifice and redemption, for instance of Mary holding the dead Christ in the early "Pietà" of 1903 [Figure 14]. In her diary Kollwitz wrestles with—without reconciling—the ideology of sacrificing one's life, or one's son, for the fatherland and the dawning realization that redemption for such sacrifices may not be forthcoming:

> Only one condition makes it all bearable: taking up the sacrifice into your will [*die Aufnahme des Opfers in den Willen*]. But how can one preserve this condition? [September 30, 1914]

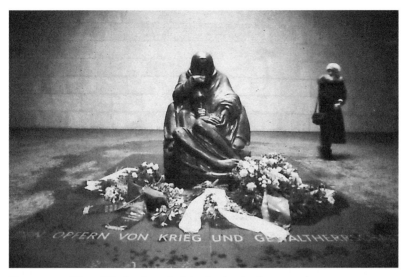

Figure 13. Neue Wache, inscription. Author's photograph.

Kache is here in the hospital. Konrad Hofferichter in the West, where there is a terrible offensive. Seventy-three hours of preparatory artillery barrages, then the attack, 23,000 captured Germans. Nevertheless for the time being the enemy has not broken through. There are supposed to be 190,000 dead and wounded on the French and English side. We aren't told the number of our dead and wounded. Sometimes I too go so far that I can see only criminal insanity in the war. But then when I think of Peter I once again sense the other feeling. Whoever has not experienced what we have experienced and with us all those who sacrificed [*hingaben*] their children a year ago, can see only the negative in the war. We know more. [October 6, 1915][39]

What the war withholds, art may provide. On October 22, 1937—the anniversary of Peter's death—Kollwitz reports in her diary that she is working on a small bronze sculpture that "has become something like a pietà. The mother is sitting and has her dead son lying between her knees in her lap. It is no longer pain, but rather thoughtful reflection."[40] The sculpture is 38 cm. high, 38 cm. deep, and 26 cm. wide. The work was never modified after 1937, and there is no indication that the pietà was ever intended as a model for a larger work or public monument. But, again, more striking is an earlier woodcut and drawing entitled "Death with a Woman in her Lap" (*Tod mit Frau im Schoß*) dating from 1921 [Figure 15]. Not a mother and dead son, but Death and a

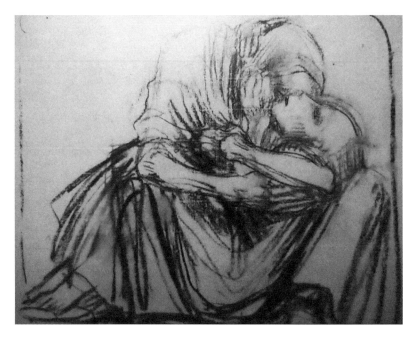

Figure 14. "Pietà" by Käthe Kollwitz, 1903. Reproduced from *Käthe Koll-witz, Schmerz und Schuld. Eine motivgeschichtliche Betrachtung*, 143; Kat. 67, *Pietà* (1903).

young woman, though one can still recognize Kollwitz and Peter in both images. Here, too, as in the diary entry above, I would suggest that we see the iconographic pietà symbolizing the heroic, redemptive sacrifice for the fatherland but also the ambivalence, the disturbing bad conscience of that symbolization, in the superimposition of Koll-witz's features, her own earlier motif of mother and dead son, and the new name for the mother-figure: death.[41]

The appropriateness of a Christian pietà to commemorate, among others, Jewish victims of National Socialism was questioned by crit-ics of the Neue Wache's new makeover, and the lack of discrimina-tion between perpetrator and victim in the language of the dedica-tion was challenged.[42] Kohl responded to criticism of the inscription in the parliament debate: "One could of course ask whether such a sweeping formulation doesn't include much that we don't want to see included. For this reason one might consider going into more detail with the formulation. But in doing that one slides into the whole

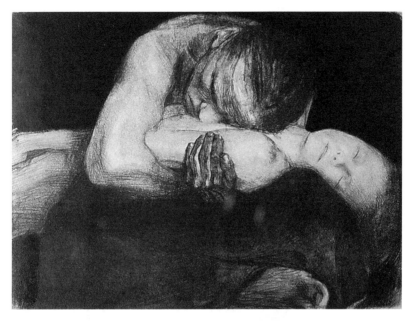

Figure 15. "Death with a Woman in her Lap" by Käthe Kollwitz, 1921. Reproduced from Otto Nagel, *The Drawings of Käthe Kollwitz,* ed. W. Timm. Tafel 99; Kat. 882, *Tod mit Frau im Schoß* (1921).

labyrinth of modern German history. The more you formulate, the less justice you'll provide";[43] justice *to whom*, of course, is the question, and Kohl's attempt at what could be termed an apotropaic invocation stands diametrically opposed to Bundespresident Richard von Weizsäcker's speech on May 8, 1985, in which he attempted to name specifically those who are being remembered and why.

In autumn 1993, shortly before the unveiling of the memorial, and in the face of a mounting scandal surrounding its design, a compromise was effected between Kohl's cabinet and various political representatives and critics at large. It was agreed that a separate memorial to Jewish victims would be erected, and two bronze tablets were mounted flanking the entrance portal to the Neue Wache: on the left a short history of the building, on the right an enumeration of who was to be honored [Figure 16]:

> The Neue Wache is the place of memory and remembrance of the victims of war and tyranny.

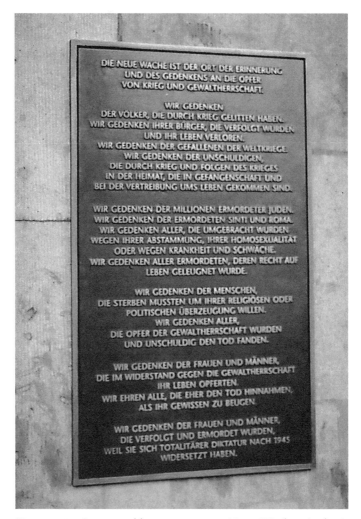

Figure 16. Bronze tablet, entrance to Neue Wache. Author's photograph.

We remember the peoples who have suffered because of war. We remember their citizens who were persecuted and lost their lives. We remember the fallen of the World Wars. We remember the innocent, who perished in the war and the consequences of the war in their homeland, in captivity, and in the expulsion [*Vertreibung*, which has come to signify the relocation of Germans from the Eastern provinces after the war].

We remember the millions of murdered Jews. We remember the murdered Sinti and Roma. We remember all those who were killed

because of their lineage, their homosexuality or because of sickness or debility. We remember all of the murdered, whose right to life was denied.

We remember the people who had to die on account of their religious or political convictions. We remember everyone who were victims of tyranny and died innocently.

We remember the women and men who sacrificed their lives in the resistance to tyranny. We honor everyone who met death rather than compromising his or her conscience.

We remember the men and women who were persecuted and murdered because they resisted totalitarian dictatorship after 1945.

In the next section I develop some analytical tools for "laying bare" the conflicting memorial discourses that thwarted the Neue Wache's purpose even before the building was reopened.

3. THE NEUE WACHE AS DIALECTICAL IMAGE

Oui, la souffrance en commun unit plus que la joie. En fait de souvenirs nationaux, les deuils valent mieux que les triomphes, car ils imposent des devoirs, ils commandent l'effort en commun.

—ERNEST RENAN, "Qu'est-ce qu'une nation?"[44]

Arthur Danto has proposed the following conceptual distinction between monument and memorial:

> We erect monuments so that we shall always remember and build memorials so that we shall never forget. . . . Monuments commemorate the memorable and embody myths of beginnings. Memorials ritualize remembrance and mark the reality of ends. . . . Monuments make heroes and triumphs, victories and conquests, perpetually present and part of life. The memorial is a special precinct, extruded from life, a segregated enclave where we honor the dead. With monuments, we honor ourselves.[45]

The German language does not have separate words for "monument" and "memorial." "*Denkmal*" is the neutral term designating both; "*Ehrenmal*" with its root of "honor" (*Ehre*) was the common term used in the beginning of the century (before World War II) to honor the war dead, but it is seldom used today and has been largely replaced by "*Mahnmal*" with its root "*mahnen*" suggesting reminder, admonition, or edification. Finally, "*Gedenkstätte*" has appeared as a neutral term for a site whose purpose is to foster remembrance. Danto's distinction is a good starting point because it

rests on the *use* to which monuments and memorials are put in the context of public commemoration,[46] which suggests considering them as modified forms of semiotic communication. According to Roman Jakobson's model, any communicative act involves the (explicit or implicit) presence of six functions: an *addresser*, who sends a *message* to an *addressee*, a *context* referred to in the message, a *code* that the addresser and addressee hold in common, and a *contact* (a physical channel between them).[47] Schematizing Danto's insights, we can say: Monuments typically *address* their producer's community (nation), while memorials may address the dead themselves; the *context* referred to in monuments is a myth of founding or legitimation, in a memorial a painful reality of loss; the *code* shared in a monument is likely a traditional iconography of national symbols, whereas memorials "tend to emphasize texts or lists of the dead"; in a monument the *contact* is one of a privileged central site manifesting the state's importance in daily life, in a memorial a "special precinct, extruded from life" and ritualized.[48] With this instrumentarium let us consider the Neue Wache and then the genre characteristics of German national war memorials.

The double bind afflicting the postwar Germanies is that the memorials commemorating the war dead are at once *also* monuments to the "birth" of modern democratic or socialist Germany: the "myth of beginning" and the "reality of ends" that Danto separates by analytical definition are here inextricably convoluted. The message of the Neue Wache as a communicative act is contradictory because the historical narrative—the context—that Kohl's newly reunified Germany wants to tell itself is just as conflated, trying to name the same event(s) under two descriptions: defeat and rebirth are "co-originary" (*gleichursprünglich*), as Heidegger would say. The oscillation between the two varies according to what instantiation one wishes to disclose in the statue of the mother mourning her dead son: Is she the mother of a concentration camp victim, a Wehrmacht soldier, or Waffen-SS officer, or NVA border guard at the Berlin wall, of a child killed in the night bombings, one of the executed plotters against Hitler, and so on? The variability of the addressee in turn recodes the message so that virtually anyone can symbolically identify himself or herself as the victim. Victimhood has become a universal currency: to turn the supremely ironical phrase from Marx's "On the Jewish Question": the Jews have achieved commemoration in so far as the Christians have become Jews.[49]

The abstraction of the dedication ("To the Victims of War and Tyranny") is matched by the sculpture's universality of address and intended affect: pity (*Mitleid*). In West Germany, Kollwitz's art was understood above all as a gesture of humanist pity, as for instance, the opening lines of the most popular monograph on her intone: "to cry together, to empathize, to struggle together, to be needed together: nothing characterizes the person Käthe Kollwitz and her work better than this emotional preposition '*mit*' ["together"] that aims for commonality."[50] Stölzl once again ascribes a clear national purpose to the work: "If any commemorative site erected by the state can found a tradition, then it cannot be wrong in being a tradition of pity. . . . Hardly any other problem in artistic design is so arduous for the Germans than that of an official commemorative site for the victims of war and tyranny. Can it be wrong to avail oneself of an artistic tradition to which we owe some of the great, binding images of humanity? Some say: that is sentimental. But what is wrong with that?"[51] It remains a question whether Kohl in his speech about the "tragedy of the century" and the "family tragedies" of German families, and Stölzl in his appeal to the unifying effect of pity, were aware of Lessing's attempt in the eighteenth century to unify the German people via a national theater and a modified Aristotelian theory of the universal cathartic effects of pity. Lessing's creative translation of the Greek "ἔλεος" as "pity" (*Mitleid*) rather than, for instance, "misery" (*Jammer*), universalized the effect of tragedy by disconnecting it—in contrast to Aristotle—from the moral judgment by the audience that a tragic hero has suffered "*undeserved* misfortune."[52]

There is, however, a second level of interpretation regarding the statue, beyond its intended effect of universal reconciliation. The selective reception of Käthe Kollwitz in West Germany as an artist of universal humanism and originality in aesthetic form stood in marked contrast to her wholesale adoption by East Germany as a "comrade of the struggling workers": public statues erected on the renamed "Käthe-Kollwitz Square" in East Berlin, several major exhibitions alongside a permanent museum, state-funded scholarly studies, and a complete edition of her graphic works all solidified the official interpretation of Kollwitz's socialist engagement, which included antiwar and antipoverty graphics and a woodcut for a memorial leaflet on the death of Karl Liebknecht, which characteristically alludes to the iconography of "the mourning of Christ" [Figure 17].[53] Kollwitz and her art thus were subject to the same Cold War ideological

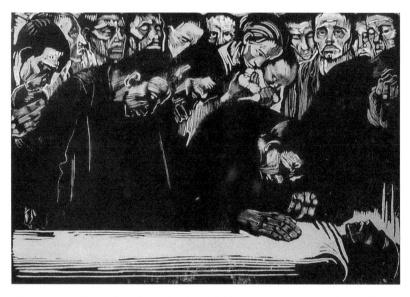

Figure 17. Memorial sheet for Karl Liebknecht, print. Käthe Kollwitz, 1920. Reproduced from *Käthe Kollwitz, Schmerz und Schuld. Eine motivge-schichtliche Betrachtung*, 127; Kat. 43, *Gedenkblatt für Karl Liebknecht* (1920).

pressures and fault lines as the Neue Wache itself, and placing one of her works within the memorial may be seen as the new state's symbolic affirmation of her western ideological image, just as East Berlin streets named after Weimar socialist and communist personalities have now been renamed and ideologically reappropriated.[54]

However, other criticisms remain. A purported *realistic* code of the sculpture is mitigated by the fact that in World War II most victims' bodies were not recovered, and that whole families and neighborhoods—civilian casualties far outnumbering military ones—were eradicated in the death camps and the bombings: as a result of modern warfare and industrial murder the gendered stylization of a surviving mother cradling the body of her soldier-son no longer has the purchase on universality Kohl claims. Furthermore, that pool of addressees is curtailed through the *symbolic* code of the memorial, for indeed the statue belongs to the Christian iconographic tradition of pietà: it thereby excludes precisely many of the groups to which it is ostensibly dedicated: Jews, Gypsies, Orthodox, atheists, communist resistance fighters, and so on.[55] Lastly, the contact, the physical channel, also

forecloses the work's reception and hence the goal of reconciliation, for the Neue Wache, as we've seen in the historical sketch above, is coded above all as a *military* memorial, whereas the overwhelming number of the dead did not belong to the military, but the *civil* sphere of society. It is the recoding of a breakdown of civil society (the rise of National Socialism) in the traditional trappings of a national war memorial that most condemns the Neue Wache.

The Neue Wache's contribution to the "cultural reservoir" of postwar social memory can be evaluated with recourse to Reinhart Koselleck's seminal study of the genre, in which he specified three ways in which a memorial to the war dead (*Kriegerdenkmal*) can establish identification:

1. "The dead, the killed, the fallen are identified in a certain respect—as heroes, victims, martyrs, victors, followers, and also even as vanquished; furthermore as keepers or bearers of honor, faith, fame, loyalty, duty; finally as guardians and protectors of the fatherland, humanity, justice, freedom, the proletariat or the particular constitution. The list can be extended."

2. "The surviving spectators themselves are confronted with an identification to which they should or must relate themselves. 'Mortui viventes obligant,' says the simple maxim, which can be filled out according to the identity structure given above. Their cause is also ours. The war memorial does not only remember the dead, it also reclaims the lost life in order to give a meaning to the process of surviving."

3. "Finally there is the case that is included in all those named, but that in itself means at once either more or less: that the dead are remembered—as dead."[56]

The present avatar of the Neue Wache has aroused such controversy because it at once partakes and does not partake of the poetics of *Kriegerdenkmäler* Koselleck outlines. The first level of identification, the dedication's addressees, is left as indeterminate and hence inclusive as possible, augmented by the semantic slipperiness of the German "*Opfer*," which up to *Kriegerdenkmäler* commemorating World War I translated *sacrificium*, a voluntary "sacrifice" for one's country, but since World War II has come to mean more the passive *victus*, "victim." The former belongs to the vocabulary of the Roman

soldier's heroic virtue, the latter to the statistics of highway fatalities, aerial bombings, and the death camps.[57]

So, too, the second level of identification, the common cause or obligation linking the dead and the living—conceivably something like "let there be no war and tyranny"—in its very anodyne abstraction can refer to both National Socialism and the GDR, and moreover seems a proleptic justification for sending Bundeswehr soldiers abroad on UN peacekeeping missions, part of Germany's incremental "normalization" as a post-Cold War national power and future permanent member of the UN Security Council. In keeping with the Lessing program of cathartic nation building, "war and tyranny" stand opposed to a passive humanity like divine or natural forces confronting a vulnerable polis—as impersonal, inscrutable fate rather than human, all-too-human political catastrophes. All of humanity appears as a real or potential "*Schicksalsgemeinschaft*," a "community united by fate," a concept with a highly compromised political history.

Furthermore, the concreteness of the figure in contrast to the generality of the dedication suggests that—to the extent that the memorial is a war memorial—the attempt is being made to distinguish the honor of those who sacrificed from the dishonorable cause for which they sacrificed, similar to the poetics, controversy, and subsequent compromise formations (the addition of a flagpole and realistic figural statues of combatants) of the American Vietnam Veterans Memorial in Washington.[58] One can only hope then that the third level, remembering the dead themselves, in their particularity, is somehow possible *despite* the memorial.

These motifs are not new, for indeed they have an insistent, recurrent presence in the hybrid genre of national monument and military memorial throughout modern German history. The nexus of civil, military, and Christian elements is specific to German war memorials as opposed to French: as one historian of World War I memorials succinctly notes, "In the German cult of the dead the citizen is celebrated as soldier, in France the soldier as citizen."[59] Whereas French memorials exhibit secular motifs of the citizen-soldier and his waiting family, Germany's memorials to its soldiers emphasized sacredness of duty to the nation, part of the larger strategy of nation building in Germany: "The religious is secularized in the national, and the secular is sacralized."[60]

Figure 18. Holzmeister, Memorial to Schlageter, Düsseldorf. Reproduced from Hubert Schrade, *Das deutsche Nationaldenkmal. Idee/Geschichte/ Aufgabe*, plate 1.

A perhaps extreme example in this tradition is presented in Hubert Schrade's 1934 study *The German National Monument*, which lays out the National Socialist program to fulfill the avowed need for a national memorial that, by 1934, was already celebrating the tenth anniversary of its first manifestation: the memorial to Schlageter, the early Nazi martyr from the Ruhr occupation [Figure 18].[61] Schrade praises the memorial, a sunken circular crypt with an overarching cross, for providing an *"Urform"* of the space that forms a community (*Urform des gemeinschaftsbildenden Raumes*): "With its main space and its crypt sunk into the fateful earth of the Ruhr, bringing the ring of community to appearance, dominated by a symbol, this memorial contains in embryo everything that shapes our expectation."[62] However, it is Munich's memorial to its thirteen thousand sons who fell in World War I that captures his unqualified approbation [Figure 19]. A mausoleum, adorned with the names of the dead and the dedication "To Our Fallen" on one side of the chamber and the assurance "They Will Rise Again" on the other, leads down to a sunken cryptlike space enclosing the full-size sculpture of a soldier in battle-dress laid out upon the altar of the fatherland [Figure 20].

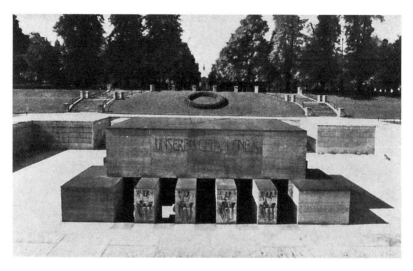

Figure 19. Knappe-Bleeker, Memorial to the Fallen, Munich (exterior). Reproduced from Hubert Schrade, *Das deutsche Nationaldenkmal. Idee/ Geschichte/Aufgabe*, plate 23.

Schrade provides first an inclusive first-person plural ("we") phenomenological description of the experience of the memorial:

> All the names have become a sign for men of one fate, as it were traces of the mythos of the fallen. . . . The view upon all the names of *one* mission [*Berufenheit*] of itself awakens in us the need for a figure in which the fate of the many, who have become one, is allegorically [*gleichnishaft*] embodied. We are prepared to descend into the crypt located below the altar-tomb-block. In it is the sought-for image of the one who represents all: a young warrior in his repose of death.[63]

Schrade then offers an exegetical interpretation of the symbol,[64] explaining why it transcends even the "community-forming" space of the Schlageter memorial, and why its figure is not that of liberal individualism, but of the nation (*Volk*):

> For by making the center of the whole ensemble the figure of the warrior reposing in the sleep of death, [the Munich memorial] also gives the individual, who seeks out the holy room, a goal. The Schlageter memorial, completely figureless, only architecture and symbol, lets the individual become placeless in it. It awaits only the community. Yet the way in which the Munich memorial addresses [*anspricht*] the individual is fundamentally different from the effect that the

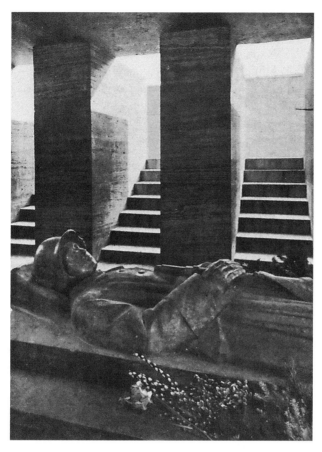

Figure 20. Knappe-Bleeker, Memorial to the Fallen, Munich (interior). Reproduced from Hubert Schrade, *Das deutsche Nationaldenkmal. Idee/Geschichte/Aufgabe*, plate 24.

individualistic figurative memorial [of the nineteenth century] exerts on the individual. For one comes to the single figure after having crossed the chamber of the community, whose walls hold the columns of names of the sacrifices [*Opfer*] and the supporters of a new national community [*Volksgemeinschaft*]. And the individual, whose image the crypt harbors, is indeed not an individual, but rather a symbol of all who fell . . . that is why we feel the symbol always as a person . . . in the originary sense proper to the concept. *Persona* comes from *personare* and that means "to sound through." The whole sounds through the one, through whom he existed and for whose sake he fell: his nation [*Volk*].[65]

My point is not, of course, that the Kohl government consciously
sought to renew a National Socialist program in its design of the
Neue Wache. Rather the homologies in situation, design, address,
and allegorical figuration—and exegetical interpretation—indicate
the powerful and unbroken function performed by memorials to the
war dead in creating a "cultural reservoir" for national identity. From
this perspective, the vagueness of the Neue Wache's dedication and
allegorical figure becomes more motivated, for only from such vague-
ness could the desired national unity possibly be fashioned out of the
wounds and ruins of recent German history.

My final example from the history of German national monuments
and memorials addresses the other aspect I named above: the uncom-
fortable conflation of *military* and *civil* motifs in the Neue Wache, for
this conflation dates back at least to the 1969 renovations carried out
to bring the building into line with the GDR's founding myth of self-
legitimation. At the conclusion of the souvenir book about the Neue
Wache by the "military publishing house of the GDR" the author
addresses precisely the spectator's apprehension and confusion caused
by the interference between a military-ceremonial building and ritu-
als (contact and code), on the one hand, and the civil-monumental
role (context) the remodeled Neue Wache was supposed to play, on
the other:

> Now and again visitors do not really know how they should recon-
> cile the military ceremony with this [that is, antifascist] tradition.
> Military demonstrations of honor before memorials in the histori-
> cally traditional national manner are common in many countries, as
> also in the GDR. Here, as in all socialist countries, the historically
> transmitted forms of military ceremony are the point of attachment.
> They extend from the weekly mounting of the guard to the Great
> Ceremonial Tattoo on special occasions. However, in a workers' and
> peasants' state like the GDR there is no possibility whatsoever that
> this ceremony would serve to glorify the demon of militarism, which
> was eradicated completely in this state. Carried out by members of a
> workers-and-peasants army in the "Friedrich Engels" Watch Regi-
> ment in honor of the pioneers of socialism and as expression of its
> reliable armed protection, from the beginning onwards it serves the
> cultivation of the antifascist tradition of the people of the GDR that is
> embodied in this memorial.[66]

That is, the GDR is a legitimate state because it too draws on its
specific traditional national forms of military ceremony, while at the
same time defining itself in opposition to the national militarism that

immediately preceded it, fascism. Furthermore, the memorial is split along the fissure dividing the unknown soldier from the unknown resistance fighter, the former performing the function of a military memorial—marking the loss of German soldiers in the previous war—the latter the function of a civil memorial and monument—marking the founding of the GDR upon the tradition of political, antifascist resistance. The unfortunate juxtaposition metonymi-cally links victims and perpetrators in what could be called "Bitburg *avant la lettre*": the soldier conceivably could have shot the resistance fighter, or vice versa.[67]

The current incarnation of the Neue Wache merely multiplies the conflicts between the military and civil registers. The external tablet must prophylactically *correct* the interior dedication, which conceiv-ably commemorates everyone who suffered during the war, implying an equivalence between fallen soldiers and murdered citizens (which the tablet corrects only to the extent that it invokes "innocence" with-out, however, explaining how it should be understood in such cases), and again between the National Socialist totalitarianism and the East German regime (which the tablet explicitly reinforces). In this self-diremption the reunified Germany assumes, ironically, the conflicted legacy of the GDR.

4. THE DIALECTIC OF HOLOCAUST MEMORIALS

A short critical excursus regarding some recent Holocaust memo-rials in Germany may provide a useful conceptual transition from the Neue Wache to the Bavarian Quarter memorial for two reasons: (1) discussing the memorials that commemorate Holocaust victims disentangles the Holocaust as a civil catastrophe from its unfortu-nate intertwinement with military and nation-building motifs in the Neue Wache; and (2) the regressive inadequacy, if not bad faith, of the Kollwitz sculpture as a figurative representation of Holocaust vic-tims has led critics (among others, James E. Young) to advocate its dialectical counterpart: "counter-monuments" (*Gegen-Denkmale*)—nonrepresentational or self-thematizing memorials—which all too often renounce their historico-commemorative specificity. "Counter-monuments" generally fall into three kinds of poetics: (1) nonrep-resentational or "negatively sublime" artworks; (2) artworks that self-reflexively thematize the transience and difficulties inherent in public commemoration as such; and (3) "limit-case" artworks that

tend toward their own self-abnegation in favor of historical documentation. Understanding what I take to be the dialectical relationship between nonrepresentational and representational forms of remembrance will prepare the possibility of moving beyond that opposition in the Bavarian Quarter memorial.

The first kind of poetics of "countermonuments" arose from debates surrounding Holocaust memorials in particular that centered on the opposition between figurative representation on the one hand, characteristic of memorials in the 1950s and 1960s and dating back to memorials commemorating fallen soldiers of World War I, and abstract or minimalist, nonrepresentational memorials on the other hand, whose justification often draws on the unrepresentability thesis by thinkers like Jean-François Lyotard, Claude Lanzman, or Dan Diner, who hold that the Holocaust has no narrative structure, only statistics. Within this opposition the Kollwitz sculpture clearly is regressive, a totem offering the promise of reintegration, via what Freud calls secondary narcissism: the *fusion* of mother and child prescriptively mirrors not the viewer's strength and ability to accept loss and separation (in what could be called a politically mature historical consciousness), but the *fantasy* of a subsuming reunion. The specularization enacted by the reciprocal gaze of mother and child itself figures the imaginary reintegration into a mythic unity, satisfying the "historical need" Nietzsche located in "the loss of myth, of the mythical homeland, the mythical maternal womb."[68]

But the other pole of the opposition, the memorials of nonrepresentability of the late 1970s and 1980s, is also open to critique. The assumption here is that what is to be remembered, what is to be gestured toward or evoked because it is not directly re-cognizable, is absence, death, mass destruction, the endpoint of the *Endlösung*. One example of this concept is Ulrich Rückriem's "Denkmal für die deportierten Hamburger Juden" (1983): a massive gray square of granite, cut into seven pieces and reassembled so that the cuts are visible, and located before the Hamburg Logengebäude, the collection point from where in 1941/42 thousands of Jews were deported. Another example is Sol LeWitt's "Black Form—Dedicated to the Missing Jews" (1987 Münster, 1989 Hamburg-Altona), a huge black block, reminiscent of Richard Serra's "Tilted Arc" (1981) in downtown Manhattan, that the artist calls a "black hole" or "perceptual barrier" meant metaphorically to denote the absent Jewish population.[69] The problem is that such a strategy can all too easily fall into

theological transcendence (the Holocaust is unique, unrepresentable) or, even worse, an aesthetic myth. Such "black holes," while they do not provide the convenient closure of universal reconciliation, do provide another kind of closure, that of historical causality and agency. The memorials mark a limit-event that in its absolute otherness implies that the Holocaust was itself extraterritorial to its historical genesis. If the first strategy collapses the crimes into an undifferentiated universal mourning, the second strategy hypostatizes them into a sublime negativity; in both cases what is missing is the historical differentiation that, especially in the land of the perpetrators, might actually make a difference toward Auschwitz not happening again.

James E. Young introduced the term "counter-monument" (following Jochen and Esther Gerz's coinage "Gegen-Denkmal") specifically to designate the second kind of poetics in my enumeration: several recent memorials, by playing with absence and presence and the processual, ephemeral nature of remembrance, cast doubt upon the function and permanence of traditional monuments. "Instead of seeking to capture the memory of events," younger artists, who never experienced the events directly, "remember only their own relationship to events, the great gulf of time between themselves and the Holocaust."[70] According to Young, these artists consider it their task "to jar viewers from complacency, to challenge and denaturalize the viewers' assumptions . . . artists renegotiate the tenets of their memory work, whereby monuments are born resisting the very possibility of their birth."[71] Examples of such "countermonuments" include Harburg's "Monument Against Fascism" by Jochen Gerz and Esther Shalev-Gerz, a twelve-meter-high, one-meter-square pillar made of hollow aluminum and plated with a layer of soft lead. An inscription near its base reads in German, French, English, Russian, Hebrew, Arabic, and Turkish: "We invite the citizens of Harburg, and visitors to the town, to add their names here to ours. In doing so, we commit ourselves to remain vigilant. As more and more names cover this 12–meter-tall column, it will gradually be lowered into the ground. One day it will have disappeared completely, and the site of the Harburg monument against fascism will be empty. In the end, it is only we ourselves who can rise up against injustice."[72] Unveiled on October 10, 1986, the pillar was sunk eight times during the next seven years until on October 8, 1993, it disappeared, only its top remaining visible.

Another example of a "counter-monument" is Horst Hoheisel's "Negative-Form" Monument in Kassel. The original Aschrott-Brunnen

(Aschrott Fountain) in City Hall Square was built in 1908 and funded by the Jewish entrepreneur and citizen of Kassel, Sigmund Aschrott. It was demolished by Nazi activists during the night of April 8–9, 1939. In 1943, two years after the deportations from Kassel had begun, the city filled in the fountain's basin with soil and planted flowers, and local citizens came to call it "Aschrott's grave." Rather than rebuild the fountain, Hoheisel's design called for a mock-up of the fountain to be inverted and buried under the original basin, writing: "I have designed the new fountain as a mirror image of the old one, sunk beneath the old place in order to rescue the history of this place as a wound and as an open question, to penetrate the consciousness of the Kassel citizens so that such things never happen again."[73] As part of the project Hoheisel had school children research the lives of individual Jewish citizens, write their life stories on paper, attach them to stones, and place these "memory-stones" before the Kassel train station as an admonitory memorial (*Mahnmal*). This dimension of historical documentation accompanying a memorial leads into the third and final poetics of countermonuments.[74]

This third kind of poetics is exemplified in recent work by the Gerzs, who have continued and radicalized their countermonument strategy in the admonitory "invisible" monument "2146 Stones—Monument Against Racism" (2146 *Steine - Mahnmal gegen Rassismus*) in Saarbrücken, where Jochen Gerz was a guest professor. There he happened upon the cell in the basement of the city castle where the Gestapo had held their prisoners. He and his students wrote to sixty-six Jewish communities and collated a list of all the locations of Jewish cemeteries in Germany before 1933. They then removed paving stones from the path leading to the Saarbrücken castle, etched the name of one cemetery on the *underside* of each stone, and replaced the stones. As the artist says, "When you cannot see something, then you are almost forced to talk about it."[75] Yet the monument would, in adherence to its own concept, need to remain completely invisible. The monument was in fact "unveiled" on May 23, 1993. The "castle square" (Schloßplatz) was renamed "square of the invisible monument" (Platz des unsichtbaren Mahnmals), and politicians convened to unveil the new street sign. Two critical observations arise here. First, conceptually one could argue that the monument itself is superfluous, that the activity leading to its emplacement—the research, the inscribing—constitutes the only real memory-work possible, and that in that case the artwork as public memorial has negated itself in favor

of remembrance in the form of historical research and documentation. The second point is, to what extent do these strict counter-monuments, in denying representation and/or narration altogether—whether through a questionable mimeticism of Jewish traditions and motives such as the *"Bilderverbot"* or in favor of the enumeration of names and places alone—contribute to the historical oblivion against which they are ostensibly struggling?

We can identify such dialectical shortcomings of "countermonuments" in a more recent Holocaust memorial as well. In May 2005 the "Memorial for the Murdered Jews of Europe" (Denkmal für die Ermordeten Juden Europas) was unveiled in Berlin, after more than ten years of rancorous debate, the formation and dissolution of committees, committee recommendations and their subsequent annulment, requests to modify the original design proposed collaboratively by Peter Eisenman and Richard Serra, precipitating the latter's withdrawal from the project, and so on.[76] In its final form, Eisenman's memorial contains about three thousand stone pillars or stellae ranging in height from 1.5 to 10 feet, spaciously erected across the five acres of undulating terrain between the Brandenburg Gate and Potsdamer Platz, in the former no-man's-land along which the wall ran and not far from the former headquarters of the Gestapo and Hitler's bunker [Figure 21]. In response to reservations expressed regarding the original design, rows of evergreen and linden trees were included, forming a visual link to the trees of the nearby Tiergarten; permanent tablets bearing a historical text were placed at the edges of the memorial, "denoting what is to be remembered here,"[77] and an underground information center was built below the memorial. The information center, simply called the *"Ort"* ("place"), comprises a corridor linking four rooms: the first room contains illuminated panels displaying letters of victims; the second room presents prewar photographs of Jewish families juxtaposed with descriptions of their fates; projected onto the walls of the third room are names of victims; the fourth room depicts information about the camps.

If the dialectical relationship between representational and nonrepresentational forms of remembrance elaborated above is cogent, then it is easy to see how this memorial fails the dual desiderata incumbent upon Holocaust artworks. In fact, a consideration of two texts that ostensibly endorse the memorial, by the writer and journalist Hanno Rauterberg and Peter Eisenman himself, reveals just how flawed the memorial's composition and expected reception are.[78]

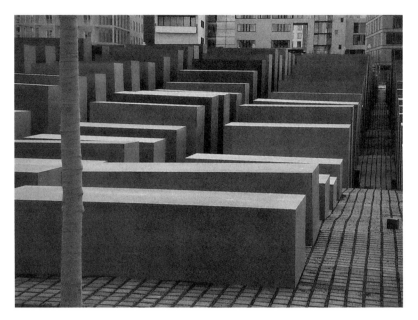

Figure 21. Eisenman, Memorial for the Murdered Jews of Europe, Berlin.
Public domain.

 Like the memorials of the 1970s and 1980s, this memorial relies
on aesthetic principles of abstract formalism and thereby gravitates
toward the nonrepresentability pole of the dialectic. However, while the
abstraction of the memorials of the earlier period was most often read
as somehow symbolizing the absent Jews, the abstraction of this memo-
rial is read self-reflexively, as symbolizing—literally spatializing—the
difficulties of the ever-incomplete, infinite task of remembrance. This
interpretation of the memorial clearly informs Young's account of the
committee's motivations for approving the revised design: "With this
memorial, which insists on its incompleteness, its working through of
an intractable problem over any solution, we found a memorial that
was as suggestive in its complex conception as it was eloquent in its
formal design. As such, it came as close to being adequate to Germa-
ny's impossible task as is humanly possible. This is finally all we could
ask of Germany's national attempt to commemorate the Nazis' murder
of European Jewry."[79] Rauterberg goes even further, extolling perhaps
a version of the negative sublime: "All that is seen here is that noth-
ing is to be seen. And that in itself is a significant achievement." In

the first-generation memorials of the 1970s and 1980s, their nonrepresentational abstraction evokes a first-order object: the murdered Jews. The nonrepresentational abstraction of Eisenman's memorial instead evokes the second-order act or process of remembrance itself, and this is clearly an issue only for the second generation of Germans and thereafter. The "Memorial for the Murdered Jews of Europe" is *for* the murdered Jews because it cannot be addressed, by this generation, *to* them, for this generation knows of (*wissen*) them, but neither knew (*kennen*) nor wronged them. But the slippage from a memorial *for* the memory of a population to a memorial *about* the memory of a population is fatal, for if the memorial is actually understood as being *about* (the perpetual process of) remembrance (of the murdered Jews), it is not really *for* the murdered Jews at all, it is for the Germans, so that they might be "invited" or "demanded" to remember (as both Young and Rauterberg characterize the effect of Eisenman's memorial).

Like the earlier nonrepresentational memorials, this memorial too lacks any relation to historical causality and agency; indeed, only the supplementary tablets mounted at the entrances to the memorial indicate who is to be remembered, much like the much *more* specific tablets affixed to the entrance to the Neue Wache. Thus in respect to historical specificity and the possibility of engendering genuine historical consciousness, this memorial regresses even behind that of the Neue Wache.

There might be a possible line of defense available to the champions of the memorial, based on some comments by Rauterberg and Eisenman himself. Rauterberg claims that Eisenman's memorial is not a "landscape of remembrance" but rather a "landscape of experience" and "the attempt to create a new immediacy." The defense, therefore, would be to deny the dialectic of representation and nonrepresentation by arguing that representation is not the correct concept to consider applying when thinking about this memorial; rather, the argument would go, the experience of the memorial as performance somehow can elicit historical consciousness. In principle this might be a promising line of reasoning; indeed, we will see that the Bavarian Quarter memorial "performs" when it successfully shocks the viewer into an experience and understanding of a given building or institution as a "dialectical image" of its past misuse under National Socialism. But unfortunately Eisenman's memorial does not possess the means adequate for such a task. Here is how Rauterberg describes the effects of the "performance landscape":

Remembrance, for [Eisenman], is walking towards an unknown
destination; it is a physical experience in which we come closer to
ourselves and, he hopes, to history. It involves a vague notion of art's
ability to bridge time and change attitudes. But even for those who
do not subscribe to this idea, unexpected impressions emerge while
walking, touching, seeing. And for some, at least, these impressions
turn out to be vital and memorable metaphors. An abstract awareness
of history slips into the here and now. We see people disappear into
the inextricable maze before our eyes. We discover how the seemingly
harmless becomes menacing. We sense that even the rational has an
irrational undercurrent. We notice how easily our notions of order
are undermined.[80]

But "an abstract awareness of history" is no awareness of history at
all: it is at most perhaps an awareness of historicity, the evanescence
of lived experience, and that awareness is insufficient for genuine his-
torical consciousness *of* the Holocaust.

Yet there is an even more troubling aspect to the experience or
performance of this memorial. The specific experience Rauterberg
invokes, that of seeing people disappear into an "inextricable maze,"
does not merely ignore historical specificity and agency, it *denies* it,
for with that image Rauterberg unwittingly echoes Kohl's infamous
warning about entering "the whole labyrinth of modern German
history" as a justification for eschewing historical specificity in the
redesigned Neue Wache. Furthermore, the image of an "inextricable
maze" swallowing people suggests that the Shoah be conceived as an
impersonal, impassive trap, as though the only agency involved was
that of those who designed and engineered it on the one hand, and
those who "wandered" into it on the other.

In his own descriptions of the anticipated experience of the memo-
rial, Eisenman emphasizes the sense of uncanniness and instability
created by the stellae and the landscape:

Unlike other site-specific work that has no memorial or political pro-
gram, it is the memorial's obdurate lack of obvious symbolism that
makes its public claim to creating the sense of a dual time: one expe-
rienced in the present; the other, the possible remembrance of another
experience of the past in the present. It is this sense of a dual time and
the way that this is experienced that is insistently architectural in its
being. This is achieved through the denial of the ground as a datum
of reference. Instead, there are two topological and undulating sur-
faces marked by the tops and bottoms of the pillars. These define a
zone of instability with respect to the datum of the surrounding street
context and to the upright subject who enters the field above the

pillars and, as the ground falls away, becomes enveloped within them. This necessity of containment and enclosure, now articulated in a different way, can only be understood as architectural.

Granted that one feels a sense of unease and instability while wandering in the memorial, it is unclear how this experience is to be understood as anything more specific than Rauterberg's "dark experience" above. By contrast, Maya Lin's Vietnam Veterans' Memorial likewise incorporates an undulating landscape that leads downward into a central depression, but unlike Eisenman's memorial, hers incorporates tablets (roughly the height of Eisenman's tallest pillars) listing names and dates. Arguably similar senses of unease, instability, and descent beneath the surface of the ground are created or "performed" by both landscapes, but in Lin's memorial the affect is linked to the means to foster specific historical awareness and remembrance. Eisenman's memorial lacks precisely those means.

Rauterberg concedes that in the absence of such means, the memorial leaves each visitor to his or her own devices for deriving historical understanding: "Each of us must decide for ourselves how far we dare to venture into this landscape of stellae and souls, and how we read it. Even so, the act of remembering is not left entirely to chance. The Information Centre underneath the memorial presents a clear, incisive, unmistakable picture of the Holocaust." That is, just as with the tablets mounted at the entrance to the Neue Wache, the subterranean information center supplements the memorial's deficiency by providing the required *historical relation*. But here too Eisenman's memorial marks a regression, for while the Neue Wache's tablets at least directly adjoin and prophylactically correct the mythic aestheticizing tendency of the Kollwitz sculpture, the Eisenman memorial and the information center are spatially disjointed and virtually independent of each other, such that each relation—the aesthetic and the historical—becomes autonomous and self-sufficient, the aesthetic tending toward myth, the historical toward mere document.[81] Even while cogently invoking precisely the (negative) dialectical relationship that *should* organize such a memorial, Rauterberg here too concedes as much: "Without this explanatory exhibition, the inexplicable above ground would be little more than a field of myth. The two places need one another, yet each has a life of its own." The final failure of the Eisenman memorial, as the most recent incarnation of "countermonument," is that its most stalwart apologists apparently misconstrue the proper application of a dialectical relationship.

Thus by remaining bound dialectically to what they try to negate, countermonuments either efface their role as public art in favor of historical documentation alone, or in denying representation, communication, or specificity, they become themselves "black holes" and *renounce* the very "memory work" they aspire to generate. In the former case, the work of art tends to deny its aesthetic relation in favor of purely a historical relation, as document; in the latter case, the work of art tends to deny its historical relation in favor of purely an aesthetic relation, as aesthetic myth. Finally, by thematizing the resistance or ephemerality of remembrance in their opposition to conventional, ever-present, and hence easily overlooked ("invisible" is Robert Musil's apt expression) monuments,[82] these countermonuments at best reflexively thematize, rather than resolve, the problem of memorials in Germany today, and of Holocaust artworks in general.

5. PLACES OF REMEMBERING IN THE BAVARIAN QUARTER

To articulate the past historically does not mean to recognize it "the way it really was." It means to seize hold of a memory as it flashes up in a moment of danger. Historical materialism wishes to hold fast that image of the past which unexpectedly appears to the historical subject in a moment of danger.

—WALTER BENJAMIN[83]

I turn now to another kind of memorial that, I think, escapes the dialectic between remembrance and forgetting, figurative representation and unrepresentability as I've expounded these oppositions above and that also eludes the entwinement of military and civil spheres, of national monument and military memorial that I've traced in the various incarnations of the Neue Wache. The Neue Wache's inscription reads "To the Victims of War and Tyranny" (*Den Opfern von Krieg und Gewaltherrschaft*), though the German "*Gewaltherrschaft*" (as opposed to the loan word "*Tyrannei*") more literally means rule or domination through force; it thus stands implicitly opposed to the state under the rule of law (*Rechtsstaat*). Those who are vulnerable to *Gewaltherrschaft* are those who stand outside the *Rechtsstaat*, are deprived of legal rule and recognition as citizens. The difference between a *Rechtsstaat* and a *Gewaltherrschaft* is subtly enacted rather than representationally or narratively re-figured (positively or negatively) in the memorial entitled "Places of Remembering in

the Bavarian Quarter" (*Orte des Erinnerns im Bayerischen Viertel*) in the central Schöneberg district in Berlin.[84] Before World War II the neighborhood was colloquially known as "Jewish Switzerland," home to wealthy assimilated middle-class Jewry. After 1933 a succession of ordinances, including the Nuremberg racial laws, curtailed, confined, and eventually removed all rights of public access to health, transportation, recreation, the right to practice a profession, partake in the public life in any way whatsoever, finally the very right of existence itself. More than six thousand Jewish citizens were deported from the neighborhood.

In 1991 the Schöneberg Arts Department formed a commission of historians, artists, and architects and held an open competition for a central "place of remembrance" for the district's central "Bavarian Square" to accompany a decentralized installation to "provoke" and "irritate" remembrance against the background of everyday life in the bourgeois neighborhood. The winning concept by the artists Renate Stih and Frieder Schnock renounces a central memorial completely, opting instead for a documentation center about Jewish life during the Nazi years to be housed in the district town hall.[85] The decentralized installation is composed of eighty small, enameled signs that have been mounted at a height of three meters on lampposts around the neighborhood, facing passersby. The signs have the same dimensions and location as conventional municipal signs and advertisements. On one side there is a typographic citation of a legal ordinance regarding the Jews and the date the ordinance was issued, on the reverse side a brightly painted, almost cartoonlike picture thematically related to the cited ordinance. For instance, one may come across a bright image of a thermometer and then read on the reverse side: "Henceforward Jewish doctors are not allowed to practice. 25.7.1938"; or an image of a loaf of bread, and on the reverse: "Jews are allowed to go grocery shopping in Berlin only in the afternoon between four and five o'clock. 4.7.1940" [Figures 22a and 22b]. One of the earliest citations reads: "All Jewish employees are dismissed from the civil service. 7.4.1933" with a picture of a rubber stamp [Figures 23a and 23b], and the last: "Documents, which relate to anti-Jewish activities, are to be destroyed. 16.2.1945" with a picture of the filing folders still used in offices today [Figures 24a and 24b]. These last two signs are mounted virtually in the shadow of the Schöneberg City Hall, while the law prescribing shopping times is mounted in front of a supermarket. There thus arises a complex

Figures 22a–22b. Places of Remembering, Berlin. Author's photographs.

Figures 23a–23b. Places of Remembering, Berlin. Author's photographs.

Figures 24a–24b. Places of Remembering, Berlin. Author's photographs.

interaction among text, image, location, and everyday practice to which I'll return presently.

The relationship between colorful icon and bureaucratic text is the first refraction; in many instances the relationship is further broken, often through irony. Thus the icon of a "welcome home" mat (*herzlich willkommen*) accompanies the text quoting an ordinance issued on the eve of the Berlin Olympic Games: "In order to avoid making a poor impression on foreign visitors, signs with extreme contents should be removed; signs such as 'Jews are not welcome here' [*Juden sind hier unerwünscht*] will suffice. 29.1.1936"; the cited ordinance forbidding Jews to be members of singing groups is accompanied by an image of the notes to the hymn "Whomever God wants to show true favor He sends into the wide world" (*Wem Gott will rechte Gunst erweisen, den schickt er in die weite Welt*); the image from the film *Der Berg ruft* is matched to the ordinance: "German film is recognized as one that is made in Germany by German citizens of German descent. 28.6.1933" [Figures 25a and 25b]. Although the vast majority of signs cite such ordinances, a few quote reminiscences and reports. For example: "'Well the time has come, tomorrow I must

Figures 25a–25b. Places of Remembering, Berlin. Author's photographs.

leave and that of course hits me hard; . . . I will write you . . . '—
Before the deportation, 16.1.1942" [reverse image: unaddressed enve-
lope] stands before a post office [Figures 26a and 26b]. Two signs
along a street of apartment buildings create a small narrative:

> Jews are not allowed to have house pets anymore. 15.5.1942
> [reverse image: a sitting cat]

> "We had a parakeet. When we received the decree stating that
> Jews were forbidden to have house pets, my husband just couldn't
> part with the animal. . . . Perhaps someone denounced him, for
> one day my husband received a subpoena to appear before the
> Gestapo. . . . After many fearful weeks I received a postcard from
> the police, stating that upon payment of a fee of three *Reichsmarks* I
> could pick up the urn containing my husband."—Report from 1943.
> [reverse image: empty birdcage]

In several ways this memorial disintegrates the traditional aesthetic
category of the unique and unified artwork. Firstly, of course, by
its location outside of any institutionally defined aesthetic space, its
decentralized dispersal within the material public sphere of anony-
mous information and command. Secondly, in several dimensions
the memorial ruptures the "representational bond"[86]—the assumed

Figures 26a–26b. Places of Remembering, Berlin. Author's photographs.

affirmation between image or text (the former by resemblance, the latter by appellation) and referent by which an artwork creates a unified aesthetic difference; this rupture, however, does not content itself with merely thematizing the disjunction.[87] At the level of image the colorful icon, often suggesting a child's pictorial vocabulary, breaks the code of realistic resemblance to its referent; at the level of script, the text—which does not denote or name but *cites*—breaks the code of realistic designation. At the level of representation the signs function virtually like a rebus: the bright icon evokes sheltered domesticity, the congenial workplace, familiar quotidian objects, the assurances of family and solidarity that the legal ordinances destroyed. Finally, at the level of utterance or mode, image, citation, and location very often comment ironically on one another.

Most importantly, however, in their mode of signification and seriality the signs—being all similar to each other without resembling any original, that is, "artworks in the age of their technological reproducibility"—no longer belong to the systemic order of representational or narrative resemblance/nonresemblance as do the dialectically related Holocaust memorials discussed earlier. The systemic order to which the signs belong is another: their authority, presence, production, and

reception are not correlative with their proximity to or representation
of an original, but rather lie in the communicational structures upon
which they are parasitic. The signs merge into the quotidian life-world of
the street because in their format and imagery, their *homomorphy*, they
mimic conventional signs. This mimicry can firstly be interpreted as a
survival strategy, in effect: by assuming the contact and codes of adver-
tisements and municipal street signs, they merge into the quotidian life-
world of the city and cannot be isolated into an autonomous memorial
or ritual that can be as easily isolated as forgotten. Indeed, the signs hap-
pened to be put up in June 1993, just a week after the fatal arson attack
in Solingen, in which five Turkish women and children were killed. Citi-
zens from the neighborhood complained to the police that neo-Nazis
were getting "cheekier and cheekier," and representatives of Jewish orga-
nizations who had approved the project wondered whether the danger of
misinterpretation was too great. It was thus decided to affix small "meta-
signs" to the signs, explaining that they are part of a memorial:

<div align="center">

Memorial
Places of Remembering in the Bavarian Quarter
Marginalization and Deprivation of Rights, Expulsion, Deporta-
tion and Murder of Berlin Jews in the years 1933–1945

</div>

But secondly, following Roger Caillois's observations on mimicry as
sympathetic magic, we can consider the signs to be "a disturbance in
the perception of space."[88] That is, the signs, to the extent that they
mimete the anonymous discursive authority possessed by authentic
municipal ordinances, also assimilate that authority and mode of
address in a gestalt switch (Wittgenstein speaks of an "aspect change")
that hovers between *use* and *mention*: in that momentary affective
disorientation, perhaps what Benjamin might accept as a "moment
of danger" in which a historical subject seizes hold of a memory, the
addressee becomes interpellated into the coordinate system of author-
ity and law which increasingly structured and eclipsed the permis-
sible life of Jewish citizens during those years, in which they were,
to speak with Paul Celan, "*auseinandergeschrieben*," "written asun-
der."[89] Each person is addressed as a *legal* (rather than cultural, eth-
nic, personal, and so on) subject of a *Rechtsstaat* precisely as the con-
tent of the sign documents the abrogation of that legal status in the
advent of a *Gewaltherrschaft*. The homomorphy in contact, code, and
implied addressee between past ordinance and present-day memorial
brings the specific cultural-political form of the period to material

expression and possibly conscious reflection. That is, just as Benjamin demonstrated how in the Baroque the artistic form of allegory, irrespective of its particular contents, expressed the age's obsession with transitoriness (*Vergänglichkeit*),[90] so too this memorial brings to expression the political-communicational form specific to National Socialism—and perhaps more generally the implicit political sovereignty that structures urban everyday life in mass society.

Here one can perhaps claim a *tertium datur* between the alternatives Benjamin postulates in the polarity of ritual versus politics: the nineteenth-century individual viewer's attentive, even reverential contemplation of the unique and sequestered artwork versus the twentieth-century mass audience's collective absorption of the reproduced and public artwork in the mode of distraction (*Zerstreuung*), film being the premier example.[91] Clearly the memorial's signs are parasitic on the rituals that structure everyday public life around the quarter—commuting, shopping, and so forth—and are thus registered, taken in, used, one might say, in the mode of distraction; however, the shock produced by the signs, once they are in fact perceived, transforms the habitual user into a reflective viewer. Whereas Benjamin sees a revolutionary (communist) potential in the mass audience's self-correcting response to film, these signs recuperate the potentially liberal-democratic individual by inducing a critical, political awareness of the habitually used and thus largely invisible structures and institutions that make possible—and conversely, that may make impossible—everyday life in a modern society.

The Bavarian Quarter memorial thus undercuts the opposition between cultic ritual and progressive politics central to Benjamin's argument and underlying Pierre Nora's observations. Nora takes deritualization to be a characteristic of modernity because, I suspect, for him ritual is linked to a historically specific notion of the temporally and spatially sacrosanct, similar to both Benjamin's characterization of nineteenth-century aesthetic experience and to the experience war memorials like the incarnations of the Neue Wache incorporate into nationalist narratives. By contrast, the Bavarian Quarter memorial locates remembrance in the habitual rituals inherent in secularized capitalist public life, as practiced by the citizen as consumer and commuter. The signs' site and situational specificity creates a *stereoscopic* effect in which today's institutions and practices are momentarily *experienced* from the perspective of their past misuse during the Third Reich, when antidemocratic political goals where pursued

Figures 27a–27b. Places of Remembering, Berlin. Author's photographs.

under the cloak of legality, as Otto Kirchheimer among others has documented.[92] A sign citing "Jewish lawyers and notaries in future may not engage in legal matters of the city of Berlin. 18.3.1933," mounted in front of the municipal courthouse, or "The baptism of Jews and the conversion to Christianity have no significance for the race question. 4.10.1936" placed before a Protestant church [Figures 27a and 27b] render these institutions, to again speak with Benjamin, monads laden with their own history.[93] And sometimes it is a history constituted by the traces of its very effacement. "Streets that bear the names of Jews, are renamed. Haberland Street, named after the founder of the Bavarian Quarter, is renamed as Treutlinger Street and Nördlinger Street. 27.7.1938" stands today at the intersection of *two* street signs marked "Haberland Street" [Figures 28a and 28b]. If everyday urban, public life is composed of secularized rituals against the background of legal order, one could perhaps call this memorial the bad faith of bureaucratic rationality.

We might characterize the experience of this memorial, which the artist Stih says is a "making visible of states of affairs,"[94] as a making legible of the implicit political sovereignty that structures the

Figures 28a–28b. Places of Remembering, Berlin. Author's photographs.

everyday life, the "second nature" of mass society; the memorial pre-
serves the history of that sovereignty for remembrance by withhold-
ing the closure afforded by figurative conciliation or transcendent
sublimity. According to Benjamin, the cognition of dialectical images
requires the perception or registering of what he calls "non-sensible
similarities" (*unsinnliche Ähnlichkeiten*).[95] Michael Rosen has sug-
gested that this concept of "non-sensible similarities" be understood
as the "tacit knowledge" by which the members of a specific society
manifest "common structures" in a variety of contexts and exhibit a
"shared, pre-discursive level of collective experience": "Despite not
being able to express that knowledge in explicit or theoretical terms,
the members of a culture share the capacity to 'map' one area of their
experience into another one in such a way that they can recognize
(though not articulate) its appropriateness."[96]

The concept of tacit, or implicit, knowledge, derives from Gilbert
Ryle's distinction between two types of knowledge: explicit "know-
ing that" (as in knowledge that can be expressed in propositions);
and implicit "knowing how," practical abilities or competences such
as the ability to drive a car, or to recognize and understand novel

sentences in one's native language.[97] Within this latter category we can distinguish a *weak* and a *strong* theory of tacit knowledge. The strong theory claims that at least some types of tacit knowledge in principle cannot be rendered explicit, cannot be expressed in propositional statements; the weak theory claims that in principle all tacit knowledge could be rendered explicit. Rosen seems to straddle this distinction in that he holds that on the one hand the tacit knowledge might not be liable to explicit formulation, while on the other hand its appropriateness can be "recognized." We can bring the issue into sharper focus with the aid of a contrast drawn by Gareth Evans. Imagine a rat that, because of repeated past experiences, has developed the *disposition* to avoid a certain food, and imagine a human being who has the *belief* that a certain food is poisonous. Both rat and human will exhibit the disposition of avoiding the food in question. The disposition developed might be quite sophisticated, responsive to variable stimuli (appearance, taste, smell, texture of the food, say, or situations likely to involve that food, and so on), yet the rat's "belief" is manifested in only one way—by its not eating the food. By contrast, the human might manifest the same belief in a potentially endless variety of ways: preventing a friend from eating the food, offering it to an enemy, trying to dilute its toxicity or acquire an immunity by ingesting it in small amounts, and so on. Evans concludes:

> It is of the essence of a belief state that it be at the service of many distinct projects, and that its influence on any project be mediated by other beliefs. The rat simply has a disposition to avoid a certain food; the state underlying this disposition is not part of a system which would generate widely varying behaviour in a wide variety of situations according to the different projects and further "beliefs" it may possess.[98]

That is, genuine belief states are inferentially connected to other belief states, such that one belief presupposes, entails, is contradicted by, other beliefs. Now, in the same article Evans argues for a purely dispositional understanding of semantic tacit knowledge—the knowledge of the syntactic and semantic rules of one's language such that one can produce and understand novel sentences in that language—because such information is "inferentially insulated" from genuine belief states. So on this view semantic tacit knowledge would be a species of the strong theory of tacit knowledge: in fact, if knowledge is some sufficiently sophisticated version of justified true belief, semantic tacit knowledge is not knowledge at all, in this robust sense. This

view of semantic knowledge seems to accord with Rosen's own under-standing of tacit knowledge: it cannot be rendered explicit, but its appropriateness can be, say dispositionally, recognized, as when we register someone making a grammatical blunder.

Such an adherence to the strong theory of tacit knowledge, how-ever, entails that the extent of historical consciousness or understand-ing produced by the shock of recognizing the inappropriateness of the street sign is necessarily restricted to that kind of dispositional reac-tion. I would suggest, therefore, that the shock of recognition must be seen as a possible trigger for further reflection, not upon semantic knowledge (the signs, after all, are written in impeccable German) but upon a pragmatic situation and its underlying political struc-ture: the viewer, in unconsciously, dispositionally taking in the street sign, belatedly registers the political and communicational structure by which he is interpellated, and that can elicit reflection—the con-sideration of one's beliefs and their inferential relations—about the nature of institutions, their function, use and abuse, and so on. Thus the memorial works precisely because the pragmatic situations within which the signs are placed and work rely on the weaker form of tacit knowledge: the implicit know-how of gaining one's practical orienta-tion on a city street, which can be rendered into explicit beliefs.

Therefore the juxtaposition between then and now of sign, site, and above all practical situation perhaps provokes explicit aware-ness of the tacit knowledge by which citizens in Nazi Germany were addressed by, operated within, and were removed from the politi-cal structures organizing their quotidian lives.[99] This suggests that a successful memorial does not recount a grand historical narrative or offer a figure of closure to a contemplative viewer but rather places the addressee within a practical situation that can produce a recogni-tion of the history embedded within the material structures and insti-tutions by means of the nonsensible similarity between their past and present incarnations.

Finally, there is no possible confusion with the military tradition of conventional monuments and memorials, for this is emphatically a *civil memorial*, designed to induce the historical experience of a civil catastrophe by citing its material annunciation. The signs achieve their effect through their aesthetic askesis: in their form and decen-tered location they cite the *contact*—the physical channel of com-munication—and the *contextual content*—everyday life around the district—that was as operative then as now, and in their *code*—their

language—they cite the juridical and municipal authority that also was as operative then as now. And each citation is a visitation, a haunting of today's juridical, municipal, and private institutions by their former incarnation. If the present form of the Neue Wache seeks to entomb history—including the history of its own previous incarnations—within a maternal figure of mythic sacrifice and redemption, that is, aesthetic semblance as myth (historical oblivion), the Schöneberg memorial shows that institutions and discourses have ghosts. To invoke Kracauer, for Germany, now, that is not much, but perhaps that is precisely enough.

6. CODA

It has been remarked in the debates about memorials that any permanent memorial eventually becomes, as Musil noted, invisible, and the Bavarian Quarter street signs are no exception.[100] At the conclusion of his reflections on coming to terms with the Nazi past Adorno entertained a sobering thought:

> If people are reminded of the simplest things: that open or disguised fascist revivals will cause war, suffering and privation under a coercive system . . . in short, that they lead to a politics of catastrophe, then this will impress people more deeply than invoking ideals or even the suffering of others. . . . Despite all the psychological repression, Stalingrad and the night bombings are not so forgotten that everyone cannot be made to understand the connection between the revival of a politics that led to them and the prospect of a third Punic war.[101]

Since reunification, construction and the modernization of the municipal infrastructure in Berlin, especially in former East Berlin, has been proceeding at breakneck pace. As they reopened foundations and streets, construction workers on the average were finding one undetonated bomb a week. The US government eventually provided Berlin with aerial bombing maps from the Second World War to aid in locating undetonated armaments. Each time a bomb is located, construction sites are blocked off, traffic is rerouted, whole apartment buildings are cleared, and the vintage ordnance is defused or exploded in controlled detonations. The past continues to send its own material memorials to posterity.

The Aesthetics of Historical Quotation

On Heimrad Bäcker's "System nachschrift"

The events surrounding the historian, and in which he himself takes part, will underlie his presentation in the form of a text written in invisible ink. The history which he lays before the reader comprises, as it were, the citations occurring in this text, and it is only these citations that occur in a manner legible to all. To write history means to *cite* history. It belongs to the concept of citation, however, that the historical object in each case is torn from its context.

—WALTER BENJAMIN[1]

Artworks are a priori negative by the law of their objectivation: They kill what they objectify by tearing it away from the immediacy of its life.

—THEODOR W. ADORNO[2]

The editor and poet Heimrad Bäcker (1925–2003) earned his early fame and literary reputation as one of the most active adherents of the avant-garde tradition in Austria, as founded by the Vienna Group of writers.[3] In the 1950s and 1960s they created individual and collective works using the experimental techniques of concrete and visual poetry, in which all facets of typography (typeface, line layout, pagination, and so on) contribute to the experience of the poem and carry semantic value; these works were intended as a specifically artistic form of political critique, with the aim of disrupting the postwar Austrian ideology of self-complacency. Bäcker published his own concrete poems and texts, edited the Austrian literary journal *neue texte,* and was codirector, with his wife, of the publishing house "edition neue texte," which published works by the original Vienna Group members, like-minded writers including Friederike Mayröcker and Ernst Jandl, and younger artists developing the avant-garde tradition in Austria.

However, in 1986 Bäcker published the volume *nachschrift*, where the German *"Nachschrift"* may be translated as "transcript" or "postscript," announcing that it and subsequent publications would fall under what he called the "system *nachschrift*": a system that can be broadly characterized as the montage presentation of quotations from documents relating to the planning, execution, and consequences of the Holocaust. For instance, a page from *nachschrift* might reproduce: a list of abbreviations of concentration camp names as used in Nazi written communications; a list of reported daily death tolls of a camp; an excerpt from an official document composed of the abstract, bureaucratic, euphemistic, and reified argot used by the Nazi administrators to refer to the extermination ("liquidation," "processing," "special treatment," even "enhanced interrogation" [*verschärfte vernehmungen*]),[4] or excerpts from a defendant's testimony during a postwar trial avowing ignorance. Thus the texts composing Bäcker's "system *nachschrift*"—*nachschrift* and the subsequent *nachschrift* 2 and *EPITAPH*—are composed entirely of reproductions of documents and less often of visual material (for example, photographs of video stills, photocopies of handwriting, photocopies of actual National Socialist bureaucratic forms, and so on).[5]

In these texts, however, Bäcker also makes clear that a different kind of reproduction or repetition is taking place: a *self-citation* of his earlier teenage self and member of the Hitler Youth. In a short autobiographical text he wrote: "At 16, I was an intern at the Linz *Tages-Post* (local news division). When it became clear that the paper would be closed (in 1943), I quit and joined the Press and Photography Office of the Hitler Youth's regional office. I had been active in the Hitler Youth since 1938; last rank: squad leader [*Gefolgschaftsführer*]. At 18 I became a member of the Party. No position in the Party. No activities in which other people would have been hurt."[6] At the conclusion of *EPITAPH* he writes, quoting the title of his adolescent book review of a glowing biography of Hitler:

> EPITAPH is a step in the process of the sublation [*Aufhebung*] of sentences that the author wrote on 27.5.1942 in the Linz *Tages-Post*: "*Wir haben den Führer gesehen! [We saw the Führer!*]. This book is a mirror of what can never be expressed with the written word, that can only be experienced by gazing upon these pictures: a part of the person Adolf Hitler!" The sublation—"negation of negation" (Jean Améry)—which may appear subjectively as a sublation of the position of a seventeen-year old, cannot be ended with a publication, but rather only with the existence of the author.[7]

The concept of "sublation"—Hegel's term for the "movement of the concept," meaning at once cancellation, preservation, and transformation—that Bäcker invokes to describe his method in the "system *nachschrift*" suggests a complex and possibly paradoxical relationship *at least* between preservation (perhaps of the historic past) and transformation (perhaps through its aesthetic presentation) lying at the heart of his project.

Both Bäcker and his critics have sought to understand his project in terms of "documentary literature" (*Dokumentarliteratur*) or "documentary poetry" (*dokumentarische Dichtung*), the latter term the title of an important methodological essay by Bäcker. For instance, Sigrid Weigel describes "Heimrad Bäcker's literature as *absolute documentation*,"[8] and Thomas Eder writes, "In Bäcker's *nachschrift* documentary literature and concrete poetry enter into an association that saves the former from aesthetic triviality and the latter from political irrelevance and ignorance."[9] In so doing these critics and others locate an implicit tension inhabiting artistic presentations of the Holocaust.[10] Such works, it is supposed, should maintain at least two relations that potentially conflict: a *historical relation*, in that the work should relate to historical events *accurately* and *truthfully*, and an *aesthetic relation*, in that the work should relate to the representation of those historical events *aesthetically*, that is, that there should be artistic considerations underlying the representation of historical information. It is supposed, further, that a work fails if it fails one or both of these relations. If it ignores or "beautifies" or mythologizes (say, through symbolization) the historical events, it fails the historical relation and becomes *merely an artwork*.[11] If it eschews all artistic considerations of representation then it fails its aesthetic relation and becomes *merely a document*.

I shall argue here that Bäcker's *nachschrift, nachschrift 2,* and *EPITAPH* successfully negotiate these potentially contrary desiderata; that is, his texts successfully maintain both the historical relation (considerations of historical accuracy and veracity) and the aesthetic relation (considerations of artistic presentation and reception). My justification of this claim rests largely on an examination of the philosophy of quotation and how quotation functions in Bäcker's texts. A certain kind of quotation, we shall see, may constitute the limit-case of the aesthetic relation in presenting historical quotations. If we recall the inverse relationship between the historical and aesthetic tendencies conjectured in the Introduction, this kind of quotation

represents a vanishingly small value for the aesthetic, thus the artwork in this case occupies a limit-value at one extreme. However, I shall argue that this limit-value of the aesthetic nonetheless fulfills the aesthetic desideratum, and thus the artwork is successful. To make this argument, I shall first discuss the syntax and semantics of quotation (§1) before presenting aspects of the theory of open quotation, based on work by François Recanati (§2), and suggesting that Bäcker's texts exhibit such open quotation. I will then turn to several methodological essays by Bäcker on his "system *nachschrift*" and interpret his method in light of the theory of open quotation (§3), before considering the specific aesthetic experience Bäcker's texts might elicit in readers (§4). Lastly, I shall explore some consequences of this understanding of Bäcker's texts in particular, and of quotation in general (§5).

1. PHILOSOPHY OF QUOTATION

How do we identify quotation? The answer most ready to hand is *syntactical*: whatever appears between single apostrophes (in Britain), double apostrophes (in the United States), or double angles (in parts of Europe), and so on, is the *quoted material*, which together with the *quotation marks* constitute an instance of *quotation*. There are at least two difficulties with this syntactic criterion. First, we can quote something when speaking, and while sometimes correlates of the graphic marks are used—for instance, a speaker may explicitly say "quote . . . unquote" or toggle the air with her fingers to mime quotation marks—they are not necessary to communicate the fact that an utterance or part of an utterance is being quoted. Suppose you're at a party and a stranger introduces herself to you with the words

 (1) Hello. My name is Melissa.

Properly this should be represented as

 (2) Hello. My name is "Melissa."

(Compare: "The name of the ship is 'Queen Elizabeth.'" or "The title of the play is 'Hamlet.'").[12] Second, there are many other conventions for indicating quotation besides the syntactic markers already indicated: tone of voice, italicization, bold face, paragraph indentation, line spacing, and so on. Thus quotation *can* occur with no syntactical marks at all and *can* be indicated by a diverse array of syntactic, semantic, and pragmatic indicators.

In fact *no* syntactic markers are used to indicate that the texts in Bäcker's system are quotations. There are, arguably, no syntactic markers of quotation in the works.[13] It is only the apparatus, which provides the sources for the texts, and the afterword by the editor, that indicate that the texts are quotations. From this it follows, I think, that it is at least conceivable that one could read *nachschrift*, say, in its entirety, until the afterword, as not being composed of quotations. If it is only the frame that indicates that the book's contents are quotations, what does this mean for the nature of quotation itself? For instance, it is a veritable commonplace of semantic theory these days that such a theory must maintain the legitimacy of the principle of compositionality: that any grammatically correct sentence can be constructed by recursively applying syntactic formation rules on a finite vocabulary.[14] Since our language has a finite vocabulary, as provided in a dictionary, it's clear that any word we utter is in some sense a quotation of that word's previous usage, regardless of how we're using the word when we utter it. If the marker indicating quotation can be as attenuated as some later framing device or commentary—as in Bäcker—then quotation is always a structural possibility of any utterance.[15]

If the *syntactic* indication of quotation is incomplete or—at least sometimes—absent, perhaps a *semantic* indication will fare better. Here the common line of reasoning is that when we quote a bit of language we are in a certain sense referring to the language itself, and not what it means or stands for. For instance, in the example (2) above, the speaker is drawing attention to the word "Melissa," not to the referent of the word "Melissa." Or compare

(3) "Melissa" has seven letters.

Clearly a predication is being made of a linguistic expression, not the person bearing the name "Melissa." So some theorists claim that quotation is a kind of *mentioning* of a bit of language (as in [3] above), in contrast to nonquotation, wherein we *use* the bit of language (say, to refer to the person named "Melissa" as in: "Let me introduce you to Melissa."). But here the problem is that the apparent distinction between use and mention is not so clear upon reflection. Isn't "Melissa" in (3) in some sense being *used* to refer to itself? Or consider

(4) Quine said that quotation " . . . has a certain anomalous feature."

Clearly the quotation here is syntactically part of the whole sentence, and contributes essentially to the meaning of the sentence. So it is being *also* used, and *not merely* mentioned. By contrast, consider

(5) Quine said, "Quotation has a certain anomalous feature."

(6) Quine said, "Quotidian has ah surtan innocuous feet, sure." (Say, as he fell asleep, working on his manuscript.)

In both (5) and (6), the quoted material is *semantically inert*: *whatever* is being quoted makes no contribution to the syntactic or semantic value of the whole sentence, as illustrated by the fact that in (6) the quoted material is syntactically and semantically deficient (indeed, consider: "Abel wrote: '&##&^$^@.'") and yet does not alter the syntactic well-formedness and semantic value (truth-conditional meaning) of the overall sentence. So we need to be careful about the use/mention distinction in general, and specifically here it cannot be used as a semantic criterion for identifying quotation, since at least some quoted material can be both used and mentioned.[16]

What about Bäcker's texts? Are they being mentioned (quoted) merely, or also used? To the extent that they describe facts about the Holocaust, or are expressions of attitudes of people, these texts are being used, not merely mentioned. But just as clearly the factual statements and the attitude expressions are not attributable to Bäcker himself. So to that extent they are being mentioned by him. So here too it seems that we cannot invoke the use/mention distinction in order to define quotation, for certain cases of quotation, as in (4) above and arguably in Bäcker's texts, the quoted material is being both mentioned and used.[17]

Recent work by François Recanati and others proves helpful in understanding Bäcker's use of quotation in his texts. Recanati distinguishes three different kinds of quotation, broadly conceived. *Closed* quotation occurs when the quotation (that is, quotation marks, if any, and the enclosed quoted material) "acquires the grammatical function of a singular term within a sentence in which it fills a slot. When that is the case, the quotation transformed into a singular term acquires a referential value"; hence "only closed quotations refer."[18] *Open* quotation is quotation that is not closed. To illustrate these two quotation types, consider a teacher instructing her pupils:

(7) "*Guten Tag.*" That is how one translates "Good afternoon" in German.[19]

Example (7) is comprised of two sentences, and contains *two* instances of quotation. The teacher first quotes the German phrase "*Guten Tag*"; then she quotes its English counterpart, "Good afternoon." But this second quotation is linguistically incorporated and fills a slot in the sentence "That is how one translates _____ in German"; it plays the role of a singular term. Therefore in the second sentence of (7), the quotation "Good afternoon" is *closed*, and the first quotation—"*Guten Tag*"—is *open*: a token of that sentence is mentioned, but it is not used as a singular term and is not incorporated into a larger syntactic or semantic unit such as a sentence. The third type of quotation is *mixed*, where the quoted material functions grammatically and semantically within the overall sentence, but does so not as a singular term. An example of this kind of quotation is our earlier example (4) above. Although mixed quotation exhibits several puzzles for an overall theory of quotation, it plays no role in our considerations, and I provide it here merely for the sake of completeness.[20]

Now in general it seems we can say that Bäcker's texts are *open quotations without quotation marks*. More intuitively, we can say that they are quotations that are *as decontextualized as possible* from their status (they are not marked as quotations) and their source (information regarding who or what is being quoted is provided only in the appendix, not in the immediate context of the quotation itself) and their semantic value (they are not incorporated into a larger semantic unit, such as a sentence, within which they function grammatically and semantically; if they did, they would be either *closed* or *mixed* quotations). The fundamental characteristic of closed quotation (the story for mixed quotation is more complicated) is that the quoted material is *semantically inert*, as we saw in (5) and (6) above: in the larger sentence "Quine said _____" anything, even meaningless, agrammatical marks, can be inserted while the sentence as a whole will remain syntactically well-formed, grammatical, and meaningful. The quoted material makes no contribution to the semantic value of the larger sentence. But in open quotation the words not only are displayed but also carry their normal meanings. In (7) "*Guten Tag*" obviously keeps its normal meaning. What distinguishes, then, open quotation from normal, nonquotational use of the same expression? "The difference with an ordinary use of that sentence is simply that the quoter engages in a form of play-acting: the quoter simulates the person whose speech he is reporting, much as an actor simulates the character whose part he is playing"; as a result, in cases of open

quotation the quoted material is "semantically active."[21] In being maximally liberated from recontextualization (for example, functioning as a singular term within the mentioning sentence), the quoted material is displayed through "play-acting" and "simulation"—traditionally *aesthetic* concepts. At the same time, the quoted material remains "semantically active"; that is, both intensionally (the linguistic meaning of the quoted material) and extensionally (for example, its reference, truth-conditions, and so on)—thus such quoted *historical* material retains its relation to that history—the facts, states of affairs, people, places to which it refers. To make these claims more precise and persuasive, we need first to consider in greater detail how meaning in open quotation works and then explore how it works in specific texts by Bäcker.

2. OPEN QUOTATION AS AESTHETIC PRESENTATION

According to Recanati's terminology, when a linguistic expression is quoted, a token of that expression type is *displayed*:

> To be sure, whenever one says something, one produces (tokens of) words, with the intention that the audience perceive them. Yet one does not normally intend the addressee to pay conscious attention to the words one utters. In linguistic communication, the words are automatically processed, and audience attention is drawn to what one says rather than to the means by which one says it. When words are mentioned, however, the *medium* itself is brought to the forefront of attention: the words are displayed, exhibited.[22]

It is not difficult to consider this idea of the display or presentation of (quoted) material in aesthetic terms: it seems a clear example of what theorists call *aesthetic distanciation* and is also Jakobson's very definition of the "poetic" (literary) function of language.[23]

Moreover, when an expression is quoted, one or more properties that the token instantiates is thereby *demonstrated*. A *token* is a singular instance of a general *type*. For instance, when (presumably) Bäcker writes "*der schreiber schreibt*" (the writer writes) multiple times (*transcript*: 119*), he is writing multiple tokens of the same three expression-types (words) or multiple tokens of the same one expression-type (sentence) or even multiple tokens of the same expression-type ("sch"), and so on.[24] The token is displayed by the quotation, but moreover, some property (or more) that the token instantiates is thereby *demonstrated* (ostended, exemplified) by the display of

the token; as Davidson observes, quotation marks "help to refer to a shape by pointing out something that has it."[25]

Recanati argues that there are three entities involved in quotation: the displayed token, the properties of the displayed token to which the quoter intends to draw the audience's attention via demonstration, and the target, that is, the thing the quoter attempts to depict through the demonstration. For example in (5) a token of the sentence "Quotation has a certain anomalous feature" is displayed. It is intended to depict (simulate, mimic, and so on) the target of the quotation: Quine's utterance. The depiction is effected through the properties shared by the displayed token and the target. The quoter therefore does three things at once: he *displays* a token, *demonstrates* certain properties of that token (a type), and thereby *depicts* the target (the original utterance).[26] Because "utterances say, pictures show,"[27] there are at least two levels of meaning operative in *any* quotation:

1. The *linguistic meaning* of the displayed token. The material which is displayed for demonstrative purposes has a certain linguistic meaning. The quoted material says something.

2. The *pictorial meaning* of the demonstration. Since the demonstration pictures something, it also has a meaning.

While *closed* meaning adds a third level of meaning, since in that case the demonstration is "linguistically recruited and assumes the role of a singular term" within the larger sentence, according to Recanati *open* quotation is limited to the two levels of meaning above.

What properties can be demonstrated by the display of a token? It turns out, virtually anything other than exclusively the extension of the token (which is what happens when the expression is merely used, rather than [also] mentioned via quotation).[28] The demonstratum can be purely semantic or linguistic properties (for example, word-types, sentence-types) or linguistic meaning (for example, the intension of a word, Kaplan's *character/content* relationship of an expression,[29] and so on), or the individual token itself (the shape or sound of the token, say), and so forth. There can be no exhaustive enumeration of the properties even potentially demonstrated by a specific quotation because the demonstratum may be determined by context. For instance, the quotation "cats" displays the token, but could thereby demonstrate: the word-type "cats," the concept *cat*, the sound-type /katz/, the grammatical concept *plural noun*, the orthographic concept *lower-case*, the concept

word-that-begins-and-ends-with-a-curved-letter, and so on.[30] "One realizes that the displayed token has those properties when one realizes that it is (intended) as a token of the relevant type. Identifying the demonstrated type is therefore like identifying the referent in an act of demonstrative reference: it is a full-fledged process of interpretation, possibly involving an assessment of the [quoter's] communicative intentions."[31] Such interpretation, Recanati suggests, may well involve conventional and conversational implicature: contextual conventions and quoter's intentions may well guide or constrain how the demonstrated type is arrived at and identified.[32] Unquoted words are used when they denote or "mean" their extension; quoted words are mentioned when they are not (only) used, which means that they indicate something other than their extension: their shape, sound, expression-token, expression-type, intensional meaning, concept, and so on. For example, page 33 of the English translation of *nachschrift* in its entirety reads:

> 2400
> 2600
> 4600
> 6600
> 9100
> number unknown
> number unknown
> 10600
> number unknown
> number unknown
> number unknown
> 12600
> 14600
> 16600
> 17600
> 21000
> 21400
> 26400
> 27030
> 29330
> 30530
> 32030
> 35079
> 36079
> 38749
> 39249
> 40449

In the appendix to the book, the note for this page reads in its entirety: "Rückerl, 155. Escalating numbers of those killed from 2 April to 1 June 1942 in Sobibor. The form of the cross is a direct result of the statistical arrangement."[33] The note provides the textual source for and the original context of the quoted matter, but it also comments on the symbolic shape serendipitously generated by the formatting, which suggests Bäcker's earlier work in concrete poetry.

An extreme example of this aspect of quotation in Bäcker is the agrammatical pastiche of clichés from Hitler's *Mein Kampf*:

erst wenn ein volkstum in allen seinen gliedern zu jenem hohen gefühl dereinst und zusammengeschmiedet unerschütterlich jede überschäumende kraft vom schicksal. denn die größten umwälzungen auf dieser erde fanatische leidenschaften zum heil der arischen menschheit dereinst das für die letzten und größten auf diesem erdball reife geschlecht ihre krönung hineinbrennt, auch in zukunft nicht nur im sinne der begrenzten auffassung sondern der schmerzlichsten erkenntnis unser blut doch zur niedersenkung bestimmt ist. wenn aus einem volke eine bestimmte summe höchster energie und tatkraft daß allein höheren menschentums überhaupt, aus dessen lichter stirne der göttliche funke und den menschen so den weg zum beherrschen, beginnen sich mit den unterjochten die letzte sichtbare spur des einstigen herrenvolkes im helleren hautton der brennstoff für die fakel des kulturfortschrittes! übrigens hat ihre letzte vollendung wie denn überhaupt die militärdienstzeit auch die menschenauslese an sich nicht durch das schrifttum sondern zahlloser größter und kleinster hetzapostel. man vergesse niemals daß alles wirklich große weltumwälzende revolutionen überhaupt und zu verwirklichen als titanenkämpfe durch den stahlharten willen darf als unerschütterlich des emporstieges eines volkskörpers durch das ersichtliche dominieren beziehungsweise sich aufheben. der durchschlagende erfolg als zur besetzung der nervenzentren des in frage kommenden staates in jeder wirklich großen weltumwälzenden nicht mehr fähig und angriffsweise auszuwerten. es ist deshalb sehr notwendig in ihren letzten folgeerscheinungen durch die allen sichtbare wiedererstehung zum stoß ins herz unseres verruchtesten gegners eine bündnismäßige stärkung für diese auseinandersetzung wirklich die weihe einer großen mission und wird ewig restlos seinem willen. (*nachschrift*: 92)

(only when a nation in all its members to that high sentiment someday forged together unshakable any exuberant force by fate for the greatest revolutionary changes on this earth fanatical passion to the benefit of aryan humanity some day a race ripe for the last and greatest the crown burn into in the future not only in the limited conception but with the painful realization our blood is nevertheless doomed to decline if in a people a certain amount of the highest

energy and active force that alone of all higher humanity from whose
bright forehead the divine spark and thus man the path of mastery
begin with the subjugated the last visible trace of the former master
people in the lighter skin color fuel for the torch of human progress!
for the rest its ultimate completion and in general the period of mili-
tary service human selection as such not by writings but countless
of the greatest and the smallest apostles of agitation it must never be
forgotten that nothing that is really great world-shaking revolutions
not even realizable except as the titanic struggles by the iron will may
as unshakable times when a nation is rising by the obvious domina-
tion or cancel one another the most striking success for occupying the
nerve centers of the state in question in every really world-shaking no
longer capable and aggressively utilizing. it is, therefore, most neces-
sary in their ultimate consequences through the resurrection visible to
all the thrust to the heart of our infamous enemy strengthening our-
selves by an alliance for this conflict really consecrated with a great
mission for our nation and will eternally serve his will completely.)
(*transcript*: 92)

Clearly this is a pastiche or collage of smaller quotations that are
combined in violation of some rules of syntax (phrases are in cor-
rect cases, but these are not well-formed sentences) and orthography
(all words are in lower case). The regular repetition of certain words
such as "*überhaupt*" lends a certain rhythmic quality to the collage as
well. Yet in terms of quotation theory, it seems that the quoted tokens
are meant to exemplify expression-types but also the general diction
and style (for example, Hitler's frequent use of "*unerschütterlich*,"
"unshakable"), so that at least two relations are operating: token-
to-type relation, and type-to-style relation. The former is a relation
of particular to universal, whereas the latter is a relation of part to
whole. Likewise some quotations of victims and witnesses reproduce
the languages or broken German of the target utterances:

mir viln nisht shtarbn!
(*transcript*: 30*)

TOT HET BITTERE EINDE (*transcript*: 36)

Der umkum fun bialystoker jidntum
Der umkum fun marzinkanzer jidn
Der umkum fun baranowitscher jidntum
Umkum fun die jidn in vilne
Der umkum fun a judish shtetl
(*nachschrift* 2: 30)

kaduk hat ihn toit gemacht
(*nachschrift* 2: 127)

dry oswiecim kcher sy baro | in auschwitz ist das haus groß
(*nachschrift* 2: 151*)

in di yorn fun der daytsher yidnoysrotung
2 *bde,*
(*nachschrift* 2: 233)

Presumably the idiomatic and orthographic properties of these tokens are likewise being demonstrated, and so here too the token-type and type-style relations are operative.[34] So the medium of quotation here exhibits a historical relation: the witnesses are reduced to expressing their testimonies in the language of the perpetrator.

By contrast the page of *nachschrift* immediately following the *Mein Kampf* montage displays a facsimile (photo-reproduction) of six words written in Hitler's hand (*transcript*: 92*). Facsimile is itself a quotation device,[35] but here what is being displayed or mentioned is not only, again, token-type and type-style relations, but moreover, a token-identity relation: the specific tokens of the word-types, as created by Hitler, are being displayed. So here the relation is *mimetic*: the quotation is a *picture* or *replica* of the quoted material, and the *pictorial meaning* accompanies the *linguistic meaning* (the six words are: "*Weltbrei*," "*Weltpresse*," "*Weltliteratur*," "*Weltboerse*," "*Weltkultur*," "*Weltsprache*," "*Juda*" ["world porridge," "world press," "world literature," "world stock-market," "world culture," "world language," "Jew"]). Several facsimiles (photocopies) of handwriting exhibit this kind of mimetic quotation (for instance *transcript*: 22–23*, 31* and 119*, *EPITAPH*: 8, 20, 27 [photograph of graffiti], 40, 43 [photograph of inscription], 45 [photograph of inscription]; *nachschrift* 2: 217). There are also passages that are mimetic copies of bureaucratic typescript (for example *transcript*: 52–53 and 112–13, *EPITAPH*: 49, *nachschrift* 2: 22, 65*, 92, 100, 134, 162, 181–83, 216), in which the very font and format of the document is photo-reproduced. These quotations are based on token-token identity (photocopy of handwriting or of a Nazi document); as such there are more properties demonstrated than in the previous quotations because there are more properties shared by the quotation and the target. Recanati defines the *mimicry* of a quotation as the existence of "a distal target which the quotation presents itself as echoing."[36] While all of the texts in the "system *nachschrift*" are mimetic in this sense, because they quote target utterances or inscriptions, those which display token-token identity relations constitute the extreme case of *mimetic quotation*.

3. BÄCKER'S POETICS OF QUOTATION

A careful consideration of Bäcker's own comments on the principles of composition of the "system *nachschrift*" reveals concerns regarding the aesthetic and historical relations similar to those raised at the outset of this chapter. And, like the critics mentioned at the outset, Bäcker understands his work to proceed *from* document *to* literature through certain transformative, linguistic procedures:

> There exist written testimonials [or evidence: *Schriftzeugnisse*] that set form free: of the letter, of the numeral, of phonetic articulation, of the sentence abbreviations, of the line length, of the order of the lines, of the addition signs, of the footnote a), b), c), of the superscript numeral 3, of the doubling of the same within a poster text set in German and Polish, of the increasing number of transport trains, of the decreasing number of those living, not yet killed, of the repetition signs, in each case one for each person killed, of the repeating statement of time of death for each life that has come to an end, of the points one to four, after which a judgment occurs,—an appendix of history.[37]

Bäcker attributes the transformative capacity to the documents themselves. Although he elsewhere uses the neutral term "*Dokument*" (document), here he writes "*Schriftzeugnisse*," which suggests "evidence" or "testimony" fixed in writing, or perhaps even an inscriptional witness (*Zeuge*). He claims that these testimonies themselves "set form free" (*die Form freigeben*), and enumerates *pictorial aspects* of the quoted materials—the tokens in all their materiality. Perhaps Bäcker is suggesting that it is the preponderance of properties that are demonstrated when a token is displayed by quotation which mimetically echoes the target utterance. That is, the richness and fullness of the *pictorial meaning*—the demonstrated properties—constitutes as it were the "form set free" of the quoted material, which lends an *aesthetic* relation to the *linguistic meaning* (the *historical* relation) of the tokens displayed. It is this transformative procedure, I suggest, that Bäcker calls a "progressive process of concretion":

> In the document I find: rudimentary concrete and concrete-visual texts, that can be deciphered in a progressive process of concretion [*Konkretion*]. A literary construct [*Gebilde*] can unfold out of the unintended effective rituals of order of a memorandum.
>
> . . .

> That which is said merely casually can become concretized. This I
> try to do, and therein I am a concrete author, who perceives the pos-
> sibility of concretion in the means of what has been recorded docu-
> mentarily. Sometimes this occurs in the method 1:1 (with identical
> [*deckungsgleich*] elements, document = text), sometimes through
> reduction, repetition, montage, serial means.[38]

It is absolutely crucial to note that Bäcker himself recognizes that
while concretion may involve manipulations of the language of the
document—"reduction, repetition, montage, serial means"—such
manipulations are *not* necessary: *open quotation alone is sufficient
to render a document aesthetic*, to transform a document into "docu-
mentary poetry" (*dokumentarische Dichtung*). Indeed, in an inter-
view he says:

> Through the new literary approaches of the Vienna Group and by
> Helmut Heißenbüttel [touchstones in the development of concrete
> poetry in the 1950s], I have found a possibility to bring this material
> into literature. Unfortunately concrete literature neglected to take up
> this stock of documents that already constitutes concrete forms that
> one needs merely to lift over [*herüberheben*]. In my texts there is a
> thingliness [*Dinglichkeit*], a clear conceptuality [*Begrifflichkeit*], and
> it doesn't depend on my ideas or imagination, nothing is spun as a
> story [*als Erzählung fortgesponnen*]. *My goal is where the document
> is identical with the text and where one succeeds in taking over the
> document identically* [*deckungsgleich*]. I consider the narrative form
> to be generally unsuited for comprehending the events adequately,
> whereas the methods of "nachschrift" are able to grasp the monu-
> mental horror of the event.[39]

And in the essay "Widerspiegelung" (Reflection) he defines "literature
as a possibility to nominate [*erklären*] even apparently nonliterary ele-
ments into literature," and we should understand the locution "*etwas
zu etwas erklären*" literally: to declare, name something as something
is precisely what open quotation does; it displays something (linguis-
tic material) and ostensively names it as something by demonstrating
certain of its properties.[40]

In other words, Bäcker understands the concretion of a document
precisely in terms of the two levels of meaning in open quotation
as expounded by Recanati: the *linguistic meaning* of the displayed
text, and the *pictorial meaning* of its demonstrated properties. In
his essay "konkrete dichtung" (concrete poetry) Bäcker writes of the
"concretization of the non-concrete, materialization of the de-mate-
rialized" (*konkretisierung des nicht konkreten, materialisation des*

entmaterialisierten) precisely in terms of the material properties that may be demonstrated in open quotation:

> the visual formulation of text . . . individual words or individual letters become signs that no longer function just semantically, but rather as a compact, encoded, decipherable unit of information. . . .
>
> the pages as a materialized surface are a moment of the realization of a text, like a canvas in painting. . . .
>
> what text is, is simultaneously spatial element, linguistic is simultaneously optical realization, semantic simultaneously aesthetic information. something is not beautifully written, rather is text as writing [*schrift*]. if one holds to this distinction, one will no longer misunderstand the new poetry—or this form of the new poetry. . . .
>
> . . . text and image are one, the aesthetic information does not inform additionally beyond the semantic [information], that is, a meaning-complex is not retrospectively aestheticized, but rather: a unified entity is sought and presented.[41]

Note that this understanding of "concretion" (*Konkretion*) as token-demonstration entails that photo-reproductions of handwriting, documents, graffiti, memorial inscriptions, reproductions of video stills, even arguably photo-reproductions of photographs, such as occur in Bäcker's *EPITAPH*, all qualify as (open) quotations in the sense that alongside their *linguistic meaning* (for example, what the graffiti "says," or what the video still "depicts") a *pictorial meaning* is produced by the demonstration of certain token-properties in the reproduction (for example, material properties of the graffiti-token itself, material properties of the photograph of the video still itself—for instance, the fuzzy screen, and so on). Thus Bäcker writes of quotation as "identical reproduction" (*deckungsgleiche Wiedergabe*): "I grasp the possibility of forming a concretion through the isolation of the series and its identical reproduction: concrete with regard to the isolated form, but concrete also in regard to the event of that night and its tremendum." I think we can understand Bäcker in the following way. The first sense of "*Konkretion*"—"isolated form"—names the displayed token as subject to demonstration, that is, the potential for *pictorial meaning*. The second sense of "*Konkretion*" applies to the historical event to which the quoted material refers ("the event of that night and its tremendum"), and this constitutes the *linguistic meaning* of the quotation. If this dual-aspect theory of quotation—as both displayed linguistic meaning and demonstrated pictorial meaning—is correct, then it explains perhaps how Bäcker can both maintain that "document" and "literature" are different, even

opposing, phenomena, and yet how in his "system *nachschrift*" they are identical:

> Literature of quotation as literature of identity with the non-literary reality (or its semblance), which itself is a collection, a monstrous mishmash [*Klitterung*] of quotations. The author operates on them, removing them out of the fluctuating somewhat reality, whereby when successful they lose nothing of their authenticity.
>
> If the document is ripped out of its isolation and forced into the isolation of a formal principle, it attains a new effectiveness. Identity of document and literature. Documents are literature that writes itself and is recognized as literature. Isolation, reduction, placement in space, sequence, lowercase printing make visible only what the document contains identically as description, report, statistic.[42]

4. THE PHENOMENOLOGY OF QUOTATION

So far I have presented in some detail a theory of open quotation and argued that Bäcker's practice of "system *nachschrift*" and his methodological reflections be understood in terms of open quotation. We can press this line of interpretation further, based on the dual-aspect nature of open quotation and the quality of pretense or simulation to which Recanati refers. At the very end of his essay "Dokumentarische Dichtung" (Documentary Poetry) Bäcker writes:

> 1. the speaking ones.
>
> 2. the speaking ones in the system *nachschrift*.
>
> The phenomenon constitutes its counter-phenomenon. Dialectic of pain and statistics.[43]

Recall that "the difference with an ordinary use of that sentence is simply that the quoter engages in a form of play-acting: the quoter simulates the person whose speech he is reporting, much as an actor simulates the character whose part he is playing"; as a result, in cases of open quotation the quoted material is "semantically active."[44] I take Bäcker's distinction between speakers (literally, "the speaking ones," which accentuates the participial, actualizing aspect) without qualification and speakers in the "system *nachschrift*" to be suggesting just such a doubling. Many passages in *nachschrift* and *nachschrift* 2 are quotations of first-personal utterances by victims and witnesses,[45] or by perpetrators,[46] or questions put to defendants on trial by prosecutors,[47] or quoted dialogue between prosecutor and defendant.[48] In being quoted they become, as it were, again speakers,

and in reading their words, the reader as it were grants them voice. As open quotations, the quoted material—the first-personal accounts— are "semantically active"; that is, the semantic values of the utterances are actualized: as truth-apt declarative sentences, as sincerity-apt attitude expressions, as felicity-apt speech acts, and so on. We can therefore understand quotation in Bäcker along the lines of the trope of *prosopopoeia*, one of whose definitions in the classical tradition is bestowing speech on the absent or the dead.[49] Paul de Man has suggested that an inversion in *voice* takes place in prosopopoeia: as we lend voice to the dead, our voices fall silent and we as it were imitate the dead: "The latent threat that inhabits prosopopeia [sic], namely that by making the death [sic] speak, the symmetrical structure of the trope implies, by the same token, that the living are struck dumb, frozen in their own death."[50] If we accept this reasoning, it would seem to follow that the inversion entails that the readers of *nachschrift*, in being rendered dumb, are forced to adopt the attitude of *aesthetic contemplation* toward the actualized quotations. This is thus another respect in which the historical relation (the actualized quoted material) and the aesthetic relation (the attitude of the audience toward that actualized utterance) inhabit Bäcker's "system *nachschrift*."

Arguably a similar inversion in *temporality* occurs: in play-acting, simulating, mimeting, echoing, reactualizing past utterances we are making them present again, and to that extent *our* present pauses in abeyance, in suspension. These speculations circle the epigraph of *nachschrift*, itself a quotation of a first-personal future-tense utterance: "Is it true, are we really going to die?" (*Ist es wahr, gehen wir wirklich in den Tod?*).[51] The target utterance itself, in its time, is a genuine question posed by, perhaps also to, certainly about and for, those "speaking ones" soon to be murdered. In being quoted, now, the quoted utterance cannot but be taken as a painfully rhetorical question. But in being quoted, now, the utterance is again "semantically active," and is again a genuine future-tense question posed by, and perhaps also to, certainly about and for, those "speaking ones in the system *nachschrift*"—but "we" includes those quoting, and those about to read the quotes, about to actualize the utterances anew. In quoting "the speaking ones," in having them speak through us, we join them in death. If there is a literary analogue to a resurrection of the dead, it is the quotation ritual practiced in "system *nachschrift*." Thus the epigraph to *nachschrift* 2: "it may be that they will not kill

us, and will allow us to live" (*es kann sein, daß man uns nicht töten wird, und uns erlauben wird, zu leben*).

This phenomenon is nowhere more *unheimlich* and *unzeitgemäß* than in two quoted passages from final letters written by captured and condemned resistance fighters to their loved ones:

> meine leiche befindet sich diesseits der schule beim straßenwärter-haus, wo albegno ist, diesseits der brücke. ihr könnt sofort mich holen kommen. (*nachschrift*: 114)
>
> (you will find my body before you get to the school, it's by the street watchman's house, where albegno is, before the bridge. you can come and pick me up right away.) (*transcript*: 114)
>
> dies ist mein letzter brief, und ich lasse dich wissen, daß ich am 1. September ums sechs uhr erschossen worden bin. (*nachschrift*: 115)
>
> (this is my last letter, and i'm letting you know that i was shot on September 1st at six o'clock.) (*transcript*: 115)

Both passages constitute impossible situations, from the standpoint of intensional semantic theory.[52] According to this theory, the referent of a tokened indexical (such as "here," "now," "I," possessive pronouns and demonstratives) is determined by a specific function (called a *character*) from context to *content* (linguistic meaning), which in turn determines the referent (extension) of the indexical. So for instance, the character of the indexical "I" is the rule that a token of "I" refers to the producer of that token; a similar rule exists for first-personal possessive pronouns, and so forth. In the first passage the utterer refers to "my corpse" in the present (not future) tense, and the first-personal possessive, according to the theory, refers to the producer of the utterance, who must be alive at the time he produces the utterance. The passage therefore can only make sense *in the future*, when the circumstance of evaluation of the utterance is his audience reading his letter after his death. The passage makes sense only in its subsequent quotation, not in its original utterance. Compare Bäcker's own commentary in an interview:

> In a sentence like "my corpse is located on this side of the school. You can come and pick me up immediately" one's own end is reflected upon, and when the writer says that, he has—even when he factually cannot do it—left time behind him. Time ruins him. But he can still say, you can come and pick me up immediately, namely me, who then is lying there.[53]

Likewise in the second text the tokened "I" according to the theory refers to the producer of the utterance—an utterance in which the producer notifies (present tense) his addressee that he has been shot dead (past perfective). Once again the passage can only make semantic sense *in the future*, as quotation.

It will perhaps be objected that one of the most compelling characteristics of the "system *nachschrift*" is its being replete with quotations that literally cannot be voiced: the system reproduces—quotes—the arcane acronyms, abbreviations, lists, and registers by which the perpetrators intentionally dissimulated and concealed their genocidal record-keeping (for example, *transcript*: 8, 22*–23*, 29*, 32, 38, and so on).[54] I would like to suggest that we can interpret such *quoted inscriptions* in a similar fashion, only here the reactualization is to be understood as a reinscription, a writing, and reading, anew, of the "*Schriftzeugnisse*." Since these texts too are open quotations, their content is "semantically active," and their original references (for example, abbreviations of concentration camps, train schedules, and so on) are reactualized as well. As direct or indirect speech acts—orders to carry out actions, say, or reports of such actions—these speech acts too are reactualized. I take this to be at least one aspect of the significance of the facsimile of (presumably) Bäcker's handwritten multiple repetition of "*der schreiber schreibt*" (the writer writes) (*transcript*: 119*) to the point of illegibility: in composing his "system *nachschrift*" Bäcker perforce must adopt the attitude of writer, record-keeper, organizer, administrator; that is, he must "simulate" the activities of the perpetrators he quotes:[55] they share the minimally described activity of "*der schreiber schreibt*." Like the timeless infinitival present tense of the lists, names, dates, "*der schreiber schreibt*"—a tautologous, intransitive, as it were stuttering internal nominative and present-tensed verb—inhabits the distinctive temporality of quotation itself—infinite, perpetually recurrent, eternal present; as Celan wrote in the "Meridian" speech, "art comes again" (*Die Kunst kommt wieder*). It is perhaps therefore no coincidence that Bäcker understands "system *nachschrift*" in terms of a lifelong temporal process (*Lebensarbeit*), the method of which is to tell no story:

> The method of "nachschrift" is not narrative. I retreat completely to the documents, which include files, commands, protocols, but also reports of those people who have survived the camps. Dealing with this has been my daily activity for decades, and I store a great deal of

information without using a computer. After all, it is not merely my "theme," it is my life's work [*Lebensarbeit*].[56]

So perhaps here too one might be able to speak of an inversion between the dead and the living, not in terms of voice, but in terms of one's very time, one's presence.

5. THE RISK OF OPEN QUOTATION

A further consequence of the decontextualization of quotation in Bäcker's text that I spoke of earlier is that the potential for different, even contradictory contextualizations is great. That potential is in fact graphically exemplified in a passage from *nachschrift 2*:

> Wenn der blockschreiber irrtümlicherweise eine nummer mit dem vermerk *verstorben* versieht, kann solch ein fehler später einfach durch die execution des nummernträgers korrigiert werden. (*nachschrift 2*: 124)

> (If the note-writer mistakenly provides a number with the remark *deceased*, such an error can be corrected later simply by means of the execution of the bearer of that number.)

Part of the affect of this quotation lies in the inversion of *direction of fit* it calls for. G. E. M. Anscombe introduced the notion in the following passage:

> Let us consider a man going round a town with a shopping list in his hand. Now it is clear that the relation of this list to the things he actually buys is one and the same whether his wife gave him the list or it is his own list; and that there is a different relation when a list is made by a detective following him about. If he made the list itself, it was an expression of intention; if his wife gave it him, it has the role of an order. What then is the identical relation to what happens in the order and the intention, which is not shared by the record? It is precisely this: if the list and the things that the man actually buys do not agree, and if this and this alone constitutes a *mistake*, then the mistake is not in the list but in the man's performance (if his wife were to say: 'Look, it says butter and you have bought margarine', he would hardly reply: 'What a mistake! we must put that right' and alter the word on the list to 'margarine'); whereas if the detective's record and what the man actually buys do not agree, then the mistake is in the record.[57]

The detective, who follows the man around the market noting what he buys, constructs a *record* of his purchases, a list that is *true* just if it correctly describes the contents of the man's shopping basket. The

detective's list should, if correct, accord with the state of the world: his list must match the contents of the man's shopping basket. The man, however, possesses a list of the items he *intends* (or, if written by his wife, is ordered) to purchase, and his actions are correct if his purchases accord with the list. The man should make the state of the world (the contents of his basket) match his list. Hence the direction of fit between statement and world is reversed from that of the detective's list, although the contents of the two lists might in fact be identical. This example serves Anscombe as a motivation for reviving the ancient concept of *practical knowledge* (knowing what one intends to do; a kind of knowledge to which the world will intentionally be made to accord) versus *contemplative knowledge* (knowing facts about the world; a kind of knowledge "that is judged as such by being in accordance with the facts"). Anscombe's distinction, however, raises a different question for our concerns: Can such *open quotations* be refunctioned from descriptions, reports of what was said and done, into prescriptions, recommendations, or even orders for what should be done? If there are no *semantic* markers indicating whether a quotation (in Anscombe's example, a list of names) be read descriptively or prescriptively, then why shouldn't Bäcker's quotations of Holocaust perpetrators be banned by German law the way that the usage of Nazi symbols or the quotation, or mere possession, of *Mein Kampf* is proscribed?[58] Or what if a speaker at a neo-Nazi rally read aloud selected passages from Bäcker's *nachschrift*?

This concern may be pressed further by considering quotation as a trope, and moreover, precisely the *inverse* of the trope of irony, specifically Romantic irony. Unlike traditional, or stable irony, whose presence is indicated by some semantic marker and in which the speaker's intended meaning is the contrary of the conventional sentence meaning, Romantic or unstable irony potentially thwarts understanding by implicitly exposing any putative justification of a stable interpretation itself to possible irony. Wayne Booth, in the standard work on the topic, provides a suitably vertiginous example:

> Irony in itself opens up doubts as soon as its possibility enters our heads, and there is no inherent reason for discontinuing the process of doubt at any point short of infinity. "How do you know that Fielding was not being ironic in his ostensibly ironic attack on Mrs. Partridge?" If I am answered this with a citation or other 'hard' data in the work, I can of course claim that Fielding was ironic in his use of them (instead). But how do I know that he was not really pretending to be ironic in their use, not in fact ironically attacking those who

take such data without irony? And so on. The spirit of irony, if there
is such a thing, cannot in itself answer such questions: pursued to the
end, an ironic temper can dissolve everything, in an infinite chain of
solvents.[59]

While Booth undertakes to bring such potentially infinite irony to
interpretive finitude, in his lecture, "The Concept of Irony," Paul de
Man resists any such containment by adverting to Friedrich Schle-
gel's theory of irony as "permanent parabasis," where parabasis is
defined by de Man as "the interruption of a discourse by a shift in
the rhetorical register."[60] Thus irony here constitutes the perpetual
potential suspension of a discourse and its comprehensibility: "So one
could say that any theory of irony is the undoing, the necessary undo-
ing, of any theory of narrative, when irony is precisely what makes
it impossible to achieve a theory of narrative that would be consis-
tent."[61] Irony constitutes this risk of suspending narrative or discourse
precisely because it requires no, and can itself ironize any, syntactic or
semantic marker, thus making it impossible to identify and segregate
ironical passages from unironical passages in a text. Thus it is always
possible that a given text might be used or interpreted ironically, that
is, as in fact *not* meaning what it apparently is asserting. Likewise, it
is always possible that a given occurrence of open quotation might be
interpreted literally, that is, as in fact *asserting* what it is apparently
only quoting. In this respect quotation and irony constitute perpet-
ual threats to understanding, albeit through inversely related opera-
tions: open quotation contains a perpetual risk of its displayed text
(perhaps a kind of figuration) becoming reactualized, rendered an
actual utterance, while irony contains a perpetual risk of its uttered
text becoming deactualized, suspended as mere display, figuration.[62]
Earlier in this chapter I recounted arguments for the conclusion that
occurrences of open quotation cannot be identified syntactically or
semantically, and that the interpretation of a quotation (that is, which
properties are being demonstrated by the displayed token) must have
recourse to pragmatic considerations such as Gricean conventional
and conversational implicature. This means that the occurrence and
interpretation of open quotation—like that of irony—are deeply con-
tingent matters, and perhaps it is a further achievement of Bäcker's
work that, in that it "sets form free" it simultaneously foregrounds
precisely that political contingency, which persists to this day.

CHAPTER FOUR

The Aesthetic-Historical Imaginary

On Shoah *and* Maus

We see the tempest in the wrecks and corpses which it has cast ashore.

—G. E. LESSING[1]

The film [*Shoah*] forces the imagination to work.

—CLAUDE LANZMANN[2]

In this final chapter I consider two works in two different media that have often occupied center stage in discussions of Holocaust art and historical understanding: Claude Lanzmann's nine-hour film *Shoah* and Art Spiegelman's two-volume graphic novel *Maus*. Although the works are rarely discussed together, I shall argue that they should be seen as inversions of each other within the analytic framework of this book. After introducing my approach as a version of the "Laocoön problem" (§1) and identifying several similarities between *Shoah* and *Maus* and their genesis (§2), I outline a revised Sartrean theory of the imaginary that will guide our understanding of the specific aesthetic-historical dynamic at work in the two works (§3). I then relate the imagination to memory and testimony by developing what I call the expressivist epistemic dimension of testimony (§4), before considering particular forms of epistemic asymmetry in *Shoah* (§5) and *Maus* (§6). I conclude by showing how a specific epistemology of testimony illuminates the relationship between these epistemic asymmetries and the imaginary, thereby constituting a distinctly epistemic variant of the minimal normative framework advocated in this study (§7).

1. THE NEW LAOCOÖN

It's true that painting, in theory, couldn't deliver a full-fledged narrative rather than an essentialized moment, at which point it probably begins moving toward being comics with multiple images and using these things as signs. But there's a province for painting, and a province for prose, and it's what comics suffered from. The guy who wrote the essay called *Laocoön*, Gotthold Lessing, had pretty much queered it for comics by telling us that there's this proper province for painting and a proper province for prose, and don't try to mess with mixing it together, you'll come up with some mongrelization. As a result, in Western art, comics suffered from this.

—ART SPIEGELMAN[3]

The model presented here, to account for the success of both *Shoah* and *Maus* as Holocaust artworks, bears some affinities to, and draws restrained inspiration from, Gotthold Ephraim Lessing's great essay *Laocoön* of 1766.[4] In that work Lessing challenges Winckelmann's interpretation of the recently discovered sculptural group of Laocoön and his two sons being attacked by a pair of sea serpents sent by the gods [Figure 29]. Both Lessing and Winckelmann agree on the interpretive premise, the fact that requires explanation, "that the pain in Laocoön's face is not expressed with the same intensity that its violence would lead us to expect," and the factual premise that "a cry is the natural expression of physical pain."[5] The question Lessing seeks to answer is why Laocoön, although clearly in excruciating pain, is *not* crying out. His solution relies on general aesthetic tenets he attributes to classical antiquity and a unique argument about the material limitations of different artistic media. He claims that "the ultimate goal of the arts is pleasure" and that "among the ancients beauty was the supreme law of the visual arts";[6] therefore, since beauty provides a certain kind of pleasure, the visual expression of suffering must be diminished in comparison with the actual suffering imputed:

> Let us consider expression. There are passions and degrees of passion which are expressed by the most hideous contortions of the face and which throw the whole body into such unnatural positions as to lose all the beautiful contours of its natural state. The ancient artists either refrained from depicting such emotions or reduced them to a degree where it is possible to show them with a certain measure of beauty.[7]

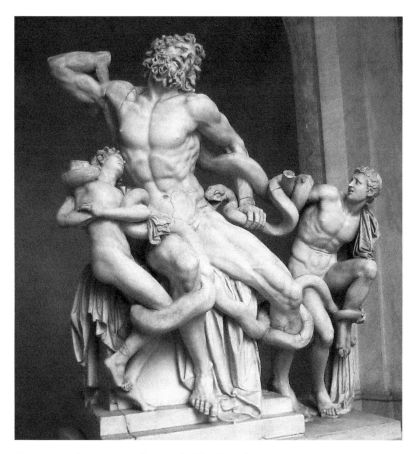

Figure 29. Laocöon sculpture. Public domain.

Thus Lessing concludes "the scream had to be softened to a sigh, not because screaming betrays an ignoble soul, but because it distorts the features in a disgusting manner."[8] Lessing's next move is to claim that what beauty as "the supreme law of the visual arts" diminishes in the portrayal of suffering is compensated through the augmentation by the spectator's *imagination*:

> If the artist can never make use of more than a single moment in ever-changing nature, and if the painter in particular can use this moment only with reference to a single vantage point, while works of both painter and sculptor are created not merely to be given a glance but to be contemplated—contemplated repeatedly and at length—then it is evident that this single moment and the point from which it is viewed cannot be chosen with too great a regard to its effect [*nicht fruchtbar*

genug gewählet werden kann]. But only that which gives free rein to the imagination is effective [*Dasjenige aber nur allein ist fruchtbar, was der Einbildungskraft freies Spiel lässt*]. The more we see, the more we must be able to imagine. And the more we add in our imaginations, the more we must think we see. In the full course of an emotion, no point is less suitable for this than its climax. There is nothing beyond this, and to present the utmost to the eye is to bind the wings of fancy and compel it, since it cannot soar above the impression made on the senses, to concern itself with weaker images, shunning the visible fullness already represented as a limit beyond which it cannot go. Thus, if Laocoön sighs, the imagination can hear him cry out.[9]

Lessing combines this line of argument with his now famous analysis of the material limits of imitative representation of painting (more generally, the visual arts) and poetry. He draws his conclusions from the means or signs used by each medium respectively:

I reason thus: if it is true that in its imitations painting uses completely different means or signs than does poetry, namely figures and colors in space rather than articulated sounds in time, and if these signs must indisputably bear a suitable relation to the thing signified, then signs existing in space can express only objects whose wholes or parts coexist, while signs that follow one another can express only objects whose wholes or parts are consecutive.

Objects or parts of objects which coexist in space are called bodies. Accordingly, bodies with their visible properties are the true subjects of painting.

Objects or parts of objects which follow one another are called actions. Accordingly, actions are the true subjects of poetry.[10]

Thus Lessing concludes that "painting can use only a single moment of an action in its coexisting compositions and must therefore choose the one which is most suggestive and from which the preceding and succeeding actions are most easily comprehensible."[11] This requirement of what has come to be called the "*fruchtbarer Moment*" (the pregnant or fecund moment), combined with the aesthetic strictures upon the expression of suffering and the compensatory role of the spectator's imagination, suffices for Lessing to explain the initial puzzle of the sculpture's restrained facial expression.[12]

It would appear that the media of film and comic book (and indeed, theater and opera), because they incorporate both visual and verbal arts, would be, as Spiegelman says in our opening quotation, "queered" by Lessing's theory. As potential "*Gesamtkunstwerke*" in virtue of their formal complexity, film and comic book can visually depict bodies and verbally depict actions; they thus seem to

transcend the medium-specific material limitations upon which Lessing's argument rests, in that these genres potentially can provide both mimesis (imitative representation of actions) and diegesis (narration of actions). Indeed, studies of the relationship between "word" and "image" are a staple of comic-book studies, which often take their cues from cinematic studies of the relationship between "voice" and "image,"[13] and hearken back to Lessing's differentiating the limits inherent in the different "signs" as forms of representation.[14] The implication then is that film and comic books approach a "totality" of representation or "meaning" in virtue of their multiple material forms of representation, or that the difference and interplay between the forms of representation undercut that implicit appeal to a "totality" of representation or "meaning" made by such *Gesamtkunstwerke.*[15] From this the next step is to claim that it is the reader's or viewer's imagination that supplements these ruptures in representation, and typically the act of supplementation is conceived as sensory, usually either visual or aural. Thus Lessing claims, "If Laocoön sighs, the imagination can hear him cry out," and "We see the tempest in the wrecks and corpses which it has cast ashore."[16] And, as we shall see, it is arguably a more or less straight line from Lessing's conception of the compensatory function of the imagination in aesthetic experience to Sartre's understanding of the "analogon" in imaging consciousness.

However, we can shift the discussion from one of forms or modes of representation to one of modes of *knowledge*, namely propositional knowledge and expressive knowledge. And this shift entails a corresponding shift towards an *epistemic* role of imagination, the role of imagination in immediate and inferential knowledge. Consider again the two examples from Lessing above: both are cast in terms of objectual imagination: the spectator imagines a figure crying out, or a devastating sea tempest. Yet the second example can also be understood as an inference, from the ocular evidence (the wreckage and the corpses) not to a visualization of a storm at sea, but rather to the consequent of a material implication: "The storm that caused this wreckage was severe," for instance. And this inference would constitute a case of propositional knowledge or belief. Likewise, were there a survivor of the storm who spoke to us, his face would transmit expressive knowledge of the disaster, and we might well respond with our participial imagination, imagining what it would be like to experience what he did. We shall presently explore these various

forms of knowledge and imagination systematically, after introducing our two chosen artworks in virtue of some suggestive similarities between them.

2. ART, HISTORY, AND GENRE CONFUSION

Surface similarities between *Shoah* and *Maus* bespeak deeper affinities. Each author worked for more than a decade on his opus: Lanzmann spent eleven years shooting more than three hundred hours of footage, while Spiegelman spent thirteen years drawing his panels. Both authors have resisted commodification by the culture industry and insisted on the formal integrity of their works.[17] Each author has identified silence and incomprehensibility as central to the nature and function of their works.[18] Both works incorporate testimonies: *Maus* of Spiegelman's father, *Shoah* of Jewish survivors, Nazi perpetrators, and Polish bystanders; and both works incorporate the interviewer, who elicits, and at times compels, the testimonies. Both works combine visual images and speech in a complex manner, as we shall see. Each work belongs to a genre of "artwork in the age of its technological reproducibility," to use Walter Benjamin's phrase, genres conventionally taken to be mass art forms: mass produced and consumed in a state of "distraction." Both these mass cultural media also were marshaled to serve the Nazi aesthetic, as one critic notes: "Spiegelman's artistic style and animating purpose are shaped by the two graphic media whose images make up the visual memory of the twelve-year Reich—cartoons and cinema. Both arts are intimately linked to the aesthetic vision and historical legacy of Nazism."[19] According to the same critic, the two media meld easily into each other: "The grammar of cinema translates readily into comic-book terms," such that *Maus* can be seen to exemplify the poetics of film:

> In a mosaic presentation akin to cinematic montage, panels and maps splash across the page, figures bleed out of and break across rectangular frames, and elaborately designed layouts greet the eye before a close-in inspection of the individual panels. When a triptych of panels zooms in from a medium shot to a close-up, the sequence of still images duplicates the dynamic telescoping of the camera lens. Unlike the height-to-width "aspect ratio" of a film screen, however, the comic frame has a malleability and elasticity that can heighten dramatic effect and visual impact, as when the dimensions of the comic book screen expand lengthwise to accentuate the horizontal movement of the transport trains.[20]

These formal similarities would suggest, upon first impression perhaps, similar readings of, or at least approaches to, *Maus* and *Shoah*.

But more importantly for our interest, both works were fraught with questions of genre and the responsibilities that genres require of their works. When *Maus* won the Pulitzer Prize in 1992, the awards committee presented Spiegelman with a "Special Award," since his book seemed to fit neither of the closest categories: biography or editorial cartooning. The author himself seemed unsure of the genre of his work: before the publication of *Maus II*, Spiegelman referred to his work-in-progress as his "comic-book novel,"[21] but after its publication, Spiegelman requested that his book be moved from the fiction to the nonfiction best-seller list of the *New York Times Book Review*. In a letter to that magazine's editors he wrote:

> If your list were divided into literature and nonliterature, I could gracefully accept the compliment as intended, but to the extent that "fiction" indicates that a work isn't factual, I feel a bit queasy. As an author, I believe I might have lopped several years off the 13 I devoted to my two-volume project if I could only have taken a novelist's license while searching for a novelist's structure.
>
> The borderland between fiction and non-fiction has been fertile territory for some of the most potent contemporary writing, and it's not as though my passages on how to build a bunker and repair concentration camp boots got the book onto your advice, how-to and miscellaneous list. It's just that I shudder to think how David Duke— if he could read—would respond to seeing a carefully researched book based closely on my father's memories of life in Hitler's Europe and in the death camps classified as fiction.
>
> I know that by delineating people with animal heads I've raised problems of taxonomy for you. Could you consider adding a special "nonfiction/mice" category to your list?[22]

Spiegelman's invocation of the difference between fiction and nonfiction mirrors our guiding framework of a potential tension between the aesthetic-autonomous and the aesthetic-heteronomous (viz. here, historical) tendencies inherent in any Holocaust artwork.

The question of genre has also been pressed hard in the case of *Shoah*, which is composed entirely of interviews with eye-witnesses and scholars, and footage of present-day sites. Commentators therefore typically refer to the film as a Holocaust documentary, an appellation that Lanzmann vigorously disavows, insisting that his film is a work of art. Here, as in the case of *Maus*, the question of factuality or authenticity appears to function as a criterion for determining genre, but such

a decision procedure tacitly assumes that the aesthetic is tantamount to fictionality. That equivalence may hold, but only if the aesthetic is taken to its limit-case of aesthetic autonomy, where the artwork creates its own world, or is exclusively self-referential, and so on. The equivalence does not hold if neither the aesthetic nor the historical tendency, albeit each opposed to the other, obtains exclusive validity. If the eyewitness testimonies, in their historical factuality and authenticity, are themselves presented in an aesthetic structure that halts short of fictionality, the normative constraints of Holocaust artworks will have been met. Moreover, we shall see that both artists, each in his own way, achieve an aesthetically mediated epistemic awareness of history through the precise engagement of the viewer's imagination.

3. SARTRE ON THE IMAGINARY

In his 1940 study *L'imaginaire* Jean-Paul Sartre seeks to isolate and identify the essential features of what he calls "imaging consciousness" through its relationship to perceptual consciousness on the one hand, and conceptual thought on the other. Proceeding from the phenomenologist credo that all consciousness is intentional, that is, consciousness *of* or *about* something, Sartre considers a series of what could be called props to the imagination, beginning with the concrete image of a portrait of someone, through to caricature and schematic drawings, until finally he considers what the philosophical tradition calls "the mental image." Sartre's principal claim against that tradition (as represented by David Hume, for example) is that the mental image is not a miniature picture of the object it represents, which can then be analysed by introspection to yield knowledge. Such an erroneous view, which assimilates imagination too closely to perceptual experience, Sartre dubs "the illusion of immanence." Against this view Sartre maintains that "here . . . an image is nothing other than a relation. The imaging consciousness that I have of [his absent friend] Pierre is not a consciousness of an image of Pierre: Pierre is directly reached, my attention is not directed at an image, but at an object."[23] In imaging consciousness the object does not necessarily exhibit the features of a perceived object—that is, an intuition—such as (if a visual perception) being viewed from a single vantage point, or providing a source of beliefs or knowledge. Sartre justifies his claim against the illusion of immanence by adducing the experience of what he calls "quasi-observation." With perception, we observe an object

and thereby learn about it; that is, we modify or increase our beliefs about the object: the perceived object can be a source of knowledge.[24] The object in imaging consciousness, however, shares with the concept of thought the feature of possessing already all the properties the imaginer believes it to have. One comes to have beliefs about a material object on the basis of perception, but one imagines an object on the basis of one's prior beliefs about it. Thus the object as imagined *cannot be a source of new beliefs or knowledge* and, like conceptual thought and unlike perception, the imaging consciousness constitutes its intentional object on the basis of prior beliefs about it.

By contrast, like perception and unlike conceptual thought, in imaging consciousness the intentional object is in some sense *present*: the experience is as though having the imagined object "present in its absence." The imaginer "posits its object as a nothingness,"[25] that is, knows that the imaged object is not present to outer sense and observation. What is present, Sartre claims, is the subjective *sense* that the absent object has for the imaginer. This sense is constituted out of the imaginer's beliefs but also feelings about the absent object. Thus the imagined object is constituted from both cognitive and affective relations to the real but absent object,[26] such that the sense of the real object is present for the imaginer in the imagined object.

Lastly, like conceptual thought but unlike perception, Sartre holds that the imagination is *spontaneous*, for him the faculty of radical freedom because not even bound by the laws of thought. Perception is passive, receptive to the independently existing objects it confronts, whereas the imaginer in Sartre's view is free to create her intentional objects. Mary Warnock has surmised that Sartre disallows the role of imagination in *memory* (and perception) because he wanted imagination to be the placeholder for his radical notion of freedom.[27] Yet several of Sartre's examples of imagining consciousness, such as thinking of his absent friend Pierre or the Pantheon, could arguably be recast as episodes of remembrance, in that the mental content—the "mental image"—in such cases is at least partly composed of beliefs about the absent object that themselves constitute memories: how Pierre last appeared to him, or how he remembers the Pantheon. Sartre considers memory in only one brief passage of his study, where he claims that memory (and anticipation) are "radically different from the problem of imagination":

> Certainly, the memory, from many points of view, seems very close
> to the image, and I was sometimes able to draw my examples from

memory to better understand the nature of the image. There is never-theless an essential difference between the thesis of the memory and that of the image. If I recall an event of my past life, I do not imagine it, I *remember* it. That is to say, I do not posit it as *given-absent*, but as *given-now* as *passed*. Pierre's handshake when leaving me yester-day evening did not undergo a modification of irreality while flowing into the past: it simply went into *retirement*; it is always real but *past*. It exists *past*, which is one mode of real existence among others. And when I want to apprehend it anew, I aim at it *where* it is, I direct my consciousness towards this past object that is *yesterday* and, at the heart of that object, I regain the event that I am seeking, Pierre's hand-shake. In a word, just as when I want to really *see* the arabesques hid-den beneath the armchair, I must look for them where they are, which is to say move the armchair, so when I *recall* this or that memory, I do not *evoke* it but I take myself to where it is, I direct my consciousness towards the past where it awaits me as a real event in retirement.[28]

Warnock has raised compelling objections to Sartre's argument and its stringent distinctions on phenomenological grounds: how often "the thought of something which did happen may merge into the thought of something which might have happened; how we may slide imper-ceptibly from expecting someone to arrive [a case of anticipation] to envisaging [that is, imagining] what he may do or say when he does; how easy it is simply not to know whether something is a remembered scene or not."[29] We can sharpen her objection by noting that the dis-tinction Sartre is drawing depends precisely on the epistemic status of judgments *about* the mental content involved. According to Sartre, one simply *knows* whether the mental content is directed at an object that is absent because belonging to the past ("in retirement") or at an object that is absent *simpliciter*, and it is that epistemic distinction which grounds the distinction between the operation of memory and of imagination. But to speak of knowledge is too strong here; at most one can speak of the thinker's *beliefs*, which of course may well be false or unjustified.[30] It therefore follows that the distinction between memory and imagination is not well defined, and that imagination can function in cases of memory as well. Memory would then share several features with imagination: it would be a kind of intentional-ity that posits its object as present-while-absent (unlike perception), it would be a source of no new knowledge (unlike perception),[31] would include cognitive and affective elements, and could be spontaneous or receptive (one may summon one's memories on the one hand, but on the other hand one's memories can be triggered involuntarily). This conclusion is of profound consequence for the artworks we are

considering in this chapter, for both *Shoah* and *Maus* incorporate testimonies by Holocaust witnesses and survivors. I will take up this consideration in the next section.

According to Sartre, imaging consciousness makes use of what he calls an *analogon*, that matter upon which imagination acts in lieu of direct perception of the absent object.[32] The "functional attitude" (the functional role of intentionality) of imaging consciousness remains unchanged, although the matter of the analogon may vary, from a painted portrait or photograph to a caricature or schematic drawing to mental image: "The image is an act that aims in its corporeality at an absent or nonexistent object, through a physical or psychic content that is given not as itself but in the capacity of 'analogical *representative*' of the object aimed at."[33] The "imaging attitude" or the "image function" then is a mode of consciousness by which an object appears to one as absent or nonexistent, and appears in virtue of cognitive and affective elements one entertains about the missing object on the basis of its analogon.

4. IMAGINATION, MEMORY, AND THE EPISTEMOLOGY OF TESTIMONY

. . . there is no species of reasoning more common, more useful, and even necessary to human life, than that which is derived from the testimony of men, and the reports of eyewitnesses and spectators.

—DAVID HUME[34]

Although Sartre clearly conceives the imaginary as one form of intentional consciousness, his theory and the scenarios he presents to illustrate it postulate an intentional *object* as that toward which imaginary consciousness is directed on the basis of some matter for visualization (that is, the analogon). Bernard Williams has effectively criticized Sartre's model of the imaginary as one of visualization, by showing that one can *narrate* what one imagines while point-by-point removing from one's consciousness the mental content of one's visualization.[35] This conclusion accords with a threefold typology of the possible intentional relations available to the faculty of the imagination:

1. *objectual* imagination: one can imagine an absent or nonexistent *object*, for example, the Eiffel Tower or a unicorn.

2. *propositional* imagination: one can imagine *that* the Eiffel Tower is in Shanghai, or *that* a unicorn is playing chess.

3. *participial* imagination: one can imagine oneself *being* Napoleon, or *seeing* a unicorn, or *running* for president.[36]

If we accept this threefold taxonomy of intentional relations as the possible functions of the faculty of imagination, we arrive at a more ramified and promising understanding of the ways in which imagination and epistemology might be involved in testimony and the aesthetic presentation of testimony in *Shoah* and *Maus*.

If memory and imagination are less distinctly different than Sartre's theory countenances, then this fact entails consequences for *testimony*, for in recounting a remembered event, a witness may in fact also be imagining objectually, propositionally, or even participially. A clear example of the problematic in question is provided by Dr. Dori Laub in his discussion of factual errors in the testimony of a witness he was interviewing regarding the inmate uprising in Auschwitz. The witness misremembered the number of crematorium chimneys that were blown up during the rebellion, and historians concluded that her testimony was fallible and hence not credible. In other words, because some of the propositions asserted in her testimony were factually false, the witness's credibility was impugned and the informational value of her testimony challenged. Dr. Laub counters the historians' dismissal by interpreting the witness's testimony as itself a performative act of rebellion:

> She was testifying not simply to empirical historical facts, but to the very secret of survival and of resistance to extermination. . . . She saw four chimneys blowing up in Auschwitz: she saw, in other words, the unimaginable taking place right in front of her own eyes. And she came to testify to the unbelieveability, precisely, of what she had eyewitnessed—this bursting open of the very frame of Auschwitz. . . . The woman's testimony . . . is breaking the frame of the concentration camp by and through her very testimony: she is breaking out of Auschwitz even by her very talking. She had come, indeed, to testify, not to the empirical number of the chimneys, but to resistance, to the affirmation of survival, to the breakage of the frame of death . . . the historians said that she knew nothing. I thought that she knew more, since she knew about the breakage of the frame, that her very testimony was now reenacting.[37]

Laub's interpretation of the testimony turns on the distinction between constative and performative utterances: rather than asserting

a knowledge claim susceptible to standards of truth (that is, histori-
cal accuracy), on his view she is instead reenacting the rebellion with
her very utterance. But this distinction fails to capture the specifics
involved in her testimony. If her utterance is not a truth-apt assertion
but an act of rebellion, what precisely is she rebelling against? What
is the "very frame of Auschwitz" such that it is related to the can-
ons of historical veracity, if her utterance is a rebellion against such
standards? Most importantly, an interpretation of her testimony that
relies entirely on the linguistic-philosophical distinction between con-
stative and performative utterances, without a more developed the-
ory of that distinction's relationship to the epistemology of testimony,
does not capture a central aspect of her testimony: that she *sincerely
believes* of what she is asserting *that* it is true.

Our previous considerations regarding the close affinity between
memory and the imaginary suggest an alternative interpretation.
Recall that the intentional contents of neither memory nor the imagi-
nation provide new knowledge, since they are themselves constituted
by the beliefs of the thinker. Since beliefs may be incorrect, it follows
that the intentional contents of memory and the imagination may
themselves be incorrect. But note further that this reasoning holds
only of testimony involving objectual imagination or propositional
imagination, that is, testimony in which the object being named
might not exist, that is, in which the implicit proposition "the object
exists," is false, or in which the explicit proposition being asserted
might be false. But if memory and imagination are closely related, and
one variety of imagination is *participial* imagination, then we may
surmise that there is another variety of knowledge involved in testi-
mony besides propositional knowledge.

This second epistemic dimension of testimony I shall call *expres-
sive*. The central idea here is that in remembering or imagining one-
self doing something, seeing something, or being in a certain state,
one adopts the attitude, behavioral disposition, and expressiveness
consonant with what one is remembering or imagining. Thus remem-
bering or "imagining *de se*" is a kind of self-knowledge that is made
manifest in one's attitudes, expressions, and behavior, including lin-
guistic behavior. The touchstone for such a conception of expressive
knowledge is Wittgenstein:

> How do words *refer* to sensations?—There doesn't seem to be any
> problem here; don't we talk about sensations every day, and give them
> names? But how is the connection between the name and the thing

named set up? This question is the same as: how does a human being learn the meaning of the names of sensations?—of the word "pain" for example. Here is one possibility: words are connected with the primitive, the natural, expressions of the sensation and used in their place. A child has hurt himself and he cries; and then adults talk to him and teach him exclamations and, later, sentences. They teach the child new pain-behavior.

"So you are saying that the word 'pain' really means crying?"— On the contrary: the verbal expression of pain replaces crying and does not describe it.[38]

When someone says "I hope that he'll come"—is this a *report* about his state of mind, or a *manifestation* of his hope?—I can, for example, say it to myself. And surely I am not giving myself a report. It may be a sigh; but it need not. If I tell someone "I can't keep my mind on my work today; I keep on thinking of his coming"—*this* will be called a description of my state of mind.[39]

But how does the person in whom it goes on know which event the process is the expectation of? For he does not seem to be in uncertainty about it. It is not as if he observed a mental or other condition and formed a conjecture about its cause. He may well say: "I don't know whether it is only this expectation that makes me so uneasy today"; but he will not say: "I don't know whether this state of mind, in which I now am, is the expectation of an explosion or of something else."

The statement "I am expecting a bang at any moment" is an *expression* of expectation. This verbal reaction is the movement of the pointer, which shows the object of expectation.[40]

According to this notion of expressivism, self-ascriptions of mental states should be understood as expressions or manifestations of that mental state and *not merely* reports, descriptions, or knowledge claims about those states.[41] The preeminent medium of such expression is the human face:

"We *see* emotion."—As opposed to what?—We do not see facial contortions and make inferences from them (like a doctor framing a diagnosis) to joy, grief, boredom. We describe a face immediately as sad, radiant, bored, even when we are unable to give any other description of the features.—Grief, one would like to say, is personified in the face.
This belongs to the concept of emotion.[42]

In this passage Wittgenstein denies that we *infer* from facial contortions to an understanding of the person's mental state, claiming rather that understanding is immediate, noninferential, and hence beyond

justification (if someone asked you *how* or *why* you believed the person was grief-stricken, what could you say other than: look at her face; this is how people look when stricken by grief). Unlike testimonial propositional knowledge (for example, a knowledge claim conveyed by speaker to hearer), which is susceptible to epistemic skepticism (How does the hearer know the claim to be true? Why should he believe it to be true?), testimonial expressivist knowledge, while it might be accompanied by a propositional claim (for example, "I'm in pain"), is itself not susceptible to the same kind of epistemic skepticism, for its criteria of evaluation is not truth, but sincerity. Moreover, Wittgenstein suggests that something has already gone wrong with the appraiser if she is struck by epistemic doubt when confronted with such facial expressiveness, for the latter, under proper circumstances, elicits an appropriate *responsiveness* from the other:

> 285. Think of the recognition of *facial expressions*. Or of the description of facial expressions—which does not consist in giving the measurements of the face! Think, too, how one can imitate a man's face without seeing one's own in a mirror.

> 286. But isn't it absurd to say of a *body* that it has pain?—And why does one feel an absurdity in that? In what sense it is true that my hand does not feel pain, but I in my hand?
> What sort of issue is: Is it the *body* that feels pain?—How is it to be decided? What makes it plausible to say that it is *not* the body?—Well, something like this: if someone has a pain in his hand, then the hand does not say so (unless it writes it) and one does not comfort the hand, but the sufferer: one looks into his face.

> 287. How am I filled with pity *for this man*? How does it come out what the object of my pity is? (Pity, one may say, is a form of conviction that someone else is in pain.)[43]

Thus Wittgenstein here *in nuce* offers an epistemic model for *testimonial expressive knowledge*: we *see* the witness's state of being, which may encompass mental states, knowledge, or belief of what she knows (and arguably, her knowledge that she knows it) as manifested in her attitude, affect, preeminently in her *face*, and this act constitutes a kind of noninferential knowledge or belief on our part, a conviction in turn manifested in our appropriate responsiveness.[44]

Now, with these conceptual pieces in place, we can return to Laub's erroneous witness and suggest that her giving testimony involved both memory and participial imagination—that she imagined herself experiencing the death, destitution, forsakenness, as well as the

triumphant turned failed uprising—and that alongside the fallible propositional claims she asserted she also manifested an expressive knowledge. Indeed, Laub introduces her with these words:

> A woman in her late sixties was narrating her Auschwitz experience to interviewers from the Video Archive for Holocaust Testimonies at Yale. She was slight, self-effacing, almost talking in whispers, mostly to herself. Her presence was indeed barely noteworthy in spite of the overwhelming magnitude of the catastrophe she was addressing, She tread lightly, leaving hardly a trace.
>
> She was relating her memories as an eyewitness of the Auschwitz uprising; a sudden intensity, passion and color were infused into the narrative. She was fully there.[45]

Wittgenstein's notion of expressive knowledge, I claim, better explicates Laub's own experience of the witness and her testimony than does invoking the idea of a performative utterance, for it is precisely the attitude, emotions, and no doubt above all the facial expressions of the witness that constitute a source of knowledge or belief for Laub other than what is explicitly stated in her utterances, and the notion of performative utterance cannot capture this second *epistemic* dimension of testimony: that in giving testimony involving participial imagination, the witness *manifests* or *expresses* not only the beliefs about which she is also reporting but also her state of being consonant with what she is reporting. And indeed Laub highlights the response her expressiveness elicits from him: "respect."[46]

5. *SHOAH* AS THE MISE-EN-SCÈNE OF THE IMAGINARY

"*Shoah* is a fiction rooted in reality [*fiction du reel*], which is something entirely different."

—CLAUDE LANZMANN[47]

Before becoming an independent film-maker, Claude Lanzmann served as assistant to Jean-Paul Sartre, and the critic Gertrud Koch has championed *Shoah's* aesthetic qualities by partially identifying them with the exercise of the imagination in Sartrean existential psychology.[48] Koch briefly alludes to Sartre's earlier, 1936 work on the imagination,[49] but passes over the later work introduced above and which, I claim, offers a deeper understanding of *Shoah's* historical and aesthetic relations.

Lanzmann famously excludes all extant historical footage from his film, and in an interview first notes that there is hardly any filmic and photographic evidence of the exterminations because the Nazis resolutely kept such actions secret, before claiming that Nazi propaganda photos of the ghetto are "'images without imagination.' They are just images that have no power." He then offers a categorical reason against the principles of documentary for his subject matter:

> And even if there had been some [historical images], I don't much like montages of archival images. I don't like the voice-over commenting on the images or photographs as if it were the voice of institutionalized knowledge. One can say whatever one wants, the voice-over imposes a knowledge that does not surge directly from what one sees; and one does not have the right to explain to the spectator what he must understand. The structure of a film must itself determine its own intelligibility.[50]

Lanzmann goes on to locate the power of the film precisely in its being composed entirely of speech and gestures surrounding the absence of the images it speaks about: "As a result, it is more thoroughly evocative and powerful than everything else. It so happens that I have met people who are convinced they saw images in the film, ones they hallucinated. The film forces the imagination to work."[51]

Lanzmann, following Sartre, identifies the work of the imagination, which his film compels, as that which demarcates his film from the genre of historical documentary. One might understand his claim to be that the *viewers* are compelled to exercise their imagination in the absence of historical images in the film, as they listen to witnesses give testimony at the site of the crimes (indeed, Lanzmann tells us that the original title for his film was *Site and Speech*),[52] and certainly one source of the film's power is precisely this imaginative task it presents to its viewers. But Lanzmann claims as well that "there are a lot of staged scenes in the film. It is not a documentary,"[53] and he discusses this aspect of the film in terms of theatricality, in which the witnesses are transformed into "protagonists" and even "actors":

> They recount their own history. But just retelling it is not enough. They had to act it out, they had to give themselves over [*irréalisent*] to it. That's what defines imagination: it de-realizes. That's what the entire paradox of the actor is about. They have to be put in a certain state of mind but also into a certain physical disposition. Not in order to make them speak, but so that their speech can suddenly communicate, become charged with an extra dimension.
> . . .

> The simple fact of filming in the present allows these people to
> pass from the status of witnesses to History to that of actors.[54]

The theatrical vocabulary deployed by Lanzmann in these passages clearly delineates an *aesthetic* dimension in counterpoint to the *historical* dimension of the past events recounted in the witnesses' testimonies and thus indicates *prima facie* a specific constellation of the tension between these two tendencies or desiderata of Holocaust artworks. In this vein Lanzmann offers additional aesthetic properties of the film to emphasize its divergence from historical documentary, including the "symphonic" compositional structure of the film eschewing chronological narration in favor of periodically recurring motifs punctuated rhythmically by long spacing shots of rails, landscape, and so on.[55] The film's aesthetic construction and compositional techniques likewise, it could be argued, elicit in part an aesthetic response from the viewer: she perceives repetitions of sounds and images (for example, traveling along rails), recurrences of thematic motifs, silent landscapes of former camps and places of mass execution, "afterimages" of the past in the present. For example, a "Secret Reich Business" memo regarding required modifications to the Saurer trucks used in the mobile gassings at Chelmo in order to increase their lethal efficiency is read aloud, accompanied by footage of driving along a highway in the contemporary Ruhr industrial area of Germany, culminating in a close-up of a Saurer truck.[56] These compositional techniques create a sense of oppressive, engulfing stillness and circularity, within which the stark and horrific testimonies of witnesses take on a further aspect: the miraculous contingency of their speakers' very survival.

However, I think that there is a different, and deeper, aesthetic dimension of the film that lies not in its reception by viewers but in, as Lanzmann first indicates, the "performances" of the witnesses themselves. Although in his comments on the imagination Lanzmann is most likely referring to Sartre's theory, that theory, as we saw earlier, describes above all *objectual* imagination. My claim is that we should understand the role of the imagination *of the witnesses* in terms of *participial imagination*: that we conceive of them as *imagining themselves seeing, experiencing* what they saw during the Holocaust. Sartre's reflections on "the role of affectivity in the consciousness of imitation," with the example of the female music hall performer Franconay's impersonation of Maurice Chevalier, can provide our initial orientation here:

When I see Maurice Chevalier, this perception includes a certain affective reaction. It projects on the physiognomy of Maurice Chevalier a certain indefinable quality that we can call his 'sense'. In the consciousness of imitation, the intended knowledge, starting from signs and the beginnings of intuitive realization, awakens this emotional reaction that comes to be incorporated in the intentional synthesis. Correlatively, the affective sense of the face of Chevalier will appear on the face of Franconay. It is this that realizes the synthetic union of the different signs, it is this that animates their fixed dryness, that gives them life and a certain depth. It is this that, giving to the isolated elements of the imitation an indefinable sense and the unity of an object, can pass for the true intuitive matter of the consciousness of imitation. Finally, it is this object as imaged that we see on the body of the imitator: the signs united by an affective sense, which is to say the *expressive nature*. This is the first time, but not the last, that we see affectivity substitute itself for the intuitive elements peculiar to perception in order to realize the object as imaged.

. . . It is indeed that the relation of the object to the matter of the imitation is here a relation of *possession*. The absent Maurice Chevalier chooses, in order to manifest himself, the body of a woman.

So, primitively, an imitator is one possessed.[57]

Like the Chevalier impersonator in Sartre's text, the witnesses are *impersonating themselves* and, again like the Chevalier impersonator, gestures, props, what Sartre calls a "situation," all contribute to the success of such participial imagination, such that, to speak with Sartre, they become *possessed* by their former selves. It is this possession that Lanzmann attempts to invoke, or incant, by means of the situations in which he places the witnesses. Thus consider Lanzmann's interview with the survivor Abraham Bomba, a professional barber who in Treblinka was forced to cut the hair of victims in the women's and children's undressing barracks, the anteroom to the gas chamber, and who had long since retired and moved to Tel Aviv at the time of the interview. Lanzmann brought him to a barbershop and had him cut hair again while being interviewed, even requesting of him, "Can you imitate how you did it?"[58] [Figure 30]. Koch captures this imaginary-aesthetic dimension well through recourse to the concept of *play*, which can operate in both registers:[59]

[Lanzmann] encourage[s] a certain margin for play. He allows entire scenarios to be played out in a borrowed railroad car, challenging his protagonists to reenact particular gestures and actions. This strategy is no doubt indebted to the concept, central to Sartrean existential psychoanalysis, that there is a physical materiality even prior to the symbolizing process of language—an impudent laugh, the barely

Figure 30. *Shoah*, Abraham Bomba. Still from DVD.

repressed sadistic glee over a threatening gesture. Such material-
ity breaks through only when gestures, physical movements, are
repeated. In playing these, everyone again becomes who he is—that
is *Shoah's* criterion for authenticity, that is the immense visual power
of this film, which so clearly sets it apart from other "interview
films." . . . It is precisely this transformation into play that deter-
mines the seriousness of the representation (*Darstellung*). Indeed,
Lanzmann seduces, lures, and cajoles the protagonists into doing
and saying things that otherwise have remained silenced and hid-
den. . . . What Lanzmann is aiming at here is precisely the problem of
the imagination—whenever something is narrated, an image (*Vorstel-
lung*) is presented, the image of something that is absent. The image,
the imaginary—and here Lanzmann is a loyal Sartrean—is the pres-
ence of an absence which is located outside the spatiotemporal con-
tinuum of the image.[60]

If I understand her correctly, then I take the claim that "everyone again
becomes who he is" to be the claim that the witness is impersonating
his former self; this would be the participial imagination. But the sub-
sequent claim—that "whenever something is narrated, an image (*Vor-
stellung*) is presented, the image of something that is absent"—is less

clear. If "image" here means mental image in the sense of visualization, then Williams's and Warnock's criticisms of Sartre's theory come into play: we can narrate imaginatively without any visualization whatsoever. Koch reads Lanzmann—and more importantly, Lanzmann's film—strictly in keeping with Sartre's theory of the imaginary, but we've seen that that theory is essentially flawed in requiring of *any* act of the imagination the visualization of an object that is absent. What is that object that is absent? For Koch, it is the "annihilation itself":

> Lanzmann remains strictly within the limits of what can be imagined: for that which cannot be imagined, the concrete industrial slaughter of millions, he suspends the concrete pictorial representation. There are no images of the annihilation itself; its representability is never once suggested by using the existing documentary photographs that haunt every other film on this subject. In this elision, Lanzmann marks the boundary between what is aesthetically and humanly imaginable and the unimaginable dimension of the annihilation. Thus the film itself creates a dialectical constellation: in the elision, it offers an image of the unimaginable.[61]

In falling back on the unrepresentability thesis of the Holocaust, Koch falls behind the best aspects of her own interpretation of the role of imagination in *Shoah*.[62] Besides the controversial debate surrounding the scope, nature, and validity of claims of unrepresentability, incomprehensibility, and unspeakability of the Holocaust,[63] the nominalization of "annihilation" entails that at issue here is the objectual imagination that, while correctly representing Sartre's theory of the imaginary, misses the actual employment of the imaginative mode in question: *participial imagination*. Koch's point seems to be that in narrating what they saw, the witnesses elicit in the *viewers'* imaging consciousness, mental images or visualizations of that for which there are no actual, existing historical images—the "annihilation itself." The act of self-impersonation, therefore, Koch must see as simply facilitating the imaginative narration: the gestures and actions serve, like Franconay's props, as an *analogon* by which the *viewers* can better imagine the absent object, the witness as he was at the time of the horror. But in this case the missing object is the witness-at-the-time, what he was doing, which is also what he is narrating—the propositional statements constituting his testimony. Thus it would be much clearer to say that the "missing object" is not the annihilation itself, but rather this particular witness's experience of, *participation* in the Holocaust, and that in remembering his participation, he is engaging in *participial*

imagination. In a seminar on *Shoah* held at Yale University in 1991, Lanzmann accepts that the Bomba interview is "staged," but still contrasts the *mise-en-scène* with representation, rather than participation:

Nico Israel: Could we return to the Bomba question? Did you say that Bomba after the war only cut men's hair or, did he cut women's hair and men's hair.

Lanzmann: That's what I said.

Israel: If that's the case, when you went back to stage the truth, as Dori Laub called it, in Israel, why did you use a setting of all-male customers?

Lanzmann: A men's shop, yes it's a good question.

Israel: Because obviously in staging the scene with the mirror in front, and having them enact a cutting, you're attempting to get at the repression through a kind of mimesis or a recollection. I was wondering why a male customer as opposed to a female customer?

Lanzmann: Yes, it's a good question. I asked this to myself. I think he would not have agreed to do this with women, and I think that I would not have agreed. I think that would have been unbearable. It would not have transmitted, I am sure. It would have been obscene.

Shoshana Felman: It confirms the fact that what you're doing in the staging is not representational.

Lanzmann: Absolutely. The film is not at all representational.[64]

That is, the denial of *Shoah* being representational, or "illustrative" (another descriptor Lanzmann rejects in the same exchange), is compossible with the assertion that the staging of the witnesses effectuates a re-presencing of their former selves, *in propria persona*, as it were.

But if this line of reasoning is cogent, it means that Koch and Lanzmann, in their Sartrean understanding of the role of the imagination in *Shoah*, remain themselves within the framework of representability or historical—that is, propositional—knowledge of the Holocaust. This assumption of propositional knowledge must be supplemented by the second epistemic dimension of testimony: *expressive knowledge*. In imagining participially, that is, imagining themselves seeing and experiencing what they did at that time, in impersonating their former selves, the witnesses *now* adopt those prior attitudes, dispositions, expressions. This is the full import of Koch's felicitous phrasing "everyone again becomes who he is." Lanzmann himself concedes that his audience already knows the history of the Holocaust, that in fact his film *presupposes* such

familiarity with the history, although he also claims that "the Holo-
caust has not been assimilated as a specific historical event, and one
may doubt that it ever will be."[65] His film—the testimonies it con-
tains—does not convey propositional knowledge in the sense of new
information (although the exacting, detailed nature of Lanzman's
questioning should not be discounted), and this is the deeper rea-
son that he so vehemently denies that the film is a documentary.
Rather in the intrusive close-up shots of the survivors' faces as they
are brought back physically to the places of their suffering, and as
they are brought back imaginatively to their former selves, it is the
expressive knowledge manifested in their faces that renders the film
so compelling and absolutely unique.

Perhaps the most disturbing example of such a mise-en-scène
occurs when Lanzmann "places" the survivor Simon Srebnik in front
of the Catholic church in the Polish village of Chelmno, in the midst
of the celebration of the Virgin Mary. As a child Srebnik had worked
for the Nazi death squads in the region, and many villagers now
remember him and are gratified to learn that he survived:

Are they glad to see Srebnik again?

Very. It's a great pleasure. They're glad to see him again because they know
all he's lived through. Seeing him as he is now, they're very pleased.[66]

But as Lanzmann asks the villagers what happened at that time, as
the Jews were locked in the same church, and eventually transported
in gassing vans to their deaths, the account turns to justification for
the genocide:

Do they miss the Jews?

Of course. We wept too, Madam says. And Mr. Kantarowski gave them
bread and cucumbers.

Why do they think all this happened to the Jews?

Because they were the richest! Many Poles were also exterminated. Even
priests.

Mr. Kantarowski will tell us what a friend told him. It happened in Mynd-
jewyce, near Warsaw.

Go on.

The Jews were gathered in a square. The rabbi asked an SS man: "Can
I talk to them?" The SS man said yes. So the rabbi said that around two
thousand years ago the Jews condemned the innocent Christ to death. And
when they did that, they cried out: "Let his blood fall on our heads and on

Figure 31. *Shoah*, Simon Srebnik. Still from DVD.

our sons' heads." Then the rabbi told them: "Perhaps the time has come for that, so let us do nothing, let us go, let us do as we're asked."

He thinks the Jews expiated the death of Christ?

He doesn't think so, or even that Christ sought revenge. He didn't say that. The rabbi said it. It was God's will, that's all!

What'd she say?

So Pilate washed his hands and said: "Christ is innocent," and he sent Barrabas. But the Jews cried out: "Let his blood fall on our heads!"

 That's all; now you know![67]

During this encounter Srebnik is standing in the center of the frame, encircled by the villagers who now ignore him as they excitedly speak to Lanzmann. But the camera remains centered, transfixed on Srebnik, and closes in on his face, which silently registers the chilling "resurrection" of the Holocaust verbally enacted around him [Figure 31]. Here the witness registers his experience in the mode of expressive knowledge, rather than asserting it in the mode of propositional knowledge.[68]

This then is my claim: that there is a very specific *epistemic asymmetry* at work in *Shoah*, between the focalized present facial expressions, expressive knowledge, elicited by the participial imagination of the witnesses on the one hand, and on the other hand the absence of all pictorial illustration (photograph, film footage, documentary-style reenactment, and so on) of the narratives that convey propositional knowledge. Paradoxically, such absence or deemphasizing of the propositional knowledge amounts to a disavowal of the traditional historical relation as found in documentaries. On the contrary, Lanzmann's film locates its historical relation precisely in the participial imagination of those he interviews and the expressive knowledge they thereby manifest. Since this participial imagination is conceived (by Lanzmann, by Koch) in aesthetic terms as a certain kind of play or acting, in that the witnesses are in a rigorous sense impersonating themselves, their former selves, this historical relation is at once also aesthetic. This is one inflection, as it were, of what we can call the *aesthetic-historical imaginary*. Spiegelman's *Maus*, I shall argue, constitutes a second inflection, in fact virtually an inversion of the first.

6. SPIEGELMAN'S *MAUS* AND THE SCHEMATIC IMAGINARY

"Comics" is a word that sometimes gives people problems. As a medium, it's as flexible and has as much potential as, say, film. . . . It's just a medium and what that vessel is filled with is dependent on the artist's interests and needs, as well as the audience's.

—ART SPIEGELMAN[69]

Expression [*Ausdruck*] is a phenomenon of interference, a function of technical procedures no less than it is mimetic.

—THEODOR W. ADORNO[70]

Between the years of 1978 and 1991 Art Spiegelman, an accomplished underground avant-garde cartoonist, created the approximately 250 panels of *Maus I* illustrating the story of his father, Vladek Spiegelman, during the Nazi regime and—within those panels—*reconstituting* his relationship to his father, who died shortly before he completed the volume.[71] In *Maus II* Spiegelman reflected on his ambivalence to the commercial success of the first volume. Critical attention has centered on the work's portrayal of history and

family drama in the context of a genre conventionally termed popular or mass art. As far as I know, no critic has juxtaposed *Maus* and *Shoah* as mirror images (*Spiegelbilder*) of one another, yet each work incorporates into its very construction an *epistemic asymmetry*.[72] In the case of *Shoah*, the film eschews all historical (archival, or reconstructed) images, thus deemphasizing the propositional knowledge while privileging the epistemic source of expressive knowledge: the witness's face as he or she enunciates the story. In the case of *Maus*, Spiegelman privileges the propositional account—Vladek's narrative—while intentionally obscuring the source of expressive knowledge, by rendering the protagonists in the guise of animals: Jews as mice, Germans as cats, Poles as pigs, Americans as dogs, French as frogs, English as fish, and so forth. In the case of *Shoah* we saw how its epistemic asymmetry operated on at least two levels of the imagination: first, the viewers were confronted with current landscapes and the witnesses' own physical gestures that, as *analogon*, constituted the material substrate upon which (in Sartre's terms) the imaging consciousness operated, and second, the witnesses underwent their own possession, via participial imagination, by their former selves. In the case of *Maus*, we shall see that the comic-strip genre and the animal imagery represent an epistemic asymmetry and serve, in classical Sartrean terms, likewise as material *analogon* for the viewer's imaging consciousness.

The historical relation of *Maus* is itself two-fold, comprising the father Vladek's pseudo-verbatim oral testimony of his life during the 1930s and 1940s (narrated time), and the son Artie's autobiographical, ambivalent relation to his father in the present day (time of narration). This second relation, between the generation of the survivors and their successors, between lived experience and the indirect mediated and partial knowledge of "postmemory,"[73] self-reflexively comments on the tensions between restoration and constitution involved in any historical representation. Thus in *Maus I* Spiegelman depicts the vacillations involved in eliciting and understanding Vladek's testimony, and the inevitable and painful lacuna in historical memory (the loss of his mother's diaries from the war),[74] while in *Maus II* he thematizes his own ambivalence, and even self-recrimination, regarding the publication, popularization, and commercialization of his father's testimony. Like no artist before him, Spiegelman's graphic novel has presented the difficulties that beset later generations to come to their *own* terms with the Holocaust.

However, it is the first historical relation, between artistic representation and historical past, which concerns our present inquiry. Although Spiegelman in interviews has conceded that he made editorial emendations to the testimony of his father that he recorded over several years when he came to create the cartoon panels,[75] he preserved the solecisms, inflections, and cadence of his father's imperfect English. In this respect, then, it is the *authenticity* of Vladek's voice, as represented in the comics, that lends historical veracity to his testimony, such that a reviewer in a journal of oral history claims, "*Maus* is not a fictional comic-strip, nor is it an illustrated novel: however unusual the form, it is an important historical work that offers historians, and oral historians in particular, a unique approach to narrative construction and interpretation."[76] Spiegelman reinforces this veridical historical relation in the work by visually reproducing historically accurate illustrations in the cartoon panels. In interviews he provides extensive references to photographic history books of Jewish life in Poland, family photographs, films such as *Shoah*, *Night and Fog*, and *Images Before My Eyes*, as well as his frequent research trips to Eastern Europe, to his father's hometown of Sosnowiec, and to Auschwitz, in order to take photographs. Commenting on his work for the second volume, Spiegelman said in an interview:

> For instance, I'm trying now to figure out what a tinshop looked like in Auschwitz because my father worked in one. There's no documentation whatsoever of that, it's hard to even find out what kind of equipment people used. I happen to be lucky enough to have met somebody who worked in a tinshop in Czechoslovakia in 1930 and so he knows approximately what it was like. And he's trying to describe equipment to me but I have a very poor head for mechanical objects and things like that. It's not something I understand well. So I sort of make little doodles and he says, "Oh no, a little bit smaller with a kind of electric motor that attaches to a belt to a ceiling thing." So I'm getting some sense of it.[77]

At one point in an interview Spiegelman himself draws the analogy between comics and film regarding the question of historically accurate images:

> Ok, so you type and write, "marched past the gate." Here you've got to find out what the weather was like, what were they wearing, how many of them were there, did they march three across, four across, five across, did the guards stand on the sides, at what points did they stand, which gate did they march through. There's a million things to solve, in that sense analogous to film, where you've got to concretely

visualize every moment. In film, most Holocaust films are quite unsatisfactory because there's just something so goofy about seeing all these well-fed actors in this context, which just immediately shatters one's ability to see into it.[78]

We thus find Spiegelman undertaking precisely the painstaking will to *visual* documentary veracity in his illustrations of his father's testimony that Lanzmann vehemently eschews in *Shoah*.

Some critics correctly note that this tendency toward historical veracity in Spiegelman's visual depictions of his father's testimony is undercut by his use of nonrealistic conventions of comics as a mode of artistic presentation.[79] Thus he will use cross-hatching on a figure's face to indicate embarrassment,[80] convey suspense through symbolic forms,[81] and even draw on traditional comic forms of presenting slapstick humor.[82] The genre conventions of the comic, a kind of semiotic short-hand, thus provide one way in which historical veracity and accuracy is counterpointed by aesthetic considerations of presentation.

Yet these isolated instances of the nonrealist comic conventions fail to capture the categorical role of the *imagination* in the perception and comprehension of comics, a role that Spiegelman himself, perhaps unwittingly invoking Sartre, clearly understands. He prefers to name his chosen medium not comics but "commix, to mix together, because to talk about comics is to talk about mixing together words and pictures to tell a story."[83] In his intriguing history of the comic form, Spiegelman likens the perception of commix to the general function of what Sartre would call schematic imaging consciousness:

> The direct fusing of words with pictures that is inherent in comics approximates the way the human brain actually formulates thoughts. You see someone you know walking down the street. He has just grown a beard and is wearing a funny hat, but you still recognize him. Your brain has matched the new image of him with all its previous images of that person. The elements all those images have in common, those "permanent signs," are the same ones a caricaturist uses. In a society that is becoming increasingly visual (which may just be a polite way of saying semi-literate), comics are the literature of the future.[84]

In a later interview Spiegelman again emphasizes the cognitive function of what could be called abstracted, visual schemata in everyday perception:

Because they deal in essences, rather than nuanced description, comics move into the way, I believe, the brain works, which is in encoded, simplified images and concentrated verbal clusters. One not only thinks in words, but in images as well. Yet those images are very stripped down. We don't even think photographically, which is already a simplification of reality, but in terms of high-definition imagery. Not necessarily with the humorous notion that a caricature would bring up, but in kind of a set of caricatures. In other words, if you are thinking about a friend, you will remember their gait, let's say, or a pronounced brow or a specific kind of clothes they often wear, or a specific body gesture. There are very highlighted and exaggerated visuals that you conjure up. This is a description of how the brain recalls things and also a description of what comics are.[85]

Spiegelman here attributes a certain kind of perceptual consciousness to the reader of comics, which he generalizes as a form of imagination; in this way Spiegelman can claim that "comic-strip drawing isn't really drawing at all, but rather a kind of *diagramming*,"[86] and that "the cartoon is schematic simplified drawing, usually involving exaggeration or distortion."[87] Or more categorically: "Cartoons echo the most fundamental processes of cognition."[88]

Sartre's theory of the imaging consciousness provides just the theoretical framework for Spiegelman's understanding of his medium and its cognitive processing. In schematic drawings, caricatures, and so on, Sartre holds that "the intuitive element is considerably reduced, and the role of conscious activity increases in importance: what constitutes the image and compensates for all the failures of perception is the intention":

The schematic drawing is constituted by schemas. Caricaturists, for example, can represent a man by means of some black lines without depth: one black point for the head, two lines for the arms, one for the chest, two for the legs. It is characteristic of the schema that it is intermediate between the image and sign. Its matter demands to be deciphered. It aims only to present relations. By itself it is nothing. Many are indecipherable if one does not know (*connaît*) the system of conventions that is the key; most require an intelligent interpretation; they have no genuine resemblance to the object they represent. Nevertheless they are not signs because they are not considered as such. In these few black lines I intend a man who is running. The knowledge aims at the image, but is not itself an image: it slips into the schema and takes the form of intuition. . . .

But it is enough of a rudiment of representation for all the knowledge to be weighed down there, thus giving a kind of depth to this flat figure. Draw a little man on bended knee with arms raised in the air:

you will project on his face an indignant amazement. But you will not *see* it there: it is there in a latent state, like an electric charge.[89]

Sartre's essential insight in the case of schematic drawings and caricatures is that due to the reduction of intuitive material in the analogon, the imaging consciousness, by means of the knowledge and affective sense the perceiver bears toward the minimally represented object, must *project* the cognitive and affective reactions onto the intentional object: "In every case, indeed, we meet this very distinctive phenomenon: knowledge enacts a symbolic mime and a mime that is hypostatized, projected onto the object."[90] Beliefs and affective sense inform the movements of the perceiver's eyes as he "reads" a caricature, such that "eye movements organize the perception, carve out the spatial environment, determine the fields of force, transform the lines into vectors"; "so that, we now see, the representative elements in the consciousness of a schematic drawing are not the lines properly called, but the movements projected onto these lines."[91] Imaging consciousness animates the matter, the cartoonist's drawings, by means of projection so as to supplement the minimal analogon and constitute the intentional relation to the object: "some knowledge came to interpret [the analogon] and fill in the gaps."[92] Schematic drawings come quite late in Sartre's presentation of progressively etiolated matter of the analogon, for their reduced matter (as compared with photographs, portraits, impersonations) entails that the imaging consciousness must make a proportionally greater contribution to the "mental image." Thus the faculty of the imagination plays a greater role than in the case of classically mimetic realism, by projecting one's cognitive beliefs and affective sense and even kinetic eye movements into the cartoonist's renderings. That is, the historical veracity and authenticity of Vladek's oral testimony is counterpointed by the role of the reader's *objectual* and *propositional* imagination in the schematic illustrations accompanying the testimony.

However, Spiegelman's brilliant innovation is to extend such schematic imaging consciousness to the *faces* of his characters [Figure 32]. A great deal has been written, by critics and by Spiegelman himself, concerning the artist's use of animal imagery for his characters. Spiegelman recounted the genesis of the idea in an interview, worthy of quotation at length:

> I asked Spiegelman how he'd hit upon the idea. "It goes back to
> that *Funny Animals* comic anthology I told you about before," he

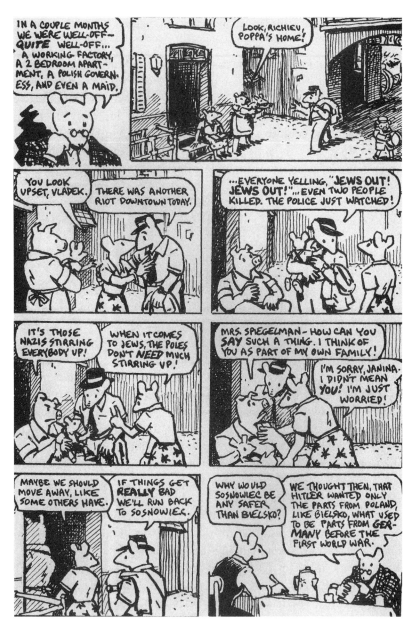

Figure 32. *Maus I*, p. 37. From *MAUS I; A SURVIVOR'S TALE/MY FATHER BLEEDS HISTORY*, by Art Spiegelman, copyright © 1973, 1980, 1981, 1982, 1984, 1985, 1986 by Art Spiegelman. Used by permission of Pantheon Books, a division of Random House, Inc.

explained. "Along with several of the other underground-comics people out in California, I had been invited to contribute a strip to his anthology of warped, revisionist animal comics. Initially, I was trying to do some sort of Grand Guignol horror strip, but it wasn't working. Then I remembered something an avant-garde-filmmaker friend, Ken Jacobs, had pointed out back in Binghamton [where Spiegelman went to university], how in the early animated cartoons, blacks and mice were often represented similarly. Early animated cartoon mice had 'darkie' rhythms and body language, and vice versa. So for a while I thought about doing an animal strip about the black experience in America—for about forty minutes. Because what did I know about the black experience in America? And then suddenly the idea of Jews as mice just hit me full force, full-blown. Almost as soon as it hit me, I began to recognize the obvious historical antecedents—how Nazis had spoken of Jews as 'vermin,' for example, and plotted their 'extermination.' And before that back to Kafka, whose story 'Josephine the Singer, or the Mouse Folk' was one of my favorites from back when I was a teenager and had always struck me as a dark parable and prophecy about the situation of the Jews and Jewishness."

"Having hit upon the metaphor, though, I wanted to subvert it, too," continued Spiegelman, the veteran deconstructionist, lighting up again. "I wanted it to become problematic, to have it confound and implicate the reader. I included all sorts of paradoxes in the text—for instance, the way in which Artie, the mouse cartoonist, draws the story of his mother's suicide, and in his strip (my own "Hell Planet" strip), all the characters are *human*. Or the moment when the mother and father are shown hiding in a cramped cellar and the mother shrieks with terror because there are 'Rats!' All those moments are meant to rupture the metaphor, to render it absurdly conspicuous, to force a kind of free fall. I always savored that sort of confusion when I was a child reading comic books: how, for instance, Donald Duck would go over to Grandma Duck's for Thanksgiving and they'd be having turkey for dinner!"

"But it's funny," Spiegelman continues. "A lot of those subtleties just pass people by. In fact, I remember how I was over at my father's one evening soon after I'd published the three-page version of 'Maus.' As usual, he had several of his card-playing buddies over—all fellow camp survivors—and at one point he passed the strip around. They all read it, and then they immediately began trading anecdotes: 'Ah, yes, I remember that, only with me it happened like this,' and so forth. Not one of them seemed the least bit fazed by the mouse metaphor—not one of them even seemed to have noticed it! A few days later, I happened to be making a presentation of some of my work at this magazine. I was sitting out in the art editor's waiting room with a couple other cartoonists, old fellows, and I pulled out 'Maus' and showed it to them. They looked it over for a while and began conferring: 'Kid's a good mouse man,' one of the said. 'Yeah, not bad on

cats, either,' said the other. Utterly oblivious to the Holocaust subject matter."[93]

Interestingly, the two communities of reception Spiegelman describes—camp survivors and fellow cartoonists—differ in their reactions to the comic along precisely historical lines on the one hand, and aesthetic ones on the other.

The various, and oftentimes ingenious, motivations and interpretations offered for Spiegelman's casting Jews as mice and Germans as cats include the following:

1. The dehumanizing of Jews as "vermin" in Nazi propaganda, for example, the film *The Eternal Jew*.[94] The epigraph to *Maus I* is comprised entirely of a quotation from Hitler: "The Jews are undoubtedly a race, but they are not human." In an interview Spiegelman elaborates:

 > *Maus*, my comic book about my parents' life in Hitler's Europe, which uses cats to represent Germans and mice to represent Jews, was made in *collaboration* with Hitler. (Now will I have to share my Pulitzer?) It was the *Nazis'* idea to divvy the human race up into species, into *Übermenschen* and *Untermenschen*, to "exterminate" (as opposed to murder) Jews like vermin, to use Zyklon-B—a pesticide—in the gas chambers. My anthropomorphized mice carry trace elements of Fips's anti-Semitic Jew-as-rat cartoons for *Der Stürmer*, but by being particularized they are invested with personhood; they stand upright and affirm their humanity.[95]

2. The figuring of Jews as mice performs a kind of poetic justice, motivated by Spiegelman's belief that Hitler banned Mickey Mouse from Germany as a Jewish art-form.[96]

3. Specific properties, relations, and functions codified by the animal symbolization, for example, cats predating on mice, dogs (Americans) being naïve, frogs as a stereotype of the French, and so on. Most interesting in this regard is Spiegelman's choice of pigs to depict Poles: "He chose pigs to represent Poles because they were non-Kosher, and because although they were outside the immediate 'food chain' of the farmyard, where cats kill mice, they were destined to eventually die."[97]

4. Closely related to the previous point is the tradition in Western literature of allegorizing human characteristics with

specific animal species, for example, Aesop's fables, Orwell's *Animal Farm*, and so on.

5. More generally, the animal imagery has been interpreted as thematizing the inhumanity particular to the Holocaust. In a trenchant review of *Maus I*, Adam Gopnik eloquently expresses this line of interpretation:

> At the heart of our understanding (or our lack of understanding) of the Holocaust is our sense that this is both a human and an inhuman experience. . . . This overlay of the human and the inhuman is exactly what *Maus*, with its odd form, is extraordinarily able to depict. One the one hand this is entirely a history of the motives and desires of particular people, the story of Vladek and Anja's hundred individual decisions, failures, betrayals, and disappointments. On the other hand it is a history in which all human intention has been reduced to the hunted animal's instinct for self-preservation, in which all will and motive has been degraded to reflex. The heart-wrenching pathos of *Maus* lies in its retrospective, historical sense: Art, drawing *Maus*, knows that Vladek and Anja are finally as helpless and doomed as mice fleeing cats—but *they* still think that they are people, with the normal human capacity for devising schemes and making bargains.[98]

6. Some critics have interpreted the "animal masks" as a device to represent indirectly what is too horrible to be presented directly. Thus Gopnik likens *Maus*'s animal imagery to medieval Ashkenazi visual depictions of the Passover using figures with the bodies of humans and the heads of animals to depict a subject too holy to be represented directly. In both the thirteenth century Bird's Head Haggadah and *Maus*, Gopnik claims, "The homely animal device is able to depict the sacred by a kind of comic indirection."[99] Andreas Huyssen, drawing on Adorno's concept of *mimesis* as a making similar (*Angleichung*) that retains difference within similitude, interprets the animal imagery as a means of negotiating traumatic memory: "Drawing the story of his parents and the Holocaust as an animal comic is the Odyssean cunning that allows Spiegelman to escape the terror of memory . . . while mimetically reenacting it."[100]

7. Spiegelman has also voiced the supposition that, had he portrayed people realistically, then on the one hand he would be pretending to an authenticity to which he is not entitled, and on the other his story would run a greater risk of

sentimentalism; for these reasons he calls the animal images
"ciphers":

> First of all, I've never been through anything like that—knock
> on whatever is around to knock on—and it would be a coun-
> terfeit to try to pretend that the drawings are representations
> of something that's actually happening. I don't know exactly
> what a German looked like who was in a specific small town
> doing a specific thing. My notions are born of a few scores of
> photographs and a couple of movies. I'm bound to do some-
> thing inauthentic.
> Also, I'm afraid that if I did it with people, it would be
> very corny. It would come out as some kind of odd plea for
> sympathy or "Remember the Six Million," and that wasn't my
> point exactly, either. To use these ciphers, the cats and mice, is
> actually a way to allow you past the cipher at the people who
> are experiencing it. So it's really a much more direct way of
> dealing with the material.[101]

Similar reasoning may be at work in Spiegelman's claim during an
interview with James E. Young, that "I need to show the events and
memory of the Holocaust without showing them. I want to show the
masking of these events *in* their representation."[102]

Without dismissing any of these lines of interpretation regarding
the role of animal imagery in *Maus*, I want to develop a related com-
ment Spiegelman made in an interview: "Cartoons personalize; they
give *specific* form to stereotypes. In *Maus*, the mouse heads are masks,
virtually blank, like Little Orphan Annie's eyeballs—a white screen
the reader can project on."[103] The fortuitous coincidence of the verb
"project" (I know of no evidence that Spiegelman has read Sartre on
the imagination) suggests a more profound affinity. We have already
seen that the meticulous research Spiegelman undertook during the
years of composing *Maus* served to visually subtend his father's oral
testimony and its *propositional knowledge*—the events as his father
related them. But Spiegelman's masking of the *faces* of his protago-
nists *artistically obscures* the means by which the reader might derive
expressive knowledge of his father's—and others'—experiences. In
the quote above the specific nature of the animal imagery (which
species for which nationality, and so on) goes unmentioned, for the
point is that the reader is to be denied the human expression of—and
hence also the opportunity of human responsiveness to—the horren-
dous events related by Vladek's testimony. Or rather, such expres-
siveness and responsiveness will operate via the reader's "imaging

consciousness," through her projection, cognitively and affectively, onto the schematic drawings, thus intending the imagined person through his or her schematic analogon. Indeed, Spiegelman portrays himself in *Maus I* and *II* as wearing a mouse mask, literalizing his own artistic process of de-facement and raising the role of projection to the second order: the reader is summoned to project not only onto the protagonists of Vladek's story, but onto the protagonist of Artie's story as well [Figures 33 and 34]. If there is a redemptory aspect in *Maus*, it is the reader's imaginative projection of humanity into the cartoon panels. This, too, as in *Shoah*, is a kind of resurrection. Perhaps Spiegelman says as much when he insists that his book requires the role of *reader*, not *looker*:

> I didn't want people to get too interested in the drawings. I wanted them to be there, but the story operates somewhere else. It operates somewhere between the words and the idea that's in the pictures and in the movement between the pictures, which is the essence of what happens in a comic. So by not focusing you too hard on these people you're forced back into your role as reader rather than looker.[104]

I thus disagree with James E. Young in his praise of *Maus* as an "antiredemptory" Holocaust artwork *simply* in virtue of the comics' genre, characterized as a nontotalized, nontotalizable juxtaposition of word and image, holding that the genre

> also suggests itself as a pointedly antiredemptory medium that simultaneously makes and unmakes meaning as it unfolds. Words tell one story, images another. Past events are not redeemed in their telling but are here exposed as a continuing cause of the artist's inability to find meaning anywhere. Meaning is not negated altogether, but whatever meaning is created in the father's telling is immediately challenged in the son's reception and visualization of it.[105]

Certainly the juxtaposition of word and image in comics as a genre potentially can disrupt certain notions of meaning such as linear narrative, the Aristotelian unities of time and space, narrative coherence and visual consistency, and so forth. If meaning is equated with coherence (for example, the reader's curiosity is completely satisfied by the conclusion of the book), then certainly *Maus* does not provide *that kind* of meaning, not in virtue of its comic-form particularly, but rather in virtue of the irretrievable loss of Anja's diaries, Vladek's unreliable memory, and so on. A second possible notion of meaning at play is *representational totality*, the idea that the meaning of an artwork is, as it were, a completely coherent, exhaustive *translation* of it

Figure 33. *Maus I*, rear flap. From *MAUS I; A SURVIVOR'S TALE/MY FATHER BLEEDS HISTORY,* by Art Spiegelman, copyright © 1973, 1980, 1981, 1982, 1984, 1985, 1986 by Art Spiegelman. Used by permission of Pantheon Books, a division of Random House, Inc.

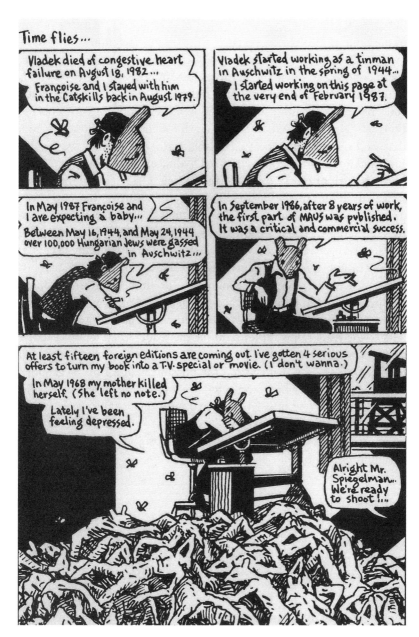

Figure 34. *Maus II*, p. 41. From *MAUS II: A SURVIVOR'S TALE/AND HERE MY TROUBLE BEGAN* by Art Spiegelman, copyright © 1986, 1989, 1990, 1991 by Art Spiegelman. Used by permission of Pantheon Books, a division of Random House, Inc.

into another medium, say conceptual understanding. It is this notion of meaning that often serves as a straw man in arguments for postmodern artworks and their interpretation that emphasize incomplete, fragmentary, and open-ended forms of aesthetic experience. It is this unmediated opposition, between traditional holistic and coherentist conceptions of meaning on the one hand, and postmodern conceptions of their subversion on the other, that underwrites Young's claim that *Maus* is antiredemptory. But this framework, as we saw in the Introduction, must itself be subjected to dialectical rethinking and, for each artwork of our inquiry, closer reading. On the one hand, *Maus* strives to maintain the historical relation of veracity and authenticity with regard to Vladek's oral testimony; in this way Vladek's testimony, reinforced by historically accurate illustrations by his son, proffers recognizable *propositional knowledge* relating the events of his and others' lives, to the extent that Vladek's testimony is itself historically accurate. Yet, Spiegelman's use of animal imagery to mask or *disfigure* his protagonists' faces disrupts and prevents any *expressive knowledge* and its elicitation of any corresponding responsiveness in the reader, but rather requires the reader's active, imaginative projection together with the consciousness that such a requirement forever removes the reader from the possibility of a full, or genuine, response, no matter how accurately the events are narrated or illustrated. The tension between these two moments is the specific inflection in which the negative-dialectical aesthetic-historical imaginary operates in *Maus*: the reader's imaginative projection is at once both redemptory and foreclosed.

7. DESCRIPTION AND EXPRESSION

Perennial suffering has as much right to expression as the tortured has to scream; for that reason it may have been erroneous to claim that no more poetry can be written after Auschwitz.

—THEODOR W. ADORNO [106]

I want to draw together the observations and arguments presented in previous sections in order to develop a distinctly epistemic variant of the minimal framework presupposed by each chapter of this book. We can explicate more carefully the relationship in *Shoah* and *Maus* between propositional knowledge and expressive knowledge by considering recent work on the epistemology of testimony in Anglophone

philosophy. Here the relevant debate centers on the epistemic sta-
tus of testimony, that is, the basis upon which we should accept the
assertions of others as knowledge, even assuming that the speaker is
warranted or justified in the belief she asserts to us. While the belief
expressed in the speaker's assertion may ultimately have derived from
a different kind of epistemic source (for instance, perception or mem-
ory), what warrant does the audience have to accept her asserted
belief as true, that is, as knowledge? The *evidential view* holds that a
speaker's assertion should be considered *evidence* for the belief being
asserted, and the question then concerns the epistemic status of the
assertion-as-evidence. Reductionists hold that testimony itself, unlike
perception, is not a fundamental source of warrant: instead, the war-
rant of testimony is derived from other, irreducible sources of jus-
tification such as perception, memory, and induction. Hume is the
historical proponent of this view, when he claims that "our assur-
ance in any argument of this kind [from testimony] is derived from
no other principle than our observation of human testimony, and of
the usual conformity of facts to the reports of witnesses."[107] That
is, we accept what a witness tells us because her reports in the past
have been reliably accurate. This inductive inference is susceptible to
Hume's famous skeptical charge of circularity regarding induction,
and historically elicited what could be called the dogmatic version
of reductionist evidentialism in Thomas Reid: any assertion is *prima
facie* worthy of acceptance until proven otherwise, since God has
implanted in us both a principle of veracity, a "propensity to speak
the truth," and a principle of credulity, "a disposition to confide in the
veracity of others, and to believe what they tell us."[108] Both Humean
skepticism and Reidian dogmatism issue from the shared assumption
that a speaker's testimony can be reduced to a more fundamental
source of epistemic warrant.

However, proponents of an antireductionist, antievidentialist view
argue that testimony possesses its own *sui generis* source of epistemic
warrant. The view that most agrees with our discussion so far is the
so-called *assurance view* of Richard Moran, developing ideas first
proposed by Angus Ross.[109] On this view, which draws on Gricean
semantic theory, bearing witness is akin to promising: the speaker's
act of giving testimony manifests the self-conscious intention of the
speaker to be held accountable by the listener for the veracity of her
testimony in virtue of the listener's very recognition of that speaker's
intention. In the basic case, as Moran introduces his view, "it is the

speaker who is believed, and belief in the proposition asserted follows from this" such that "believing the person (as opposed to believing the truth of what is said) is a legitimate, and perhaps basic, source of new beliefs."[110] Moran draws the basic distinction between the evidential and the assurance views as follows:

> On the evidential view, dependence on the freedom of the other person just saddles us with an additional set of risks; now we have to worry not only about misleading (natural) evidence, but deliberate distortion as well. On the assurance view, dependence on someone's freely assuming responsibility for the truth of P, presenting himself as a kind of guarantor, provides me with a characteristic reason to believe, different in kind from anything provided by evidence alone.[111]

Thus the implicit assurance or guarantee given by the speaker through her intentional asserting of testimony constitutes an independent source of epistemic warrant for the truth of her assertion, irreducible to some other source of epistemic justification (such as perception, memory, or induction). Just as a speaker's intentionally voicing a promise to you is *ipso facto* a reason to hold her accountable for that promise, so too, argues Moran, a witness's intentionally bearing testimony is *ipso facto* a reason to hold her accountable for the veracity of that testimony:

> If, unlike a piece of evidence, the speaker's words have no independent epistemic value as a phenomenon, then how do they *acquire* the status of a reason to believe something? It seems that this can only be by virtue of the speaker's there and then explicitly *presenting* his utterance as a reason to believe, with this presentation being accomplished in the act of assertion itself. The epistemic value of his words is something publicly conferred on them by the speaker, by presenting his utterance as an assertion. And indeed, it is *because* the speaker's words have no independent status as evidence that their contribution to the audience's belief must proceed through the recognition of the speaker's intention. . . . The speaker's intent then, is that for the audience, the very fact that this speaker is freely and explicitly presenting P as worthy of belief constitutes his speech as a reason to believe that P.[112]

Moreover, on the assurance view, the epistemic warrant for a speaker's testimony, as in the related case of promising, is moral: the speaker is conferring an epistemic warrant upon her testimony in virtue of the mutually recognized attitude of assurance she implicitly undertakes in making her assertion. "It is not just that a particular free action is seen to have some epistemic import, but rather that the epistemic import of what he does is dependent on the speaker's attitude toward

his utterance and presentation of it in a certain spirit, whereas by contrast, it is in the nature of genuinely evidential relations that they are not subject to anyone's conferral or revocation." This "attitude" or "spirit" is ethical in nature, as is the attitude or spirit in which a promise is made.[113]

This assurance view of the ethico-epistemic warrant for testimony provides insight into the aesthetic constructions of *Shoah* and *Maus*, and also of Dori Laub's reflections on the ethical response to Holocaust witnesses. Lanzmann has constructed his film so that the viewer is confronted with the witness bearing testimony in a context in which virtually all evidential relations to that testimony have been removed. That is, the lack of historical film footage or photographs, because the Nazis strove to eradicate not only peoples but also the evidence of their eradication, is conjoined with the temporal disjunction: the sites of testimony, the sites of the Nazi crimes, thirty to forty years later, are likewise largely bereft of evidential warrant. As a result, the viewer is compelled to enter into precisely the ethical relation Moran adumbrates, to attend to the attitude and spirit of the witness, who is the *sole* source of epistemic warrant during these scenes.[114] I would suggest that the compelling power of these scenes derives at least in part from precisely the frailty and solitude of the witness's spirit made manifest during his testimony, which earlier we termed *expressive knowledge*.

Moran's assurance view can also illuminate our earlier discussion of Dori Laub's reflections on listening to Holocaust witnesses. The historians who raised skeptical doubts about the veracity of the witness's testimony, once it was ascertained that she had erred regarding the number of chimneys blown up during the rebellion in Auschwitz, clearly have adopted a reductionist, evidential view of testimony. They are treating the witness's statements as though they can be completely divorced from her enunciation of them, and are then inquiring about the epistemic warrant for those assertions: How good was her perception, her memory, can we accept her statements based on induction on her previous (un)reliability, and so on? Moran's analysis allows us to interpret Laub's ethical response of *respect* toward the witness slightly differently. Moran evokes the ethical attitude and spirit of the speaker only at the conclusion of his article and does not develop the notion further, but we can. Moran assumes that the attitude, with the usual *ceteris paribus* qualifications (asserted sincerely, under conditions enabling communication, to the proper audience,

and so on), is tantamount to the issuing of a guarantee or assurance and hence constitutes a reason to believe the speaker's testimony. But in the case discussed by Dori Laub, the speaker's testimony is factually false, while the attitude adopted is one of fervent sincerity. While Moran considers cases where one might not believe the person (for example, the speaker is a con man) and hence have a reason not to believe his testimony, he does not consider the converse case: where we have a reason to believe the witness, *despite* the factual inaccuracy of her testimony, *in virtue* of the attitude or spirit she manifests in making her testimony. Here, expressive knowledge and propositional knowledge come apart, and yet—this is, I believe, Laub's reaction, expressed differently—we still recognize, honor, and respect the ethical undertaking by the speaker. Consider a parallel case where a speaker is making a sincere promise to you while you know that due to conditions unknown to the speaker and beyond his control, it will be impossible for him to fulfill his sincere promise. Nonetheless you would recognize, honor, and respect the ethical undertaking that the speaker has, in virtue of his sincere act of promising, made to you, the accountability he has freely taken upon himself toward you.

When we turn to *Maus* we find even a more complicated situation. It soon becomes apparent that Vladek is not a completely reliable narrator of his own life story, for reasons of fallible memory, but also guilt, rationalization (he destroyed his wife's notebooks), and the fact that he was a bit of a con man himself before the war. But it is equally apparent that Artie (Spiegelman's depiction of himself in the comic book) hopes to rebuild their relationship by means of his recording Vladek's testimony. Spiegelman in various interviews has emphasized this motivation in the genesis of *Maus*: "As an adult I never really had a relationship with my father outside interviewing him—that was the relationship. We found a common ground even though it meant keeping the microphone as a wall between us."[115] Thus here the assurance view, the ethical bond between the witness and the addressee, is thought to engender a broader, emotional bond between father and son. This motivation might go some way toward explaining *why* Spiegelman goes to such lengths to research the panels in which he illustrates his father's testimony, for in doing so he is providing the evidential relations to lend credence to Vladek's testimony; he is reinforcing via historically accurate illustrations the evidential justification for the propositional knowledge asserted by Vladek, given that the epistemic warrant implied by Vladek's attitude and spirit is less than

ideal. The assurance view also provides yet another interpretation of why the people in *Maus* are troped as animals: given the wayward memory and questionable sincerity of Vladek, Spiegelman could not portray human faces as connected to their testimonies in the direct way Moran's model stipulates, for it's not clear to what extent Vladek might still be a "con man." If this line of reasoning is cogent, then masking the human faces is itself an aesthetic indication of the fallibility of *these* human faces to convey sincerely expressive knowledge.

We have therefore recast our interpretations of *Shoah* and *Maus* in epistemic terms to arrive at a new *Laocoön*. We have shown how the specific aesthetic choices made by Lanzmann and Spiegelman can be interpreted in light of the epistemic limitations those choices place on the understanding of witnesses' testimony and the role of imagination afforded by the complex interplay of those formal aesthetic means. In this way, imagination mediates between the historical and aesthetic relations specifically constructed in *Shoah* and *Maus*, in virtue of the *epistemic interferences* between propositional knowledge and expressive knowledge in each of those works, and the "pregnant moments" produced by their epistemic asymmetries. It is for these reasons at least in part, I contend, that both works, as inverted inflections of the aesthetic-historical imaginary, deserve their near-canonical status as successful Holocaust artworks.

Conclusion

The Morality of Holocaust Art

Not experience alone but only thought that is fully saturated with experience is equal to the phenomenon. . . . To whoever remains strictly internal, art will not open its eyes, and whoever remains strictly external distorts artworks by a lack of affinity. Yet aesthetics becomes more than a rhapsodic back and forth between the two standpoints by developing their reciprocal mediation in the artwork itself.

—THEODOR W. ADORNO[1]

The preceding chapters have offered philosophical analyses of specific Holocaust artworks as fulfilling, in different but exemplary ways, the dual desiderata of the normatively minimalist framework by maintaining both a historical and an aesthetic relation, the two normative constraints on Holocaust artworks that we have identified. In conclusion, I want to suggest that the normative *source* of each desideratum is specifically moral in nature.

The source of the desideratum of historical accuracy and authenticity in the context of the Holocaust extends beyond the obligation to remember the dead in virtue of what Berel Lang has aptly termed "the moral enormity" of the Holocaust.[2] He has proposed what he calls "the moral radical of historical representation" as an attempt to measure the historian's moral burden when weighing alternative interpretations or representations of historical events, whereby the extent of the difference between representations is multiplied by the moral consequences of the issue for the present-day "moral community" and its cohesiveness.[3] Unfortunately, Lang's *consequentialist* construal of the moral obligation to historical accuracy can undercut the force of that very obligation: a false or otherwise factually misleading representation that nonetheless increases general public awareness of the Holocaust, or otherwise strengthens the cohesiveness of one's moral community, would be justified by Lang's argument, as he

himself acknowledges in his endorsement of popularizing Holocaust films and books.[4]

Rather than relying on potentially self-undermining consequential-ist lines of argument, Avishai Margalit explicates the moral enormity of the Holocaust, and the resultant injunction that it be remembered accurately, in terms of the Holocaust's direct assault on our most common notion of morality and humanity altogether:

> Radical evil consists, I suggest, of acts that undermine the very foun-dation of morality itself. Nazi eliminative biologism, as exercised in the elimination of Jews and Gypsies as subhuman, was a direct onslaught on morality itself. Such an attack on morality should be recorded and remembered. And with it, gross crimes against human-ity that undercut the root of morality, that is, shared humanity . . . [5]

Habermas likewise understands the Holocaust as a denial of our notion of a shared humanity:

> Something happened there [in Auschwitz] that no one could previ-ously have thought even possible. It touched a deep layer of solidar-ity among all who have a human face. Until then—in spite of all the quasi-natural brutalities of world history—we had simply taken the integrity of this deep layer for granted. At that point a bond of naiveté was torn to shreds—a naiveté that as such had nourished his-torical continuities. Auschwitz altered the conditions for the continu-ation of historical life contexts—and not only in Germany.[6]

Margalit and Habermas identify the moral import of the Nazi ideology in its utter rejection of our *constructivist* notion of morality as shared humanity, a constitutive ideal that grounds our self-conception as ratio-nal agents in a moral community.[7] The moral injunction to represent accurately the Holocaust is in effect the moral injunction to re-mem-ber, to literally re-collect and reaffirm our own moral self-conceptions. Thus Margalit: "The source of the obligation to remember, I maintain, comes from the effort of radical evil forces to undermine morality itself by, among other means, rewriting the past and controlling collective memory."[8] The moral basis of the historical injunction to remember the victims and how they perished thus reaches backward to the dead, as when Adorno tell his students, "We can render the only service to the victims of which we are still capable: not to forget them,"[9] but also reaches forward, for the act of remembrance is *ipso facto* the reaffir-mation of our moral self-conception, as when Margalit writes, "Nazi crimes carried out by an ideology that denied our shared humanity are glaring examples of what morality requires us to remember."[10]

With regard to the source of normativity for the aesthetic constraint on Holocaust artworks, we find at least two possibilities. The first source is simply that of a *nonmoral* criterion of identity: in order to be an artwork at all, an object must demonstrate some aesthetic property or other. Even if we espouse an institutional theory of art, whereby art is defined *de facto* as whatever institutional authorities (critics, museums, publishers, galleries) recognize as art, we can hold that such works have a counterfactual dispositional property to be granted the status of art under certain (institutional, say) conditions. Or we can assume a functional definition of aesthetic properties: an aesthetic property is that property in virtue of which a thing is perceived or experienced, under certain conditions, aesthetically. Either of these definitions of aesthetic property, while controversial, is enough to ground the normative requirement that an artwork maintain an aesthetic relation.[11]

The second possible source of the aesthetic normative constraint, however, can be found in Adorno's philosophy, and it is a distinctly *moral* source. In *Negative Dialectics* Adorno posited a "new categorical imperative":

> Hitler has imposed a new categorical imperative on human beings in their state of unfreedom: to arrange their thoughts and actions in such a way that Auschwitz should never be repeated, that nothing of the sort should ever happen again. This imperative is as resistant to explanation as was the given nature of Kant's imperative in its day. To treat it discursively would be an outrage: it gives us a bodily sensation of an external moral factor. 'Bodily,' because it represents our active sense of abhorrence in the face of the intolerable physical pain to which individuals are exposed.[12]

The bodily sensation providing "an external moral factor" is a noncognitive physical response to one's environment, the nonconceptual, and hence nondialecticizable, immediate corporeal reaction to the world. Because art is, as Hegel recognized, not merely conceptual but also sensuous materiality as mode of expression, aesthetic experience is also in part bodily responsiveness.

Recently critics have come to understand Adorno's infamous dictum "to write poetry after Auschwitz is barbaric" not as evidence of the unrepresentability or uniqueness of the Shoah,[13] but rather as what Adorno called the "antinomy of culture and barbarism" at the historical juncture when culture and barbarism have become virtually indistinguishable because of the near total "absolute integration"

of individual autonomy and critical intelligence into economic and social-psychological processes of subsumptive and collective identification.[14] In his postwar lectures he explicitly identified late capitalism and its tendency toward reified thinking as at the very least enabling conditions for what happened in Auschwitz and after: "Genocide is absolute integration. One might say that the pure identification of all people with their concept is nothing other than their death."[15] In the same lectures he revisited the antinomy of culture and barbarism, and offered this gloss:

> I once said that after Auschwitz one could no longer write poetry, and that gave rise to a discussion I did not anticipate when I wrote those words. . . . I would readily concede that, just as I said that after Auschwitz one *could not* write poems—by which I meant to point to the hollowness of the resurrected culture of that time—it could equally well be said, on the other hand, that one *must* write poems, in keeping with Hegel's statement in his *Aesthetics* that as long as there is an awareness of suffering among human beings there must also be art as the objective form of that awareness. And, heaven knows, I do not claim to be able to resolve this antinomy, and presume even less to do so since my own impulses in this antinomy are precisely on the side of art, which I am mistakenly accused of wishing to suppress.[16]

Adorno invokes art because the sensuous materiality of art corresponds to a bodily moment constitutive of morality, the mimetic response to suffering:

> As soon as one attempts to provide a logical foundation for a proposition such as that one should not torture, one becomes embroiled in a bad infinity; and probably would even get the worst of the logical argument, whereas the truth in this proposition is precisely what falls outside such a dialectic. What I wish to point out is this practical moment, which does not coincide with knowledge but is constitutive of moral philosophy. The extra-logical element to which I am appealing . . . is quite simply the moment of aversion to the inflicting of physical pain on what Brecht once called the torturable body of any person. . . . [T]he true basis of morality is to be found in bodily feeling, in identification with unbearable pain . . . morality, that which can be called moral, i.e. the demand for right living, lives on in openly materialist motifs. The metaphysical principle of the injunction that 'Thou shalt not inflict pain'—and this injunction is a metaphysical principle pointing beyond mere facticity—can find its justification only in the recourse to material reality, to corporeal, physical reality, and not to its opposite pole, the pure idea.[17]

Art's partly sensuous, material constitution makes it possible to be "the refuge of the mimetic element of knowledge, that of the elective

affinity of the knower and the known,"[18] but such mimetic knowledge occurs nonconceptually, therefore not directly by means of representational images or words that can all too easily be subsumed under concepts, and thereby consoled and forgotten:

> The abundance of real suffering permits no forgetting; Pascal's theological "On ne doit plus dormir" should be secularized. But that suffering—what Hegel called the awareness of affliction—also demands the continued existence of the very art it forbids; hardly anywhere else does suffering still find its own voice, a consolation that does not immediately betray it. The most significant artists of the period have followed this course. The uncompromising radicalism of their works, the very moments denounced as formalist, endows them with a frightening power that impotent poems about the victims lack.[19]

The moral imperative of the aesthetic relation is dialectically bifurcated. On the one hand, it is a moral injunction against any aestheticizing of suffering that would embellish, transfigure, or derive however sublimated a consoling pleasure from the somatic stratum of suffering:

> The so-called artistic rendering of the naked physical pain of those who were beaten down with rifle butts contains, however distantly, the possibility that pleasure can be squeezed from it. The morality that forbids art to forget this for a second slides off into the abyss of its opposite. The aesthetic stylistic principle . . . make[s] the unthinkable appear to have had some meaning; it becomes transfigured, something of its horror removed. By this alone an injustice is done the victims, yet no art that avoided the victims could stand up to the demands of justice.[20]

On the other hand, the moral imperative not to forget the victims and their suffering cannot mean to reproduce the suffering of the victims, which would be impossible and immoral; rather, it is to remain mindful of it, in virtue of the artwork's structure as the objective form of that mindfulness. In this way genuine artworks resist aesthetic categories such as harmony, completion, and beauty, by incorporating, but not resolving or transfiguring, a somatic element: the *sense* of semblance is both "meaning" (*Sinn*) and bodily "sensation" (*Sinn*), materialist in Adorno's understanding of the term.

Let us return to the artworks we have considered in this study. The causal theory of names is a materialistic theory of meaning, and the objective form of Celan's poems, which incorporate hidden allusions to mortal name-using communities, produces the awareness of irretrievable loss. In the Bavarian Quarter memorial, the interpellation of

passers-by into quotidian institutions and practical contexts haunted
by former citizens' disenfranchisement and destruction is materialis-
tic: people are addressed, commanded, perhaps mimetically shocked
into historical consciousness by the nonsensuous similarity between
then and now. In Bäcker's quotational texts the reader undergoes a
materialistic ventriloquism: the dead speak through the reader's reac-
tualization of their words, their forlorn hope and growing despair. In
Shoah and *Maus* the mimetic response centers on the face: in *Shoah*
the witness is "possessed" by his former self, the knowledge he thereby
conveys is not propositional, but expressive, via his participial imagi-
nation; in *Maus* we are summoned by the disfiguring schematism of
the faces as much as the authenticity of Vladek's cadences. To imagi-
natively project human expressiveness onto and feel solidarity with
the anguish of torturable bodies rendered as cartoon mice as it were
reconstructs our morality, our shared humanity. It is perhaps the pre-
cise affective counterpoint to the only form of hope Adorno allows
himself to venture, the self-conscious spontaneity of thought presup-
posed by moral constructivism: "If the subject, mind, reflecting itself
critically, does not equate itself to, and 'devour,' everything which
exists, it may happen that the mind, which has become as unidentical
to the world as the world has become to it, takes on a small moment
of not-being-engulfed-in-blind-contingency: a very paradoxical form
of hope, if you like."[21]

|||

In this study I have argued that a minimalist framework, in which
reciprocally countervailing historical and aesthetic tendencies are
both maintained, provides the normative model for explaining how
successful Holocaust artworks both uphold an intentional relation
to historical events and remain aesthetic constructs. This minimalist
framework derives from Adorno's *Aesthetic Theory*, in which he sets
into negative-dialectical motion a series of conceptual pairs from the
tradition of philosophical aesthetics, one exemplary instance being
the "dialectic of aesthetic semblance." So understood, successful
Holocaust artworks themselves evince a negative-dialectical—that
is, a co-constitutive conflictual, irreconcilable—relationship between
their aesthetic-autonomous and aesthetic-heteronomous (here, histor-
ical) tendencies.

I have further argued that the contours of such a "system of irrec-
oncilability," that is, the determinate features of such irreconcilability,

will be specific to each artwork, perhaps nominalistically so, and that reenacting as well as discursively comprehending (the two moments of aesthetic experience for Adorno) a specific artwork may well benefit from additional conceptual resources beyond Adorno's favored tradition of German Idealism. The chapters comprising this book offer exemplary accounts of specific artworks as systems of determinate irreconcilability, that is, as specific inflections of the dialectic of aesthetic semblance, whereby those accounts enlist those theories and concepts—the causal theory of names, the dialectical image, tacit knowledge, open quotation, conversational implicature, imaging consciousness, expressivism, the assurance theory of testimony, and so on—whose illuminative potential is demonstrated in the interpretations themselves.

Therefore I have also argued that work in contemporary philosophy—Anglophone as well as Continental—may provide the clarity and conceptualization to explicate a successful Holocaust artwork more precisely than with the means afforded by the minimalist framework alone. In this respect, the interpretive method practiced here—determinate in its ecumenical discursivity—echoes Adorno's spirit, in that the stubborn and ultimately unwarranted divide between these two philosophical traditions is itself considered a symptom of an intellectual and social antagonism at a dialectical standstill that thereby obscures the regulative ideal of its possible reconciliation: "thinking experience" (*denkende Erfahrung*), which Adorno also called "the morality of thought."[22]

ACKNOWLEDGMENTS

1. Lessing, *Hamburgische Dramaturgie*, 70. Stück, in *Werke*, 4: 558–59.

INTRODUCTION: THE JUDGMENT OF HOLOCAUST ART

1. Adorno, *Aesthetic Theory*, 184 (translation modified).
2. Langer, *Holocaust and the Literary Imagination*, 8–9.
3. Ibid., 30. The exhortation with which his programmatic first chapter concludes, however, appears to suggest that aesthetic displeasure and disharmony alone can replace or "translate" the historical relation: "To create beauty out of nothingness—this is the dark challenge facing the human spirits who sought expression, if not renewal, by translating the agony of annihilation into the painful harmonies—and discords—of an art of atrocity" (30).
4. Ezrahi, *By Words Alone*, 14. Rosenfeld, in *A Double Dying*, seeks to develop "practical criticism that will allow us to read, interpret, and evaluate Holocaust literature" (19), and posits "governing laws" (29) of successful Holocaust literature while recognizing "the writer's ability to absorb history into myth or legend" (80). Ezrahi faults works for their "imposition of aesthetic forms on historical events rather than transforming those events through the imagination" (32), and in effect places works according to the extent to which they imaginatively distort historical facts: "At the furthest end of the spectrum that measures the imaginative representation of cataclysmic history is the writer who distills reality into the essential symbols or myths of the concentrationary universe, which is thereby transformed from a historical event or social aberration into a human mutation" (150).
5. I venture some thoughts on *one* theory of the imagination in Chapter 4, in the interests of explicating the artworks under consideration in that chapter.
6. Young, in *Writing and Rewriting the Holocaust* (85–89), recounts the emergence of various terms to name these events during and after World War II; and Agamben, in *Remnants of Auschwitz* (28–31), claims that the history of the term "Holocaust" reveals its usage to be "essentially Christian" and anti-Semitic, and that both "Holocaust" and "Shoah" are euphemisms

with connotations of religious sacrifice, and therefore should not be used. Adorno uses "Auschwitz" synecdochically to name not only the planning and execution of the Final Solution, but also the subjective and objective conditions that brought about the industrial murder of entire groups of people, conditions he held to continue unabated in the postwar period. This study observes established convention in its use of "Holocaust" and "Shoah," but strictly speaking the terms are being used "under erasure."

7. While this relation is conceived here as generally as possible, for one explication see Genette, *Aesthetic Relation.*

8. I take up these questions to a limited extent below and in the Conclusion to this study.

9. There is a second line of argument motivating my turn to Adorno's philosophical aesthetics. Anecdotal evidence suggests that Adorno's infamous dictum that "to write poetry after Auschwitz is barbaric" (Adorno, "Cultural Criticism and Society," *Prisms,* 34) was a response to Celan's poem "Todesfuge," and that Celan's later poetry, which divests itself of traditional aesthetic ornament, induced Adorno to develop an aesthetic theory that could conceptually ground and explicate such works. The result was his posthumous work *Aesthetic Theory.* Cf. Rosenfeld, *Double Dying,* 13; Claussen, "Nach Auschwtiz," 54–68; Rothberg, *Traumatic Realism,* 25–58 (esp. 46–47); Tiedemann, "'Not the First Philosophy,'" x–xxvii (esp. n12).

10. For helpful introductions to Adorno's aesthetic theory, see Zuidervaart, *Adorno's Aesthetic Theory.* Jarvis, *Adorno: A Critical Introduction,* successfully presents Adorno's aesthetics in the context of his entire *oeuvre.* On aesthetic autonomy and heteronomy, see Bubner, "Über einige Bedingungen gegenwärtiger Ästhetik"; and Geuss, "Form and 'the new' in Adorno's '*Vers une musique informelle.*'"

11. Hegel, *Aesthetics: Lectures on Fine Art,* 1: 111 (translation modified).

12. "According to traditional aesthetics, classical sculpture aimed at the identity of the universal and the particular—the idea and the individual—because already it could no longer depend on the sensual appearance of the idea" (*Aesthetic Theory,* 160–61); "Though in classicism the subject stands aesthetically upright, violence is done to it, to that eloquent particular that opposes the mute universal" (*Aesthetic Theory,* 162).

13. Echoed by Adorno: "If, however, art were totally without the element of intuition, it would be theory, whereas art is instead obviously impotent in itself when, emulating science, it ignores its own qualitative difference from the discursive concept; precisely art's spiritualization, as the primacy of its procedures, distances art from naïve conceptuality and the commonsense idea of comprehensibility" (*Aesthetic Theory,* 95).

14. "That doctrine of the beautiful as the sensual semblance of the idea was an apology for immediacy as something meaningful and, in Hegel's own words, affirmative" (*Aesthetic Theory,* 90).

15. "The more the emancipation of the subject demolished every idea of a preestablished order conferring meaning, the more dubious the concept of meaning became as a refuge of a fading ideology. Even prior to Auschwitz it was an affirmative lie, given historical experience, to ascribe any positive

meaning to existence. This has consequences that reach deep into aesthetic form" (*Aesthetic Theory*, 152–53).

16. "Because aesthetic appearance cannot be reduced to its intuition, the content of artworks cannot be reduced to the concept, either. The false synthesis of spirit and sensuousness in aesthetic intuition conceals their no less false, rigid polarity; the aesthetics of intuition is founded on the model of a thing: In the synthesis of the artifact the tension [*Spannung*], its essence, gives way to a fundamental repose" (*Aesthetic Theory*, 97).

17. *Aesthetic Theory*, 109–10.

18. Adorno rehabilitates Kant's notion of natural beauty as the "double-character" or "double-poledness" of art as both cognitive content (*Sinn*) and sensible material. See *Aesthetic Theory*, 5, 252–54, and *passim*.

19. *Aesthetic Theory*, 110.

20. Ibid., 101.

21. Adorno, *Philosophy of New Music*, 30 (translation modified).

22. *Aesthetic Theory*, 6, translated as "autonomy."

23. "Artworks are, as synthesis, analogous to judgment; in artworks, however, synthesis does not result in judgment; of no artwork is it possible to determine its judgment or what its so-called message is. It is therefore questionable whether artworks can possibly be *engagé*, even when they emphasize their *engagement*. What works amount to, that in which they are unified, cannot be formulated as a judgment, not even as one that they state in words and sentences" (*Aesthetic Theory*, 123).

24. *Aesthetic Theory*, 103f.

25. Ibid., 16, translated as "being-for-other."

26. Ibid., 100–18.

27. See Adorno, *Kierkegaard*, 123–44. Cf. also Menke, "Adorno's Dialectic of Appearance"; and Huhn, "Adorno's Aesthetics of Illusion."

28. In the medieval period "*Schein*" meant both (1) *splendor* and *lumen* (Greek: αὐγή, ψῶς), "shining of the stars," then metaphorically "fame," "luck," and "beauty"; and (2) *phaenomenon* and *apparentia* (Greek: φαινόμμενον), which implies the difference between seeming and being. This second usage of "*Schein*" has itself two meanings: it can mean what is revealed (*das Offenbare*) as well as what is merely appearance, illusion, or semblance (Greek: ψεῦδος; Latin: *illusio*). It is this doubledness, between revelation and mere appearance, which entered into idealist aesthetics and reaches its negative dialectical culmination in Adorno. See Ritter, *Historisches Wörterbuch der Philosophie*, entry "*Schein*"; and also Bolz, *Eine kurze Geschichte des Scheins*, for further bibliography.

29. Wellmer, "Truth, Semblance, Reconciliation," 10.

30. *Aesthetic Theory*, 7.

31. Ibid., 168 (translation modified). On synthesis: "The synthesis achieved by means of the artwork is not simply forced on its elements; rather, it recapitulates that in which these elements communicate with one another; thus the synthesis is itself a product of otherness. Indeed, synthesis has its foundation in the spirit-distant material dimension of works, in that in which synthesis is active. This is united by the aesthetic element of form with

noncoercion. By its difference from empirical reality the artwork necessarily constitutes itself in relation to what it is not, and to what makes it an artwork in the first place" (*Aesthetic Theory*, 7–8 [translation modified]).

32. "Double-character" is a place-holder for negative-dialectical junctures with which Adorno intends to reform the concepts of "identity-thinking" in the philosophical tradition, for "all aesthetic categories must be defined both in terms of their relation to the world and in terms of art's repudiation of what world." Thus: "If art had absolutely nothing to do with logicality and causality, it would forfeit any relation to its other and would be an a priori empty activity; if art took them literally, it would succumb to the spell; only by its double character, which provokes perpetual conflict, does art succeed in escaping the spell by even the slightest degree" (*Aesthetic Theory*, 138).

33. *Aesthetic Theory*, 118–36; "*Rätselcharakter*" translated as "enigmaticalness."

34. Ibid., 118.

35. Ibid., 106; cf. 121. Thus each chapter of this study includes reflections upon the phenomenological experience of the artwork in question. Perhaps the reading of Celan's "Meridian" speech in Chapter 2 undertakes most rigorously such an internal reenactment of the movements of the text.

36. *Aesthetic Theory*, 122, 131.

37. Indeed, it has even been argued that postmodernism and poststructuralism arose explicitly as a response to the Holocaust. See Eaglestone, *Holocaust and the Postmodern*.

38. Friedlander, *Probing the Limits of Representation*, 4–5.

39. Lang, *Holocaust Representation*, 39, 8. I consider Lang's argument for a moral grounding of Holocaust representation in the Conclusion.

40. Ibid., 59, 81. Cf. also Lang, *Act and Idea in the Nazi Genocide*, 123f.

41. Kaplan, *Unwanted Beauty*, 2, 13.

42. Young, *At Memory's Edge*, 5–11. Friedlander, *Nazi Germany and the Jews*, 1: 3.

43. For a historically informed and trenchant critique, see Hansen, "'Schindler's List' is Not 'Shoah.'" Cf. also Adorno's comments on a viewer's reaction to a dramatization of Anne Frank's diary as a case of exceptionalist sentimentalism in his essay "The Meaning of Working Through the Past," in *Critical Models*, 101.

44. This is Berel Lang's (given his championing of historical authenticity, quite paradoxical) argument for endorsing historically dubious but popularizing books and movies about the Holocaust. The argument rests on a consequentialist construal of the moral constraint on Holocaust representation, such that there is "an arguable social and pedagogical justification for such writings, irrespective of how bad—sensationalist, mawkish, triumphalist, historically problematic—it is" (Lang, *Holocaust Representation*, 49–50; cf. also 70–71). I consider Lang's moral constraint on Holocaust literature in the Conclusion.

45. Bernard-Donals, "Beyond the Question of Authenticity," 201, 210–11.

46. "Testimonial narratives do not disclose history; instead, they disclose—where the narrative most clearly shows its seams—the effect of events upon witnesses. As a memoir, *Fragments* functions in the same way. . . . The effect of testimony, in Doesseker's case coded in the language of the Shoah and structured by a language that displaces the reader's sense of the normal (or of history), opens a moment in which the reader of the testimony becomes a secondhand witness, seeing not the experience described but something that stands beyond or before it, not history but history's real" (ibid., 205, 206).

47. "Whatever originated the writing—whatever brought Doesseker to write *Fragments*—is lost to memory and is only available in the historical record; what readers see through the anxiety, the *Unheimlichkeit*, resulting from the repetitive language of the book is likewise lost when they try to regularize it as knowledge. The best we can say is that the moments are related structurally; their homology is lost" (ibid., 208).

48. Margalit, *Ethics of Memory*, 174, 148.

49. Adorno, *Aesthetic Theory*, 320–21.

50. Young, *Texture of Memory;* and Young, *At Memory's Edge.* I discuss his notion of "counter-monuments" in Chapter 2.

51. Eaglestone, *Holocaust and the Postmodern*, 38–39, 70. Eaglestone invokes the criteria of reader's identification and pleasure to demarcate testimony from *fiction*, as though the reader's assumption that a testimony is a first-person report of what a witness experienced did not already render the pretense of fiction moot. Furthermore, the criterion of reader's identification is itself problematic: Might not a camp survivor identify with another witness's testimony? Finally, Eaglestone's rejection of aesthetic pleasure directly contradicts Brett Ashley Kaplan's advocacy of it, indicating perhaps complementary theses that need to be dialectically mediated.

52. Felman and Laub, *Testimony*, xx. Cf. also Caruth, *Trauma*; and Caruth, *Trauma, Narrative and History.* For a critical evaluation of Caruth's theory of trauma that relates it directly to deconstructive notions of "materiality" and "performativity," see Leys, *Trauma*, chap. 8, which elicited a spirited response from Felman, *Juridical Unconscious*, 173–82, and comment in Leys, *From Guilt to Shame*, chap. 5.

53. Rothberg, *Traumatic Realism*, 104, 140, and his readings of possessions left by survivors in works by Ruth Klüger and Charlotte Delbo as instances of "traumatic realism" (chaps. 3–4). Rothberg seeks to surmount versions of what I call the "postmodern dichotomy" by aggrandizing them into an even more abstract theory, in which mimetic realism (linked to witness testimony), antirealist modernism (linked to bystanders), and commodified postmodernism (linked to later generations) are "harnessed together" into a Benjaminian constellation that "offers an alternative to the periodizing discourse of modern history and opens up the possibility of thinking through the overlapping of historical moments that so many works of Holocaust representation share" (11). The discontinuous juxtaposition of these different representational orders into a constellation "bear[s] witness to the traumatic legacies of modern historical extremity" and apparently fosters "working

through—instead of repetitively acting out—the traumas of the past" (11).
Thus "some version of this constellation [of the threefold representational
orders] is at work in all Holocaust representations (if often in subtextual or
even negative form)" (13).

54. Bernard-Donals and Glejzer, *Between Witness and Testimony*.
Although drawing on postanalytic philosophy of language rather than
trauma theory, Lyotard argues for a similar structure: "The differend is the
unstable state and instant of language wherein something which must be
able to be put into phrases cannot yet be. This state includes silence, which is
a negative phrase, but it also calls upon phrases which are in principle pos-
sible. This state is signaled by what one ordinarily calls a feeling . . . [human
beings] are summoned by language, not to augment to their profit the quan-
tity of information communicable through existing idioms, but to recognize
that what remains to be phrased exceeds what they can presently phrase,
and that they must be allowed to institute idioms which do not yet exist"
(Lyotard, *Differend*, 13).

55. Van Alphen, *Caught by History*, 10.

56. In drawing on trauma theory to explicate Holocaust artworks, these
theories also tend to discount aesthetic structure and intention in favor of the
historiographical rupture characteristic of traumatic witnessing: "But even
as the survivor's remembrance of her experiences is owing partly to trau-
matic phenomena, the testimonial value she attaches to them may be based
as significantly on literary ambitions, which is to say on the culturally refined
dimension of the linguistically expressive aspect of trauma" (Spargo, "Intro-
duction," 18).

57. The best explication of this paradigm shift between the philosophy of
consciousness pursued by German Idealism and the philosophy of language
inaugurated by Frege's writings remains that by Tugendhat, *Traditional and
Analytical Philosophy*. Cf. also Rorty, *Linguistic Turn*.

58. *Aesthetic Theory*, 95.

59. Ibid., 181.

60. Ibid., 99.

61. Ibid., 176.

62. Ibid., 357.

1. MANDELSHTAM'S MERIDIAN: ON PAUL CELAN'S AESTHETIC-HISTORICAL MATERIALISM

1. Heidegger, *Sein und Zeit*, 166.

2. Wittgenstein. *Philosophical Investigations*, §432.

3. Adorno, *Aesthetic Theory*, 4 (translation modified).

4. For a useful discussion, see Angehrn, "Dekonstruktion und
Hermeneutik."

5. Josef Chytry in *Aesthetic State* traces this *Denkfigur* from German Ide-
alism to Adorno and Marcuse.

6. Bakhtin, "Discourse in the Novel," 296–97.

7. Ibid., 328.

8. Morson and Emerson, *Mikhail Bakhtin*, 324.

9. De Man often slides between Fregean sense and reference (and in one passage badly misconstrues them: cf. his *Allegories of Reading*, 13) when he speaks of "signified," which suggests that he has a one-dimensional (Russellian) rather than a two-dimensional (Fregean) understanding of meaning and reference. This raises complications with his idea of rhetorical vs. referential undecidability that I cannot treat here.

10. De Man, "Dialogue and Dialogism," 111.

11. Ibid.,109.

12. Roberts, "Poetics Hermeneutics Dialogics," 131. Roberts defines "the mutual unintelligibility of their perspectives on meaning" (this conjunction already indicating their mutual intelligibility, namely, that of rival theories of *meaning*): "Whereas de Man sees the classical trivium of grammar, rhetoric, and logic as riven within by the middle term, and thus disarticulated from 'the knowledge of the world in general,' Bakhtin sees 'the world in general' obtruding on this classical epistemology from without, as an open totality of singular event-contexts, at once concretizing its abstract potentiality and radically denying its abstract unity" (ibid., 134). Yet the distinction concrete actualization versus abstract potential, either in its Aristotelian-Hegelian (essence and appearance) or Wittgensteinian (rule and application) variants is itself already a presupposition which, we shall see, Celan's poetics does not share in any straightforward sense.

13. De Man, "Dialogue and Dialogism," 109.

14. References here refer to the English translation, *The Complete Prose and Letters*, hereafter cited as "CPL," and checked against *Sobranie sochinenii v chetyrex tomax [Собрание сочинений в четырех томах]*, hereafter cited as "SS," with page references to both.

15. In one of the few extensive considerations of Mandelshtam and Bakhtin, Svetlana Boym explores Mandelshtam's notion of dialogue, especially in terms of gender and genre, as orchestrated in his *Египетская марка* (1928): see Boym, "Dialogue as 'Lyrical Hermaphroditism.'"

16. Mandelshtam *SS* 2: 371; *CPL*: 404–5.

17. Mandelshtam *SS* 2: 373; *CPL*: 406.

18. Mandelshtam *SS* 2: 363–64; *CPL*: 397.

19. Mandelshtam *SS* 2: 374; *CPL*: 407. On Bergson and Mandelshtam, see Fink, *Bergson and Russian Modernism, 1900–1930*, 63–77.

20. Mandelshtam *SS* 2: 382; *CPL*: 414.

21. Mandelshtam *SS* 2: 412-13; *CPL*: 442.

22. For a related understanding of the concept of recontextualization, see Rorty, "Inquiry as Recontextualization."

23. From an earlier draft of the essay: Mandelshtam *SS* 3: 182; *CPL*: 445.

24. Cf. the French translation, "De l'interlocuteur," in *Poésie* 35 (1985): 7–20; and the German translation "Vom Gegenüber" in Werner Hamacher and Winfried Menninghaus, eds., *Paul Celan* (Frankfurt: Suhrkamp, 1988): 201–8. This is especially important since Mandelshtam uses both the calque "адресат" and the Russian "собеседник" (with emphasis on the destiny and destination on the one hand, and the dialogic encounter on the other) in the

essay, both of which are rendered "addressee" in Harris's English translation. Moreover, in the same translation "господа," "друзья," and "знакомые" are all rendered "friends," an unfortunate leveling of distinctions in intimacy and political solidarity.

25. Mandelshtam *SS* 2: 236; *CPL*: 68 (translation modified).

26. Broda, *Dans le main de personne*, in her extended interpretation of Celan's reading of Mandelstham, focuses on the ambiguity in Celan's use of "niemand," as both existential and substantivized negation, and she interprets it in line with Mandelshtam's notion of the addressee. Broda does not consider, however, the role of Mandelshtam in the Meridian speech nor the critique of aesthetic semblance. Eskin, *Ethics and Dialogue*, explores "the transcendental significance of dialogue" (xiii) along the lines of Levinas, who "conceives ethical dialogue—in contradistinction to dialogue as reciprocal speech communication—as a non-reciprocal, asymmetric dynamic" (8), but such a reading does not comport with Mandelshtam's juridical concept of reciprocal rights. Moreover, if the normative and naturalistic reading I develop in this chapter of Celan's poetics makes sense, it at least questions Eskin's claim that "his texts can plausibly be read as poetologically complementing and poetically staging and illuminating" (11) Levinas's transcendental ethics.

27. Mandelshtam *SS* 2: 234; *CPL*: 67–68. (translation modified).

28. Mandelshtam *SS* 2: 237–38; *CPL*: 71 (translation modified).

29. Mandelshtam *SS* 2: 240; *CPL*: 73.

30. Mandelshtam *SS* 2: 239; *CPL*: 72.

31. Note that the standard translation of Iser's notion as "implied reader" rather than "implicit reader" itself implies an element of historicized response (who does the implying?) and slightly shifts the fundamentally structuralist aspirations of his theory. Cf. Iser, *Der implizite Leser.*

32. Mandelshtam *SS* 2: 236–37; *CPL*: 70.

33. The notion of "mutual recognition" itself has a history (Fichte, Hegel, Schelling) and interpretive controversies. Mandelstam's notion seems to come closest to the incipient notion of self-awareness through another which the early Hegel (in his *Jenaer Realphilosophie*, ca. 1805) called "Sichselbstsein in einem Fremden" and associated with "love"; cf. Honneth, *Kampf um Anerkennung*, 170f. In 1909–10 Mandelshtam studied in Heidelberg and may have come across the writings of Fichte and company while there.

34. Mandelshtam *SS* 2: 239; *CPL*: 72.

35. Mandelshtam *SS* 2: 240; *CPL*: 73 (translation modified).

36. Mandelshtam *SS* 2: 240; *CPL*: 73 (translation modified).

37. Mandelshtam *SS* 2: 236; *CPL*: 69–70.

38. Mandelshtam *SS* 2: 240; *CPL*: 72 (translation modified).

39. One may also read this as a fledgling "third" way of self-legitimation and self-authorization for Russian culture in contradistinction to the traditional authorities of state autocracy and church. On Russian modernity and the sociology of cultural authority, see Freidin, "By the Walls of Church and State."

40. Mandelshtam *SS* 2: 240; *CPL*: 73 (translation modified).

41. Celan's library, now in the Deutsches Literaturarchiv in Marbach, includes several editions of Mandelshtam's works, including the well-marked, four-volume *Sobranie sochinenii* edited by Struve and Filippov. Each of the poems Celan translated is marked with the exact date the translation was done. It is also clear he was intimately familiar with the entire corpus of Mandelshtam's writings. On Celan's Russian library, comprising more than five hundred titles, see Ivanovíc, *"Kyrillisches, Freunde, auch das."* The critical edition of Celan, *Der Meridian*, edited by Bernhard Böschenstein und Heino Schmull, helpfully reproduces Celan's Mandelstham radio essay along with other materials and drafts of the speech. Further unpublished materials attesting to Mandelshtam's significance for Celan can now be found in Celan, *"Mikrolithen sinds, Steinchen"*; and Celan, *Die Gedichte aus dem Nachlass*. For a comprehensive overview of the influence of Russian poetry in Celan's work, see Ivanovíc, *Das Gedicht im Geheimnis der Begegnung.*

42. Cf. Gogol, "Paul Celan and Osip Mandelshtam"; Terras and Weimar, "Mandelshtam and Celan"; Terras and Weimar, "Mandelshtam and Celan: A Postscript."

43. Cf. Parry, *Mandelstamm der Dichter*; and Olschner, *Der feste Buchstab.*

44. Böschenstein, "Celan und Mandelstamm." The citation is from a letter of Celan to Reinhard Federmann and Alfred Margul-Sperber in 1962, with which Böschenstein concludes his article. Cf. also Celan, *"Mikrolithen sinds, Steinchen,"* 45, 47, 48.

45. Cf. Laub and Podell, "Art and Trauma," esp. 994; and Felman and Laub, *Testimony*, 25–40. There Felman and Laub read Celan's later poetics as a deaestheticization of art (specifically the musicality of verse) in favor of testimony, an opposition this chapter seeks to set into negative-dialectical relation.

46. Cf. the paronomastic inscription of the river Bug in a poem that also addresses Mandelshtam, "ES IST ALLES ANDERS": "am Heck kein Warum, am Bug kein Wohin, ein Widderhorn hebt dich" Celan, *Gesammelte Werke*, 1: 284; hereafter cited as *GW* volume: page. The English translation by Michael Hamburger understandably misses the encrypted reference: "on the stern no why, on the bow no whither, a ram's horn lifts you" (Hamburger, *Poems of Paul Celan*, 217).

47. In his radio broadcast on Mandelshtam, Celan includes several of his translations at key junctures in the text (which is itself structured as a dialogue between three voices). Celan's translation of Mandelshtam's elegy to his mother follows his equating remembrance and Jewishness: "The horizons grow dark—leave-taking asserts its right, expectation recedes, and remembrance dominates the field of time. For Mandelshtam Jewishness also belongs to what is remembered" (Celan, "Die Dichtung Ossip Mandelstamms" [1960], reprinted in Celan, *"Mikrolithen sinds, Steinchen,"* 196–206, here 202). Cf. Olschner: the poem "that remembers Mandelshtam's deceased mother against the background of her burial is a poem that Celan, probably mindful of his own mother, whose time of death and grave he could not know, composed anew as it were

through an act of identification with Mandelshtam" (Olschner, *Der feste Buchstab*, 260).

48. Celan, *GW* 5: 624. The account of Mandelshtam's death is now fully attested: cf. Shentalinsky, *Arrested Voices*.

49. Enzensberger, *Museum der modernen Poesie*, 402.

50. Israel Chalfen, in *Paul Celan*, reports that Celan's mother insisted that "correct literary German be spoken at home" (40), and that "early on she showed a predilection for reading and spent every free moment with books. She especially liked to read the German classics, and in later years she competed with her son in quoting their favorite authors" (31), and that he asserted he would never write poems in any other language than his "mother tongue" (101).

51. One of Celan's acquaintances recalls: "No matter how far he came on his path, all his poems are calls, addresses from the long since irrevocable solitude of the survivor, and what he wrote he also wrote in order to justify his survival before his dead" (Sanders, "Erinnerung an Paul Celan," 312). Another acquaintance recalls: "Often he mentioned that he felt guilty, because he had escaped the concentration camp, as though he himself had sent his parents, the members of his family, to their deaths" (Szász, "'Es ist nicht so einfach,'" 330).

52. The text, now in Celan's materials in the Deutsches Literaturarchiv in Marbach, has been reproduced in Celan, *Die Gedichte aus dem Nachlass*, 371.

53. On the figure of semantic chiasmus, see Lausberg, *Handbook of Literary Rhetoric*, §723 and §§800–803. On inversion in Celan's poetry, see Hamacher, "Second of Inversion."

54. Celan, *GW* 1: 284.

55. The letter is in part cited in Pöggeler, *Spur des Wortes*, 156f. Throughout his life Celan used the "meridian" as a metaphor of the chronotopes of his past: cf. Chalfen, *Paul Celan*, 144–45.

56. Cited in Pöggeler, *Spur des Wortes*, 407 n15. Celan continues: "(And including this sentence, in thought of you, : Topos-research? Certainly. But in the light of what is to be researched: in the light of u-topia. - a half-thought, ach, I know.)" Pöggeler suggests that Celan developed his poetological vocabulary in part through conversations with the philosopher. Cf. Pöggeler, "Dichtungstheorie und Toposforschung," 89ff. The image of "islands" may also recall Mandelshtam's figure of the shipwrecked sailor and the message in the bottle washing up on another shore.

57. Celan, *GW* 3: 202. According to Barnert, *Mit dem fremden Wort*, 78–82, Jean Paul used the expressions to refer to two different orthographic conventions for quotation.

58. Celan, "Die Dichtung Ossip Mandelstamms," 196–97.

59. Celan performs the same chiasmic metathesis upon the name "Reinhard Federmann" as he does with "Hasenfuß" in a letter to Federmann (February 23, 1962): "Ich erinnere mich, daß ich, unter manchem anderen unserem Milyi und Dor auch geschrieben hab: 'Grüß den Reinmann und Federhart?'" Cited in Brierley, *"Der Meridian,"* 128. (Brierley's extensive study of the "Meridian" speech provides many of the sources which Celan

directly or obliquely cites. At the time the study was written, however, the presence of Mandelshtam in the speech was not recognized.) On metathesis in Celan's poetry, see Perels, "Erhellende Metathesen."

60. Szondi, "Eden."

61. Derrida, *Schibboleth: pour Paul Celan* (Paris: Éditions Galilée, 1986); citations refer to the English translation in Aris Fioretos, ed., *Word Traces: Readings of Paul Celan*. For an explication of Derrida's philosophy as that of quasi-transcendental infrastructures ("spacing," "différance," "trace," "supplement," and so on), see Gasché, *Tain of the Mirror*.

62. These points are presented in chapter 2 of Derrida's *Of Grammatology* and in "Signature Event Context" in Derrida, *Limited Inc*. For a lucid presentation of Derrida's critique in the context of contemporary linguistic philosophy, see Wheeler, "Indeterminacy of French Interpretation"; and Wheeler, *Deconstruction as Analytic Philosophy*.

63. Derrida, "Shibboleth," 17, 36, 46.

64. Ibid., 16. *Physis* alludes to a fragment (no. 112) attributed to Heraclitus: "*physis kruptesthai philei*," and probably as well to Heidegger's explication of the pre-Socratic concept of nature or Being as nonteleological becoming in his *Einführung in die Metaphysik*. Lacoue-Labarthe, in his reading of Celan is more forthright: "The experience of the You, the encounter, opens onto nothing other than the experience of Being: of the no-thing of being." Lacoue-Labarthe, *La poésie comme expérience*, 98.

65. Derrida, "Shibboleth," 17; cf. 53: "*The date succeeds only in effacing itself; its mark effaces it a priori.*"

66. Ibid., 31.

67. Ibid., 28.

68. Ibid., 32.

69. On Derrida's critical descent from Husserl, see Habermas, *Philosophical Discourse of Modernity*, 167–79. On Derrida's argument being a critique of the metaphysical conception of sense rather than a critique of the (intersubjective) phenomenon of sense itself, see Menke, "'Absolute Interrogation.'"

70. Derrida, "Shibboleth," 58 and 68, respectively.

71. Ibid., 31.

72. Ibid., 58.

73. Ibid., 18.

74. On this conclusion, see Wellmer, *Zur Dialektik von Moderne und Postmoderne*, 81–86.

75. Interestingly, Derrida and Quine converge here in the thesis of the underdetermination of linguistic meaning. See Wheeler, *Deconstruction as Analytic Philosophy*.

76. Wittgenstein, *Philosophical Investigations*, §202.

77. Ibid., §219.

78. Ibid., §217.

79. Wittgenstein, *Remarks on the Foundations of Mathematics*, VI 28.

80. Wittgenstein, *Philosophical Investigations*, §289. All citations from Wittgenstein and cited commentary are from McDowell, "Wittgenstein on Following a Rule."

81. Wittgenstein, *Philosophical Investigations*, §198 and §202, respectively.

82. This point is what distinguishes McDowell's argument, which I am following here, from that of Saul Kripke's reading of Wittgenstein in *Wittgenstein on Rules and Private Language*. Kripke holds that understanding is interpretation, and he locates its justification in public endorsement. Meaning on this view is public, but radically inductive (and potentially revisionist), since only future public practice will legitimate any given application of a rule. In this sense Kripke falls on the Derridean horn of the dilemma. I pursue these questions in greater detail in the first chapter of my *Thinking with Tolstoy: An Essay in Reconstruction* (manuscript).

83. The classic argument of this is Nelson Goodman's problem of induction: see *Fact, Fiction and Forecast*. For an excellent example from the history of chess, see Hacking, "Rule, Scepticism, Proof, Wittgenstein."

84. Evans, "Causal Theory of Names," 19.

85. McDowell, "Wittgenstein on Following a Rule," 284.

86. Such a view can be found in Searle, "Proper Names."

87. Kripke, *Naming and Necessity*.

88. Evans, "Causal Theory of Names," 18.

89. Evans, *The Varieties of Reference*, 381.

90. Ibid., 389.

91. Ibid., 391.

92. That Celan did not publically "baptize" (Kripke's term) the proper names, as Evans's model requires, is here beside the point, namely their recognizability to producers in the linguistic community.

93. Celan, *GW* 2: 72.

94. Walter Benjamin uses a similar pun as the entire text under the title "For Men" in *One-Way Street*: "Überzeugen ist unfruchtbar" ("To convince [or: To over-procreate] is unproductive"). Benjamin, *Gesammelte Schriften*, 4/1, 87.

95. Celan, *GW* 3: 186.

96. "Wirklichkeit zu entwerfen . . . , Richtung zu gewinnen," in Celan, *GW* 3: 186. While I interpret Celan as radicalizing the incipient existential aspect of Mandelshtam's evocation of mutual recognition between lyric poet and providential addressee, Levine, in his nuanced, psychoanalytically inflected *Belated Witness*, 8–11 and 165, finds that for both Mandelshtam and Celan (especially in the "Meridian" speech) "it is less a question of the specular relation which may obtain between an 'I' and a 'you,' less a matter of their respective identities being mutually recognized, than of according a place to the otherness which the 'you' 'brings with' it (*bringt mit*) and which it in a certain sense impersonates" (10). My reading claims that for Mandelshtam of "On the Interlocutor" the existence—though not the identity, person, character, and so on—of the addressee is far more assured than for Celan, and (in §9 of the present chapter) I attribute two temporalities and two associated addressees to Celan's poetology, one of which resonates with Levine's interpretation here.

97. This interpretive line, with caution, could be developed further by considering Barbara Johnson's understanding of apostrophe as the expression of

Lacanian demand for the absent mother in "Apostrophe, Animation, and Abortion." While such a structure may well animate many of Tsetaeva's poems (see Ciepiela, "Demanding Woman Poet"), Celan's apostrophes do not seek a self-less (re)union with the other, but rather the self's orientation in the reality it projects.

98. Celan had met Buber and admired his works: cf. Lyon, "Paul Celan and Martin Buber," and Schwerin, "Bitterer Brunnen des Herzens, Erinnerungen an Paul Celan." Thematically, Buber's dialogism and phenomenology of the "encounter" are clearly present in Celan's "Meridian" speech and reach even to the lexical level: Celan says that poem and addressee are "*zugewandt*," a recurring term in Buber. Most strikingly, both converge in their notion of "breath, breathing," which Buber relates to the spirit ("*Geist*," from Greek "*pneuma*": "wind," "air," "breath") that comes into being in the encounter between I and Thou: "in truth namely language is not located in people, rather the person stands in language and speaks out of it,—in this way all word, all spirit. Spirit is not in the I, but between I and Thou. It is not like the blood that circulates in you, but rather like the air, in which you breathe" (Buber, *Schriften zur Philosophie*, in *Werke*, 1: 103); "But in the great faithfulness, which is the breathing space [*Atemraum*] of the genuine conversation, whatever I at that moment want to say already has in me the character of that which wants to be spoken. . . . It bears, unknown to me, the sign that indicates the belongingness to the common life of the word" (ibid., 1: 283). Celan's familiarity with Buber and his association of him with Jerusalem is attested in Chalfen, *Paul Celan*, 144.

Celan's neologism "counter-word" ("*Gegenwort*") in the Meridian speech perhaps should be seen in the constellation of "presence" ("*Gegenwart*") and "concrete objectivity" ("*Gegenstandlichkeit*") as Buber emphasizes them in the genuine dialogic encounter. The presence of Buber (and Kierkegaard) in Bakhtin is also well documented; he began reading them at the age of fifteen and to the end of his life held Buber to be greatest philosopher of the twentieth century. Cf. Frank, "Voices of Mikhail Bakhtin," 19, with further references.

99. On this interpretation of Derrida as an "inverted Romantic" see Menke, *Die Souveränität der Kunst*, 212–36, and my discussion in "Under the Sign of Adorno."

100. Habermas, *Philosophical Discourse of Modernity*, 205. Cf. also Menke, who speaks of Derrida's "universalization of the aesthetic," in his "'Absolute Interrogation,'" 363–66.

101. Celan, "Die Dichtung Ossip Mandelstamms," 197 (original underlining).

102. Celan, GW 3: 167–68; echoed in Meridian speech, GW 3: 197.

103. Ibid., 3: 186.

104. Ibid., 3: 185–86.

105. "Die Dichtung Ossip Mandelstamms," 206.

106. Celan, GW 3: 201.

107. See, for instance, the reading of the Meridian speech in the context of Heidegger's philosophy of art by Lacoue-Labarthe, *La poésie comme*

expérience; and Fóti, "A Missed Interlocution"; regarding Celan's encounter with Heidegger's linguistic philosophy, see Fynsk, "Realities at Stake in a Poem." Lyon, *Paul Celan and Martin Heidegger*, provides a helpful chronology of the relationship on the basis of a meticulous consideration of available textual evidence.

108. Heidegger, *Sein und Zeit*, 145.

109. Ibid., 328f.

110. "Die Dichtung Ossip Mandelstamms," 198.

111. Celan, *GW* 3: 191–92.

112. Ibid., 3: 188.

113. Ibid., 3: 190.

114. Ibid., 3: 187.

115. For a psychoanalytically insightful interpretation of the difference between art's "coming again" and poetry's "coming between," see Levine, "Pendant: Büchner, Celan, and the Terrible Voice of the Meridian."

116. "Die Dichtung Ossip Mandelstamms," 196.

117. Ibid., 206.

118. Letter to Wilhelmine Jaeglé, mid-end of January, 1834. Cf. Büchner, *Sämtliche Werke*, 2: 377.

119. The recurrent invocation of "a step" in the speech by Celan, who moved permanently to Paris after the war, might also be a multilingual pun, for "step" in French [*pas*] also means "not" or "contrary."

120. Conversation in July 1965 with Dietlind Meinecke, reported in Meinecke, *Wort und Name bei Paul Celan*, 50.

121. Celan, *GW* 3: 188, 189, respectively. A counterword of sorts was spoken by the author Christoph Hein on November 4, 1989, on Alexanderplatz (East Berlin), before thousands of demonstrators who had taken to the streets to celebrate the changes popular dissent had wrought in the GDR government, including the appointing of its new leader, Egon Krenz. Hein cautioned against premature self-congratulation in view of the "great amount of painstaking work" that remained to reform the society by evoking an earlier revolutionary whose dream of a socialist society went terribly awry: Erich Honecker. Cf. "Der alte Mann und die Straße" in Hein, *Die fünfte Grundrechenart*, 194–96.

122. Celan, *GW* 3: 194.

123. And in the poem "Tübingen, Jänner" (*GW* 1: 226) Celan, through the detour of a certain Hölderlin, considers another conflict of times: "if a man came into the world, today, with / the patriarchs' beard of light: he should / if he spoke of this / time, he / should / only babble and babble, / al-, al- / waysways."

124. Celan *GW* 5: 158–59.

125. Ibid., 2: 351. Celan's dated, technical term "Balme" belongs to the geological vocabulary he often draws on in his late lyrics to symbolize, like Mandelshtam, sedimented time, history, and so on. While often it is a case of freeing up such sedimented history, here an awful inversion has taken place. *Balme* is defined as "an overhanging rock face that at times protrudes like a cornice several meters over the softer and hence more easily weather-beaten

layers." *Meyers Großes Konversations-Lexikon*, 2: 311. For an intriguing reading of geological terms in selected poems from Celan's middle period, see Tobias, *Discourse of Nature*, esp. 14–41.

126. Celan, *GW* 3: 194.

127. Ibid., 3: 195.

128. Ibid., 3: 196.

129. Ibid., 1: 204.

130. Brierley, *"Der Meridian,"* and many after him see *"das ganz Andere"* as a citation of Rudolf Otto's definition of God in his influential *Das Heilige*. The reference also may, perhaps, be refracted through Buber's comment in *Ich und Du*: "Certainly God is 'the completely Other'; but he is also the completely Same [*das ganz Selbe*]: the completely present [*Gegenwärtige*]. Certainly he is the mysterium tremendum, that appears and casts down; but he is also the secret of what is completely obvious [*Geheimnis des Selbstverständlichen*] that is closer to me than my I" (Buber, *Werke*, 1: 131).

131. And here I note another meridian: at the outset of his "Epistemo-Critical Prologue" to *The Origins of German Tragic Drama*: here 29 and 44–45 (translation modified), Benjamin says that "pausing for breath [*Atemholen*] is the mode most proper to the process of contemplation" and later likens his antideductive, discontinuous method of "productive skepticism" to "the pause for breath, after which the thought can lose itself toward the very minutest thing leisurely, without the slightest inhibition." Celan calls this pause first a *"Verhoffen"*—a hunting term indicating the moment when a deer freezes to scent the wind, to check for danger—and second "the thought," the latter echoing Benjamin's understanding of the reader's devoted attention to "the most minute thing."

132. The quotes indicate citation; compare Mandelshtam: "The question I have posed [about the unity and continuity of Russian literature] becomes particularly acute in view of the quickening tempo of the historical process. It is certainly an exaggeration to regard each year of contemporary history as a century, but something like a geometric progression, a regular and natural acceleration, is perceptible in the stormy realization of the already accumulated and still-increasing potential of historical energy. Due to the quantitative change in the content of events occurring over a given time interval, the concept of a unit of time has begun to falter, and it is no accident that contemporary mathematical science has advanced the theory of relativity" ("On the Nature of the Word," in Mandelshtam *SS* 2: 241; *CPL*: 117).

133. Goethe, *Faust*, line 1700, in *Werke*, 3: 57.

134. Celan, *GW* 3: 197.

135. Ibid. This may be a temporalization of Hegel's ontological definition of art as "mere appearance [*Schein*] . . . and the artwork stands in the *middle* between immediate sensuousness and ideal thought. It is *not yet* pure thought, but, despite its sensuousness, is *no longer* a merely material existence [*Dasein*] either" (Hegel, *Vorlesungen über Ästhetik*, *Werke*, 13: 60).

136. For instance, Christopher Fynsk, "Realities at Stake in a Poem," to my mind reads Celan too much as a Heideggerian. "Nicht erst vom Wort

her" he translates as "and not simply verbally," which obscures what I take, together with the quotation marks surrounding "Entsprechung," to be a critical dismissal of Heidegger's lecture "Die Sprache." Fynsk's translation also misses the parallelism between "vom Wort her" (197) and "Vielleicht ist das Gedicht von da her es selbst" (Celan, *GW* 3: 196), part of the entire rhetoric of direction and movement in Celan's discourse. Finally, the Mandelshtam radio broadcast version cited above makes Celan's dismissal unambiguous.

137. The original: "Die Weise, nach der die Sterblichen, aus dem Unter-Schied in diesen gerufen, ihrerseits sprechen, ist: das Entsprechen. . . . Die Sterblichen sprechen, insofern sie hören. Sie achten auf den heißenden Ruf der Stille des Unter-Schiedes, was es ins lautende Wort bringt. Das hörend-entnehmende Sprechen ist Ent-sprechen. . . . Die Sprache spricht. Ihr Sprechen heißt den Unter-Schied kommen, der Welt und Dinge in die Einfalt ihrer Innigkeit enteignet. Die Sprache spricht. Der Mensch spricht, insofern er der Sprache entspricht" (Heidegger, "Die Sprache," in *Unterwegs zur Sprache*, 32–33). In two essays in the same collection ("Das Wesen der Sprache" and "Das Wort") Heidegger explicates these ideas through an interpretation of Stefan George's poem "The word" ("Das Wort"), particularly its last line: "kein ding sei wo das wort gebricht" ("may there be no thing where the word is wanting").

138. In the original: "Wir finden als bestimmend nicht den Menschen im Angesicht der Dinge, die er zu verantworten unternähme and damit erst zu ihrer vollen Dinghaftigkeit brächte. So grundwichtig dieser Akt auch ist, als bestimmend finden wir doch die Menschen miteinander, die sich über Situationen zu verständigen unternehmen. Nicht die Dinge, sondern die Situationen sind primär; und wenn Stefan Georges Spruch, kein Ding sei, was das Wort gebricht, eben für die Dinge zutreffen mag—auf die Situationen die dem Menschen zu kennen gegeben werden, ehe er die Dinge zu kennen bekommt, ist es unanwendbar" (Buber, "Das Wort, das gesprochen wurde," in his *Schriften zur Philosophie*, *Werke*, 1: 442–53 [here 448]). See Pöggeler, "Kontroverse zur Ästhetik Paul Celans," 233.

139. Menninghaus, in *Paul Celan*, 24, suggests that by "actualized language" Celan is drawing on Saussure's structuralist distinction between "langue" and "parole," but besides the question of Celan's familiarity with the linguist's writings, that structuralist distinction (between abstract and ideal linguistic rules and their concrete and imperfect mastery by an individual) operates just as easily at the monological level (for example, speaking overtly or in foro interno), and hence is ultimately insufficient for understanding Celan's dialogic poetics.

140. Celan, "Die Dichtung Ossip Mandelstamms," 197; echoed in the "Meridian," *GW* 3: 197–98, and in *GW* 3: 168.

141. Celan, "Die Dichtung Ossip Mandelstamms," 197 (original underlining).

142. Now reproduced in the Marbach catalog *"Fremde Nähe". Celan als Übersetzer*, ed. Gellhaus et al., 341.

143. Cf. Reichert's "Nachbemerkung," in Celan, *Ausgewählte Gedichte*, 188.

144. Mandelshtam *SS* 1: 40.

145. Celan, "Die Dichtung Ossip Mandelstamms," 201.

146. Celan, *GW* 3: 198.

147. Celan, "Die Dichtung Ossip Mandelstamms," 198 (original underlining); repeated almost verbatim in "Meridian," *GW* 3: 199.

148. In the "Meridian" passage cited directly before this quote it is clearer that Celan is not just referring to animate interlocutors: "For the poem that is heading for the Other, every thing, every human being is a form of this Other." Such pronouncements might partially explain both Heidegger's and Adorno's fascination with the poet. It is known that Adorno made copious notes and marginalia to Celan's *Sprachgitter* and planned to write on his poetry. Adorno's own utopian notion of a noncoercive relationship between human beings and things reads almost as a gloss on Celan: "In its proper place, even epistemologically, the relationship of subject and object would lie in a peace achieved between human beings as well as between them and their Other" (Adorno, "On Subject and Object," *Critical Models*, 247).

149. Celan, *GW* 3: 175.

150. Ibid., 3: 195.

151. Ibid., 3: 167.

152. Ibid., 3: 177–78.

153. Celan, "Die Dichtung Ossip Mandelstamms," 199 (original underlining); echoed in Bremen and Meridian speeches, *GW* 3: 186 and 199.

154. Celan, "Die Dichtung Ossip Mandelstamms," 199 (original underlining).

155. Celan, "Die Dichtung Ossip Mandelstamms," 206. And in *"Leideform"* ("passive form") one can also hear *"Leiden"* ("to suffer"). The source is the beginning of the chapter "Alagez" in Mandelshtam's *Journey to Armenia*:

> What tense would you choose to live in?
> "I want to live in the imperative of the future passive participle—in the 'what ought to be.'" I like to breathe that way. That's what I like. It suggests a kind of mounted, bandit-like, equestrian honor. That's why I like the glorious Latin "Gerundive"—it's a verb on horseback. (Mandelshtam *SS* 2: 172; *CPL*: 374)

156. See Olschner, *Der feste Buchstab*, for a detailed description and consideration of the poetics of Celan's translations.

157. Celan, *GW* 3: 73.

158. Ibid., 2: 24.

159. Mandelshtam *SS* 2: 145; *CPL*: 350.

160. The poem "STIMMEN" (*GW* 1: 147–49) composed of eight parts separated by asterisks, constitutes the entire first cycle in the book. The poem's first part has been interpreted with emphasis on its linguistic self-reflexivity by Werner Hamacher in his article "The Second of Inversion: Movements of Figure through Celan's Poetry," esp. 356–58, and with emphasis on its dialogical structure by Sieghild Bogumil in "Zur Dialoggestalt von Paul Celans Dichtung."

161. See, for instance, Celan's bitter letters about the reception of the "Meridian" speech, cited in Brierley, *"Der Meridian,"* 366–67.

162. Celan, *GW* 3: 198.

163. Cf. Walter Benjamin, "Character and Fate," in Benjamin, *Selected Writings*, 1: 204. How far can one interpret Celan? "Chiromancy," from the Greek for "hand," suggests the chiasmus, "marking with diagonal lines X," which in fact is the figure of coincidence in the Benjamin citation. Celan also holds that "the true poem is a handshake," and two people shaking hands literally is a crossing and an inversion (of right hands). If one can read their fate/character from the lines of their hands, these two intersect at the handshake.

164. Celan, *GW* 3: 202.

165. Mandelshtam, "On the Nature of the Word," in Mandelshtam *SS* 2: 253–54; *CPL*: 128.

166. Poems include "SCHWIMMHÄUTE" (*GW* 2: 297), "Mapesbury Road" (*GW* 2: 365), "Erst wenn ich dich" (*GW* 3: 76). Note that on my reading Celan's collection of poems entitled *Zeitgehöft* should not be translated into English as *Farmstead of Time* (as one edition does), but rather something like *Time-Haloed*.

167. Husserl, *Vorlesungen zur Phänomenologie des inneren Zeitbewußtseins*, 30.

168. Ibid., 52–53.

169. Ibid., 91.

170. Speier, "Zum Verhältnis von Ästhetik."

171. Celan, *GW* 3: 186, 199.

172. MacIntyre, "Relativism, Power, and Philosophy," 185 (final emphasis is mine).

173. Celan, *GW* 3: 202. And we recall the passage from Mandelshtam's *Journey to Armenia*: "I want to live in the imperative of the future passive participle—in the 'what ought to be'" (Mandelshtam *SS* 2: 172; *CPL*: 374).

174. Celan, *GW* 3: 171.

175. Celan is reported to have said that with one collection of poems (*Fadensonnen*) he had wanted to create something like contraband, in his words: "an opposition, a 'thou.'" Cameron, "Erinnerung an Celan," 339.

176. Celan, *GW* 1: 211.

177. Mandelshtam *SS* 1: 109.

178. Celan, *GW* 5: 142–43.

179. Cameron, "Das Dunkle und das Helle," 158.

180. Celan, *GW* 3: 186.

181. Ibid., 5: 624.

182. Gadamer, *Wahrheit und Methode,* 310–11 (emphasis in bold is mine).

183. Habermas, *On the Logic of the Social Sciences*, 170. The fullest presentation of the argument can be found in Habermas, "Zu Gadamers 'Wahrheit und Methode,'" in the collection *Hermeneutik und Ideologiekritik*. It should be noted that "conservatism" is not a political designation as such, but refers to the amalgamation of history into a single authoritative tradition.

So for instance, on the Left, Fredric Jameson justifies the research and revisionist criticism of the past also in terms of a single tradition: "These matters can recover their original urgency for us only if they are retold within the unity of a single great collective story; only if, in however disguised and symbolic a form, they are seen as sharing a single fundamental theme—for Marxism, the collective struggle to wrest a realm of Freedom from a realm of Necessity; only if they are grasped as vital episodes in a single vast unfinished plot" (Jameson, *Political Unconscious*, 19–20).

184. Gadamer, *Wahrheit und Methode*, 301.

185. "Epilogue to the Revised Edition" of Gadamer, *Gadamer on Celan*, 150.

186. Original: "das Gedicht, nur dann, wenn es die Vergänglichkeit der Dinge und seiner selbst mitsprechen läßt, Aussicht hat zu dauern" cited in Böschenstein, "Celan und Mandelstamm," 160–61.

187. Benjamin, "On the Concept of History," in Benjamin, *Selected Writings*, 4: 390–91.

188. Ibid., 396 (translation modified).

189. Ibid., 391 (translation modified).

190. Celan, *GW* 1: 261.

191. Benjamin, "On the Concept of History," in Benjamin, *Selected Writings*, 4: 395 (translation modified).

192. Ibid.

193. Celan, *GW* 1: 131–32.

194. *Poems of Paul Celan*, translated by Michael Hamburger, 97.

195. For another instance of such homonymic enciphering of proper names, see Olsson on the semantics of "Rosa" in "Spectral Analysis: A Commentary on 'Solve' and 'Coagula.'"

196. On Erich Einhorn's friendship with Celan, see Chalfen, *Paul Celan*, 114–15.

197. Celan, *GW* 1: 288.

198. This was first noticed by Parry, *Mandelstamm der Dichter*, 186–87. So far as I know there has been no systematic investigation of Russian puns in Celan. Another pun is "toskanisch" in the poem "IN EINS" and Mandelshtam's use of "тоска" is his poetry; in this respect cf. also Celan, *"Mikrolithen sinds, Steinchen,"* 119. On Hebrew and French multilingual puns in Celan, see Petuchowski, "New Approach to Paul Celan's 'Argumentum e Silentio'"; and Petuchowski, "Bilingual and Multilingual Wortspiele in the Poetry of Paul Celan."

199. See the postwar correspondence between Celan and Erich Einhorn, and the biographical essay by Einhorn's daughter, in *Einhorn: du weißt um die Steine. Briefwechsel*, edited by Marina Dmitrieva-Einhorn.

200. Celan, *GW* 1: 289.

201. Ibid., 1: 270.

202. Cf. Hannah Arendt, *On Revolution*, and Celan: "I still believe, meaning to last the whole evening and not trying to be pithy, in people, Jews, love, truth, tree-frogs, writers and baby-bringing storks. And—but only a bit, and that only in the (Eastern? does that exist at all?) intimate

hemisphere—in—in a Viennese song that I learned as a boy in Czernow-
itz, it's called, I believe—in 'solidarity, solidarity'" (cited in Brierley, *"Der
Meridian,"* 354)

203. Chalfen, *Paul Celan,* 82.

204. "PETROPOLIS DIAPHAN," *GW* 5: 92–93.

205. Celan's fragment and an excerpt from Ehrenburg's autobiography
are published in the Marbach catalog *"Fremde Nähe." Celan als Übersetzer,*
ed. Axel Gellhaus et al., 347.

206. Celan, *GW* 1: 272.

207. Celan, *GW* 5: 623. The temporal juxtaposition of "aeon" and "heart-
beat" probably derives from a line from Mandelshtam's poem "Sumerki svo-
body" (1918), *SS* 1: 72.

208. Celan, *GW* 3: 200.

209. Ibid., 3: 198 (my emphasis).

210. Adorno, *Aesthetic Theory,* 101–2, 107.

2. CONFLICT AND COMMEMORATION: TWO BERLIN MEMORIALS

1. Marx, "Der achtzehnte Brumaire des Louis Bonaparte," in *Werke,* 3/1:
271.

2. Nietzsche, "Vom Nutzen und Nachtheil der Historie für das Leben," in
Sämtliche Werke, 1: 270.

3. "N" refers to *Konvolut* N of Benjamin's theoretical notes for the *Pas-
sagenwerk,* collected in Benjamin, *Gesammelte Schriften,* vol. 5.

4. Pierre Nora, "Between Memory and History," 12. German neoconser-
vative philosophers such as Odo Marquard and Hermann Lübbe have argued
similarly that the loss of a substantive lived tradition in modernity produced
compensatory constructions of memory such as the humanities, memorials,
and museums. See Lübbe, "Zeit-Verhältnisse," in Zacharias, *Zeitphänomen
Musealisierung,* 40–50; and Lübbe, *Die Aufdringlichkeit der Geschichte.*
These references come from Huyssen, "Denkmal und Erinnerung im Zeital-
ter der Postmoderne," 11.

5. Riegl, *Der moderne Denkmalkultus.*

6. On the American example, cf. Steven Knapp's rejoinder to Alisdair
MacIntyre's argument that American liberal individualism wrongfully denies
its collective responsibility for the historical fact of slavery: "But if 'mod-
ern Americans' automatically inherit this morally tainted collective identity,
should we conclude that modern '*black* Americans' inherit it as well? . . . Col-
lective identities, unlike individual ones, frequently overlap. In this sense the
voluntarism MacIntyre criticizes as a product of liberal individualism merely
describes a feature of large-scale collectivities as such" (Knapp, "Collective
Memory and the Actual Past," 143).

7. Santner, *Stranded Objects,* xiii.

8. Sichorovsky, *Born Guilty,* 7. Quoted in Santner, *Stranded Objects,*
38–39.

9. On the controversy surrounding Sander's film see *October* 72 (spring 1995). The filmscript is available from Verlag Antje Kunstmann (Munich: 1992). On the vexed historical issues, see chapter 2, "Soviet Soldiers, German Women, and the Problem of Rape," in Naimark, *Russians in Germany*, 69–140.

10. The director has said he was strongly influenced by Stanley Kubrick's film *Full Metal Jacket*, but his film lacks the ambivalences of Kubrick's film. The Wehrmacht's participation in mass civilian killings and the Holocaust is documented in a controversial exhibition (which brought the ruling conservative CSU and extreme right parties to an embarrassing encounter as they marched simultaneously against the exhibition in Munich) and the exhibition catalog, *Vernichtungskrieg: Verbrechen der Wehrmacht, 1941 bis 1944*, ed. Hamburger Institut für Sozialforschung (Hamburg: Hamburger Edition, 1996).

11. Santner, *Stranded Objects*, 45.

12. Ibid., 34–35.

13. Ibid., 35.

14. As of 2000 those born in Germany of non-German parents are granted *jus soli* citizenship, but must choose between German nationality and the nationality of their parents before their twenty-third year. Germany does not generally allow dual citizenship and before the year 2000 relied exclusively on a *jus sanguinis* concept of citizenship dating back to 1913.

15. The memorial, like many others in Berlin at least, has been repeatedly vandalized and repaired.

16. On the notion of various concentric contexts of identity, see Forst, *Kontexte der Gerechtigkeit*. On the emergence of modern personal identity as authenticity, see Trilling, *Sincerity and Authenticity*; and Gleason, "Identifying Identity."

17. I say "pertinent" rather than "determinative" here because the interplay between situation, subjective perception, and action is rich and improvisational. Thus I would loosen up Clifford Geertz's top-down definition of culture as "a set of control mechanisms" in favor of Pierre Bourdieu's notion of "habitus," which he defines as "systems of durable, transposable *dispositions*, structured structures predisposed to function as structuring structures, that is, as principles of the generation and structuring of practices and representations which can be objectively 'regulated' and 'regular' without in any way being the product of obedience to rules, objectively adapted to their goals without presupposing a conscious aiming at ends or an express mastery of the operations necessary to attain them and, being all this, collectively orchestrated without being the product of the orchestrating action of a conductor" (*Outline of a Theory of Practice*, 72; cf. also 79). Bourdieu's definition, which strains to straddle the subject-object and active-passive distinctions commonly made in the sociology of behavior, avoids the "obedience to rules" that at times seems to undergird Geertz's idea of culture, which is often cited in contemporary culturological studies. Geertz writes that "culture is best seen not as complexes of concrete behavior patterns—customs,

usages, traditions, habit clusters—as has, by and large, been the case up to now, but as a set of control mechanisms—plans, recipes, rules, instructions (what computer engineers call 'programs')—for the governing of behavior" (Geertz, *Interpretation of Cultures,* 44), which seems to slight the possibility of improvisation that Bourdieu emphasizes.

18. On postconventional identity as a reflexive, critical relationship to substantive forms and symbols of national identity, see Habermas, "Eine Art Schadensabwicklung."

19. Halbwachs, *Collective Memory.*

20. Bloch, "Mémoire collective, tradition et coutume." On this point, see Burke, "History as Social Memory"; and Connerton, *How Societies Remember,* 38–39.

21. On action under a description, see Anscombe, *Intention.*

22. Quoted in Theißen, "Die Bundesrepublik auf dem Weg nach Deutschland," 88.

23. Hegel, *Aesthetics,* 2: 638 (translation modified).

24. English edition: Schinkel, *Collection of Architectural Designs,* ed. Kenneth Hazlett, Stephen O'Malley, and Christopher Rudolph.

25. Kracauer, "Tessenow baut das Berliner Ehrenmal," reprinted in *Schriften,* 5/2: 211–14.

26. "Hindenburg weiht die Neue Wache zum Ehrenmal," *Deutsche Allgemeine Zeitung,* June 2, 1931. Cited in Jürgen Tietz, "Schinkels Neue Wache Unter den Linden: Baugeschichte, 1816–1993," in Stölzl, *Die Neue Wache Unter den Linden,* 25.

27. Quoted in "Die Neugestaltung Berlins," *Nachtexpress Berlin* (December 15, 1945), reproduced in Tietz, "Schinkels Neue Wache Unter den Linden: Baugeschichte, 1816–1993," 77.

28. Cf. Topfstedt, *Städtebau in der DDR, 1955–71.*

29. Demps, *Die Neue Wache,* 171.

30. The first grave of the unknown soldier dates from 1896 in the United States to honor the "unknown dead" of the Civil War, but the genre came into its own following World War I (the cenotaph in London, the Arc de Triomphe in Paris) and represented the national symbolization of the new realities of war: mass death (a simple soldier, rather than a general, is honored) and anonymous, total destruction (the body stands for all the dead whose bodies could not be found or identified). See Ken S. Inglis, "Grabmäler für Unbekannte Soldaten," in Stölzl, *Die Neue Wache Unter den Linden,* 150–71; and Volker Ackermann, "'Ceux qui sont pieusement morts pour la France . . .' Die Identität des Unbekannten in Frankreich," in Koselleck and Jeismann, eds., *Der politische Totenkult: Kriegerdenkmäler in der Moderne,* 281–314.

31. See "Aide-mémoire," in *Der Architekt* 12 (1984): 570f. On resistance to the project because of the lack of differentiation between victim and perpetrator, see, for example, "'Des Widerstands an anderem Ort gedenken': Einwände gegen ein Mahnmal für alle Opfer der Gewaltherrschaft," in *Franfurter Allgemeine Zeitung,* April 15, 1986. In general I rely here on Bernhard Schulz's synopsis, "Kein Konsens im Land der Menschenketten: Zur Vorgeschichte einer 'Zentralen Gedenkstätte

der Bundesrepublik Deutschland,'" in Stölzl, *Die Neue Wache Unter den Linden,* 176–77.

32. For documentation and evaluation of the controversy, see Hartman, *Bitburg in Moral and Political Perspective.*

33. *Frankfurter Allgemeine Zeitung,* January 28, 1993.

34. "Die Debatte des Deutschen Bundestages am 14. Mai 1993 zur zentralen Gedenkstätte Neue Wache," in Stölzl, *Die Neue Wache Unter den Linden,* 212–22, here 214–17.

35. Christoph Stölzl, "Die Trauer der Mutter: Plädoyer im Denkmalstreit um die Neue Wache: sprechendes Mitleid statt sprachlosem Stein," in Stölzl, *Die Neue Wache Unter den Linden,* 195–97, here 195.

36. Cf. the following entries from Käthe Kollwitz's diary:

This was also the day on which Peter asked Karl [his father] in the evening for his permission to go with the contingent of the Landsturm. Karl speaks against it using everything he can. I sense a feeling of gratitude that he is struggling for him so, but I know it will not change anything anymore. Karl: "The Fatherland doesn't need you yet, or else it would already have summoned you." Peter quietly but firmly: "The fatherland doesn't need my age group yet, but it needs *me.*" He constantly turns silently to me with entreating looks, that I might speak on his behalf. Finally he says: "Mother, when you embraced me you said: don't believe that I am a coward, we are prepared." I stand up, Peter follows me, we stand at the door and embrace and kiss and I implore Karl on Peter's behalf.—This one hour. This sacrifice [*Opfer*] to which he charmed [*hinriß*] me to which we charmed Karl. [August 10, 1914]

On October 4, Peter, in his field-gray uniform, greets his family at the train station:

"The boy looked so good. . . . He told us of the field church service earlier in the day. The minister had reminded them of the Roman hero who threw himself into the chasm so that others could cross it. . . . So now their sacrifice [*Opfer*] has been blessed by the church too." [October 4, 1914]

Käthe Kollwitz, *Die Tagebücher,* 152, 167.

37. For example, diary entries for December 1, 1914 ("The memorial should have Peter's figure, lying stretched out, the father at his head, the mother at his feet, it should stand for the sacrificial death [*Opfertod*] of the young military volunteers"), December 3, 1914, December 9, 1914 ("You should lie stretched out, your hands answering the call to sacrifice [*Hingabe*]: 'Here I am.'"), February 15, 1915, April 15, 1915, August 11, 1915, August 28, 1915 ("I am making very slow progress on the work. It is something different than the other works. It is much less a matter of art as one of humanity. First and foremost a matter between Peter and me"), and so on. *Tagebücher,* ibid. Käthe Kollwitz comes to see Peter, or Peter's death, as the seed [*Samenkorn*] that has been "placed in me." In a remarkable passage she inverts the conventional simile of artistic production and human

reproduction by imagining herself impregnated with the seed of her (dead) son. In an allusion to Goethe's aphorism "seeds should not be ground up" (*Saatfrüchte sollen nicht vermahlen werden*) that recurs in her diary and artwork, she writes: "Peter was the seed that should not have been ground up. He himself was the seed. I am the bearer and developer of his seed. . . . And since I ought to be the bearer, I wish to serve faithfully. Since I have realized this I feel almost cheerful and wonderful. Not only am I allowed to complete my [artistic] work—I ought to complete it" (February 15, 1915; *Tagebücher*, ibid., 183).

38. For examples of the theme of mother and dead child or dead soldier-son in Kollwitz's oeuvre from 1903 onward, see Nagel, *Käthe Kollwitz*, plates 31, 46, 47, 63, 65–67, 69–71, 106–7, 121, and the studies on pp. 202–3, 210–11, 228–33, 264–65, 306–19, 330–31, 366–67, 404–5. For various perspectives on this complex, see Käthe-Kollwitz-Museum, *Käthe Kollwitz, Schmerz und Schuld*.

39. Kollwitz, *Tagebücher*, 166, 199–200. Cf. also her ambivalence when her husband tries to forestall their other son's going to the front: "Karl wants to write the War Ministry and request that the boy not be sent to the front. This is so unpleasant to me. Why? Karl says: 'You only have strength for sacrifices [*zum Opfern*] and for letting go—not the least for holding on [*zum Halten*]'" [November 27, 1914] (ibid., 176).

40. Kollwitz, *Tagebücher*, 690.

41. Note that in the preliminary sketches death leans over the woman, whose head falls back to the left, with a vague object below her head. Kollwitz wrote to Arthur Bonus, "Is it not a crown of thorns that lies at the lower left? I imagined that Death takes the woman gently. And the crown of thorns remains lying below. Or, he [Death] gently lays her out, but still she is no longer wearing the thorns" (cited in Nagel, *Käthe Kollwitz*, 366). Nagel also notes that "the motif of the back head tossed back can be found already in the lithographic print 'Pietà' of 1903" (ibid.).

42. For collections of critical texts on the redesign of the Neue Wache cf.: *Streit um die Neue Wache: Zur Gestaltung einer zentralen Gedenkstätte*, ed. Jörg Fessmann; *Im Irrgarten deutscher Geschichte. Die Neue Wache 1818–1993*, ed. Daniela Büchten and Anja Frey; *Nationaler Totenkult: Die Neue Wache. Eine Streitschrift zur zentralen deutschen Gedenkstätte*, ed. Schmidt, Mittig and Böhm.

43. "Die Debatte des deutschen Bundestages . . . ," in Stölzl, *Die Neue Wache Unter den Linden*, 216.

44. Renan, *Oeuvres complètes*, 1: 904.

45. Danto, "Vietnam Veterans Memorial," 152; quoted in Young, *Texture of Memory*, 3.

46. This largely corresponds to what Victor Turner calls the "operational meaning" of a symbol. See note 64, below.

47. Jakobson, "Linguistics and Poetics," 66. See Todd, *Fiction and Society*, for a sophisticated use of Jakobson's model to explore nineteenth-century literary institutions in Russia.

48. Sturken, "Wall, Screen, and Image," 120.

49. Marx wrote, with unmatched irony: "The Jew has emancipated himself in a Jewish manner, not only by acquiring financial power but also because through him and without him *money* has become a world power and the practical Jewish spirit has become the practical spirit of the Christian peoples. The Jews have emancipated themselves in so far as the Christians have become Jews" (Marx, *Werke*, 1: 482).

50. "Mitweinen, mitfühlen, mitkämpfen, mitnötig sein: Nichts kennzeichnet den Menschen Käthe Kollwitz und das Werk besser als diese emotionale und auf Gemeinsamkeit ausgerichtete Präposition 'mit'" (Krahmer, *Käthe Kollwitz*, 7 [cf. also 12, 59, 80, and so on]).

51. Stölzl, "Die Trauer der Mutter . . . ," *Die Neue Wache Unter den Linden*, 196–97.

52. Cf. Lessing's *Hamburgische Dramaturgie*, 74.–79. Stücke. Aristotle, *Poetics* 1453a1–6: "Such a combination [a bad man falling into misfortune] may produce a humane feeling, but neither pity [ἔλεος] or fear [φοβος], for pity relates to an undeserved misfortune, and fear to that of one like ourselves." On the translation of "ἔλεος" cf. Schadewalt, "Furcht und Mitleid?"

53. On the divergent receptions of Kollwitz, see Gudrun Fritsch and Annette Seeler, "Der Blick auf Käthe Kollwitz im Wandel der Zeiten: Nachruhm und Wirkungsgeschichte nach 1945," in Stölzl, *Die Neue Wache Unter den Linden*, 137–49.

54. See Finlayson, "Naming Myth and History."

55. This point is made at greater length by Reinhart Koselleck, "Stellen uns die Toten einen Termin?" in J. Fessmann, ed., *Streit um die Neue Wache: Zur Gestaltung einer zentralen Gedenkstätte*, 27–34.

56. Reinhart Koselleck, "Kriegerdenkmale als Identitätsstiftungen der Überlebenden." Perhaps the most striking instance of the third category, the dead themselves, devoid of ideological description or cause, can be found in the prosopopoetic inscription of the Memory Hall (Kansas City, Missouri) to the fallen of World War I: "WE ARE THE DEAD," with bronze tablets listing the names of soldiers from Kansas City who had been killed. For a description of the entire memorial, see Mayo, *War Memorials*, 86–90. The work of Koselleck's *Arbeitsgruppe* has resulted in the massive six-volume study by Lurz, *Kriegerdenkmäler in Deutschland*.

57. Compare this passage from Käthe Kollwitz's diary (quoted in n. 36, above), when she visited Peter after he enlisted in the Landsturm: "He told us about the army chuch service. The minister had reminded them of the Roman hero who threw himself into the chasm and bridged it with his body. The old Dutch prayer of thanks. So now they are also consecrated by the church for their sacrifice [*Opfer*]" [October 4, 1914] (*Tagebücher*, 167).

58. See Griswold, "Vietnam Veterans Memorial and the Washington Mall"; Sturken, "Wall, Screen, and Image"; Wagner-Pacifici and Schwartz, "Vietnam Veterans Memorial." Stephen Greenblatt explores a simliar dilemma (how to representationally distance noble combatants from an ignoble cause) in his "Murdering Peasants."

59. Jeismann and Westheider, "Wofür stirbt der Bürger?", 36–39.

60. Nipperdey, *Deutsche Geschichte 1800–1866*, 300.

61. For details about the "Schlageter-Kult" and the memorial, see Lurz, *Kriegerdenkmäler in Deutschland*, 5: 316–24.

62. Schrade, *Das deutsche Nationaldenkmal*, 107. Cf. also his companion volume, *Sinnbilder des Reiches*.

63. Ibid., 109.

64. Victor Turner distinguishes three levels or fields of meaning of a ritual symbol: exegetical meaning (interpretations given by indigenous informants), the operational meaning (how the symbol is used by its practitioners), and the positional meaning (the symbol's relationship to other symbols in the culture). Turner, *Forest of Symbols*, 48–58.

65. Schrade, *Das deutsche Nationaldenkmal*, 111.

66. Demps, *Die Neue Wache*, 178.

67. Cf. Koselleck, "Bilderverbot," reprinted in J. Fessmann, ed., *Streit um die Neue Wache*, 96–100. Note that the problem of commemorating soldiers while maintaining a moral distinction between them is not particular to modern German history. James Mayo reports that the cemetery of the former Andersonville Prisoner of War Camp in Georgia, where between February 1864 and April 1865 more than twelve thousand of the forty-five thousand imprisoned Union enlisted men died of disease, malnutrition, overcrowding, and exposure, had a not dissimilar problem in distinguishing remembrance from honor: "One burial area is set aside symbolically to dishonor a group of prisoners who were called the Raiders. These traitors to their fellow Union soldiers stole personal possessions and even killed inmates to further their black market trade. The ring leaders of the Raiders were eventually caught and hanged. Near the center of the cemetery, the Raider gravestones are clearly set apart from other graves. The area is a symbolic prison. While the grounds are maintained in the same manner as the remaining cemetery, an annual ritual keeps the Raider graves in disgrace. On Memorial Day American flags are placed before each Union soldier's grave except for the Raiders. By placing these graves in a separate burial plot and denying them the honor of Memorial Day flags, the nation's sentiment is made clear: 'We have the duty to bury and preserve the grave of any soldier, but we are not obliged to honor the disgraced'" (Mayo, *War Memorials as Political Landscape*, 218).

68. Nietzsche, *Die Geburt der Tragödie*, in *Sämtliche Werke*, 1: 146. My thanks to Gordon Finlayson for this reference.

69. Here I draw on Franziska Kirchner, "Zur Frage der Abstraktion oder Gegenständlichkeit im heutigen Denkmal," in *Orte des Erinnerns: Das Denkmal im Bayerischen Viertel*, 1: 44–46.

70. Young, *Texture of Memory*, 27. He has developed and apparently endorsed this principle of memorials in his subsequent *At Memory's Edge*.

71. Ibid., 28.

72. Quoted in Young, *Texture of Memory*, 30.

73. Quoted in ibid., 43.

74. In more recent writing he has assimilated the Bavarian Quarter memorial to this type of "countermonument." See Young, *At Memory's Edge*, 113–16.

75. Interview with Jochen Gerz in the television show, "Denkmaldämmerung," SWF 3, March 26, 1992.

76. On the controversy in general, which received international press attention as well, see Kramer, *Politics of Memory*. On the controversy surrounding the early competition and proposed designs for memorial to the Jews, which Kramer summarizes, see *Der Wettbewerb für das "Denkmal für die ermordeten Juden Europas." Eine Streitschrift*. James E. Young, who served on the final selection committee, also recounts the political wrangling and ultimate compromises in "Germany's Holocaust Memorial Problem—and Mine," in his *At Memory's Edge*, 184–223. I discuss the genesis and interpretation of this memorial in greater detail in my "Dialectical Reflections on Peter Eisenman's 'Memorial for the Murdered Jews of Europe,'" forthcoming in *Architectural Theory Review* 17.2/3 (2012).

77. Young, *At Memory's Edge*, 214.

78. The two texts, "Building Site of Remembrance" by Rauterberg, and "The Silence of Excess" by Eisenman, are found in the large-format illustrated volume *Holocaust Memorial Berlin*, ed. Eisenman Architects.

79. Young, *At Memory's Edge*, 216.

80. Rauterberg, "Building Site of Remembrance."

81. In his otherwise appreciative essay on the memorial, Mark Godfrey likewise concedes: "The problem of how to integrate the field and the Ort together had not been solved" (Godfrey, *Abstraction and the Holocaust*, 243).

82. Musil, "Denkmale," in *Gesammelte Werke*, 7: 506–9.

83. Benjamin, "On the Concept of History," in Benjamin, *Selected Writings*, 4: 391 (translation modified).

84. The full title of the memorial is: "Places of Remembering in the Bavarian Quarter—Ostracism and Deprivation of Rights, Expulsion, Deportation and Murder of Berlin Jews in the Years 1933 to 1945."

85. The documentation is now partly available as the second volume of *Orte des Erinnerns: Jüdisches Alltagsleben im Bayerischen Viertel*. On the memorial itself, see vol. 1, *Das Denkmal im Bayerischen Viertel*, and the workbook the artists published with the opening of the memorial: *Arbeitsbuch für ein Denkmal in Berlin*, available from the "Dokumentationsstelle" in the Schöneberg Museum.

86. Foucault, *This Is not a Pipe*, 32–34.

87. One sign alone is accompanied by the image of ontological negativity: "Jews are forbidden to emigrate—23.10.1941," whose reverse image is undifferentiated blackness.

88. Caillois, "Mimicry and Legendary Psychasthenia," 70.

89. Celan, "Engführung," *GW* 1: 195–204. In "Durch die Enge geführt," Peter Szondi has examined the way this poem does not represent but rather enacts the Holocaust textually. My suggestion is that something similar *can* occur with this memorial, to the extent that the viewer feels *addressed* by the signs.

90. Benjamin, *Ursprung des deutschen Trauerspiels*, in *Gesammelte Schriften*, 1/1: 203–430; Benjamin, *Origin of German Tragic Drama*.

91. Benjamin, "Das Kunstwerk im Zeitalter seiner technischen Repro-
duzierbarkeit" (zweite Fassung), in Benjamin. *Gesammelte Schriften*, I/2:
471–508; "The Work of Art in the Age of Its Technological Reproducibility:
Second Version," in Benjamin, *Selected Writings*, 3: 101–33.

92. One of the defining characteristics of the Nazi regime was that the
most antidemocratic actions were masked as "legality". Cf. Kirchheimer's
comprehensive analysis in *Political Justice: The Use of Legal Procedure for
Political Ends*. Cf. also his earlier writings, in particular "The Legal Order
of National Socialism," which he held as a public lecture at Columbia Uni-
versity in December 1941, and which was published in *Studies in Philoso-
phy and Social Science* IX (1941): 456–75. These early essays are reprinted
with introduction, biographical essay, and bibliography in *Politics, Law and
Social Change: Selected Essays of Otto Kirchheimer*.

93. Benjamin, "On the Concept of History," Thesis XVII, in Ben-
jamin, *Selected Writings*, 4: 396. Note that in his "Epilogue," Santner
draws on Benjamin's theses on history as well, but to argue for regaining
an "oppressed past," "one that never in fact took place but that never-
theless might become available to future generations" (Santner, *Stranded
Objects,* 152), so that postwar generations "may yet be able to unearth new
resources of identification out of the unconscious layers for the history into
which they were born" (153). Drawing on a passage from Christa Wolf's
Kindheitsmuster, Santner identifies "moments in which one is shocked into
sync with one's humanity," and advocates "paleontological memory-work
[that] will hit on the fossilized traces of a once vital and intact solidar-
ity with the victim" (160). Santner's plea to regain images of humanist
empathy and pity with which one can identify is thus not far from the
intended effects of the Neue Wache ("to unearth new resources of identifi-
cation"). I would first suggest that such a program for regaining an alterna-
tive, oppressed history can be better fulfilled in documenting such political
actions as the Rosenstraße protest in 1943, when German wives took to
the streets when their Jewish husbands were to be deported, and arguably
forced their release. Secondly, *showing* lost moments of empathy and soli-
darity (as in Wolf's novel) remains at the level of representation; bringing
about the possibility for those moments (what more can be done?) is better
effected, I think, by the Bavarian Quarter memorial because it addresses,
interpellates the viewer situationally: it *produces* the situation not unlike
that which would (or would not) precipitate a Rosenstraße protest.

94. Cited in *Arbeitsbuch*, 5.

95. Cf. "On the Mimetic Faculty," in Benjamin, *Selected Writings*, 2: 720–
22. In the early sketches to his unfinished *Passagenwerk*, Benjamin writes
that "similarity is the organon of experience," a thought he later develops
into his theory of genuine experience or recognizability in convolut N of the
same work. Cf. Benjamin, *Arcades Project*, 868, and 456–88.

96. Rosen, *On Voluntary Servitude*, 240–43.

97. Ryle, *Concept of Mind*.

98. Evans, "Semantic Theory and Tacit Knowledge," 337.

99. It remains to be seen to what extent this model of tacit knowledge and the implicit political function of communicational structures *per se* (prior to their specific content) is generalizable. An initial observation, requiring a more careful construal of "social control" than provided by its author, would be: "Watching television for long stretches confirms individuals in passive, isolated, privatized roles, and consumes a good deal of time that could be put to productive political uses. It is more a form of social control than an ideological apparatus" (Eagleton, *Ideology*, 35).

100. The evanescence of a memorial's "visibility" is a point made by recent articles by Andreas Huyssen ("Denkmal und Erinnerung im Zeitalter der Postmoderne") and James E. Young ("Die Zeitgeschichte der Gedenkstätten und Denkmäler des Holocausts") in the collection *Mahnmale des Holocaust: Motive, Rituale und Stätten des Gedenkens*, ed. James E. Young, 9–18, and 19–40, respectively.

101. "The Meaning of Working Through the Past," in Adorno, *Critical Models*, 102–3.

3. THE AESTHETICS OF HISTORICAL QUOTATION: HEIMRAD BÄCKER'S "SYSTEM *NACHSCHRIFT*"

1. Benjamin, *Arcades Project*, 476 [N11, 3].

2. Adorno, *Aesthetic Theory*, 133.

3. The original members of the group were Friedrich Achleitner (who wrote an important afterword to *nachschrift*), H. C. Artmann, Konrad Bayer, Gerhard Rühm, and Oswald Wiener.

4. For example, cf. *transcript*: 25, 52, 62, 64, 103, 118. Unless otherwise indicated, quotations from *nachschrift* are from Heimrad Bäcker, *transcript*, trans. Patrick Greaney and Vincent Kling. On the language of the Third Reich in general, see Klemperer, *LTI. Notizbuch eines Philologen*.

5. In the notes to *EPITAPH* (54), Bäcker states that his project "nachschrift" includes *nachschrift*, the radio-text "Gehen wir wirklich in den Tod?" (1988) and *EPITAPH*. Clearly *nachschrift* 2 belongs to this project as well.

6. Bäcker, "Über mich," 89. On Bäcker's youth, see Amann, "Heimrad Bäcker."

7. Bäcker, *EPITAPH*, 53. In *nachschrift* Bäcker quotes a sentence from the Hitler biography and in the footnote refers to his book review, characterizing the latter as "similarly marked by a dangerous, imbecilic mania for hero worship." Cf. *transcript*: 97, 138 n97.

8. Weigel, "Zur Dialektik von Dokumentation und Zeugnis in Heimrad Bäckers 'System *nachschrift*,'" 256.

9. Eder, "Sagt ein Bild mehr als tausend Worte?"

10. See, for example, several essays on Bäcker's work collected in Eder and Kastberger, *Die Rampe. Porträt Heimrad Bäcker*. Patrick Greaney, in "Aestheticization and the Shoah: Heimrad Bäcker's *transcript*," emphasizes the tension between aesthetic unity on the one hand, and fragmentation and potential interminability of the "system *nachschrift*" on the other.

11. See, for example, Friedrich Achleitner's afterword to *nachschrift*, where he invokes the view that the Holocaust is an "unimaginable totality," any description of which runs the risk of becoming "ornamentation, elevated into a horrible image-reality" (Ornament, abgehoben in eine grausige Bild-wirklichkeit) (Bäcker, *transcript*: 147 [translation modified]).

12. Cf. Anscombe, *"Analysis* Competition—Tenth Problem"; and Washington, "Identity Theory of Quotation."

13. There do occur instances of embedded quotation, in which the embedded quotations only are syntactically marked with quotation marks (for example, *transcript*: 35, 96, *EPITAPH*: 38) or by italicization (*nachschrift 2*: 16, 32, 141, 155, 158, 159, 197, 211, 231) or unmarked (*nachschrift 2*: 202). In at least four cases Bäcker places one quotation before another on the same page, as though serving as an epigraph (*transcript*: 54 [quote from a survivor of Hiroshima]; *nachschrift 2*: 185 [quote from Hilberg], 217 [quote from Hitler], 232 [quote from Eichmann]). This is one way in which Bäcker introduces more self-conscious aesthetic and editorializing devices in *nachschrift 2* as opposed to the more ascetic presentation of quotations in *nachschrift 1*. Another indication of the same tendency is Bäcker's editorial judgments in some of the footnotes; cf. *nachschrift 2*: 242 n66, 243 n102ff. A related complication is quotations of translations (e.g, *transcript*: 63, from a translation from Yiddish; *transcript*: 95, from a translation from Italian; and both of these further translated from German into English in *transcript*), so that in these cases the translation itself should be considered an act of quotation.

14. Cf., for example, Davidson, "Quotation."

15. This is closely related to claims in Derrida, "Signature Event Context." Note: for purposes of this essay I construe "utterance" to mean both spoken and inscribed language.

16. For an excellent treatment of these issues, see Washington, "Identity Theory of Quotation." For a contrary view, see Cappelen and Lepore, *Language Turned on Itself*.

17. Interestingly, free indirect discourse likewise elides a strict demarcation between use and mention, but while it foregrounds the role of a narrative consciousness, Bäcker's quotational method eschews even that tincture of subjectivity, and in this regard hews closer to historical documentation. My thanks to Cliff Spargo for raising this question.

18. Recanati, "Open Quotation," 650. A singular term is a linguistic expression that indicates or refers to an individual. Examples of types of singular terms in English include logically proper names (for example, "Venus"), demonstratives ("this" and "that" used ostensively), and definite descriptions ("the tallest person in the room," "The President of the United States"). Recanati first introduced his typology of quotation in Recanati, *Oratio Obliqua, Oratio Recta*, chap. 13.

19. This is an alteration of an example from Recanati.

20. For sustained treatments of mixed quotation, see Cappelen and Lepore, "Varieties of Quotation"; and their *Language Turned on Itself*; and papers in "A Case Study in Philosophy and Linguistics: Mixed Quotation," in Murasugi and Stainton, *Philosophy and Linguistics*, 209–85.

21. Recanati, "Open Quotation," 652.

22. Ibid., 639. Cf. Christensen, "Alleged Distinction"; and Searle, *Speech Acts*.

23. Jakobson, "Linguistics and Poetics," 62–94. Cf. also Jan Mukarovsky's definition of poetic language as "the maximum of foregrounding of the utterance" ("Standard Language and Poetic Language," 16).

24. I attach an asterisk to those pages that bear no page numeral. To my knowledge it has not been noted in the literature on Bäcker that photocopied pages are not given a page numeral in *nachschrift*, although they are accorded an "invisible number" in the ascending series of numbers that constitute the pagination. Thus this page has no page number, but is preceded by page 118 and succeeded by page 120. Why do these pages bear no numeral but yet are numbered in the series? These pages are photo-reproductions of original documents, and as such do not exhibit the uniform format of the other pages that contain quotations but not photo-reproductions of (target) original inscriptions. In this way the unnumbered pages interrupt the uniform format, and perhaps for this reason are not accorded explicit page numerals.

25. Davidson, "Quotation," 90. Although it does not refer to Goodman, *Languages of Art*, Recanati's discussion is consistent with Goodman's definition of exemplification as "possession plus reference" (Goodman, *Languages of Art*, 53), as when for instance a tailor's booklet of cloth swatches both possesses and refers to certain of its properties (for example, color, weave, texture, pattern). Goodman, anticipating Derrida's "Signature Event Context," countenances contexts in which further properties, including "____ is an exemplification," might be exemplified, and explicitly observes that exemplification occurs in both aesthetic and nonaesthetic contexts.

26. Recanati, "Open Quotation," 642.

27. Ibid., 650.

28. While there are many questions and controversies I am ignoring here, in roughly Fregean terms the *extension* of a singular term is an object, that of a predicate is a class of objects, and that of a sentence is a truth-value.

29. Cf. Kaplan, "Demonstratives."

30. On this aspect, see especially Saka, "Quotation and the Use-Mention Distinction."

31. Recanati, "Open Quotation," 641–42.

32. Cf. papers in Grice, *Studies in the Way of Words*.

33. *transcript*: 33, 133.

34. Notice that the first two passages are rightfully *untranslated* from *nachschrift* into *transcript*: they are as it were shibboleths of translation, material signifiers that defy any idealized notion of translation as the passage of meaning content from one language to another.

35. Cf. Derrida, "Signature Event Context."

36. Recanati, "Open Quotation," 645.

37. Bäcker, "Widerspiegelung," 61–62.

38. Ibid., 62. Cf. a similar explication of his method: "Most of the texts of my linguistic topography of Mauthausen arose during my repeated study of the

book, *The History of the Concentration Camp Mauthausen* by Hans Marsálek. Their method: sequencing [*Reihung*], repetition, omission or simple reproduction of quotations" ("Mauthausen. Beiträge zur Topographie," 124). And: "When I quote documents, there is no literariness [*Literarizität*] beyond the quotation (with the exception of sequencing, repetition, omission; with the exception of the system *nachschrift*)" (Bäcker, "Dokumentarische Dichtung," 280).

39. Veichtblauer and Steiner, "Heimrad Bäcker," 86 (my emphasis).

40. Bäcker, "Widerspiegelung," 62–63.

41. Bäcker, "konkrete dichtung," 86. In another essay, Bäcker contrasts the "*Konkretion*" of a memorial stone at Mauthausen with "*Symbol*" and emphasizes the physical materiality of the former over the transcendent ideality (presumably) of the latter. He says the memorial stone and its inscription is part of a "space in which we find ourselves as historical beings." I say more about the temporality of quotation later. Cf. Bäcker, "Mauthausen: Beiträge zur Topographie," 122.

42. Bäcker, "Dokumentarische Dichtung," 280.

43. Ibid., 280.

44. Recanati, "Open Quotation," 652.

45. For example, *transcript*: 7, 30*, 35, 42, 50, 54, 63, 68, 81, 109, 124; *nachschrift* 2: 7, 8, 9, 10, 11, 23, 34, 40, 43, 90, 91, 98, 136, 152, 167, 178, 190, 192, 203, 204, 227, 228.

46. For example, *transcript*: 27, 40, 44, 45, 46, 56, 57, 67; *nachschrift* 2: 21, 24, 37, 45, 49, 55, 68, 69, 70, 71, 85, 87, 125, 139, 157, 158, 168, 169, 170, 172, 174, 175, 176, 177, 184, 188, 189, 193, 196, 199, 200, 201, 209, 232.

47. For example, *transcript*: 37, 48, 75, 103; *nachschrift* 2: 194, 195, 198, 205, 206, 211.

48. For example, *transcript*: 55, 111.

49. Cf. Lausberg, *Handbook of Literary Rhetoric*, §826. In the interview previously cited Bäcker says: "I start with the defeated individual, who is opposed by the monster of the collective. The individual succumbs to the massive powers of violence and I make his voice audible" (Ich gehe vom unterliegenden Einzelnen aus, dem die Fratze des Kollektivs gegenübersteht. Der Einzelne unterliegt den großen Gewaltmächten und ich mache seine Stimme hörbar) (Veichtblauer and Steiner, "Heimrad Bäcker," 86).

50. De Man, "Autobiography as De-Facement," 78.

51. The English rendering cannot capture the chilling spatial metaphor of the German expression. Literally the sentence reads "Are we really going into death?" and in a sense, "system *nachschrift*" is a mass grave where the dead—the speaking ones—reside.

52. Cf. Kaplan, "Demonstratives," *passim*.

53. Veichtblauer and Steiner, "Heimrad Bäcker," 86.

54. And in *nachschrift* 2: 12, 14–15, 18, 19, 20, 25, 26, 27, 29, 33, 50, 51, 52, 56, 57, 58, 59, 60, 61, 63, 64, 75–82, 84, 86, 93, 94, 95, 96, 97, 99, 102–21, 126, 130, 131, 132, 133, 137, 138, 140, 143, 145–46, 147, 148–49, 150, 163, 166, 171, 173, 186, 187, 208, 210, 213, 214, 215, 218, 219, 220, 222, 223, 224, 225. On this aspect of the language of "system *nachschrift*," see

Bäcker, "Dokumentarische Dichtung"; and Thomas Eder, "Language Based on a Division of Labor? On the Representation of the Holocaust in Heimrad Bäcker's *nachschrift*."

55. Arguably something similar is going on when one notices formalistic similarities between "concretized" Nazi administrative documents and administrative documents from the trials of the perpetrators (for example, *nachschrift* 2: 206, 208, 210, 213, 214, 215, 216, 219, and so on).

56. Veichtblauer and Steiner, "Heimrad Bäcker," 86.

57. Anscombe, *Intention*, 56.

58. Paragraph 2 of Article 5 of the Federal Republic's constitution (*Grundgesetz*) restricts freedom of expression in accordance with the concept of "*streitbare Demokratie*" ("militant democracy") that is, to protect the institutions of democracy from antidemocratic forces.

59. Booth, *Rhetoric of Irony*, 59 n14, quoted by de Man, "Concept of Irony," 166.

60. De Man, "Concept of Irony," 178. Schlegel's text, "Die Ironie ist eine permanente Parekbase" is Fragment 668 in Schlegel, *Kritische Ausgabe*, 18: 85. De Man interprets the same text in terms of the self-conscious narrator in his "Rhetoric of Temporality," 218ff.

61. De Man, "Concept of Irony," 179.

62. This point could be expressed in Fregean terms by stating that in cases of open quotation or irony the *force* can come apart from the *content* of a proposition.

4. THE AESTHETIC-HISTORICAL IMAGINARY: ON *SHOAH* AND *MAUS*

1. Lessing, *Laocoön*, 22.

2. Lanzmann, "Site and Speech," 41.

3. Witek, *Art Spiegelman*, 275.

4. "Newer Laocoön" might be a more accurate title for this section, as Lessing's essay has inspired a rich succession of refurbishments. See Raaberg, "*Laokoon* Considered and Reconsidered."

5. Lessing, *Laocoön*, 8.

6. Ibid., 14, 15; cf. 39.

7. Ibid., 15.

8. Ibid., 17. Lessing further argues that the proper end of the artistic visual depiction of suffering is to arouse pity: "For the sight of pain provokes distress; however, the distress should be transformed, through beauty, into the tender feeling of pity" (17). However, we can consider his arguments independently of this further claim.

9. Ibid., 19–20.

10. Ibid., 78.

11. Ibid., 78; and "Similarly, poetry in its progressive imitations can use only one single property of a body. It must therefore choose that one which awakens the most vivid image of the body, looked at from the point of view under which poetry can best use it. From this comes the rule concerning the

harmony of descriptive adjectives and economy in description of physical objects" (78–79).

12. Critical expositions of Lessing's theory can be found in Wellbery, *Lessing's Laocoon*; and Richter, *Laocoon's Body and the Aesthetics of Pain*, chap. 3.

13. Representative lines of inquiry in this field include: deconstructive readings of the "purity" of word and image in Mitchell, *Picture Theory*; advocacy of "the relational play of a plurality of interdependent images as the unique ontological foundation of comics," in Thierry Groenstein, "The Impossible Definition," in Heer and Worcester, *Comics Studies Reader*, 128; and the claim that "comic art is composed of several kinds of tension, in which various ways of reading . . . must be played against each other," in Charles Hatfield, "An Art of Tensions," Heer and Worcester, *Comics Studies Reader*, 132. Another useful anthology of readings of specific comic book artists is Varnum and Gibbons, *Language of Comics*.

14. Obviously the forms of film and comic book differ in myriad ways, including the role of "gutters" and visually represented speech in comic books, and so on. For an excellent close reading of one comic book master by another, cf. John Benson, David Kasakove, Art Spiegelman, "An Examination of 'Master Race,'" in Heer and Worcester, *Comics Studies Reader*, 288–305.

15. Cf., for example, Friedlander's introduction to the very influential *Limits of Representation*, discussed in the Introduction.

16. Lessing, *Laocoön*, 20, 22.

17. I make this claim despite the views of some critics, like Rothberg, who maintain that Spiegelman participates in the culture industry and thereby denies his work aesthetic autonomy: "In *Maus*'s multimedia marketing (through magazines, exhibitions, the broadcast media, and now a CD-ROM version), as well as through its generic identity as a (non)fiction comic strip, Spiegelman's project refuses the modernist notion of autonomous culture that ultimately grounds Adorno's position. His handling of the Holocaust denies the existence of an autonomous realm in which aesthetic issues can be debated without reference to the material bases of their production. He heretically reinserts the Holocaust into the political realm by highlighting its necessary imbrication in the public sphere and in commodity production" (*Traumatic Realism*, 206). But Rothberg's conclusion is too fast: the cultural productions he lists (and which could be augmented by the 2011 publication of the book and DVD-ROM *Meta-Maus* by Spiegelman) are all secondary and subservient to *Maus I* and *Maus II*, and in that relation the primacy and modernist identity of the aesthetic work is maintained and in fact reinforced. More to the point, in the work Spiegelman writes, "I've gotten 4 serious offers to turn my book into a T.V. special or movie. (I don't wanna.)" (Spiegelman, *Maus II*, 41), a refusal to submit his work to cultural-industrial diffusion. Lanzmann's self-understanding as a high-modernist *auteur* is infamous and different in degree though not in kind from Spiegelman's.

18. Regarding *Shoah* in these respects, see Shoshana Felman, "The Return of the Voice: Claude Lanzmann's *Shoah*," in Felman and Laub, *Testimony*,

204–83. Regarding *Maus* in these respects, see Young, *At Memory's Edge*, 12–41.

19. Doherty, "Art Spiegelman's *Maus*," 71–72.

20. Ibid., 78.

21. Spiegelman and Mouly, *Read Yourself Raw*, 7.

22. "Letter to the Editor," *New York Times Book Review*, December 29, 1991, 4. Quoted in Young, *At Memory's Edge*, 38.

23. Sartre, *Imaginary*, 7.

24. In his study generally Sartre does not take adequate care to distinguish *belief* from *knowledge* when analyzing perception, thought, and imagination.

25. Sartre, *Imaginary*, 11f.

26. Sartre also claims that kineasethetic sensations, as in the movements of the eye in tracing the lines of schematic drawing, also enter into the constitution of the imaged object. I will return to this in my discussion of *Maus*.

27. Warnock, *Imagination*, 180.

28. Sartre, *Imaginary*, 181.

29. Warnock, *Imagination*, 179.

30. Warnock also attacks the presupposition for forming such beliefs about one's mental content in the case of imagination: "In order to be a case of true imagining Sartre is here maintaining that one *must* form a mental picture, concentrate upon it, separate it from the world, recognize it as unreal, and, in his words, 'present it to oneself as a nothingness.'" But, as Warnock notes, to require the positing of such a self-standing mental image contradicts Sartre's extended arguments against such an account of imagining in his attack on Hume, for example (Warnock, *Imagination*, 178–79).

31. For a defense of the claim that memory is not a faculty for gaining knowledge but rather one for retaining knowledge, see Evans, *Varieties of Reference*, 235–48.

32. "Moreover, in the three cases [mental representation, photography, caricature], I aim at the object [his absent friend Pierre] in the same way: it is on the ground of perception that I want to make the face of Pierre appear, I want to 'make it present' to me. And, as I cannot make a direct presentation of him spring up, I make use of a certain matter that acts as an *analogon*, as an equivalent of perception" (Sartre, *Imaginary*, 18). Cf. Warnock's gloss: "The [mental] image . . . [is] nothing in itself but only our way of attempting to *bring* within our perceptual grasp, by means of an analogue, something which [is] *not* within our grasp" (Warnock, *Imagination*, 178).

33. Sartre, *Imaginary*, 20.

34. Hume, *Enquiries Concerning Human Understanding and Concerning the Principles of Morals*, 111.

35. Williams, "Imagination and the Self," esp. 33–37.

36. This typology, although presented differently, underlies the study of the imagination by Walton, *Mimesis as Make-Believe*; but cf. also Williams, "Imagination and the Self," 38, on "participation"; and Ryle, *Concept of Mind*, chap. 8, on imagining as pretending. In this regard see Ricoeur, "Sartre and Ryle on the Imagination."

37. Dori Laub, "Bearing Witness," in Felman and Laub, *Testimony*, 62–63.

38. Wittgenstein, *Philosophical Investigations*, §244.

39. Ibid., §585.

40. Wittgenstein, *Zettel*, §53; cf. §§472, 540–45.

41. It is an open question in the scholarship on Wittgenstein whether an expressivist interpretation of self-ascriptions of mental states ("psychological verbs" in Wittgenstein's parlance) should be understood as *ipso facto* excluding any acknowledgment of them as truth-apt propositional assertions, or whether in making such a truth-evaluable assertion one *also* manifests or expresses the mental state. The former view is defended in Tugendhat, *Self-Consciousness and Self-Determination*, the latter view in Finkelstein, *Expression and the Inner*.

42. Wittgenstein, *Zettel*: §225. Cf. Wittgenstein, *Blue and Brown Books*, 162ff., and Wittgenstein, *Philosophical Investigations*, §§536ff., and part II, section vi.

43. Wittgenstein, *Philosophical Investigations*, §§285–87. Note this dialectic arguably ends in Wittgenstein's assertion: "To use a word [as in "pain"] without a justification does not mean to use it without a right" (§289).

44. "My attitude towards him is an attitude towards a soul. I am not of the *opinion* that he has a soul" (Wittgenstein, *Philosophical Investigations*, 178 (part II, iv). Notice that on this construal expressive knowledge, unlike propositional knowledge, is not necessarily factive (see §7 below). Moreover, the state of being expressed or manifested by the witness need not be principally a self-conscious mental state such as that of propositionally articulable knowledge about events recounted; rather the witness may manifest noncognitive attitudes and emotions, disbelief or traumatic shock, partial or belated (*nachträglich*) understanding or awareness of what she *experienced* but did not understand when the event first occurred about which she is now recounting. My thanks to Michael G. Levine for pressing me on this point.

45. Laub, "Bearing Witness," 59.

46. Ibid. Laub himself portrays his response as "respect[ing], that is, the silence out of which this testimony spoke" (60), where he tropes her failure of memory as silence: "My attempt as interviewer and as listener was precisely to respect—not to upset, not to trespass—the subtle balance between what the woman *knew* and what she *did not*, or *could not, know*. It was only at the price of this respect, I felt, this respect of the constraints and of the boundaries of silence, that what the woman *did know* in a way that none of us did—what she came to testify about—could come forth and could receive, indeed, a hearing" (61). Perhaps because he is working within a presupposed opposition of conscious, propositional knowledge on the one hand, and trauma-induced lapses, silence, on the other, Laub's portrayal tacitly precludes consideration of (1) the kind of expressive knowledge outlined by Wittgenstein and (2) his own attitude of respect as at least partly a response to such expressiveness.

47. Lanzmann, "Site and Speech," 44.

48. Koch, "Aesthetic Transformation of the Unimaginable." For example: "A statement of memory need not contain anything of how I experience [a given] situation. For this reason Lanzmann must insist that the people in his film do not narrate memories but reexperience situations. . . . This strategy [of 'playing out entire scenarios'] is no doubt indebted to the concept, central to Sartrean existential psychoanalysis, that there is a physical materiality even prior to the symbolizing process of language. . . . Such materiality breaks through only when gestures, physical movements, are repeated. In playing these everyone again becomes who he is" (20–21). The English version is a partial translation of the German original: "Die ästhetische Transformation der Vorstellung vom Unvorstellbaren. Claude Lanzmanns Film *Shoah.*"

49. Sartre, *L'Imagination*.

50. Lanzmann, "Site and Speech," 40.

51. Ibid., 41.

52. Ibid., 39.

53. Ibid., 42.

54. Ibid., 44–45.

55. Ibid., 46–47.

56. Lanzmann, *Shoah*, 103f. Note: Lanzmann has disavowed the English translation: cf. "Seminar with Claude Lanzmann, 11 April 1990," 84, n1. Therefore all quotations are checked against the transcript he himself prepared: *Shoah* (Paris: Éditions Fayard, 1985).

57. Sartre, *Imaginary*, 28–29.

58. Lanzmann, *Shoah*, 115. In an interview Lanzmann describes this scene in language reminiscent of Sartre:
"I asked him to imitate, to do the same gesture, and suddenly the man came back. . . . He started to cut the hair of the customer as he did in 1942 in the gas chamber . . . and you have suddenly a kind of explosion of truth. . . . He relives for himself the scene" (interview with Roger Rosenblatt, PBS, April 27–30, 1987, quoted in Brinkley and Youra, "Tracing *Shoah*," 124).

59. Walton, *Mimesis as Make-Believe*, makes the concept of make-believe the central property of his theory of imagination.

60. Koch, "Aesthetic Transformation," 20–21.

61. Ibid., 21.

62. Similar in this respect is Jean-François Lyotard's brief discussion of *Shoah* in *Heidegger and "the jews,"* 25–29. For an alternative line of criticism of Koch's use of Sartre, in order to interpret *Shoah* along the lines of phenomenological film theory and practice, cf. D'Arcy, "Claude Lanzmann's *Shoah* and the Intentionality of the Image," esp. 141–42.

63. See, for example, Mandel, "Rethinking 'After Auschwitz.'"

64. "Seminar with Claude Lanzmann, 11 April 1990," 97.

65. Lanzmann, "From the Holocaust to 'Holocaust,'" 29.

66. Lanzmann, *Shoah*, 95.

67. Ibid., 99–100.

68. Compare Lanzmann's comments during a seminar on May 4, 1986: "*Shoah* is certainly not a historical film. . . . The purpose of *Shoah* is not to transmit knowledge, in spite of the fact that there is knowledge in the

film. . . . *Shoah* is not a historical film, it is something else. . . . To condense in one word what the film is for me, I would say that the film is an *incarnation*, a *resurrection*, and that the whole process of the film is a philosophical one" (quoted in Felman and Laub, *Testimony*, 213–14).

69. "RAW Magazine: An Interview with Art Spiegelman and Françoise Mouly," in Witek, *Art Spigelman*, 25–26.

70. Adorno, *Aesthetic Theory*, 114.

71. Witek, *Art Spiegelman*, 125.

72. Spiegelman's awareness of *Shoah* is attested with his typically lapidary appreciation:
"Interviewer: *Shoah* is the only thing I've seen lately that's been any good.
Spiegelman: Yeah, it's amazing" (Witek, *Art Spiegelman*, 114).

73. "Postmemory is a powerful and very particular form of memory precisely because its connection to its object or source is mediated not through recollection but through an imaginative investment and creation. This is not to say that memory itself is unmediated, but that it is more directly connected to the past. Postmemory characterizes the experience of those who grow up dominated by narratives that preceded their birth, whose own belated stories are evacuated by the stories of the previous generation shaped by traumatic events that can be neither understood nor recreated" (Hirsch, *Family Frames*, 22).

74. Cf. Spiegelman in an interview: "On the other hand, . . . if I had access to my mother's diaries, perhaps I'd have to find yet another way to trying to indicate that, okay, I have those two stories but I don't have the other five or six or seven million stories that could have gone alongside it. . . . In spite of the fact that everything's so concretely portrayed box-by-box, it's not what happened. It's what my father tells me of what happened and it's based on what my father remembers and is willing to tell and, therefore, is not the same as some kind of omniscient camera that sat on his shoulder between the years 1939 and 1945. So, essentially, the number of layers between an event and somebody trying to apprehend that event through time and intermediaries is like working with flickering shadows. It's all you can hope for" (Brown, "Of Mice and Memory," 98).

75. Witek, *Art Spiegelman,* 87–88. Michael Rothberg (*Traumatic Realism*, 207–8) correctly notes that Spiegelman at times either exacerbates or corrects his father's vernacular solecisms when incorporating their taped interviews into the panels of *Maus*, and he suggests possible motivations of self-hatred and ironical caricature. I would suggest that Spiegelman's manipulation of his father's language parallels Lanzmann's manipulation of the situational 'staging' of his witnesses testimonies: in both cases aesthetic design and intention inform the documentary realism of the testimonies themselves. In an interview Spiegelman himself said, "Working from a transcript of the tape I'd kind of rewrite, and rewrite, and rewrite, trying to get rid of as many words as possible . . . and always with my father's voice echoing in my head so that I could hear if it sounded close to what he actually was saying, to keep the cadences, and in fact the broken English, which was an important part of making the story come alive. So we're constantly checking back to what my

father actually said, trying to present a very condensed verbal form, while always breaking things down into page units, so that there would be a visual idea for each page, and each panel" (interview with Art Spiegelman, "Talk of the Nation," NPR, February 20, 1992).

76. Brown, "Of Mice and Memory," 91.

77. Ibid., 99.

78. Witek, *Art Spiegelman*, 112.

79. Brown, "Of Mice and Memory," 102. Young, *At Memory's Edge*, 12–41, esp. 15–24.

80. Anja's embarrassment when she learns that Vladek understands her speaking in English about him. Spiegelman, *Maus*, 16.

81. For example, the ground on which Vladek is walking is depicted as a Star of David in *Maus*, 80.

82. The depiction of the ghetto falling ill due to a cake made with laundry soap instead of flour. *Maus*, 119.

83. Spiegelman, "Commix," 61. For several years Spiegelman gave a lecture course on the history of comics at the New School for Social Research.

84. Spiegelman, "Commix," 61.

85. Witek, *Art Spiegelman*, 146. Cf. another interview: "What I mean is (this is actually in that *Print* magazine article, to get it phrased more succinctly than I'll be able to do now), your brain is an abstracting device. When you leave here, mainly you'll remember that I wore a vest, that I had hair going that way, maybe, a couple of notions, and you'll have abstracted some sense of me; you won't be carrying a hologram of me, and vice-versa, and it's abstract enough that if I show up not wearing a vest, with hair parted another way, you'll still be able to superimpose that first image on the second image and still find me, but it'll have been through some kind of abstracting. It'll be through some kind of cartoon-making in your head. It seems to me that you think in a combination of short-hand images and words; that's how most thought happens. I don't think it's just me because I'm a cartoonist. When I've discussed it with people and read about it, this is how it works. That means that comics have a pipeline to something very basic about the way people think" (108). Cf. also 165–66, 194–95, 220, 271.

86. Witek, *Art Spiegelman*, 68–69.

87. Ibid., 88.

88. Spiegelman, "Mightier than the Sorehead," 45.

89. Sartre, *Imaginary*, 29–30.

90. Ibid., 32.

91. Ibid., 30, 34.

92. Ibid., 50.

93. Witek, *Art Spiegelman*, 81–82; cf. 90. Witek analyses the development of Spiegelman's style and technique in his *Comic Books as History*, chap. 4.

94. Witek, *Art Spiegelman*, 91.

95. Spiegelman, "Mightier than the Sorehead," 46.

96. Ibid.

97. Witek, *Art Spiegelman*, 124; cf. also 232–33.

98. Gopnik, "Comics and Catastrophe," 32–33.

99. Ibid., 34.

100. Huyssen, "Of Mice and Mimesis," 72.

101. Interview with Gary Groth, "Art Spiegelman and Françoise Mouly," in Groth and Fiore, *New Comics*, 190–91.

102. Young, *At Memory's Edge*, 32.

103. Spiegelman, "Mightier than the Sorehead," 46.

104. Brown, "Of Mice and Memory," 103–4.

105. Young, *At Memory's Edge*, 22–23.

106. Adorno, *Negative Dialectics*, 362–63 (translation modified).

107. Hume, *Enquiries*, 111. My characterization of the problem is indebted to the entry "Epistemological Problems of Testimony," *Stanford Encyclopedia of Philosophy*, online resource.

108. Reid, *Inquiry and Essays*, 94–95.

109. Ross, "Why Do We Believe What We Are Told?"

110. Moran, "Getting Told and Being Believed," 273, 275.

111. Ibid., 279.

112. Ibid., 288–89.

113. Ibid., 297.

114. These scenes of direct testimony are counterpointed to an extent by scenes presenting and interpreting evidence, as when Professor Raul Hilberg displays and explains a German train order for Auschwitz. Note that this Gricean view of the epistemic warrant of testimony might constitute a resolution to the problematic of Holocaust denial and evidence outlined by Lyotard at the beginning of his *The Differend: Phrases in Dispute*.

115. Witek, *Art Spiegelman*, 125; cf. also 89–90, 110.

CONCLUSION: THE MORALITY OF HOLOCAUST ART

1. Adorno, *Aesthetic Theory*, 349–50.

2. Given that those persecuted in the Holocaust included holders of various religious faiths as well as atheists, it would seem inappropriate *de ovo* to identify the obligation to remember with a religious faith, although memorials addressed to an arguably religiously specified group (for example, "The Memorial to the Murdered Jews of Europe") might well draw on religious contexts.

3. "The formula thus asserts that the risk or burden of evidence incurred in choosing among alternative historical representations increases—first—in proportion to the distance between the alternative chosen and those rejected; and secondly, with that distance multiplied by a moral weight assigned to the common issue at stake between them. In its mathematical form this would be $R = (A_1-A_2) \times W$" (in Friedlander, *Probing the Limits of Representation*, 309). Cf. also Lang, *Holocaust Representation*, 61.

4. Lang, *Holocaust Representation*, 48–49, 70–71.

5. Margalit, *Ethics of Memory*, 79.

6. Habermas, "Historical Consciousness and Post-Traditional Identity," 251–52. One need not endorse Habermas's uniqueness claim here: he has

been taken to task for overlooking centuries of slavery and colonialism in this pronouncement (my thanks to Chad Kautzer). Cf. J. M. Bernstein's interpretation of the significance of Auschwitz in Adorno's thought: "not the acting against moral norms, but acting to remove the conditions through which moral predicates apply distinguishes the Nazi genocide," *Adorno: Disenchantment and Ethics*, 382.

7. On moral constructivism, see Rawls, "Kantian Constructivism in Moral Theory," and "Themes in Kant's Moral Philosophy," both in Rawls, *Collected Papers*, 303–58, 497–528; Korsgaard, *Sources of Normativity*; Schneewind, *Invention of Autonomy*.

8. Margalit, *Ethics of Memory*, 83. A corollary of this view is that all crimes against humanity stand under the same moral injunction of remembrance.

9. Adorno, *Metaphysics*, 124.

10. Margalit, *Ethics of Memory*, 9.

11. Of course, what constitutes an aesthetic property or concept is itself a controversial question. At a general level I take an aesthetic property to be a second- or third-order (for example, "soothing" and "harmonious," respectively) response-dependent property that is weakly supervenient on first-order nonaesthetic properties, suitably relativized to cultural contexts, aesthetic traditions, and so on. Cf. Zemach, "What Is an Aesthetic Property?"; Sibley, "Aesthetic Concepts"; and, on response-dependent concepts, Johnston, "Dispositional Theory of Value."

12. Adorno, *Negative Dialectics*, 365 (translation modified). Cf. also Adorno, "Education After Auschwitz," *Critical Models*, 191–204. On the "external moral factor" in the context of Adorno's moral theory, see Schweppenhäuser, *Ethik nach Auschwitz*; Schweppenhäuser, "Adorno's Negative Moral Philosophy"; Menke, "Tugend und Reflexion"; Bernstein, *Adorno: Disenchantment and Ethics*, esp. chap. 8.

13. Adorno, "Culture and Criticism," in *Prisms*, 34.

14. Particularly helpful here is Rothberg, *Traumatic Realism*, 34–56. Rothberg, however, tends to read Adorno's later qualification of his dictum within his notion of "context of guilt" (*Schuldzusammenhang*) in *Negative Dialectics* solely in terms of trauma and survivor guilt, whereas Adorno meant something more extensive: the systemic material inequalities of global capitalism: "A society which in its absurd present form has rendered not work, but people superfluous, predetermines, in a sense, a statistical percentage of people of whom it must divest itself in order to continue to live in its bad, existing form. And if one does live on, one has, in a sense, been statistically lucky at the expense of those who have fallen victim to the mechanism of annihilation and, one must fear, will still fall victim to it. Guilt reproduces itself in each of us . . . if one were fully aware of all these things at every moment, one would really be unable to live. One is pushed, as it were, into forgetfulness, which is already a form of guilt" (Adorno, *Metaphysics*, 112–13). In the same lectures Adorno clearly indicates that the scope of such a context of guilt includes the contemporary catastrophes of Vietnam and

South Africa (101–2, 130), and that "of course that name [Auschwitz] stands for something unthinkable beyond the unthinkable, namely, a whole historical phase" (116). Elsewhere he demarcates the context technologically: "Furthermore, one cannot dismiss the thought that the invention of the atomic bomb, which can obliterate hundreds of thousands of people literally in one blow, belongs in the same historical context as genocide" (Adorno, "Education After Auschwitz," *Critical Models*, 192).

15. Adorno, *Metaphysics*, 108. Cf. *Negative Dialectics*, 362.

16. Adorno, *Metaphysics*, 110. Adorno invokes Hegel's notion of the "awareness of suffering" or "consciousness of affliction" at strategic junctures in his argumentation for the role of modern art in several texts. Unfortunately, the passage in Hegel to which Adorno is referring is the result of an editorial misconstruing of Hegel's orthography. See *Critical Models*, 324, n22.

17. Adorno, *Metaphysics*, 116–17.

18. Adorno, *Negative Dialectics*, 45 (translation modified).

19. Adorno, "Commitment," 88. This understanding of art's capacity to elicit a mimetic response to suffering goes back at least to the interpretation of the swinging feet of the hanged maidservants in the *Odyssey* in Adorno and Horkheimer, *Dialectic of Enlightenment*, 61–62.

20. Adorno, "Commitment," 88.

21. Adorno, *Metaphysics*, 135.

22. Adorno, *Aesthetic Theory*, 122; Adorno, *Minima Moralia*, 73–75.

BIBLIOGRAPHY

Adorno, Theodor W. *Aesthetic Theory.* Translated by Robert Hullot-Kentor. Minneapolis: University of Minnesota Press, 1999.

———. "Commitment." In *Notes to Literature*, vol. 2, 76–94. Translated by Shierry Weber Nicholsen. New York: Columbia University Press, 1992.

———. *Critical Models: Interventions and Catchwords.* Translated by Henry W. Pickford. New York: Columbia University Press, 2005.

———. *Kierkegaard: Construction of the Aesthetic.* Translated by Robert Hullot-Kentor. Minneapolis: University of Minnesota Press, 1989.

———. *Metaphysics: Concepts and Problems.* Edited by Rolf Tiedemann. Translated by Edmund Jephcott. Stanford: Stanford University Press, 2000.

———. *Minima Moralia: Reflections from a Damaged Life.* Translated by E. F. N. Jephcott. New York: Verso Press, 1989.

———. *Negative Dialectics.* Translated by E. B. Ashton. New York: Continuum, 1973.

———. *Philosophy of New Music.* Translated by Robert Hullot-Kentor. Minneapolis: University of Minnesota Press, 2006.

———. *Prisms.* Translated by Samuel and Shierry Weber. Cambridge, MA: MIT Press, 1988.

Adorno, Theodor W., and Max Horkheimer. *Dialectic of Enlightenment.* Translated by Edmund Jephcott. Stanford: Stanford University Press, 2002.

Agamben, Giorgio. *Remnants of Auschwitz: The Witness and the Archive.* Translated by Daniel Heller-Roazen. New York: Zone Books, 1999.

Amann, Klaus. "Heimard Bäcker: nach Mauthausen." In Thomas Eder and Klaus Kastberger, eds., *Die Rampe. Porträt Heimrad Bäcker*, 11–26. Linz, Austria: Trauner, 2001.

Angehrn, Emil. "Dekonstruktion und Hermeneutik." In Andrea Kern and Christoph Menke, eds., *Philosophie der Dekonstruktion: Zum Verhältnis von Normativität und Praxis*, 177–200. Frankfurt: Suhrkamp, 2002.

Anscombe, G. E. M. "*Analysis* Competition—Tenth Problem." In *Collected Philosophical Papers*, vol. 2, 220–23. Oxford: Basil Blackwell, 1981.

———. *Collected Philosophical Papers*, vol. 2: *Metaphysics and Philosophy*. Oxford: Blackwell, 1981.

———. *Intention*. Cambridge, MA: Harvard University Press, 2000.

Arendt, Hannah. *On Revolution*. New York: Viking, 1963.

Bäcker, Heimrad. "Dokumentarische Dichtung." In Helmut Eisendle, ed., *Österreich lesen: Texte von Artmann bis Zeemann*, 277–80. Vienna: Deuticke, 1995.

———. *EPITAPH*. Linz, Austria: Edition MÄRZ, 1990.

———. "konkrete dichtung," *Die Künstlervereinigung MAERZ 1913–1973*, 84–86. Linz, Austria: Künstlervereinigung MÄRZ, 1973.

———. "Mauthausen. Beiträge zur Topographie." In Detlef Hoffmann, ed., *Der Angriff der Gegenwart auf die Vergangenheit: Denkmale auf dem Gelände ehemaliger Konzentrationslager*, 113–31. Rehburg-Loccum, Germany: Evangelische Akademie, 1996.

———. *nachschrift*. Graz, Austria: Droschl, 1993.

———. *nachschrift 2*. Graz, Austria: Droschl, 1997.

———. *transcript*. Translated by Patrick Greaney and Vincent Kling. Champaign, IL: Dalkey Archive Press, 2010.

———. "Über mich." In Thomas Eder and Klaus Kastberger, eds., *Die Rampe. Porträt Heimrad Bäcker*, 89. Linz, Austria: Trauner, 2001.

———. "Widerspiegelung." *Die Rampe. Hefte für Literatur* 3 (1994): 59–62.

Bakhtin, Mikhail. "Discourse and the Novel." In *The Dialogic Imagination*, 259–422. Edited by Michael Holquist. Translated by Caryl Emerson and Michael Holquist. Austin: University of Texas Press, 1981.

Barnert, Arno. *Mit dem fremden Wort. Poetisches Zitieren bei Paul Celan*. Frankfurt: Stroemfeld, 2007.

Benjamin, Walter. *The Arcades Project*. Translated by Howard Eiland and Kevin McLaughlin. Cambridge, MA: Harvard University Press, 1999.

———. *Gesammelte Schriften*. Edited by R. Tiedemann and H. Schweppenhäuser. Frankfurt: Suhrkamp, 1972–89.

———. *The Origins of German Tragic Drama*. Translated by John Osborne. London: Verso, 1985.

———. *Selected Writings*. Vols. 1–4. Edited by Michael Jennings. Cambridge, MA: Harvard University Press, 1996–2003.

Bernard-Donals, Michael. "Beyond the Question of Authenticity: Witness and Testimony in the *Fragments* Controversy." In M. Bernard-Donals and Richard Glejzer, eds., *Witnessing the Disaster: Essays on Representation*

and the Holocaust, 196–217. Madison: University of Wisconsin Press, 2003.

Bernard-Donals, Michael, and Richard Glejzer. *Between Witness and Testimony: The Holocaust and the Limits of Representation*. Albany: State University of New York Press, 2001.

Bernstein, J. M. *Adorno: Disenschantment and Ethics*. Cambridge: Cambridge University Press, 2001.

Bloch, Marc. "Mémoire collective, tradition et coutume." *Revue de Synthèse Historique* 40 (1925): 73–83.

Bogumil, Sieghild. "Zur Dialoggestalt von Paul Celans Dichtung." *Celan-Jahrbuch* 5 (1993): 23–52.

Bolz, Norbert. *Eine kurze Geschichte des Scheins*. Munich: Wilhelm Fink Verlag, 1991.

Booth, Wayne. *A Rhetoric of Irony*. Chicago: University of Chicago Press, 1974.

Böschenstein, Bernard. "Celan und Mandelstamm: Beobachtungen zu ihrem Verhältnis." *Celan-Jahrbuch* 2 (1988): 153–68.

Bourdieu, Pierre. *Outline of a Theory of Practice*. Translated by Richard Nice. Cambridge: Cambridge University Press, 1977.

Boym, Svetlana. "Dialogue as 'Lyrical Hermaphroditism': Mandel'stam's Challenge to Bakhtin." *Slavic Review* 50 (1991): 118–26.

Brierley, David. *"Der Meridian." Ein Versuch zur Poetik und Dichtung Paul Celans*. Frankfurt: Peter Lang, 1984.

Brinkley, Robert, and Steven Youra. "Tracing *Shoah*." *PMLA* 111.1 (1996): 108–27.

Broda, Martine. *Dans les main de personne. Essay sur Paul Celan*. Paris: Éditions du Cerf, 1986.

Brown, Joshuah. "Of Mice and Memory." *Oral History Review* 16.1 (1988): 91–109.

Buber, Martin. *Werke*. Munich: Kösel Verlag, 1962.

Bubner, Rüdiger. "Über einige Bedingungen gegenwärtiger Ästhetik." *Neue Hefte für Philosophie* 5 (1973): 38–73.

Büchner, Georg. *Sämtliche Werke*. Edited by Henri Poschmann and Rosemarie Poschmann. Frankfurt: Deutscher Klassiker Verlag, 1999.

Büchten, Daniela, and Anja Frey, eds. *Im Irrgarten deutscher Geschichte. Die Neue Wache 1818–1993*. Schriftenreihe des Aktiven Museums Faschismus und Widerstand in Berlin e.V., no. 5, 1995.

Burke, Peter. "History as Social Memory." In Thomas Butler, ed., *Memory: History, Culture and the Mind*, 97–114. Oxford: Blackwell, 1989.

Caillois, Roger. "Mimicry and Legendary Psychasthenia." Translated by

John Shepley. In Annette Michelson, Rosalind Kraus, Douglas Crimp, and Joan Copjec, eds., *October: The First Decade 1976–1986*, 58–74. Cambridge, MA: MIT Press, 1987.

Cameron, Esther. "Das Dunkle und das Helle. Zur möglichen Eindeutigkeit des 'Meridians.'" In Chaim Shoham and Bernd Witte, eds., *Datum und Zitat bei Paul Celan*, 156–69. Bern, Switzerland: Peter Lang, 1987.

———. "Erinnerung an Celan." In Werner Hamacher and Winfried Menninghaus, eds., *Paul Celan*, 338–42. Frankfurt: Suhrkamp, 1988.

Cappelen, Herman, and Ernie Lepore. *Language Turned on Itself: The Semantics and Pragmatics of Metalinguistic Discourse*. Oxford: Oxford University Press, 2007.

———. "Varieties of Quotation." *Mind* 106 (1997): 429–50.

Caruth, Cathy, ed. *Trauma: Explorations of Memory*. Baltimore, MD: Johns Hopkins University Press, 1995.

———. *Trauma, Narrative and History*. Baltimore, MD: Johns Hopkins University Press, 1996.

Celan, Paul. *Die Gedichte aus dem Nachlass*. Edited by Betrand Badiou, Jean-Claude Rambach, and Barbara Wiedemann. Annotated by Barbara Wiedemann and Bertrand Badiou. Frankfurt: Suhrkamp, 1997.

———. *Gesammelte Werke in fünf Bänden*. Edited by Beda Allemann and Stephan Reichert in collaboration with Rolf Bücher. 5 vols. Frankfurt: Suhrkamp, 1986.

———. *Der Meridian: Endfassung, Entwürfe, Materialien*. Tübinger Ausgabe. Edited by Bernhard Böschenstein, Heino Schmull, Michael Schwarzkopft, and Christiane Wittkop. Frankfurt: Suhrkamp, 1999.

———. *"Mikrolithen sinds, Steinchen": Die Prosa aus dem Nachlaß*. Edited with commentary by Barbara Wiedemann and Betrand Badiou. Frankfurt: Suhrkamp, 2005.

———. *Poems of Paul Celan*. Translated with an introduction by Michael Hamburger. New York: Persea Books, 1989.

Chalfren, Israel. *Paul Celan. Eine Biographie seiner Jugend*. Frankfurt: Suhrkamp, 1983.

Christensen, Niels. "The Alleged Distinction Between Use and Mention." *Philosophical Review* 76 (1967): 358–67.

Chytry, Josef. *The Aesthetic State*. Berkeley: University of California Press, 1986.

Ciepiela, Catherine. "The Demanding Woman Poet: On Resisting Marina Tsvetaeva." *PMLA* 111 (May 1996): 421–34.

Claussen, Detlev. "Nach Auschwitz: Ein Essay über die Aktualität Adornos." In Dan Diner, ed., *Zivilisationsbruch: Denken nach Auschwitz*, 54–68. Frankfurt: Fischer, 1988.

Connerton Paul. *How Societies Remember*. Cambridge: Cambridge University Press, 1989.

Danto, Arthur. "The Vietnam Veterans Memorial." *The Nation* (August 31, 1986): 152.

D'Arcy, Michael. "Claude Lanzmann's *Shoah* and the Intentionality of the Image." In David Bathrick, Brad Prager, and Michael D. Richardson, eds., *Visualizing the Holocaust: Documents, Aesthetics, Memory*, 138–61. Rochester, NY: Camden House, 2008.

Davidson, Donald. "Quotation." In *Truth and Interpretation*, 79–92. Oxford: Clarendon Press, 1984.

De Man, Paul. *Allegories of Reading*. New Haven, CT: Yale University Press, 1979.

———. "Autobiography as De-Facement." In *The Rhetoric of Romanticism*, 67–81. New York: Columbia University Press, 1984.

———. "The Concept of Irony." In *Resistance of Theory*, 163–84. Minneapolis: University of Minnesota Press, 1986.

———. "Dialogue and Dialogism." In *Resistance to Theory*, 106–14. Minneapolis: University of Minnesota Press, 1986.

———. "The Rhetoric of Temporality." In *Blindness and Insight: Essays in the Rhetoric of Contemporary Criticism*, 187–228. Minnesota: University of Minneapolis Press, 1983.

Demps, Laurenz. *Die Neue Wache: Entstehung und Geschichte eines Bauwerkes*. Berlin: Militärverlag der Deutschen Demokratischen Republik, 1988.

Derrida, Jacques. *Of Grammatology*. Translated by G. C. Spivak. Baltimore, MD: Johns Hopkins University Press, 1976.

———. "Shibboleth: for Paul Celan." In Aris Fioretos, ed., *Word Traces: Readings of Paul Celan*, 3–74. Translated by Joshua Wilner. Baltimore, MD: Johns Hopkins University Press, 1994.

———. "Signature Event Context." Translated by Samuel Weber and Jeffrey Mehlman. In *Limited, Inc.*, 1–24. Evanston, IL: Northwestern University Press, 1988.

Dmitrieva-Einhorn, Marina, ed. *Einhorn: du weißt um die Steine. Briefwechsel*. Berlin: Friedenauer Presse, 2001.

Doherty, Thomas. "Art Spiegelman's *Maus*: Graphic Art and the Holocaust." *American Literature* 68.1 (1996): 69–84.

Eaglestone, Robert. *The Holocaust and the Postmodern*. Oxford: Oxford University Press, 2004.

Eagleton, Terry. *Ideology: An Introduction*. New York: Verso, 1991.

Eder, Thomas. "Language Based on a Division of Labor? On the

Representation of the Holocaust in Heimrad Bäcker's *nachschrift*." *New German Critique* 93 (2000): 82–86.

———. "Sagt ein Bild mehr als tausend Worte? Heimard Bäckers Photographien im Kontext der *nachschrift*." In Bernhard Fetz and Klaus Kastberger, eds., *Die Teile und das Ganze. Bausteine der literarischen Moderne in Österreich*, 276–83. Vienna: P. Zsolnay, 2003.

Eder, Thomas, and Klaus Kastberger, eds. *Die Rampe. Porträt Heimrad Bäcker*. Linz, Austria: Trauner, 2001.

———. *Heimrad Bäcker*. Graz, Austria: Droschl, 2002.

Eisenman, Peter. "The Silence of Excess." In Eisenman Architects, eds., *Holocaust Memorial Berlin*, unpaginated. Baden, Germany: Lars Müller, 2005.

Enzensberger, H. M., ed. *Museum der modernen Poesie*. Frankfurt: Suhrkamp, 1960.

Eskin, Michael. *Ethics and Dialogue in the Works of Levinas, Bakhtin, Mandel'shtam, and Celan*. Oxford: Oxford University Press, 2000.

Evans, Gareth. "The Causal Theory of Names." In *Collected Papers*, 1–24. Oxford: Clarendon Press, 1985.

———. "Semantic Theory and Tacit Knowledge." In *Collected Papers*, 322–42. Oxford: Clarendon Press, 1985.

———. *The Varieties of Reference*. Edited by John McDowell. Oxford: Clarendon Press, 1982.

Ezrahi, Sidra DeKoven. *By Words Alone: The Holocaust in Literature*. Chicago: University of Chicago Press, 1980.

Felman, Shoshana. *The Juridical Unconscious: Trials and Traumas in the Twentieth Century*. Cambridge, MA: Harvard University Press, 2002.

Felman, Shoshana, and Dori Laub. *Testimony: Crises of Witnessing in Literature, Psychoanalysis, and History*. New York: Routledge, 1992.

Fessmann, Jörg, ed. *Streit um die Neue Wache: Zur Gestaltung einer zentralen Gedenkstätte*. Berlin: Akademie der Künste, 1993.

Fink, Hilary. *Bergson and Russian Modernism, 1900–1930*. Evanston, IL: Northwestern University Press, 1999.

Finkelstein, David H. *Expression and the Inner*. Cambridge, MA: Harvard University Press, 2003.

Finlayson, Gordon. "Naming Myth and History: Berlin After the Wall." *Radical Philosophy* 74 (1995): 5–17.

Forst, Rainer. *Kontexte der Gerechtigkeit*. Frankfurt: Suhrkamp, 1994.

Fóti, Véronique. "A Missed Interlocution: Heidegger and Celan." In *Heidegger and the Poets: Poiesis, Sophia, Techne*, 78–98. Atlantic Heights, NJ: Humanities Press, 1992.

Foucault, Michel. *This Is not a Pipe.* Translated by James Harkness. Berkeley: University of California Press, 1983.

Frank, Joseph. "The Voices of Mikhail Bakhtin." In *Through the Russian Prism: Essays on Literature and Culture*, 18–33. Princeton, NJ: Princeton University Press, 1990.

Freidin, Gregory. "By the Walls of Church and State: Literature's Authority in Russia's Modern Tradition." *Russian Review* 52 (1993): 149–65.

Friedlander, Saul. *Nazi Germany and the Jews.* New York: Harper and Row, 1984.

———, ed. *Probing the Limits of Representation: Nazism and the "Final Solution."* Cambridge, MA: Harvard University Press, 1992.

Fynsk, Christopher. "The Realities at Stake in a Poem: Celan's Bremen and Darmstadt Addresses." In Aris Fioretos, ed., *Word Traces: Readings of Paul Celan*, 159–84. Baltimore, MD: Johns Hopkins University Press, 1994.

Gadamer, Hans-Georg. *Gadamer on Celan.* Edited and translated by R. Heinemann and Bruce Krajewski. Albany: State University of New York Press, 1997.

———. *Wahrheit und Methode. Grundzüge einer philosophischen Hermeneutik.* Tübingen, Germany: Mohr, 1986.

Gasché, Rodolphe. *The Tain of the Mirror.* Cambridge, MA: Harvard University Press, 1986.

Geertz, Clifford. *The Interpretation of Cultures.* New York: Basic Books, 1973.

Gellhaus, Axel, Rolf Bücher, Sabria Filiali, Peter Goßens, Ute Harbusch, Thomas Heck, Christine Ivanović et al., eds. *"Fremde Nähe". Celan als Übersetzer.* Marbach am Neckar, Germany: Deutsche Schillergesellschaft, 1997.

Genette, Gérard. *The Aesthetic Relation.* Translated by G. M. Goshgarian. Ithaca, NY: Cornell University Press, 1999.

Geuss, Raymond. "Form and 'the new' in Adorno's '*Vers une musique informelle*.'" In *Morality, Culture, and History*, 140–66. Cambridge: Cambridge University Press, 1999.

Gleason, Philip. "Identifying Identity: A Semantic History." *The Journal of American History* 69.4 (1983): 910–31.

Godfrey, Mark. *Abstraction and the Holocaust.* New Haven, CT: Yale University Press, 2007.

Goethe, Wolfgang. *Werke.* Edited by Eric Trunz. Munich: C. H. Beck, 1986.

Gogol, John. "Paul Celan and Osip Mandelshtam: Poetic Language as Ontological Essence." *Revue des langues vivantes* 40 (1974): 341–54.

Goodman, Nelson. *Fact, Fiction and Forecast.* Cambridge, MA: Harvard University Press, 1983.

———. *Languages of Art.* Indianapolis, IN: Hackett, 1976.

Gopnik, Adam. "Comics and Catastrophe." *The New Republic* (June 22, 1987): 29–34.

Greaney, Patrick. "Aestheticization and the Shoah: Heimrad Bäcker's *transcript.*" *New German Critique* 109 (2010): 27–51.

Greenblatt, Stephen. "Murdering Peasants: Status, Genre, and the Representation of Rebellion." In *Learning to Curse: Essays in Early Modern Culture*, 99–130. New York: Routledge, 1990.

Grice, Paul. *Studies in the Ways of Words.* Cambridge, MA: Harvard University Press, 1989.

Griswold, Charles. "The Vietnam Veterans Memorial and the Washington Mall: Philosophical Thoughts on Political Iconography." *Critical Inquiry* 12 (1986): 688–719.

Groth, Gary, and Robert Fiore, eds. *The New Comics.* New York: Berkeley Book, 1988.

Habermas, Jürgen. "Eine Art Schadensabwicklung." In *Eine Art Schadensabwicklung: kleine politische Schriften VI*, 115–58. Frankfurt: Suhrkamp, 1987.

———. "Historical Consciousness and Post-Traditional Identity: The Federal Republic's Orientation to the West." In Shierry Weber Nicholsen, ed. and translated, *The New Conservatism*, 249–67. Cambridge, MA: MIT Press, 1990.

———. *The Philosophical Discourse of Modernity.* Translated by Frederick G. Lawrence. Cambridge, MA: MIT Press, 1987.

———. *On the Logic of the Social Sciences.* Translated by Shierry Weber Nicholsen and Jerry A. Stark. Cambridge, MA: MIT Press, 1988.

———. "Zu Gadamers 'Wahrheit und Methode.'" In Jürgen Habermas, Dieter Henrich, and Jacob Taubes, eds., *Hermeneutik und Ideologiekritik*, 45–56. Frankfurt: Suhrkamp, 1971.

Hacking, Ian. "Rule, Scepticism, Proof, Wittgenstein." In Ian Hacking, ed., *Exercises in Analysis*, 113–24. Cambridge: Cambridge University Press, 1985.

Halbwachs, Maurice. *The Collective Memory.* Translated by Francis J. Ditter and Vida Y. Ditter. New York: Colophon, 1980.

Hamacher, Werner. "The Second of Inversion: Movements of a Figure through Celan's Poetry." In *Premises: Essays on Philosophy and Literature from Kant to Celan*, 337–88. Translated by Peter Fenves. Cambridge, MA: Harvard University Press, 1997.

Hansen, Miriam Bratu. "'Schindler's List' Is not 'Shoah': The Second

Commandment, Popular Modernism, and Public Memory." *Critical Inquiry* 22 (1996): 292–312.

Hartman, Geoffrey, ed. *Bitburg in Moral and Political Perspective*. Bloomington: Indiana University Press, 1986.

Heer, Jeet, and Kent Worcester, eds. *A Comic Studies Reader*. Jackson: University Press of Mississippi, 2009.

Hegel, Georg Wilhelm Friedrich. *Aesthetics: Lectures on Fine Art*. Translated by T. M. Knox. Oxford: Oxford University Press, 1998.

———. *Werke*. Frankfurt: Suhrkamp, 1970.

Heidegger, Martin. *Sein und Zeit*. 15th ed. Tübingen, Germany: Max Niemeyer, 1993.

———. *Unterwegs zur Sprache*. Pfullingen, Germany: Neske, 1959.

Hein, Christoph. *Die fünfte Grundrechenart. Aufsätze und Reden 1987–1990*. Frankfurt: Luchterhand, 1990.

Hirsch, Marianne. *Family Frames: Photography, Narrative and Postmemory*. Cambridge, MA: Harvard University Press, 1997.

Honneth, Axel. *Kampf um Anerkennung. Zur Grammatik sozialer Konflikte*. Frankfurt: Suhrkamp, 1992.

Huhn, Thomas. "Adorno's Aesthetics of Illusion." *The Journal of Aesthetics and Art Criticism* 44.2 (1985): 181–89.

Hume, David. *Enquiries Concerning Human Understanding and Concerning the Principles of Morals*. Edited by L. A. Selby-Bigge and P. H. Nidditch. Oxford: Clarendon Press, 1975.

Husserl, Edmund. *Vorlesungen zur Phänomenologie des inneren Zeitbewußtseins*. Ed. Martin Heidegger. 2d ed. Tübingen, Germany: Niemeyer, 1980.

Huyssen, Andreas. "Denkmal und Erinnerung im Zeitalter der Postmoderne." In James E. Young, ed., *Mahnmale des Holocaust. Motive, Rituale und Stätten des Gedenkens*, 9–18. Munich: Prestel, 1993.

———. "Of Mice and Mimesis: Reading Spiegelman with Adorno." *New German Critique* 81 (2000): 65–82.

Iser, Wolfgang. *Der implizite Leser. Kommunikationsformen des Romans von Bunyan bis Beckett*. Munich: Wilhelm Fink Verlag, 1972.

Ivanovíc, Christine. *Das Gedicht im Geheimnis der Begegnung. Dichtung und Poetik Celans im Kontext seiner russischen Lektüren*. Tübingen, Germany: Niemeyer, 1996.

———, ed. *"Kyrillisches, Freunde, auch das . . . ". Die russische Bibliothek Paul Celans im Deutschen Literaturarchiv Marbach*. Marbach am Neckar, Germany: Deutsche Schillergesellschaft, 1996.

Jakobson, Roman. "Linguistics and Poetics." In Krystyna Pomorska and

Stephen Rudy, eds., *Language in Literature*, 62–94. Cambridge, MA: Belknap Press of Harvard University Press, 1987.

Jameson, Fredric. *The Political Unconscious: Narrative as a Socially Symbolic Act*. Ithaca, NY: Cornell University Press, 1981.

Jarvis, Simon. *Adorno: A Critical Introduction*. New York: Routledge, 1998.

Jeismann, Michael, and Rolf Westheider. "Wofür stirbt der Bürger? Nationaler Totenkult und Staatsbürgertum in Deutschland und Frankreich seit der Französischen Revolution." In R. Koselleck and M. Jeismann, eds., *Der politische Totenkult: Kriederdenkmäler in der Moderne*, 23–50. Munich: Wilhelm Fink Verlag, 1994.

Johnson, Barbara. "Apostrophe, Animation, and Abortion." In *A World of Difference*, 184–99. Baltimore, MD: Johns Hopkins University Press, 1987.

Johnston, Mark. "Dispositional Theories of Value." *Proceedings of the Aristotelian Society*, suppl. vol. 63 (1989): 139–74.

Kaplan, Brett Ashley. *Unwanted Beauty: Aesthetic Pleasure in Holocaust Representation*. Urbana: University of Illinois Press, 2007.

Kaplan, David. "Demonstratives. An Essay on the Semantics, Metaphysics, and Epistemology of Demonstratives and Other Indexicals." In J. Almog, J. Perry, and H. Wettstein, eds., *Themes from Kaplan*, 481–564. New York: Oxford University Press, 1989.

Käthe-Kollwitz-Museum, ed. *Käthe Kollwitz, Schmerz und Schuld: eine motivgeschichtiche Betrachtung*. Berlin: Gebr. Mann, 1995.

Kirchheimer, Otto. *Political Justice: The Use of Legal Procedure for Political Ends*. Princeton, NJ: Princeton University Press, 1961.

———. *Politics, Law and Social Change. Selected Essays of Otto Kirchheimer*. Edited by Frederic S. Burin and Kurt L. Shell. New York: Columbia University Press, 1969.

Klemperer, Victor. *LTI. Notizbuch eines Philologen*. Berlin: Aufbau Verlag, 1947.

Knapp, Steven. "Collective Memory and the Actual Past." *Representations* 26 (1989): 123–49.

Koch, Gertrud. "The Aesthetic Transformation of the Unimaginable: Notes on Claude Lanzmann's 'Shoah.'" Translated by Jaime Owen Daniel and Miriam Hansen. *October* 48 (1989): 15–24.

———. "Die ästhetische Transformation der Vorstellung vom Unvorstellbaren. Claude Lanzmanns Film *Shoah*." In *Die Einstellung ist die Einstellung: Visuelle Konstruktionen des Judentums*, 143–70. Frankfurt: Suhrkamp, 1992.

Kollwitz, Käthe. *Die Tagebücher*. Edited by Jutta Bohnke-Kollwitz. Berlin: Wolf Jobst Siedler, 1989.

Korsgaard, Christine. *The Sources of Normativity.* Cambridge: Cambridge University Press, 1996.

Koselleck, Reinhart. "Bilderverbot: Welches Totengedenken?" In *Frankfurter Allgemeine Zeitung*, April 8, 1993. Reprinted in Jörg Fessmann, ed., *Streit um die Neue Wache: Zur Gestaltung einer zentralen Gedenkstätte*, 96–100. Berlin: Akademie der Künste, 1993.

———. "Kriegerdenkmale als Identitätsstiftungen der Überlebenden." In Odo Marquard and Karlheinz Stierle, eds., *Identität* (= *Poetik und Hermeneutik* VIII), 255–76. Munich: Wilhelm Fink Verlag, 1979.

Koselleck, Reinhart, and Michael Jeismann, eds. *Der politische Totenkult: Kriegerdenkmäler in der Moderne.* Munich: Wilhelm Fink Verlag, 1994.

Kracauer, Siegfried. *Schriften.* Edited by Inka Mülder-Bach. Frankfurt: Suhrkamp, 1990.

Krahmer, Catherine. *Käthe Kollwitz.* Hamburg: Rowohlt, 1981.

Kramer, Jane. *The Politics of Memory.* New York: Random House, 1996.

Kripke, Saul. *Naming and Necessity.* Cambridge, MA: Harvard University Press, 1980.

———. *Wittgenstein on Rules and Private Language.* Cambridge, MA: Harvard University Press, 1982.

Lacoue-Labarthe, Philippe. *La poésie comme expérience.* Paris: Christian Bourgois, 1986.

Lang, Berel. *Act and Idea in the Nazi Genocide.* Chicago: University of Chicago Press, 1990.

———. *Holocaust Representation: Art Within the Limits of History and Ethics.* Baltimore, MD: Johns Hopkins University Press, 2000.

Langer, Lawrence L. *The Holocaust and the Literary Imagination.* New Haven, CT: Yale University Press, 1975.

Lanzmann, Claude. "From the Holocaust to 'Holocaust.'" In Stuart Liebman, ed., *Claude Lanzmann's Shoah: Key Essays*, 27–36. Oxford: Oxford University Press, 2007.

———. *Shoah.* Paris: Éditions Fayard, 1985.

———. *Shoah: An Oral History of the Holocaust.* New York: Pantheon, 1985.

———. "Seminar with Claude Lanzmann, 11 April 1990." Transcribed by Ruth Larson. Edited by David Rodowick. *Yale French Studies* 79 (1991): 82–99.

———. "Site and Speech: An Interview with Claude Lanzmann about *Shoah*." With Marc Chevrie and Hervé Le Roux, in Stuart Liebman, ed., *Claude Lanzmann's Shoah: Key Essays*, 37–50. Oxford: Oxford University Press, 2007.

Laub, Dori, and Daniel Podell. "Art and Trauma." *International Journal of Psycho-Analysis* 76 (1995): 991–1005.

Lausberg, Heinrich. *Handbook of Literary Rhetoric: A Foundation for Literary Study.* Edited by David E. Orton and R. Dean Anderson. Leiden, The Netherlands: Brill, 1998.

Lessing, Gotthold Ephraim. *Hamburgische Dramaturgie, Werke,* vol. 4, edited by Herbert G. Göpfert et al. Munich: Hanser, 1973.

———. *Laocoön: An Essay on the Limits of Painting and Poetry.* Translated by Edward Allen McCormick. Baltimore, MD: Johns Hopkins University Press, 1984.

———. *Werke.* Edited by Herbert G. Göpfert et al. Munich: Carl Hanser, 1970–79.

Levine, Michael G. *The Belated Witness: Literature, Testimony, and the Question of Holocaust Survival.* Stanford: Stanford University Press, 2006.

———. "Pendant: Büchner, Celan, and the Terrible Voice of the Meridian." *MLN* 122.3 (2007): 573–601.

Leys, Ruth. *From Guilt to Shame: Auschwitz and After.* Princeton, NJ: Princeton University Press, 2007.

———. *Trauma: A Genealogy.* Chicago: University of Chicago Press, 2000.

Liebman, Stuart, ed. *Claude Lanzmann's Shoah: Key Essays.* Oxford: Oxford University Press, 2007.

Lübbe, Hermann. *Die Aufdringlichkeit der Geschichte: Herausforderungen der Moderne vom Historismus bis zum Nationalsozialismus.* Graz, Austria: Styria, 1989.

———. "Zeit-Verhältnisse," in Wolfgang Zacharias, *Zeitphänomen Musealisierung: Das Verschwinden der Gegenwart und die Konstruktion der Erinnerung.* Essen, Germany: Klartext-Verlag, 1990.

Lurz, Meinhold. *Kriegerdenkmäler in Deutschland.* 6 vols. Heidelberg, Germany: Esprint, 1985–87.

Lyon, James K. "Paul Celan and Martin Buber. Poetry as Dialogue." *PMLA* 86 (1971): 110–20.

———. *Paul Celan and Martin Heidegger: An Unresolved Conversation, 1951–1970.* Baltimore, MD: Johns Hopkins University Press, 2006.

Lyotard, Jean-François. *Heidegger and "the jews."* Translated by Andreas Michael and Mark Roberts. Minneapolis: University of Minnesota Press, 1990.

———. *The Differend: Phrases in Dispute.* Translated by Georges Van Den Abbeele. Minneapolis: University of Minnesota Press, 1988.

MacIntyre. Alisdair. "Relativism, Power, and Philosophy." In Michael

Krausz, ed., *Relativism: Interpretation and Confrontation*, 182–204. Notre Dame, IN: University of Notre Dame Press, 1989.

Mandel, Naomi. "Rethinking 'After Auschwitz': Against a Rhetoric of the Unspeakable in Holocaust Writing." *Boundary 2* 28.2 (2001): 203–28.

Mandelshtam, Osip. *The Complete Prose and Letters.* Edited by Jane Gary Harris. Translated by Jane Gary Harris and Constance Link. Ann Arbor, MI: Ardis, 1979.

———. *Sobranie sochinenii v chetyrex tomax.* [*Собрание сочинений в четырех томах*]. Edited by G. P. Struve and B. A. Filippov. Washington: Inter-Language Literary Associates, 1964–1981.

Margalit, Avishai. *The Ethics of Memory.* Cambridge, MA: Harvard University Press, 2002.

Marx, Karl. *Werke.* Edited by Hans-Joachim Lieber and Peter Furth. Darmstadt, Germany: Wissenschaftliche Buchgesellschaft, 1964.

McDowell, John. "Wittgenstein on Following a Rule." In *Mind, Value and Reality*, 221–62. Cambridge, MA: Harvard University Press, 1998.

Meinecke, Dietlind. *Wort und Name bei Paul Celan.* Bad Homburg, Germany: Gehlen, 1970.

Menke, Christoph. "Adorno's Dialectic of Appearance." In Michael Kelly, ed., *Encyclopedia of Aesthetics*, vol. 1, 20–23. Oxford: Oxford University Press, 1998.

———. "'Absolute Interrogation'—Metaphysikkritik und Sinnsubversion bei Jacques Derrida." *Philosophisches Jahrbuch* 97 (1990): 351–66.

———. *Die Souveränität der Kunst. Ästhetische Erfahrung nach Adorno und Derrida.* Frankfurt: Suhrkamp, 1991.

———. "Tugend und Reflexion. Die 'Antinomien der Moralphilosophie.'" In Axel Honneth, ed., *Dialektik der Freiheit: Frankfurter Adorno-Konferenz 2003*, 142–62. Frankfurt: Suhrkamp, 2005.

Menninghaus, Winfried. *Paul Celan: Magie der Form.* Frankfurt: Suhrkamp, 1980.

Meyers Großes Konversations-Lexikon. 6th ed. Leipzig/Vienna: Bibliographisches Institut, 1906.

Mitchell, W. J. T. *Picture Theory.* Chicago: University of Chicago Press, 1994.

Moran, Richard. "Getting Told and Being Believed." In Jennifer Lackey and Ernest Sosa, eds., *The Epistemology of Testimony*, 272–306. Oxford: Clarendon Press, 2006.

Morson, Gary Saul, and Caryl Emerson. *Mikhail Bakhtin: Creation of a Prosaics.* Stanford: Stanford University Press, 1990.

Mukarovsky, Jan. "Standard Language and Poetic Language." In Paul L.

Garvin, ed., *A Prague School Reader on Esthetics, Literary Structure, and Style*, 17–30. Washington, DC: Georgetown University Press, 1964.

Murasugi, Kimiko, and Robert Stainton, eds. *Philosophy and Linguistics.* Boulder, CO: Westview Press, 1999.

Musil, Robert. *Gesammelte Werke.* Edited by Adolf Frisé. Hamburg: Reinbek, 1981.

Nagel, Otto. *Käthe Kollwitz: Die Handzeichnungen.* Edited by Werner Timm. Stuttgart, Germany: Kohlhammer, 1980.

Naimark, Norman M. *The Russians in Germany: A History of the Soviet Zone of Occupation, 1945–1949.* Cambridge, MA: Harvard University Press, 1995.

Die Neue Wache als Ehrenmal für die Gefallenen des Weltkrieges. Berlin: Deutscher Kunstverlag, 1936.

Nietzsche, Friedrich. *Sämtliche Werke.* Edited by Giorgio Colli and Mazzino Montinari. Berlin/New York: Walter de Gruyter, 1967–77.

Nipperdey, Thomas. *Deutsche Geschichte 1800–1866.* Munich: C. H. Beck, 1987.

Nora, Pierre. "Between Memory and History: Les Lieux de Mémoire." *Representations* 26 (1989): 7–25.

Olschner, Leonard Moore. *Der feste Buchstab: Erläuterungen zu Paul Celans Gedichtübertragungen.* Göttingen, Germany: Vandenhoeck & Ruprecht, 1985.

Olsson, Anders. "Spectral Analysis: A Commentary on 'Solve' and 'Coagula.'" In Aris Fioretos, ed., *Word Traces: Readings of Paul Celan*, 267–79. Baltimore, MD: Johns Hopkins University Press, 1994.

Orte des Erinnerns. Vol 1: *Das Denkmal im Bayerischen Viertel*, and vol. 2: *Jüdisches Alltagsleben im Bayerischen Viertel.* Berlin: Edition Hentrich, 1994–95.

Otto, Rudolf. *Das Heilige.* Stuttgart: Perthes, 1917.

Parry, Christoph. *Mandelstamm der Dichter und der erdichtete Mandelstamm im Werk Paul Celans.* Inaugural dissertation, Marburg, 1978.

Perels, Christoph. "Erhellende Metathesen. Zu einer Verfahrensweise Paul Celans." In Hamacher, Werner, and Winfried Menninghaus, eds., *Paul Celan*, 127–38. Frankfurt: Suhrkamp, 1988.

Petuchowski, Elizabeth. "A New Approach to Paul Celan's 'Argumentum e Silentio.'" *Deutsche Vierteljahrsschrift für Literaturwissenschaft und Geistesgeschichte* 52 (1978): 111–36.

———. "Bilingual and Multilingual Wortspiele in the Poetry of Paul Celan." *Deutsche Vierteljahrsschrift für Literaturwissenschaft und Geistesgeschichte* 52 (1978): 635–51.

Pickford, Henry. "Dialectical Reflections on Peter Eisenman's 'Memorial for the Murdered Jews of Europe.'" *Architectural Theory Review* 17.2/3 (forthcoming 2012).

———. "Under the Sign of Adorno." In Simon Jarvis, ed., *Theodor W. Adorno: Critical Evaluations*, vol. 4, 106–23. New York: Routledge, 2007.

Pöggeler, Otto. "Dichtungstheorie und Toposforschung." *Jahrbuch für Ästhetik* 5 (1960): 89–201.

———. "Kontroverse zur Ästhetik Paul Celans." *Zeitschrift für Ästhetik und Allgemeine Kunstwissenschaft* 25 (1980): 202–43.

———. *Spur des Wortes. Zur Lyrik Paul Celans*. Freiburg, Germany: Karl Alber, 1986.

Raaberg, Gwen. "*Laokoon* Considered and Reconsidered: Lessing and the Comparative Criticism of Literature and Art." In Alexej Ugrinsky, ed., *Lessing and the Enlightenment*, 59–67. New York: Greenwood Press, 1986.

Rauterberg, Hanno. "Building Site of Remembrance." In Eisenman Architects, eds., *Holocaust Memorial Berlin*, unpaginated. Baden, Germany: Lars Müller, 2005.

Rawls, John. *Collected Papers*. Edited by Samuel Freeman. Cambridge, MA: Harvard University Press.

Recanati, François. "Open Quotation." *Mind* 110 (2001): 637–87.

———. *Oratio Obliqua, Oratio Recta: An Essay on Metarepresentation*. Cambridge, MA: MIT Press, 2000.

Reichert, Klaus. "Nachbemerkung." In Paul Celan, *Ausgewählte Gedichte*, 187–88. Frankfurt: Suhrkamp, 1970.

Reid, Thomas. *Inquiry and Essays*. Edited by R. Beanblossom and K. Lehrer. Indianapolis, IN: Hackett Publishing Company, 1983.

Renan, Ernest. *Oeuvres complètes*. Edited by Henriette Psichari. Paris: Calmann-Lèvy, 1947–61.

Richter, Simon. *Laocoon's Body and the Aesthetics of Pain*. Detroit, MI: Wayne State University Press, 1992.

Ricoeur, Paul. "Sartre and Ryle on the Imagination." In Paul A. Schilpp, ed., *The Philosophy of Jean-Paul Sartre*, 167–78. La Salle, IL: Open Court, 1981.

Riegl, Alois. *Der moderne Denkmalkultus. Sein Wesen und seine Entstehung*. Vienna, Austria: Braumüller, 1903.

Ritter, Joachim, ed. *Historisches Wörterbuch der Philosophie*. Basel: Schwalbe, 1971–2005.

Roberts, Matthew. "Poetics Hermeneutics Dialogics: Bakhtin and Paul

de Man." In Gary Saul Morson and Caryl Emerson, eds., *Rethinking Bakhtin: Extensions and Challenges*, 115–34. Evanston, IL: Northwestern University Press, 1989.

Rorty, Richard. "Inquiry as Recontextualization: An Anti-Dualist Account of Interpretation." In *Objectivity, Relativism, and Truth*, 93–112. Cambridge: Cambridge University Press, 1991.

———, ed. *The Linguistic Turn: Essays in Philosophical Method.* Chicago: University of Chicago Press, 1992.

Rosen, Michael. *On Voluntary Servitude: False Consciousness and the Theory of Ideology.* Cambridge, MA: Harvard University Press, 1996.

Rosenfeld, Alvin H. *A Double Dying: Reflections on Holocaust Literature.* Bloomington: Indiana University Press, 1980.

Ross, Angus. "Why Do We Believe What We Are Told?" *Ratio* 27.6 (1986): 69–88.

Rothberg, Michael. *Traumatic Realism: The Demands of Holocaust Representation.* Minneapolis: University of Minnesota Press, 2000.

Ryle, Gilbert. *The Concept of Mind.* Chicago: University of Chicago Press, 2002.

Saka, Paul. "Quotation and the Use-Mention Distinction." *Mind* 107 (1998): 113–35.

Sanders, Rino. "Erinnerung an Paul Celan." In Werner Hamacher and Winfried Menninghaus, eds., *Paul Celan*, 311–14. Frankfurt: Suhrkamp, 1988.

Santner, Eric. *Stranded Objects: Mourning, Memory and Film in Postwar Germany.* Ithaca, NY: Cornell University Press, 1990.

Sartre, Jean-Paul. *The Imaginary.* Translated by Jonathan Weber. New York: Routledge, 2004.

———. *L'Imagination.* Paris: Alcan, 1936. Translated by Forrest Williams as *Imagination: A Psychological Critique.* Ann Arbor: University of Michigan Press, 1962.

Schadewalt, Wolfgang. "Furcht und Mitleid? Zur Deutung der Aristotelischen Tragödiensatzes." In Matthias Luserke, ed., *Die Aristotelische Katharsis: Dokumente ihrer Deutung im 19. und 20. Jahrhundert*, 246–88. Hildesheim, Germany: Olms, 1991.

Schinkel, Karl Friedrich. *Collection of Architectural Designs.* Edited by Kenneth Hazlett, Stephen O'Malley, and Christopher Rudolph. New York: Princeton Architectural Press, 1981.

Schlegel, Friedrich. *Kritische Ausgabe.* Edited by Ernst Behler. Paderborn, Germany: Schöningh, 1963.

Schmidt, Thomas E., Hans-Ernst Mittig, Vera Böhm et al., eds. *Nationaler*

Totenkult: die Neue Wache. Eine Streitschrift zur zentralen deutschen Gedenkstätte. Berlin: Karin Kramer Verlag, 1995.

Schneewind, J. B. *The Invention of Autonomy.* Cambridge: Cambridge University Press, 1998.

Schrade, Hubert. *Das deutsche Nationaldenkmal: Idee/Geschichte/Aufgabe.* Munich: Albert Langen/Georg Müller, 1934.

———. *Sinnbilder des Reiches.* Munich: Albert Langen/Georg Müller, 1938.

Schweppenhäuser, Gerhard. "Adorno's Negative Moral Philosophy." In Tom Huhn, ed., *The Cambridge Compantion to Adorno*, 328–54. Cambridge: Cambridge University Press, 2004.

———. *Ethik nach Auschwitz: Adornos negative Moralphilosophie.* Hamburg, Germany: Argument-Verlag, 1993.

Schwerin, Christoph. "Bitterer Brunnen des Herzens. Erinnerungen an Paul Celan." *Der Monat* 2, no. 279 (1981): 73–81.

Searle, John. "Proper Names." *Mind* 67 (1958): 166–73.

———. *Speech Acts.* Cambridge: Cambridge University Press, 1969.

Shentalinsky, Vitaly. *Arrested Voices: Resurrecting the Disappeared Writers of the Soviet Regime.* Translated by John Crowfoot. New York: Free Press, 1996.

Sibley, Frank. "Aesthetic Concepts." In John Benson, Betty Redfern, and Jeremy Roxbee Cox, eds., *Approach to Aesthetics: Collected Papers on Philosophical Aesthetics*, 1–23. Oxford: Clarendon Press, 2001.

Sichorovsky, Peter. *Born Guilty: The Children of the Nazis.* Translated by Jean Steinberg. London: I. B. Taurus, 1988.

Spargo, R. Clifton. "Introduction: On the Cultural Continuities of Literary Representation." In R. Clifton Spargo and Robert H. Ehrenreich, eds., *After Representation? The Holocaust, Literature, and Culture*, 1–22. New Brunswick, NJ: Rutgers University Press, 2010.

Speier, Hans-Michael. "Zum Verhältnis von Ästhetik, Geschichtlichkeit und Sprachsetzung im Spätwerk Celans." In Chaim Shoham and Bernd Witte, eds., *Datum und Zitat bei Celan*, 97–121. Bern, Switzerland: Peter Lang, 1987.

Spiegelman, Art. "Commix: An Idiosyncratic Historical and Aesthetic Overview." *Print*, November–December 1988: 61–73, 195–96.

———. "Interview with Art Spiegelman." *Talk of the Nation*, National Public Radio, February 20, 1992.

———. "Letter to the Editor." *New York Times Book Review* (December 29, 1991): 4.

———. *Maus: A Survivor's Tale.* Vols. I and II. New York: Pantheon, 1986, 1991.

———. "Mightier than the Sorehead." *The Nation*, January 17, 1994: 45–46.

Spiegelman, Art, and Françoise Mouly, eds. *Read Yourself Raw*. New York: Pantheon, 1987.

Stih, Renata, and Frieder Schnock. *Arbeitsbuch für ein Denkmal in Berlin: Orte des Erinnerns im Bayerischen Viertel—Ausgrenzung und Entrechtung, Vertreibung, Deportation und Ermordung von Berliner Juden in den Jahren 1933 bis 1945*. Berlin: Gatza Verlag, 1993.

Stölzl, Christoph, ed. *Die Neue Wache Unter den Linden: Ein deutsches Denkmal im Wandel der Geschichte*. Berlin: Koehler & Amelang, 1993.

Sturken, Marita. "The Wall, the Screen, and the Image: The Vietnam Veterans Memorial." *Representations* 35 (1991): 118–42.

Szász, János. "'Es ist nicht so einfach . . . ': Erinnerungen an Paul Celan; Seiten aus einem amerikanischen Tagebuch." In Werner Hamacher and Winfried Menninghaus, eds., *Paul Celan*, 325–37. Frankfurt: Suhrkamp, 1988.

Szondi, Peter. "Durch die Enge geführt. Versuch über die Verständlichkeit des modernen Gedichts." In *Schriften 2*, 345–89. Frankfurt: Suhrkamp, 1978.

———. "Eden." In *Schriften 2*, 390–400. Frankfurt: Surhkamp, 1978.

Terras, Victor, and Karl S. Weimar. "Mandelstam and Celan: Affinities and Echoes." *Germano-Slavica* 1.4 (1974): 11–29.

———. "Mandelshtam and Celan: A Postscript." *Germano-Slavica* 2.5 (1978): 353–70.

Theißen, Hermann. "Die Bundesrepublik auf dem Weg nach Deutschland." In Schmidt, Mittig, and Böhm, eds., *Nationaler Totenkult: Die Neue Wache. Eine Streitschrift zur zentralen deutschen Gedenkstätte*, 87–97. Berlin: Karin Kramer Verlag, 1995.

Tiedemann, Rolf. "'Not the First Philosophy, But a Last One': Notes on Adorno's Thought." In T. W. Adorno, *Can One Live After Auschwitz? A Philosophical Reader*, x–xxvii. Translated by Rodney Livingston et al. Stanford: Stanford University Press, 2003.

Tobias, Rochelle. *The Discourse of Nature in the Poetry of Paul Celan*. Baltimore, MD: Johns Hopkins University Press, 2006.

Todd, William Mills, III. *Fiction and Society in the Age of Pushkin*. Cambridge, MA: Harvard University Press, 1986.

Topfstedt, Thomas. *Städtebau in der DDR, 1955–71*. Leipzig, Germany: Seemann, 1988.

Trilling, Lionel. *Sincerity and Authenticity*. Cambridge, MA: Harvard University Press, 1972.

Tugendhat, Ernst. *Self-Consciousness and Self-Determination*. Translated by Paul Stern. Cambridge, MA: MIT Press, 1986.

————. *Traditional and Analytical Philosophy: Lectures on the Philosophy of Language*. Translated by P. A. Gorner. Cambridge: Cambridge University Press, 2010.

Turner, Victor. *The Forest of Symbols. Aspects of Ndembu Ritual*. Ithaca, NY: Cornell University Press, 1967.

Van Alphen, Ernst. *Caught by History: Holocaust Effects in Contemporary Art, Literature, and Theory*. Stanford: Stanford University Press, 1997.

Varnum, Robin, and Christina T. Gibbons, eds. *The Language of Comics: Word and Image*. Jackson: University Press of Mississippi, 2001.

Veichtblauer, Judith, and Stephan Steiner. "Heimard Bäcker. 'Die Wahrheit des Mordens.' Ein Interview." In Thomas Eder and Klaus Kastberger, eds., *Die Rampe. Porträt Heimrad Bäcker*, 85–88. Linz, Austria: Trauner, 2001.

Vernichtungskrieg: Verbrechen der Wehrmacht, 1941 bis 1944, ed. Hamburger Institut für Sozialforschung. Hamburg, Germany: Hamburger Edition, 1996.

Wagner-Pacifici, Robin, and Barry Schwartz. "The Vietnam Veterans Memorial: Commemorating a Difficult Past." *American Journal of Sociology* 97.2 (1991): 376–420.

Walton, Kendall. *Mimesis as Make-Believe*. Cambridge, MA: Harvard University Press, 1990.

Warnock, Mary. *Imagination*. Berkeley: University of California Press, 1976.

Washington, Corey. "The Identity Theory of Quotation." *Journal of Philosophy* 89 (1992): 582–605.

Weigel, Sigrid. "Zur Dialektik von Dokumentation und Zeugnis in Heimrad Bäckers 'System *nachschrift*.'" In Thomas Eder and Martin Hochleitner, eds., *Heimrad Bäcker*, 256–61. Graz, Austria: Droschl, 2002.

Wellbery, Davide E. *Lessing's Laocoon: Semiotics and Aesthetics in the Age of Reason*. Cambridge: Cambridge University Press, 1984.

Wellmer, Albrecht. "Truth, Semblance, Reconciliation: Adorno's Aesthetic Redemption of Modernity." In *The Persistence of Modernity: Essays on Aesthetics, Ethics, and Postmodernism*, 1–35. Translated by David Midgley. Cambridge, MA: MIT Press, 1991.

————. *Zur Dialektik von Moderne und Postmoderne. Vernunftkritik nach Adorno*. Frankfurt: Suhrkamp, 1985.

Der Wettbewerb für das "Denkmal für die ermordeten Juden Europas." Eine Streitschrift. Berlin: Verlag der Kunst, 1995.

Wheeler, Samuel C., III. *Deconstruction as Analytic Philosophy*. Stanford: Stanford University Press, 2000.

————. "Indeterminacy of French Interpretation: Derrida and Davidson." In E. LePore, ed., *Truth and Interpretation: Perspectives on the Philosophy of Donald Davidson*, 477–94. Oxford: Blackwell, 1986.

Williams, Bernard. "Imagination and the Self." In *Problems of the Self: Philosophical Papers 1956–1972*, 26–45. Cambridge: Cambridge University Press, 1973.

Witek, Joseph, ed. *Art Spiegelman: Conversations*. Jackson: University Press of Mississippi, 2007.

———. *Comic Books as History: The Narrative Art of Jack Jackson, Art Spiegelman, and Harvey Pekar*. Jackson: University Press of Mississippi, 1989.

Wittgenstein, Ludwig. *The Blue and the Brown Books*. New York: Harper, 1958.

———. *Philosophical Investigations*. 2d ed. Translated by G. E. M. Anscombe. Oxford: Blackwell, 1958.

———. *Remarks on the Foundations of Mathematics*. Revised edition by G. H. von Wright, R. Rhees, and G. E. M. Anscombe. Translated by G. E. M. Anscombe. Cambridge, MA: MIT Press, 1983.

———. *Zettel*. Edited by G. E. M. Anscombe and G. H. von Wright. Translated by G. E. M. Anscombe. Berkeley: University of California Press, 1967.

Young, James E. *At Memory's Edge: After-Images of the Holocaust in Contemporary Art and Architecture*. New Haven, CT: Yale University Press, 2002.

———, ed. *Mahnmale des Holocaust: Motive, Rituale und Stätten des Gedenkens*. Munich: Prestel, 1994.

———. *The Texture of Memory: Holocaust Memorials and Meaning*. New Haven, CT: Yale University Press, 1993.

———. *Writing and Rewriting the Holocaust: Narrative and the Consequences of Interpretation*. Bloomington: Indiana University Press, 1988.

Zemach, Eddy. "What Is an Aesthetic Property?" In Emily Brady and Jerrold Levinson, eds., *Aesthetic Concepts: Essays After Sibley*, 47–60. Oxford: Clarendon Press, 2001.

Zuidervaart, Lambert. *Adorno's Aesthetic Theory: The Redemption of Illusion*. Cambridge, MA: MIT Press, 1991.

INDEX

addressivity, 23, 40, 41, 42
Adorno, Theodor W.: *Aesthetic Theory,*
4, 6, 14, 73, 209; Anglophone
philosophy would benefit aesthetics
of, 13–14, 210; on art making
determinate its irreconcilability, 7,
14; on artworks as a priori negative,
137; on artworks as systems of
irreconcilability, 1, 14, 209–10; on
artworks revealing ever new layers,
17; on "Auschwitz," 212n6; on
constitutive tension between poles
of artwork, 4, 5–6, 14; dialectic of
aesthetic semblance, 4–8, 17–18,
209; on expression as phenomenon
of interference, 184; fascination
with Celan, 227n148; on future of
art, 73; on instrumentalization, 12;
on internal and external approaches
to art, 204; on invoking ideals
and suffering of others, 136; on
mimesis, 193; on modernity, 76;
on moral imperative of aesthetic
relation, 208; on morality of
thought, 210; on new categorical
imperative, 206; on normatively
minimalist framework for art, 7,
16; on riddle-character of art, 7,
14; on self-conscious spontaneity
of thought, 209; on true basis of
morality, 207; on writing poetry
after Auschwitz, 198, 206–7,
212n9
aesthetics: aesthetic autonomy, 4, 6–8,
15, 17–18, 41, 43, 61, 62, 166,
167; aesthetic distanciation, 144;
aesthetic heteronomy, 4, 6, 7, 8,
9, 17, 166, 209; applied normative
philosophical, 1–3; dialectic of
aesthetic semblance, 4–8, 13,
14, 17–21, 31, 39–40, 51, 61,

67, 72, 136, 209, 210; functional
definition of aesthetic properties,
206, 251n14; genuine artworks as
resistant to aesthetic categories,
208; Idealist versus deconstructive
theories of, 18; open-ended
experiences, 198; relationship to
nonaesthetic, 5, 6, 17–18, 20
Aesthetic Theory (Adorno), 4, 6, 14,
73, 209
Altun, Cemal, 80
analogon, 170, 180, 185, 189, 195
Anscombe, G. E. M., 157–58
Arendt, Hannah, 70, 229n202
Aristotle, 107, 195, 235n52
Aschrott-Brunnen (Kassel), 117–18
assurance view of testimony, 199–203,
210

Bäcker, Heimrad, 137–59; Anglophone
philosophy for understanding work
of, 15; concrete poetry, 3, 15, 137,
139, 147, 150–52; in Hitler Youth,
138; poetics of quotation of, 150–
53. *See also* system *nachschrift*
Bakhtin, Mikhail, 19–21, 22, 23, 26,
41, 217n12
Balmont, Konstantin Dmitriyevich, 24,
25–26
Bavarian Quarter memorial (Berlin),
124–36; as civil memorial, 135;
controversy surrounding, 75; as
counter-monument, 236n74; as
decentralized, 125; disintegrates
traditional category of unified
artwork, 128–30; interaction
between text, image, location, and
everyday practice, 125, 127; and
materialist theory of meaning,
208–9; as performance landscape,
121; purpose of, 125; shows that

poems resist hermeneutical subsumption, 65; deconstruction versus, 17, 31; Gadamer's Idealist, 61–62
"Hinausgekrönt" (Celan), 71
Hitler, Adolf: Adorno on new categorical imperative of, 206; Bäcker's *nachschrift* contains facsimiles of writing of, 149; Bäcker's review of biography of, 138, 239n7; bunker of, 119; failed attempt on life of, 84, 106; *Mein Kampf,* 147–48, 158; quoted in Spiegelman's *Maus,* 192; at wreath-laying ceremony at Neue Wache, 90
Hofgarten (Berlin), 97
Hoheisel, Horst, 117–18
Holocaust artworks: Anglophone philosophy for illuminating, 14–15; Bäcker's system *nachschrift,* 138, 139; condemning the Holocaust, 3–4; defining, 3–4; monument versus document interpretations of, 18; morality of, 204–10; normative criteria of judgment for, 1–3, 204–5, 209; normatively minimalist framework for, 7, 16; postmodernism and study of, 8–15; two requirements for, 2, 3–4, 15. *See also* Bäcker, Heimrad; Celan, Paul; Holocaust memorials
Holocaust memorials, 115–24; aesthetic versus documentary aspects of, 10; evaluative criteria for, 2; political controversies surrounding, 1, 116; slippage from memorials for memory to memorials about memory, 121. *See also* Bavarian Quarter memorial; "Memorial for the Murdered Jews of Europe"; Neue Wache ("New Watch")
"Horseshoe-Finder, The" (Mandelshtam), 60, 65
Hume, David, 167, 170, 199
Husserl, Edmund, 32, 34, 35, 36, 57, 59
Huyssen, Andreas, 193, 239n100

Idealism, 14, 18, 19, 24–25, 210
identity: collective, 75, 77, 79–82; contexts of, 80, 82
imagination: aesthetic-historical imaginary, 184, 198; in central tension of art, 2; epistemic role of, 164–65; Lessing on art and, 162–63; *Maus* and the schematic imaginary, 184–98; and memory, 168–69, 171, 174–75; Sartre on, 167–70, 171,

176, 177–78, 180, 181, 187; *Shoah* as mise-en-scène of the imaginary, 175–84; typology of, 170–71; of witnesses, 171–72, 177–78
"In Eins" (Celan), 69–70, 229n198
institutional theory of art, 206
instrumentalization, 10, 11–12
irony, 158–59

Jakobson, Roman, 106, 144
Jameson, Fredric, 229n183
Jandl, Ernst, 137
Jetztsein, 59
Johnson, Barbara, 222n97
Journey to Armenia (Mandelshtam), 55, 227n155, 228n173

Kamen' (Mandelshtam), 27, 41, 44, 50
Kant, Immanuel, 4, 5, 10, 13, 206, 213n18
Kaplan, Brett Ashley, 10
Kaplan, David, 145, 241n29, 242n52
Kassel, 117–18
Khlebnikov, Velimir, 26, 30
Kirchheimer, Otto, 131
Knapp, Steven, 230n6
knowledge: epistemic role of imagination, 164–65; epistemology of testimony, 170–75, 198–203, 250n114; expressive, 16, 164, 172–75, 194–95, 198, 201, 202, 203, 246n41, 246n44; mimetic basis of, 207–8; practical versus contemplative, 158; propositional, 164, 172, 174, 181–82, 194, 198, 202–3; Sartre on imagination and, 168, 169, 172; tacit, 133–35, 210, 239n99
Koch, Gertrud, 175, 178–79, 180, 181, 184, 247n48
Kohl, Helmut, 74, 77, 84, 97–99, 102–3, 107, 108, 114, 122
Kollwitz, Käthe: death of her son, 99–100, 233n36, 233n37, 234n39, 235n57; "Death with a Woman in Her Lap," 101, *103,* 234n41; diverging receptions in West and East Germany, 107–8; Karl Liebknecht memorial woodcut, 107, *108; Pietà* of 1903, 100, *102;* sculpture in Neue Wache, 98, 99–103, *101,* 108–9, 116, 123
"konkrete dichtung" (Bäcker), 151–52
Koselleck, Reinhart, 109, 235n55, 235n56
Kracauer, Siegfried, 76, 88–89, 136
Kripke, Saul, 15, 36, 222n82